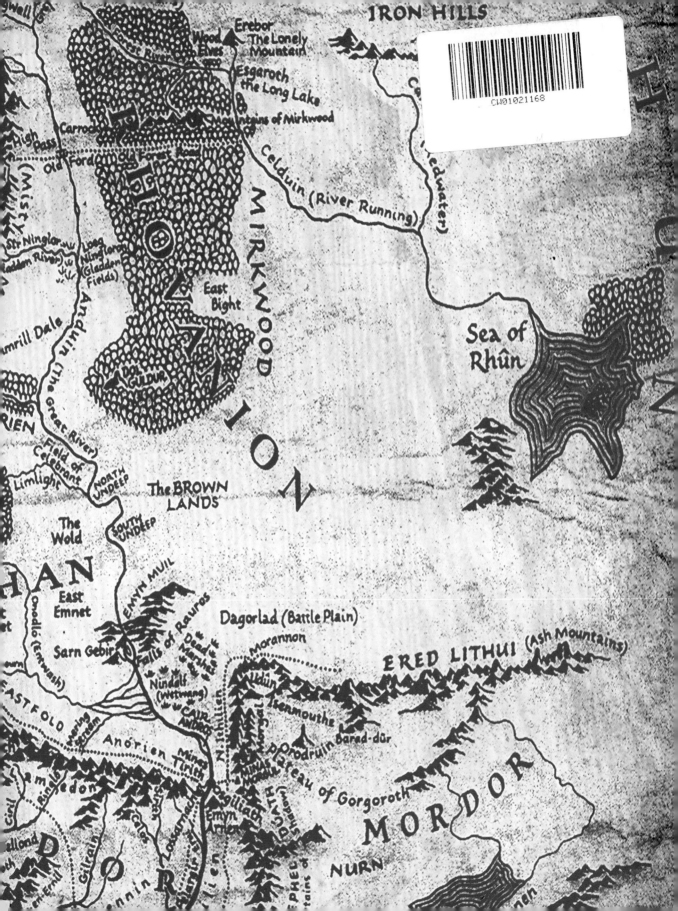

Polygon

Year of the Ring

INSIGHT EDITIONS

SAN RAFAEL · LOS ANGELES · LONDON

CONTENTS

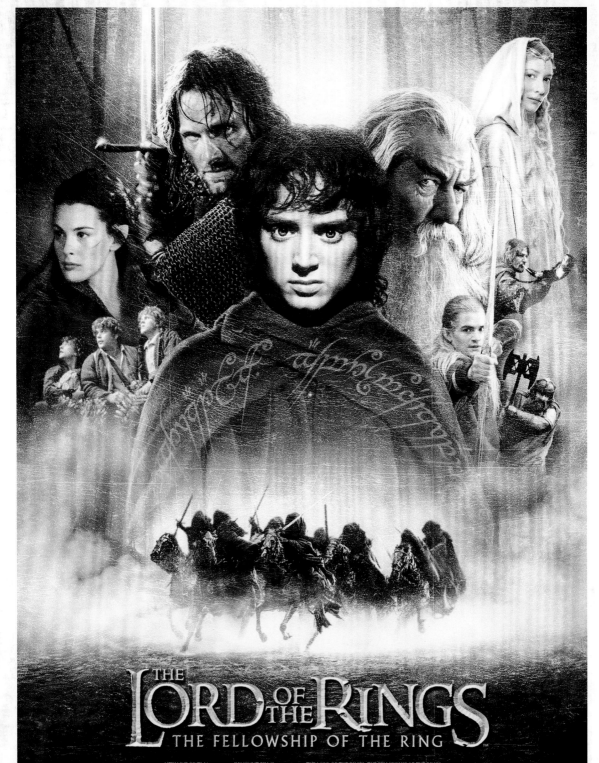

THE LORD OF THE RINGS
THE FELLOWSHIP OF THE RING

NEW LINE CINEMA PRESENTS A WINGNUT FILMS PRODUCTION "THE LORD OF THE RINGS: THE FELLOWSHIP OF THE RING"
ELIJAH WOOD IAN McKELLEN LIV TYLER VIGGO MORTENSEN SEAN ASTIN CATE BLANCHETT JOHN RHYS-DAVIES BILLY BOYD DOMINIC MONAGHAN ORLANDO BLOOM
CHRISTOPHER LEE HUGO WEAVING FEATURING SEAN BEAN AND IAN HOLM WITH ANDY SERKIS AS GOLLUM CASTING JOHN HUBBARD AND AMY MacLEAN COSTUME DESIGNER NGILA DICKSON RICHARD TAYLOR
SPECIAL MAKEUP CREATURE ARMOUR AND MINIATURE EFFECTS WETA LTD. NZ VISUAL EFFECTS SUPERVISOR JIM RYGIEL MUSIC BY HOWARD SHORE FILM EDITOR JOHN GILBERT PRODUCTION DESIGNER GRANT MAJOR DIRECTOR OF PHOTOGRAPHY ANDREW LESNIE A.C.S. ASSOCIATE PRODUCER ELLEN M. SOMERS CO-PRODUCERS RICK PORRAS JAMIE SELKIRK
EXECUTIVE PRODUCERS MARK ORDESKY BOB WEINSTEIN HARVEY WEINSTEIN PRODUCED BY ROBERT SHAYE MICHAEL LYNNE PRODUCERS BARRIE M. OSBORNE PETER JACKSON FRAN WALSH TIM SANDERS BASED ON THE BOOK BY J.R.R. TOLKIEN
PG-13 PARENTS STRONGLY CAUTIONED SCREENPLAY BY FRAN WALSH & PHILIPPA BOYENS & PETER JACKSON DECEMBER 19 DIRECTED BY PETER JACKSON
EPIC BATTLE SEQUENCES AND SOME SCARY IMAGES

AMERICA ONLINE KEYWORD: Lord of the Rings www.lordoftherings.net

FOREWORD

As with Mordor, one does not simply walk into a celebration of *The Lord of the Rings.*

When Polygon's Middle-earth scholar, Susana Polo, first broached the topic of paying tribute to Peter Jackson's trilogy on the occasion of *The Fellowship of the Ring*'s 20th anniversary, we immediately realized there couldn't be just one story to rule them all. Maybe that worked for Sauron, but it wasn't right for sizing up the staying power of one of the all-time great movie series.

The stakes were too high. Fans had spent 20 years thinking about *The Lord of the Rings*, and Jackson, through making-of diaries, Extended Edition special features, and screening Q&As, had told them countless tales from his time in the fantasy-friendly biomes of New Zealand. But as fans ourselves, we wanted any excuse to revel in what looked more and more like a cinematic miracle. We went there in the early 2000s, and we were desperate to go back again. But how?

J.R.R. Tolkien's rich and intricate world-building could easily go overlooked in a gushing appreciation of the adaptation—so we had to go micro. But *The Lord of the Rings* is as epic as epics get—so whatever we did had to feel as big as Frodo and the Fellowship's quest. The answer, forged from the fires of Eregion, was the Year of the Ring, a yearlong commitment to going deep on all things Rings, which would be possible only with time, distance, and a small army of curious folk.

The big question at the heart of every story in this book is "How?" How did Jackson carry the trilogy over a finish line that few could even imagine, let alone see? From the early days of Tolkien's conception of the saga through Hollywood's fires of development hell to the endless scroll of fantasy TikTok, there were plenty of times when the *Lord of the Rings* movies could have gone horribly awry. A nine-figure price tag does not buy a legacy. But Jackson, his essential collaborators, Fran Walsh and Philippa Boyens, and a troupe of actors and crew members who couldn't have possibly understood what they were really signing up for did the thing. To this day, the *Lord of the Rings* movies still play in theaters packed with cheering crowds, thanks to thousands of tiny choices.

The Year of the Ring puts those choices—and their modern legacies—under a microscope. Understanding the trilogy on a molecular level required an immense amount of research and reconsideration from Susana (not to mention hundreds of emails to equally sophisticated *LOTR* buffs, many of whom contributed to this book). If you thought Frodo and Sam had it rough, try curating 52 weeks' worth of thought-provoking, expectation-inverting writing about one of the 20th century's best-known pieces of pop culture! Success meant poring through history books, scouring defunct webpages, and not allowing any piece of the trilogy to feel too precious (*my precious*). Every bit of meat was back on the menu when it came to devouring *The Lord of the Rings* with new perspective. The results should surprise you. They surprised us.

The Lord of the Rings trilogy changed the lives of those involved and those of the viewers who have come to cherish it. As these stories written and compiled by Susana illustrate, it continues to do so.

Matt Patches, Executive Editor

A LONG-AWAITED BOOK

This book began, as many good stories—and many good Tolkien stories—do: humbly, ingenuously, and in a state rather different from the final result. As Tolkien says in his own foreword to the second edition of *The Lord of the Rings*, "This tale grew in the telling." And this tale grew from a Zoom meeting in late 2020, when my editor, Matt Patches, and I were tossing ideas around.

We're both editors on the entertainment team at Polygon.com, which is to say that we were in charge of figuring out how to create entertaining writing about as many aspects of pop entertainment as possible—with the exception of games. (And also, sometimes, games.) On the agenda that day was finding a long-term editorial project for the new year. Ideally, something that would be independent of our usual news cycles of film and television and comic book releases.

This is a bit of a holy grail for folks in our line of work, if I'm allowed to borrow a MacGuffin from a different fantasy tradition. Covering news as it breaks, and entertainment as it gets watched and read and played; that's groceries. But a feature series? That's a weekly dinner at a nice restaurant. That's one night a week you don't have to open the refrigerator (utilize all the different ways journalists have of discovering news to write about) and figure out how you're going to make a meal out of this (whatever it is that the entertainment industry, or artists, or fans, or celebrities are or aren't doing at the moment). It still takes work—nice restaurants don't pay for themselves—but in the best case it can be more thoughtful and less reactive, and you don't have to do the dishes after. (I'm not sure what the dishes are in this metaphor; I just hate doing the dishes.)

And if the series is on a subject we know will pique reader interest even though it's not the new, shiny thing? That's kind of like making your own

new, shiny thing. In 2020, Polygon's entertainment team had had to do a lot of that, as theatrical releases screeched to a halt, television production shut down, and even the American monthly comics industry ceased production for a stretch. New, shiny things had, in general, been in short supply.

We didn't know what 2021 would hold. Vaccines, presumably, but movies? New TV? More coronavirus waves? There was one thing we could be certain about: December 2021 would mark the 20th anniversary of the release of *The Fellowship of the Ring*. It was Matt who asked, speculatively, if we could publish some kind of feature about Peter Jackson's *Lord of the Rings* trilogy every week of 2021.

We didn't know what 2021 would hold.

"Do I think we can come up with 52 things to say about the *Lord of the Rings* movies?" I remember scoffing. "Uh, *yeah*." I can now recognize that this was my "I will take the ring to Mordor" moment, and that maybe I shouldn't have been sarcastic about it.

This was my quest: I would ensure that, on every Wednesday in 2021, Polygon published a feature related in some way to the trilogy.

I'm fairly confident that no blood was involved in the making of Polygon's Year of the Ring, but there was certainly sweat and tears. In 2021, I only

had two answers to "Hey! How's it going, Susana?": Either "Well, I know what we're doing for Year of the Ring next week" (this meant *Oh, pretty normal, can't complain*) or "I don't know what we're doing for Year of the Ring next week" (this meant *Terrible. End of the world. No light in tunnel, nothing will ever taste sweet again.*). But by the time we published the last article on Wednesday, Dec. 29, 2021, it was, as Elijah Wood says as Frodo at Mount Doom, "*done.*" And while sometimes a post may have gone up on the *later* end of the work day, none of them missed their Wednesday deadline. And they were all, if I may say so, interesting writing, entertaining writing, edifying writing, or vital writing. And most of the time more than one of those.

And now you get to hold them in your hands! Here you'll find a year's worth of features (most essays, some interviews, some lists, some . . . stranger still) lightly adapted for the wonderfully tactile and noninteractive format of a book. They are mostly the same pieces that were originally published on Polygon as the Year of the Ring project.

Some pieces in the Year of the Ring project just weren't suitable for the printed page, for a variety of dry reasons. In the cases where we had to drop a Year of the Ring piece, we've swapped in another Polygon piece of interesting, entertaining, edifying, or vital writing on Jackson's movies. All this really means is that when you close the cover on this tome, there'll still be more waiting for you to read on Polygon.com itself. Including one of my personal favorite pieces, "The Orc-Daddies of Middle-Earth, Ranked," which had to be cut not because it was too spicy for the good folks at Insight Editions, but because it just really didn't hit the same without a picture of each orc-daddy in all his glory.

And what will you have read by the time you close the cover of this book? Some of them are pieces I knew I wanted in Year of the Ring from the moment it began, like author and former editor of Star Trek.com Kendra James' memoir of that unfairly maligned demographic, Legolas fangirls (page 138). Others dropped completely into my lap, like when *The Owl House*'s Molly Knox Ostertag—whose Sam/Frodo fancomics I'd been appreciating all quarantine—emailed to ask if she

Some were stories I didn't even know needed to be told until a writer showed up with them . . .

could write an illustrated essay on the topic of queerness and *The Lord of the Rings* (page 202). Some were ideas that were just waiting for the right writer, as when the Reverend Tom Emanuel pitched me something completely different, only to prove a perfect voice to write about how the Jackson trilogy was received by conservative American Christians (page 198). Some were stories I didn't even know needed to be told until a writer showed up with them, like James Grebey's profile of Brett Beattie, the actor and stuntman who appears both as Gimli and one of the trilogy's best-kept secrets (page 42). You'll also find a piece about the origin of orcs and the history of the "monster race" in fantasy fiction that is entirely unique to this book (page 175). It's a subject that we never quite got the right pitch for in 2021, creating a gap in the original Year of the Ring project that this book gave me the opportunity to rectify.

The first piece I wrote for the Year of the Ring remains one of my favorites in it. It was the series' kickoff essay, a pouring-out of my own love for a story that tells the reader that, in hard times, despair is an easy illusion and hope is the difficult and only solution; an idea that had come to feel acutely vital (page 233). It was published confidently, innocently, and optimistically on the morning of January 6, 2021.

So the other things you'll find within the covers of this book include references to the state of the world in 2021, from the COVID-19 pandemic to pop culture. Netflix's *The Queen's Gambit* was big at the time. Amazon Prime Studios was in production on the first season of *The Lord of the Rings: The Rings of Power* but had yet to announce the series' name. Wētā Digital, the New Zealand–based visual-effects company that produced the trilogy's digital effects, had not yet changed its name to Wētā FX. The Max streaming service was still called HBO Max. X was still called Twitter. By the

time you read this, for all I know, it may no longer be called anything.

As Cate Blanchett says as Galadriel in the opening of *The Fellowship of the Ring*, "The world is changed," and no doubt it will continue to. I am writing this in 2023. If you're reading it at any time in 2025, you are as far from the me sitting in my armchair working on this introduction as I am from the me sitting in my desk chair writing and editing the essays in this book.

But that's why we're here, isn't it, you and I? Because no matter how things change, *The Lord of the Rings* doesn't seem to reach the limit of its relevance. And more than two decades after the release of Peter Jackson's *The Fellowship of the Ring*, it's safe to say that Jackson and the many, many filmmakers on his team adapted that sublime aspect of Tolkien's work as well. As Molly Knox Ostertag, in this very book, quotes Italo Calvino, a classic is a work "that has never finished what it has to say."

As you embark on this journey through everything we had to say about *The Lord of the Rings*, as Bilbo said at his long-awaited birthday party, "I hope you are all enjoying yourself as much as I am."

Because no matter how things change,
The Lord of the Rings
doesn't seem to reach the limit of its relevance.

HOW TO READ THIS BOOK

There are multiple ways to read this book. First, obviously, you can read it through front to back. We've tried to present the pieces in a satisfying way, grouped by various themes. You can also read it in whatever order you want—each piece is written to stand on its own.

And there's another way. A slower, more methodical way, that just might make you see *The Lord of the Rings* in an entirely new light.

We originally named this project the "Year of the Ring" because it was a feature column that came out every week of the 20th-anniversary year of *The Fellowship of the Ring*. But that presented a new puzzle when it came time to put it all in a book: If a book's cover says *Year of the Ring*, what does that imply about its pages? The anniversaries of the films are long gone now, and a book, unlike a column in a periodical, doesn't get parceled out over a year.

We'd already found a title that fit a concept. Now we'd have to fit the concept to the title. We were aided by one of the nerdier hobbies I've ever had, one that in part inspired the Year of the Ring in the first place.

ON THIS DAY IN THE *LORD OF THE RINGS* . . .

I used to run @OnThisDayinLOTR, a deliciously pedantic Lord of the Rings–themed Twitter account that tweeted the events of J.R.R. Tolkien's fantasy saga on the calendar dates on which they occurred. This was an act made possible by the blessed, superlative pedantry of Tolkien himself, who once revised several chapters of his epic because he realized he'd gotten the phases of the moon wrong.

In the second appendix of *The Return of the King*, the Professor provided a 3,000-year-plus timeline that detailed events relating to Frodo's quest and the War of the Ring. His dates were based on the Shire calendar, which is roughly analogous to ours.

Combine that with a careful reading of the text of *The Lord of the Rings*, and it's not difficult at all to pinpoint even minor moments, like the day that Pippin drops his elven brooch for Aragorn, Legolas, and Gimli to find or when Aragorn and the hobbits spend a night sleeping under the petrified remains of the trolls that nearly ate Bilbo in *The Hobbit*.

Needless to say, I did that careful reading. Then I fed all my work into a Google calendar file and started tweeting the events on their days, accompanied by appropriate screencaps from Peter Jackson's Lord of the Rings movies—because I knew from my professional life that tweets get more engagement when they have images.

I first wrote about what running @OnThisDayinLOTR had taught me about *The Lord of the Rings* for Polygon in 2020. In 2021, I repurposed that piece, with more pandemic-related insight, for the Year of the Ring. And here I am in 2023, repurposing it again for the structure of the book you hold in your hands.

YOU CAN READ THIS BOOK LIKE A *LORD OF THE RINGS* CALENDAR

Because we've structured it like one.

Our starting point is September, the month of Frodo and Bilbo's birthday, and the month Frodo leaves Bag End to hike out to Rivendell to deliver a magic artifact into safe hands and visit with his uncle, who had scandalously absconded there 17 years previously. Then October, when the Hobbits reach Rivendell and the Council of Elrond occurs.

In November we hit our first story lull, when the Fellowship is resting and waiting before setting out on their quest, and you'll find our first themed months, before the story picks back up again for the winter and spring, and then slows back down to *The Lord of the Ring*'s lazy late spring and summer months, where we've stashed lots more pieces that don't directly relate to specific events of the War of the Ring.

So, if you're so inclined, you can read *The Year of the Ring* along with your year and then some, as the story of *The Lord of the Rings* laps itself for a second September, October, and November. And you can follow along with the events of *The Lord of the Rings* using the timeline running through the book which will teach you a lot of unforgettable details about *The Lord of the Rings*.

For example, did you know that about two-thirds of the plot happens in March? The Fellowship splits up on February 26, and the Ring is destroyed a mere four weeks later on March 25. (Not coincidentally, March is one of the largest sections of this book.)

We all know that Gandalf died while defeating the Balrog, but did you know that between the beginning of their battle on the Bridge of Khazad-dûm and its end on the peak of Zirakzigil, they fought for ten days straight?

There are only two exact time stamps in *The Lord of the Rings*: the beginning of the Battle of Helm's Deep at midnight on March 3, and the moment Frodo wakes up in Rivendell on Oct. 24 at 10 a.m..

Don't be confused by the Entmoot beginning on Feb. 30—that's not a typo.

In the Shire calendar, all 12 months of the year have 30 days, which Hobbits round out to a full 365 with the celebration of two Yuledays at the new year and three midsummer days (a holiday period called Lithe) between the months of June (Forelithe) and July (Afterlithe). Or, translated from the Middle-earthen language of Westron, the months of "Before holiday" and "After holiday." In leap years, a fourth day is added to Lithe, the absolutely perfectly named holiday of Overlithe.

Hobbits observe Yuledays and Lithedays by partying—the Old Took would invite Gandalf himself to do the fireworks—sleeping, and doing absolutely nothing. Yuledays and Lithedays do not belong to their neighboring months, and they are not numbered (there is no Lithe 1, Lithe 2, etc.). They also do not have any days of the week assigned to them. They are a perfect limbo of disregarding responsibilities, a time out of time reserved *specifically* for doing whatever you want.

The liberation of these holidays from weekday designation makes for the most fantastic innovation of the Hobbit calendar: Every calendar date falls on the same weekday every year. Bilbo and Frodo's Sept. 22 birthday is on a Thursday, *and it is always on a Thursday*. Incidentally, the One Ring was destroyed on a Sunday.

BUT I DIGRESS

@OnThisDayinLOTR is not the only social media account to post the events of *The Lord of the Rings* on their calendar dates. But was mine, and it taught me a lot—not just about the milestones of Middle-earth, but about how a big, fantastic story can resonate with many people in little, beautifully mundane ways.

Every year, I would watch people cry when Boromir died, rejoice when Éowyn tore off her helmet, and jeer when Denethor bit the dust. Inevitably, someone would reply with "Fool of a Took!" when Pippin dropped the stone in the well, and with "Fly, you fools!" when Gandalf fell. (And someone would always attempt to "correct" me when I said that Gandalf solved the riddle of the Moria door, even though *that is what actually happens in the book and it was altered for the movie*.) When I would tweet that Frodo and Sam were leaving the road to travel overland in the final fever-dream stretch to Mount Doom, someone would always tweet encouragement, or talk about how their thesis was *nearly* done, or just reply, "Mood."

On March 25, 2020, at the end of a month in which life had seemed to grow more uncertain by the hour, the Ring was still destroyed. My followers replied, "So happy for some good news!" or "I really wish someone would destroy the ring in real life." People responded with GIFs of Elijah Wood's bedraggled Frodo gasping out, "It's done!" Things were, shall we say, *not done*. But in that month, and those to come, communing with the familiar beats of *The Lord of the Rings* gave us all succor in our wanhope

and distress, to borrow a phrase from the Professor.

Tolkien's opus is a story of small people beset by massive events. And there's something deeply appropriate in how the writer's attention to detail—even to the level of inventing a whole calendar system—allows readers to maintain that connection between the epic events of his story and the events of their lives.

THERE AND BACK AGAIN

I quietly stopped scheduling tweets from @OnThisDayinLOTR in 2022 because I had seriously fallen out of love with Twitter (if indeed I had ever been in love with it in the first place). Since the story was reaching its natural November conclusion anyway,

I decided that "After the Ring: The Battle of Bywater. Saruman is slain. This marks the end of the War of the Ring." would be the final calendar tweet of @OnThisDayinLOTR. The account began as a way to immerse myself in one of my favorite stories, evolved into a way that I immersed myself in other readers' connections to one of my favorite stories, then became a part of a yearlong professional project of immersing myself in Peter Jackson's unsurpassed adaptation of that story. And now, it's the structural foundation of the object you currently hold in your hands. I hope you dash through these pages, enjoying all the good work I, my coworkers, and our contributors did to celebrate Tolkien and the Lord of the Rings movies. But I hope that later, you return and make the long journey in Middle-earth part of your journey as well.

On March 25, 2020, at the end of a month in which life had seemed to grow more uncertain by the hour, the Ring was still destroyed.

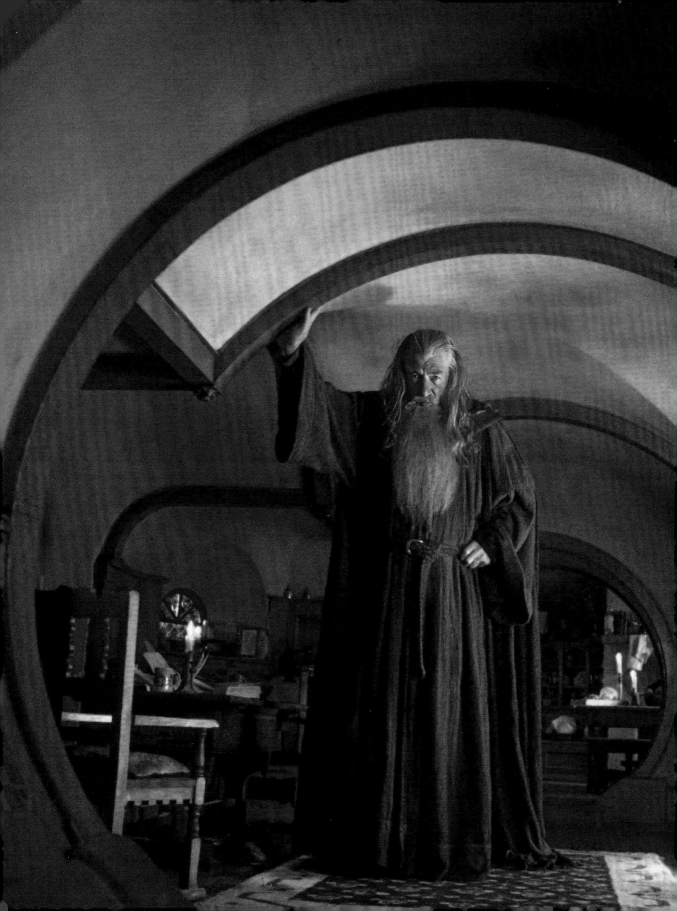

CHAPTER ONE

SEPTEMBER: LEAVING THE SHIRE

THE FELLOWSHIP OF THE RING REDEFINED MOVIE MAGIC WITH A SINGLE LINE

DO JUST A LITTLE, AND YOU CAN TRUST TOLKIEN TO DO A LOT

Susana Polo

There are countless iconic lines from Peter Jackson's Lord of the Rings trilogy, but "You shall not pass" sits at the apex of the mountain (of Doom). Ian McKellen's line reading is oft quoted in doorways, by annoying siblings, or simply when holding a big stick. It's been parodied innumerable times. More than any other, it is the Gandalf line.

Just as Leonard Nimoy with "Live long and prosper," and Mark Hamill with "May the force be with you," McKellen has absorbed "You shall not pass!" as his public catchphrase. Go ahead and google the videos—the august monarch of the stage seems to revel in the delight it produces when he cheekily tells a group of starstruck students that if they don't study properly for their upcoming exams, then . . . well, you can guess. It's delightful.

But there is another Gandalf line, one that has all the might of "You shall not pass!" and more. It's a display of the Grey Wizard's uncanny power, it's a moment for McKellen to flex his skills, and it's a point of high tension for the audience. It's Gandalf at his most puissant, and his most human. And deep inside of the line is the key to how Philippa Boyens, Peter Jackson, and Fran Walsh succeeded at adapting J.R.R. Tolkien's *The Lord of the Rings*.

THE AFFAIRS OF WIZARDS

The line in question is delivered early in The Fellowship of the Ring, before the adventure has even really begun. Bilbo has just returned from his surprise party disappearance, and he and Gandalf are discussing his old ring, with the wizard very much in favor of Bilbo leaving it behind for his nephew. Bilbo had planned to do that all along, but here in the moment, he abruptly changes his mind. Gandalf's pushing only agitates him until he finally makes a low accusation: Gandalf simply wants the ring for himself.

This produces an immediate change in the kindly old wizard, as he bellows Bilbo's full name at him. The room darkens, a wind whips up out of nowhere, Gandalf's voice grows sepulchrally deep as he calls out a warning:

"Do not take me for a conjuror of cheap tricks!"

Which is ironic, because this is the first time a new audience is shown that Gandalf is something other than a conjuror

of cheap tricks. The scene isn't the first time we see magic in the contemporaneous (i.e., not a flashback) *Fellowship* setting—Bilbo popped the Ring on only a few minutes earlier—but it is the first time we see magic being scary. Before a single Black Rider has set foot in the Shire, Gandalf transforms into a monster.

This back-and-forth ends with Gandalf at his most human, which is kind of the point. A line after the "conjuror" bit, the old wizard gives Bilbo a kindly "I'm trying to help you" and a hug, patting his hair in the manner of a family member or intimate friend. This is the duality of Gandalf—everything you need to know about his character over all three movies, delivered in about 15 seconds.

It's also one of the most literally translated moments in Jackson's Lord of the Rings trilogy. First, as in the movie, Bilbo provokes Gandalf by implying that he desires the Ring. "But you won't get it. I won't give my precious away, I tell you!" he cries, and Tolkien writes in *The Fellowship of the Ring*, "His hand strayed to the hilt of his small sword."

> Gandalf's eyes flashed. "It will be my turn to get angry soon," he said. "If you say that again, I shall. Then you will see Gandalf the Grey uncloaked." He took a step towards the hobbit, and he seemed to grow tall and menacing; his shadow filled the little room.
>
> Bilbo backed away to the wall, breathing hard, his hand clutching at his pocket. They stood for a while facing one another, and the air of the room tingled. Gandalf's eyes remained bent on the hobbit. Slowly his hands relaxed, and

he began to tremble.

> "I don't know what has come over you, Gandalf," he said. "You have never been like this before. What is it all about? It is mine isn't it? I found it, and Gollum would have killed me, if I hadn't kept it. I'm not a thief, whatever he said."
>
> "I have never called you one," Gandalf answered. "And I am not one either. I am not trying to rob you, but to help you. I wish you would trust me, as you used." He turned away, and the shadow passed. He seemed to dwindle again to an old grey man, bent and troubled.

But what's really remarkable about this tiny moment is how brilliantly Jackson brings a rather odd glimpse of Gandalf's power to life—and how little he decided to push it to do so.

SUBTLE AND QUICK TO ANGER

The effect is actually quite simple. Jackson doesn't even push-pull on the lens. The lighting dips, the sound of creaking timbers is added to the audio, Howard Shore's score plays some uneasy strings. A fan flutters the candles and Bilbo's jacket. The rest is all on Sir Ian McKellen.

He drops his voice into his chest and doesn't even really raise his volume, aside from the first surprising bellow of "Bilbo Baggins!" He draws his shoulders back and lets his arms hang, lengthening his silhouette—growing taller-seeming without actually growing taller. He lets his sleeves fall over his hands, emphasizing his face and beard as the brightest objects in frame. His mouth hangs open

> *The real magic was rare and subtle and strange.*

at the end of the sentence, as if his body is merely a puppet for the being within it, or as an old man who has just given a great exertion.

There's no obvious green screen effect that enlarges Gandalf against the frame of Bag End. There's no detectable filter on McKellen's voice. There's no flare of wind and polar-reversed color on him as for Galadriel—even though Tolkien describes her turn in remarkably similar language:

> She lifted up her hand and from the ring that she wore there issued a great light that illumined her alone and left all else dark. She stood before Frodo seeming now tall beyond measurement, and beautiful beyond enduring, terrible and worshipful. Then she let her hand fall, and the light faded, and suddenly she laughed again, and lo! she was shrunken: a slender elf-woman, clad in simple white, whose gentle voice was soft and sad.

The scene does a lot with a little, which was exactly Tolkien's approach.

MAGIC AND MEDDLING

Our idea of what magic looks like has (like all cinema) evolved from live theater. And in this case, from theatrical effects and the misdirecting aesthetic of stage magicians. Which is how *Fellowship* introduces Gandalf, with his fireworks that amuse young and old hobbits alike—a conjuror of cheap tricks!

Tolkien was trying to do something decidedly different. The magic wasn't the point, in the way it would have been if Frodo had been a student at a wizard boarding school, or a surgeon-turned-superhero, or if he was the creation of a group of friends rolling dice to explore a dungeon.

And so, in Middle-earth the flashy stuff—making things go bang and disappear in a puff of smoke, colorful costumes, light shows—that wasn't real magic. The real magic was rare and subtle and strange.

It makes perfect storytelling sense that Boyens, Jackson, and Walsh would leap on this particular moment to include nearly verbatim in the movie. It's a transitional point in the script. Our homey hobbit characters are about to connect with the dark history of *Fellowship*'s opening battle scene, and that transition will only work if the audience can viscerally feel that these small creatures are on the edge of something far more dangerous and strange than they thought.

TIMELINE 2001

SEPTEMBER **18**
After two months of imprisonment in Isengard, Gandalf escapes with the help of the eagle lord Gwaihir.

The Nazgûl arrive at Orthanc and ask Saruman for directions to the Shire, the location Gollum confessed under torture. Saruman lies, saying that Gandalf is still imprisoned in his tower, and that he also gave up the location of the Ring. He gives them directions to the Shire.

SEPTEMBER **19**
Gandalf reaches Edoras, but is refused entry.

The screenwriters' brilliance is creating a moment that also does the extremely vital task of establishing what "real magic" looks like in Middle-earth and puts it in direct contrast to flashy "cheap tricks."

Boyens, Jackson, Walsh would have known that their audience had a learned visual shorthand for cinematic magic, and there's nothing bad or good about that shorthand. Film is a world in which what you see and hear is the only thing you get. Tolkien's medium of prose allowed him to describe magic by how it feels, and that's exactly what he did. Gandalf "seemed to grow tall and menacing," Galadriel "stood before Frodo seeming now tall beyond measurement."

By finding a way to visualize those feelings, and resisting the urge to do any more, Boyens, Jackson, and Walsh made "Do not take me for a conjuror of cheap tricks!" into a statement of purpose. One that went on to serve throughout the trilogy, from the smallest details of costumes to the biggest excesses of computer-generated effects.

The Lord of the Rings films believed in the power of Tolkien's aesthetic to not only communicate his ideas, but to enthrall an audience. It's a show of confidence, not only in the adaptation itself, but also in the material its sourced from.

In other words, Boyens, Jackson, and Walsh believed in the magic.

Sir Ian McKellen at the after-show party of the world premiere of The Lord of the Rings: The Fellowship of the Ring

If you want to read more about...

> *Gandalf, turn to page 96—"The Truth About Gandalf" (March)*

> *Tolkien's best writing that actually made it into the movie, turn to page 146—"The Best Easter Eggs in* The Lord of the Rings *Movies Are in the Dialogue" (June)*

SEPTEMBER **20**

Two carts of Frodo's belongings are sent off to Buckland to help create the illusion that he is simply moving.

Theoden finally grants Gandalf an audience, but ignores his warnings and commands him to take any horse so long as he leaves his lands immediately.

SEPTEMBER **22**

17 years before setting out on the Ring Quest, Frodo helps celebrate his 33rd and his uncle's 111th birthdays at a Long-Awaited Party.

The Nazgûl cross the southernmost border of the Shire.

SEPTEMBER **23**

Turning over his keys to Lobelia Sackville-Baggins, Frodo, Sam, and Pippin leave Bag End.

One Black Rider arrives in Hobbiton, asking after a Mr. Baggins.

Gandalf leaves Rohan on the back of Shadowfax; lord of the Mearas, who are like to horses as elves are like to men. Descended from Felaróf, the steed of the first King of Rohan, only the king and princes of Rohan may ride the Mearas, and Shadowfax had been considered untamable.

TOM BOMBADIL IS THE STAN LEE OF *THE LORD OF THE RINGS*

HEAR ME OUT!

Susana Polo

There are two kinds of Lord of the Rings book fans: the ones who despise Tom Bombadil, hands down the weirdest character in the trilogy, and the ones who have memorized every word of his silly rhyming songs.

Then there are Lord of the Rings movie fans, who may know nothing of the character, as Philippa Boyens, Peter Jackson, and Fran Walsh couldn't find room for him in their three-picture adaptation—even in the Extended Editions. Anyone who hasn't read the books has likely encountered Bombadil discourse, but may have never fully understood how one character can inspire such strong emotions.

I have an answer for movie fans. An answer that might even turn some Bombadil skeptics into Bombadil boosters.

Tom Bombadil is the Stan Lee cameo of *The Lord of the Rings*.

WHO IS TOM BOMBADIL, REALLY?

Multimedia *LOTR* buffs know Tom Bombadil as one of the most famous omissions that the movie trilogy makes from J.R.R. Tolkien's books. (He's also a particular favorite of famous Tolkien nerd Stephen Colbert.)[*]

But to elaborate for the viewer's sake, Tom Bombadil marks a strange three-chapter digression early in the pages of *The Fellowship of the Ring*. Frodo, Sam, Merry, and Pippin take a shortcut through the Old Forest on the border of the Shire, only to be mesmerized and nearly drowned by an intelligent and malicious tree known as Old Man Willow. They are rescued by a cheerful, bearded man "too large and heavy for a hobbit, if not quite tall enough for one of the Big People," wearing a blue coat, yellow boots, and a hat with a feather in it. He constantly spouts almost nonsensical rhyming couplets.

> There was a sudden deep silence, in which Frodo could hear his heart beating. After a long slow moment he heard plain, but far away, as if it was

coming down through the ground or through thick walls, an answering voice singing:

> Old Tom Bombadil is a
> merry fellow,
> Bright blue his jacket is, and
> his boots are yellow,
>
> None has ever caught him
> yet, for Tom, he is the master:
> His songs are stronger
> songs, and his feet are
> faster.

This is Tom Bombadil, "Tom Bom, jolly Tom, Tom Bombadillo!" who whisks them off to his wholesome home to meet his beautiful wife, Goldberry, the "River-woman's daughter." And in addition to not being a man or a hobbit or a dwarf or a wizard, Tom has *weird* powers. A chapter later, he rescues the hobbits from a terrifying undead creature, the Barrow-wight, simply by commanding it. He can speak to plants and animals (his pony's name is Fatty Lumpkin). Weirdest of all, he can put on the Ring of Power without turning invisible or being tempted by it.

Readers have attempted for decades to puzzle out a place for Tom Bombadil in the larger Middle-earth myth, suggesting that he is secretly one of Middle-earth's gods, or demigods. Venerable fansite The Tolkien Sarcasm Page still hosts a (humorous) theory that he is the Witch-king of Angmar on vacation. Even readers who like Tom Bombadil must admit that he raises questions. Where the hell did this guy come from?

HERE'S WHERE TOM BOMBADIL CAME FROM

For most of his life, Tolkien picked away at what he saw as his ultimate creative work, *The Silmarillion*. When finished, he wanted the book to be an intricate collection of serious heroic myth intended to evoke wonder and emotion in adults. But in the meantime, he was in the habit of making up stories for his children, the most famous of which became *The Hobbit* itself.

But there was more than just *The Hobbit*. Around 1925, Tolkien wrote a novella, *Roverandom*, to console one of his sons, who had lost his toy dog on a family vacation. Tom Bombadil also began life as a story inspired by a household toy. After one of his sons' dolls—kitted out with a feathered hat—was rescued from a severe toilet dunking at the hands of its owner's brother, Tolkien wrote a poem, "The Adventures of Tom Bombadil," that laid out in detail how Tom met Goldberry, daughter of the river, escaped Old Man Willow, and encountered a Barrow-wight.

After the success of *The Hobbit*, Tolkien's publisher was very interested in another book about hobbits for children, and the author mused on this for about a

SEPTEMBER **24**

Fleeing from a Black Rider, Frodo, Sam, and Pippin shelter for the night with Gildor and his company of elves.

TIMELINE
2001

SEPTEMBER **25**

Frodo, Sam, and Pippin escape from Black Riders, after which Farmer Maggot helps them find their way back to the road. After meeting up with Merry, the hobbits cross Buckleberry Ferry and arrive in Crickhollow.

week before he wrote his first attempt at the first chapter of the sequel, about Bilbo Baggins having a big birthday party just before leaving on a new adventure.

The Hobbit is a very episodic tale, likely due to its origins as a bedtime story conceived by a hardworking father. Bilbo encounters trolls, goblins, wargs, elf kings, and even Beorn the skin-changer, and passes them by within a chapter or two. There's no real attempt to weave them into detailed system of world-building. And you can see the remnants of Tolkien trying to replicate that format in the opening chapters of The Lord of the Rings, as he peppers the story with strange and relatively uncon-nected adventures.

A Black Rider appears to menace Odo, Frodo, and Bilbo's nephew, Bingo Baggins—who Tolkien had quickly decided would be the new hero of the story—but they were rescued by a friendly farmer. Then they met some elves, and it was only at this point that Tolkien seized on the idea that the ring had been made by "the Necromancer," a villain vaguely alluded to in the pages of The Hobbit who never actually became involved in the plot. The Black Riders were looking for the ring, and Bingo's job was to take it to Mordor and destroy it.

The ringbearer's name was still Bingo when Tolkien inserted Old Man Willow, Tom Bombadil, and the Barrow-wight into the narrative. He had not yet even conceived of characters like Aragorn and Faramir, or even why the Necromancer wanted the ring so badly. It was only as he got Bingo and his cousins to Rivendell that Tolkien came up with the origins of the Ring Quest, upgraded the Necromancer to Sauron, and realized this sequel could be a vehicle for his dreams of writing a grand and heroic romantic epic. The Hobbit, the popular children's story he'd penned, could be set in the same world as The Silmarillion, but after its principal events.

To understand Tom Bombadil is to understand that Tolkien wrote the first seven or eight chapters of what would become The Fellowship of the Ring as if it were The Hobbit 2, a cheerful, simple sequel of adventure, suspense, and gentle asides to its intended audience: children.

WHICH BRINGS ME TO STAN LEE

Stan Lee is a real comics creator and fictional character who has appeared in nearly two dozen Marvel Cinematic Universe movies. In the films, he appears seemingly without any regard for the continuity of time, space, or the average human lifetime: as a librar-ian in modern-day New York, a general in WWII, or an astronaut lost in outer space. In playful attempts to make his appear-ances fit with the rest of Marvel mythology, fans have suggested that he is an immortal, has supernatural powers, or might even be one of Marvel's fabled Watchers, an alien race charged with observing the totality of space and time.

SEPTEMBER **26**

Two Black Riders arrive in Bree, asking for a Mr. Baggins.

The hobbits leave the Shire, enter the Old Forest, are menaced by Old Man Willow and come under the protection of Tom Bombadil.

SEPTEMBER **28**

The four hobbits leave Tom Bombadil's house, only to be taken by the Barrow-wight.

SEPTEMBER **27**

In the house of Tom Bombadil, Frodo puts on the ring for the first time.

The biggest complaint that Bombadil detractors have about Tom is that he does not feel coherent with the rest of Tolkien's mythology. Tolkien connects almost all of the elements of the early *Fellowship* chapters to his larger mythology with later additions—the Barrow-wight encounter is even instrumental to Éowyn's slaying of the Witch-king.

But there is nothing else in *The Lord of the Rings* like Tom Bombadil. He has weird powers without explanation, and he is completely, as he and Gandalf both aver, unconcerned and unconnected with the fate of the Ring. But that all makes sense if you think of Tom Bombadil as a cameo.

The modern audience understands that Stan Lee is a real person whose accomplishments make him worthy of inclusion in every movie or TV show based on a Marvel property. He is a reference that everyone is familiar with. And to Tolkien's children, the intended audience for *The Hobbit*, Tom Bombadil is a reference that everyone is familiar with.

In another way, Tom Bombadil actually makes *The Lord of the Rings* more like a real-world mythological system than not. Our understanding of ancient mythology is replete with strange additions, like Athena being birthed fully formed from the head of Zeus, that many academics believe is due to those stories being adopted from other mythologies—the Mesopotamian goddess Inanna making a cameo in the Greek Cinematic Universe by another name. Tolkien's favorite mythological system of all, Norse sagas, are also full of references that we may never know the origins of, due to the incomplete and, in some cases, biased textual record of living oral traditions.

And this is why it's entirely reasonable that Boyens, Jackson, and Walsh declined to include Tom Bombadil in their movies. The cameo didn't make sense anymore because the reference had become the kind of thing you have to read a whole biography of J.R.R. Tolkien to tease out.

So who is right? The Bombadil haters or the Bombadil lovers? It all might come down to how you feel about Stan Lee cameos.

If you want to read more about...

> *How Tolkien wrote LOTR, turn to page 175—"The* Lord of the Rings *Movies Declined to Address Tolkien's Greatest Failure" (July)*

> *What Jackson & Co. left out from the books, turn to page 228—"The Return of the King Needed One More Ending" (Second December)*

But there is nothing else in
The Lord of the Rings
like Tom Bombadil.

THE FIRST NOTE IN
THE LORD OF THE RINGS
HAS AN ANCIENT HISTORY

COMPOSER HOWARD SHORE FOUND A SOUND WORTHY OF GALADRIEL

Rebecca Long

The *Lord of the Rings: The Fellowship of the Ring* opens with a monologue. Galadriel, the elven queen, details the history of Middle-earth, the dangers of mythmaking, and the things that should not have been forgotten, but were.

The film also begins with a sound.

Just before a choir sings "Footsteps of Doom" in J.R.R. Tolkien's fictional language of Sindarin, and Cate Blanchett launches into her narration, viewers hear an ominous drone. The dissonant rumble comes from a monochord, played by the late multi-instrumentalist and composer Sonia Slany. In the first measure of Howard Shore's score, this obscure instrument sets the emotional tone for the trilogy, and the literal tone for the nearly 11 hours of music that follow.

For thousands of years, the monochord has been used for tuning, science, and healing. And like the One Ring, it represents bygone knowledge from our distant past that's almost, but not quite, lost. The age and history of the instrument make it a fit to open Peter Jackson's *Fellowship*, but the first scene nearly looked—and sounded—very different.

"The prologue sequence proved a rather tough nut to crack," says musicologist Doug Adams, author of *The Music of the Lord of the Rings Films*, who was chosen by Shore to document the creation of the soundtrack. Early on, the filmmakers developed a number of different openings for which Shore composed original music. Adams describes one opening that threw viewers into the story right away with no narration, accompanied by a more traditional composition (akin to, but not exactly the same as, the first track of the condensed soundtrack released in 2001 alongside *Fellowship*). Another iteration, which can be heard on *The Lord of the Rings: The Rarities Archive*, a companion CD to Adams' book, prominently featured the "Realm of Gondor" theme, used in the final films when the armies of men and elves first marched against Mordor. In fact, the leitmotif was originally intended to "be all over the place" in *Fellowship*, but was reworked into the main theme of *The Return of the King*.

When the filmmakers eventually settled on the narrated introduction viewers have come to know and love, multiple actors were considered to voice the prologue. Adams recalls Ian McKellen and Elijah Wood taking stabs at the monologue, and at least a consideration of Christopher

"Much that once was is lost, for none now live who remember it."

Sonia Slany standing by her monochord

to the project because of the unique completeness of Peter Jackson and his collaborators' translation of Tolkien's world. The fully realized cultures, languages, and lore spurred Shore's desire to craft a soundtrack that not only "commented on the story," but also felt diegetic, Adams says—"like music that the characters could have heard in their own world," reflecting different eras, regions, and cultures of Middle-earth.

Shore's overarching aim was to create a score that sounded like it "was discovered, rather than written."

To achieve the "element of antiquity," Shore sought out ancient sounds and instruments from around the world, including the Indian sarangi, the Iranian ney, the hurdy-gurdy, and the monochord. Their sounds can be heard most prominently in scenes set at Lothlórien, while the Rivendell elves were accompanied by a more conventional orchestral arrangement of arpeggiated figures, low strings, and chimes. Shore deviated from Western instrumentation to reflect the mysteriousness of the woodland elves—one of the oldest cultures of Middle-earth. "Rivendell is about learning and knowledge, but this is different," Shore is quoted as saying in *The Music*

Lee reading the text as Saruman. Blanchett eventually took center stage as Galadriel, and with her, new music.

Shore's overarching aim was to create a score that sounded like it "was discovered, rather than written," says Adams, and the first track was pivotal in writing that sonic narrative. Although he signed on to score the Lord of the Rings movies in part because of his own personal relationship to the story (the composer was in the jazz-rock fusion band Lighthouse in the '60s and '70s and read *The Lord of the Rings* on the tour bus), he was also drawn

TIMELINE
2001

SEPTEMBER 29

Gandalf reaches the Shire.

Black Riders raid Crickhollow and the Prancing Pony; the horn of Buckland is sounded for the first time in one hundred years.

The hobbits arrive at the Prancing Pony and meet Aragorn.

SEPTEMBER 30

The four hobbits and Aragorn leave Bree with Bill the Pony.

Five Black Riders storm through Bree, searching for the Ring along the Road.

Gandalf reaches Bree.

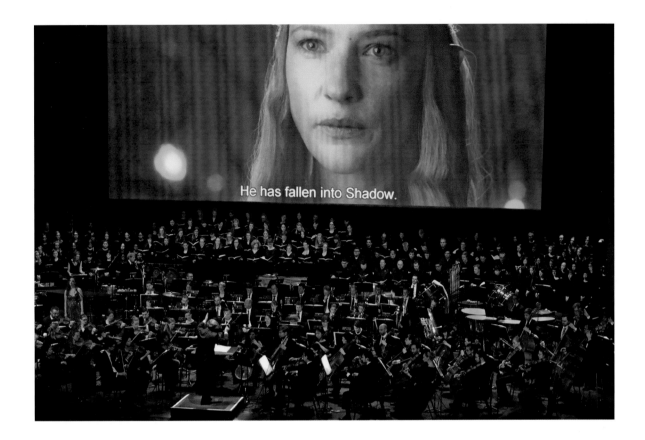

He has fallen into Shadow.

"The Lord of the Rings *in Concert*" at the David H. Koch Theater, *April 7, 2015*

of *"The Lord of the Rings" Films*. "The Lothlórien music stretches into sustained, arrhythmic shapes that sound neither dangerous nor comforting, but create a sense of unanswered anticipation." When Galadriel was chosen to narrate the prologue, the accompaniment changed to weave in the music of Lothlórien, including her signature sound: the monochord.

Shore was particularly drawn to the instrument for its age. Monochord literally means "one string," and as Dr. Rich Walter, curator at the Musical Instrument Museum, points out, the noise made by a vibrating string is "about as ancient a musical sound as we have" aside from the thumping of a drum. Formally invented around 300 BCE with origins extending into prehistory, the monochord classically consisted of one wire stretched out across a hollow wooden body. The original version was used as an experimental device to study tuning and harmonic principles, not for music-making. While it's not exactly clear who developed the monochord, evidence suggests the Greek mathematician Euclid designed it. However, Pythagoras often gets the credit for reinventing the instrument to explore the relationship between ratios of string length and musical intervals. From his studies, he developed mystical concepts like the music of the spheres—the hypothesis that the planets in our solar system all emit their own unique celestial hum based on their orbit—as well as core tenets of music theory. The monochord was later employed in the mid-medieval period by Guido of Arezzo, the Italian monk and music scholar who invented modern staff notation.

Countless other philosophers and mathematicians made use of the apparatus

in attempts to uncover truths about the cosmos, numbers, and sound. Dr. William O'Hara, Aassistant professor of music theory at Gettysburg College, tells Polygon that "the monochord represents a kind of origin story for Western music." Much like Galadriel's introduction to Middle-earth, the time period in which alchemists relied on the monochord to uncover mysteries about the universe was a prologue to modern music theory and the invention of instruments like the harpsichord. O'Hara remarks that the iconic device has taken on a mythic status among contemporary musicians and scholars, who view the monochord as a symbol of perfect sound and "ancient, lost musical knowledge."

Today, the traditional one-stringed instrument is used mostly for demonstration purposes. "Contemporary monochordists," says O'Hara, "almost universally use many-stringed instruments" like the 50-stringed monochord Sonia Slany played for Howard's *The Lord of the Rings* score. The resulting sound of the many-stringed version, with strings all tuned to the same pitch (which Walter comments could be more accurately described as a "polychord"), is what Adams describes in his book as a "faint metallic slithering" similar to the noise made by the Indian tanpura, which can also be heard in the Rings trilogy. When you play a few strings on the monochord, O'Hara explains, the rest move too, in a phenomenon called sympathetic vibration. But due to natural human error, subtle differences from wire to wire create resonant oscillations, forming a unique sonic landscape. Whether caused by gongs, bells, or strings, two or more sounds that are almost but not exactly identical are "more vibrant, more exciting, and more alive than if they were exactly the same," muses Walter. "That's when some weird stuff happens."

Finding a player for such an uncommon instrument was never a certainty for The *Lord of the Rings* production, and although Shore wanted it, the monochord was marked "optional" in the score. Orchestra contractor Isobel Griffiths was responsible for finding musicians for the unusual instruments Shore hoped to use, and Slany was already on her radar for her principal instrument, the violin. Slany also played the monochord in both musical and therapeutic settings, and ended up being the perfect fit. According to Paul Clarvis, Slany's husband and an accomplished musician himself, she had read J.R.R. Tolkien's famous trilogy years prior to lending her monochord to the films' soundtrack, and felt the story "evoked a very calm sound world." Adams attests that Slany, who passed away in January 2021 after a long illness, "was a real blessing" for the movies.

In 2000, the *Independent* spoke with Slany about her monochord, a soundbed variation developed by German Swiss music therapist Dr. Joachim Marz in the 1980s. At the time of the interview, the instrument, consisting of a seven-foot-by-four-foot wooden table with a barrel-shaped belly underneath, lined by 50 wires, was one of only four such monochords in England. To use O'Hara's words, it looks like something "straight out of Middle-earth." Clarvis explains that Slany commissioned the instrument to be built after studying sound therapy in her early 20s. In therapy sessions, a person would lie on the wooden board, absorbing the sound bath, while she plucked and strummed the strings below. In recording sessions for *The Fellowship of the Rings*' opening track, a microphone took the person's place as Slany played F natural and C natural.

Andrew Barclay, principal percussionist for the London Philharmonic Orchestra (LPO), who has been in the ensemble

for over 25 years and performed for the Rings recordings, remembers that Slany, along with the other musicians who played unusual instruments, typically recorded separately from the main orchestra. This was because of booth space, but also for audio separation. Instruments like the monochord can be unpredictable—they may not produce the sound composers expect, or they may be hard to hear over the rest of the orchestra. Barclay says *The Lord of the Rings* was and remains the LPO's biggest undertaking by far, taking several years to complete, with countless niche instruments included.

Although Slany didn't use her monochord all that frequently for soundtrack recordings, chances are you've heard her violin playing before. Clarvis shared an extract from her funeral service detailing her career highlights: She toured and recorded with artists including the Cranberries, Björk, and Radiohead. Her solos can be heard in James Bond movies and in the original Hunger Games trilogy of films. She even played alongside the London Symphony Orchestra during the 2012 London Olympic Games. However, like many violinists, Clarvis says, "she had a complicated relationship with her instrument." But "not so with the monochord,"

which was personal and dear to her.

Her kinship with the instrument is apparent in the opening thunder of *Fellowship*'s soundtrack. The monochord appears easy to play—with all the strings tuned to one or two notes, there are no chords to worry about, and they can simply be improvisationally strummed to create a hypnotic wash of noise. But as Walter wisely says, "There's no such thing as an instrument so simple that it can't be played really, really well." Slany played the monochord really, really well. And its droning and mystique successfully set the emotional pace for a film about forgotten history, above all else. In the monochord's hazy humming, Shore found a sound to evoke things that were, things that are, and things that have not yet come to pass in the land of Middle-earth.

If you want to read more about...

> *The secret talents that made Jackson's* The Lord of the Rings *into a masterpiece, turn to page 110—"The Jeweler Who Forged* Lord of the Rings' *One Ring never got to see it in film" (March)*

> *Or page 42—"Gimli's Uncredited Body Double Put in the Work, and He Has the Tattoo to Prove It" (October)*

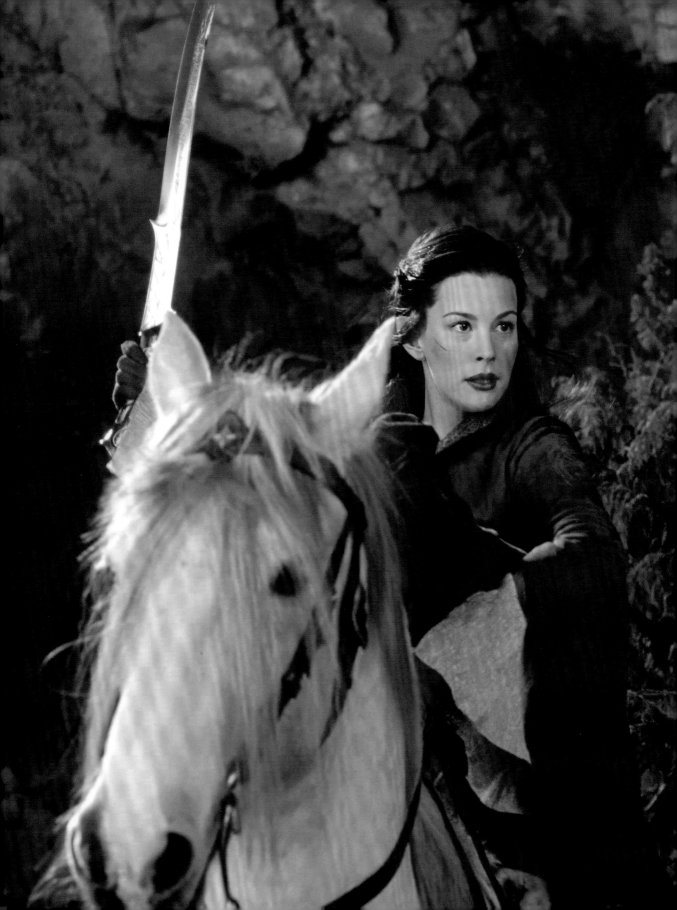

CHAPTER TWO

OCTOBER: RIVENDELL

I WORE ARWEN'S DRESS TO PROM THANKS TO A WELCOMING *LORD OF THE RINGS* FANDOM

TOLKIEN BUFFS EMBRACED NEWCOMERS WHO SPARKED TO THE MOVIE TRILOGY

Andrea Ayres

Growing up, I wanted no part of my dad's love of fantasy books. He was always trying to get the family to watch the Rankin/Bass version of *The Hobbit*, which frightened me more than it interested me. I never understood what he loved about wizards, or J.R.R. Tolkien. It wasn't until after he died that I discovered my own love of fantasy through the *Lord of the Rings* movies and online fandom.

I was one of many, many fans of the *Lord of the Rings* movies who found a home in spaces built by fans of the *Lord of the Rings* books who made it easy for a new generation to understand Tolkien. In an era when the internet and internet fandom looked very different than it does now, a worldwide community stepped up to help newcomers bring *The Lord of the Rings* into their everyday lives—and, for me, into a painstaking re-creation of Arwen's dress.

THEONERING.NET TO RULE THEM ALL

Before I saw *The Fellowship of the Ring*, my relation to fandom was limited at best. Basically, my knowledge began and ended with LiveJournal.

In those early days, folks wrote long blog posts and created avatars and glitzy custom message board signatures (extra points if they were animated). There was a methodicalness to it all with boards under moderation, and the rules clear from the start. That's not to say there weren't flame wars, but the spaces tended to be small enough that it didn't result in the same sorts of internet-culture cataclysms of today that bleed out into the general spaces of social media.

I was not the only person for whom *The Fellowship of the Ring* ignited an all-consuming interest. This influx of new fans purchased mountains of *LOTR*-related paraphernalia, and then they read the books—and when there were no more books, and still months until *The Two Towers*, they scoured any source for information on the films yet to come and the process of getting them made. That's what drew me online, and how I found TheOneRing.net.

Fans Erica Challis, Michael Regina, William Thomas, and Chris Pirrotta created TheOneRing.net (abbreviated as TORn) in 1999. It was a simple-to-navigate website which detailed the latest news about film

30

production, important dates in the *LOTR* calendar, and fan gatherings. But what set TORn apart was its ability to make news and foster connection.

Dubbed "Ringer Spies," fans contributed to the gathering of tips to send and post on TORn. Film locations were scouted, photos of the actors were posted, and interviews were conducted. The hunger for any and all information about the upcoming films helped make TORn into a repository for the greater *LOTR* universe. The most common way to connect was through TORn's message boards and small local gatherings. Fans joined to watch the Oscars together, dressing up in costumes and rooting for Peter Jackson's saga. TORn published books like *The People's Guide to J.R.R. Tolkien* and enjoyed a fairly friendly relationship with the cast and crew.

> *TORn and sites like it represented a mostly honest effort to democratize Middle-earth for new generations*

TORn and sites like it represented a mostly honest effort to democratize Middle-earth for new generations using guides, wikis, and memes, bringing *The Lord of the Rings* out of the 1950s and into digital spaces, making it easier to digest and more accessible to a new generation.

Literature and pop culture collided online, as people could access the world of Tolkien however, whenever, and wherever they wanted. Some people remixed—the 2005 video "They're Taking the Hobbits to Isengard" first premiered on the joke flash website Albino Blacksheep when YouTube was a mere six months old. Some people absorbed—want to learn the ancient language of Sindarin? Cool, there's a fan-made website for that.

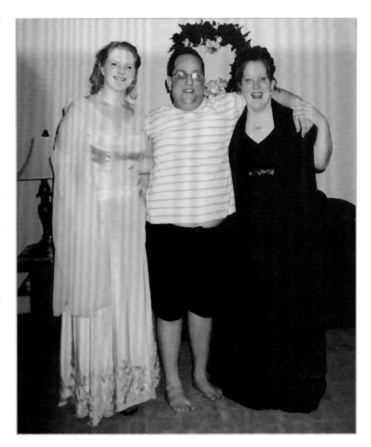

The writer in her hand-altered dress.

But my interests in online fandoms had a far more practical purpose.

THE BRIDGE DRESS

In the Extended Edition DVD extras, *The Fellowship of the Ring* costume designer Ngila Dickson revealed the great lengths the team went to age the silk velvet that made up most of the elves' costumes. It was bleached, dyed, etched, sandpapered, and trimmed with more fabric that had been dyed, aged, and beaded over. That work had seemed to give Arwen an ethereal glow my teenage self desperately wanted. And, okay, it didn't hurt that I had a massive crush on Aragorn. Either way, I knew I had to have one of these gowns.

Specifically, the Bridge Dress, named for the place Arwen first appears in the costume. In the trilogy, she and Aragon

meet on a stone bridge in Rivendell and reaffirm their love for each other, even though she is immortal and he will one day die. She wears an ivory dress with long, flowing sleeves and long, beaded train.

Through TORn's community, I found AlleyCatScratch.com, a costume website that hasn't changed much in 15 years. You can still find hundreds of process photos, detailed descriptions, and sources for materials, as well as dozens of pictures of fans wearing their costume replicas. If all these people who looked nothing like Liv Tyler or Cate Blanchett were creating costumes, I thought, maybe I could too?

LOTR fan forums explained it was possible on a limited budget, and with sewing skills picked up from one sixth-grade home economics class. The users at AlleyCatScratch had a pattern for the beadwork on Arwen's Bridge Dress available to print, and guides on what kind of beads and sequins to buy—and even affordable substitutions for the makeup used in the film.

I picked a similar dress to buy and alter, but in blue—I wasn't about to look like a bride for prom. My mom thought I was getting in over my head. I was committed to seeing it through. My questions were met with tips, easily adaptable sewing patterns, and words of encouragement. And when I got frustrated, forum users told me to enjoy the journey of making and not fixate on the outcome, showing me kindness when I could not show it to myself. I only ever succeeded in beading the bottom part of the dress, but I'd never been more proud of myself.

I never thought I'd be the type of person to wear a *Lord of the Rings*–inspired prom dress. Hell, I never thought I'd go to prom.

What my dad loved about *The Lord of the Rings* was reading the books with his father. He wanted to have that experience with his kids, and sadly, I was never able to while he was alive. But through the films I found fans eager to share their community, expertise, and fandom with new people. I could experience his love of fantasy in a new way: by connecting with others, embracing a kind of story that didn't click until I saw it in live action, in real costumes, and online. My journey as a *LOTR* fan might be quite specific, but the *LOTR* book community made sure it was for everyone—especially movie fans.

If you want to read more about...

> *TheOneRing.net and online* LOTR *fandom, turn to page 182*–"Revisiting The Lord of the Rings' *Shockingly Chill Panel at San Diego Comic-Con 2001*" (August)

TIMELINE
2001

OCTOBER **01**
Aragorn and the hobbits enter the Midgewater Marshes.

OCTOBER **03**
Gandalf arrives at Weathertop and is driven off by Black Riders, but not before leaving a marked rune behind for Aragorn to find.

OCTOBER **04**
Aragorn and the hobbits leave the Midgewater Marshes.

ONE CANNOT SIMPLY SEPARATE THE *LORD OF THE RINGS* MOVIES FROM MEME IMMORTALITY

YOU COULD SAY THAT *LOTR* AND MEMES FORM A SYMBIOTIC . . . RING

Isabelle Lichtenstein

In Peter Jackson's *The Fellowship of the Ring*, Elrond calls a secret meeting with representatives of the three free races in Middle-earth—humans, elves, and dwarves—to discuss what to do about the One Ring. As Elrond commands that the Ring must be destroyed in the fires of Mount Doom, Boromir utters a line that has since become one of the most iconic *Lord of the Rings* memes of all time: "One does not simply walk into Mordor."

Sean Bean, who plays Boromir, delivers the line with the gravitas necessary for the movie's pivotal scene. However, the contrast between his serious line reading and the fact that the quote comes after a brief pause and almost out of nowhere caught the attention of *The Lord of the Rings* fans. A screencap of the scene, featuring Boromir making a circular hand gesture, overlaid with the famous line, quickly became a popular meme, spreading across major social sites of the time.

When the first film was released in 2001, memes were just beginning to find their footing online. They had been around for years—one of the first modern examples of ephemeral media, transmitted memetically via the internet, a 24-second CGI animation of a dancing baby, became popular in 1996—but the landscape was rapidly evolving. At the same time, fandoms were thriving on websites and forums meant to connect members around the world.

The Lord of the Rings memes arrived in the digital space at a moment where dedicated fanbases were purposely trying to share as much content with as many people as possible. The fun of making

OCTOBER **09**
Glorfindel and other scouts leave Rivendell, searching for Frodo.

OCTOBER **18**
Aragorn and the hobbits find Bilbo's trolls, and meet Glorfindel on the road.

Gandalf reaches Rivendell.

OCTOBER **06**
Aragorn and the hobbits reach Weathertop. In battle with Black Riders, Frodo is stabbed with a Morgul-blade.

OCTOBER **11**
Glorfindel drives three Ringwraiths away from the Bridge of Mitheithel.

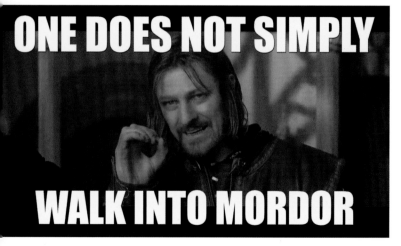

memes attracted people who hadn't seen the movies, who watched the movies so they could make better memes, which attracted more people and . . . the rest is history, a symbiotic relationship that has kept the Peter Jackson trilogy front and center in online consciousness for two decades.

From Éowyn's iconic "I am no man!" scene in *The Return of the King* to a line about menus uttered by an Uruk-hai in *Two Towers,* which has captivated and confused the internet for years, there are dozens upon dozens to choose from. An online search of "*Lord of the Rings* memes" produces hundreds of articles chronicling the best and most known. Pages have popped up on almost every social media site to allow fans to share their love of the memes, from Reddit's r/LOTRmemes to Instagram's @dankLOTRmemes and Tumblr's LOTRreactionmemes.

Boromir's Mordor meme isn't the only *The Lord of the Rings* meme in rotation, but Walking to Mordor is one of the oldest and most recognizable from the franchise. While the image became part of the internet's meme lexicon after the movie's release in 2001, one of the first noted uses wasn't until 2004, when a user on the forum Something Awful posted an image of Boromir in a car with the text "One does not simply drive into Mordor."

The original moment from the film was itself popular, but this adaptation of the line rocketed it to another level. The edited version of the meme situated it as a snowclone, a formulaic phrase that can be customized but still convey the same origin. Other iterations, like "One does not simply insert a USB on the first try" and "One does not simply hit the snooze button just once," began popping up across the internet, cementing the meme's status in the digital space. It was a straightforward template that could be adapted to any phrase, making it an easy format for seasoned and new meme users alike to enjoy. Ultimately, it helped pave the way for similar snowclone memes to thrive.

"It's just an easily digestible, low-effort meme from a simpler time," redditor and member of r/LOTRmemes u/bottle_O_pee says. "That being said, that meme became so popular [that] it started a sort of renaissance in the meme world."

To use the Boromir meme nowadays is to understand that it has been run into the ground, but that it's too integral to internet culture to ever really die.

Now, though, the meme's purpose has drastically changed. The humor behind it has evolved from being a funny, culturally relevant twist on the meme to an indicator of someone doing something inane or ridiculous. While its widespread use was a major factor of this change, it also became common knowledge that the line in the meme isn't actually what Boromir says at that moment in the film—he's actually talking about the great Eye of Sauron, hence his curled hand—contributing to its

absurdity. Meme humor has also majorly evolved, favoring smarter topics or formats and directly contrasting with the meme's uncreative, template-like layout. To use the Boromir meme nowadays is to understand that it has been run into the ground, but that it's too integral to internet culture to ever really die.

"*Lord of the Rings* memes are popular because the series is popular," says u/bottle_O_pee. "Sometimes [the] simplest answer is the best."

While the breadth of memes that the franchise has spawned is impressive, what's more impressive is how long the memes have stuck around. Boromir's line, for example, has been passed around the internet for 20 years, long surpassing the average four-month life span of a meme.

In many ways, the longevity of the trilogy's memes is a reflection of its fandom. *The Lord of the Rings* fans have been around since the first book's publication in 1954; Fanlore even published a 100-year timeline of the fandom, beginning with 1916, when Tolkien first started putting pen to paper. What solidified the fanbase as a major cultural group, though, was its passionate dedication to the franchise and to Tolkien himself. Fans have created clubs around it, lined up for hours to see the films, and dissected every single aspect of the source content through articles, podcasts, and documentaries.

That commitment to the trilogy is as strong today as it's ever been, thanks to the stories' launch into the mainstream by the films and the internet's ability to deliver *The Lord of the Rings* content to almost anyone anywhere at any time. The Reddit page r/LOTR has seen its subscriber count increase by over 4600% since just 2013, and detailed wikis continue to chronicle every corner of the trilogy and its fans—and these are just a small sampling of the fandom's growth and dedication.

"It doesn't matter that it came out 20 years ago," says Cates Holderness, head of editorial and trends expert at Tumblr. "[Fans are] rewatching it every couple of weeks, and they have found a community of people who also love these movies. They can engage forever with this one entertainment property."

This increase can also be attributed to circulation of *The Lord of the Rings* memes online. As they spread across the internet, anyone who interacts with the memes also engages with the films, regardless of how far removed from the content they are. For nonfans, they're a gateway into a fantasy world that otherwise requires an immense amount of time to get into. Memes allow a person to dip their toes into *The Lord of the*

Rings without putting in the considerable effort to unpack its story. It's a constant cycle; as new fans are introduced to the story through memes, they become meme creators and circulators themselves, pulling in more new fans as they go.

The *Lord of the Rings* films have also managed to become a cultural keystone in their two-decade-long existence. Even those who haven't seen or read the trilogy have heard of it, typically knowing at least some general plot points. The major characters themselves have become entities separate from the story. Referring to Gandalf or Frodo nowadays doesn't always pertain to the *Lord of the Rings* books or movies; to many, the former is just a funny, slightly neurotic wizard, and the latter is a small, furry-footed hero, both fully removed from their original context.

Because there is now such a widespread cultural understanding of the trilogy, *Lord of the Rings* memes can be used and comprehended by everyone—not just fans. "One does not simply walk into Mordor" is funny because fantasy heroes can never just waltz into the climax of the story; it's a universal story element, rather than one tied to a specific world. Neither the character of Boromir nor the line he utters is important to the meme at all; instead, it's the cultural perception that propelled it to the top of the meme charts and has kept it there ever since.

"There's a low barrier of entry when it comes to memes, because so much of the language and the cultural understanding of memes is ubiquitous," says Holderness. "The context is there without having to have seen the movies."

The films themselves are also infinitely quotable, from Samwise Gamgee proclaiming "There's some good in this world, Mr. Frodo, and it's worth fighting for" in *The Two Towers* to a visibly sober Legolas saying "I think it's affecting me" after a drinking competition with Gimli in *The Return of the King.* Because of the number of memorable lines that Jackson and co-writers packed into the script (page 146), almost every scene has at least one moment that could easily be transformed into a meme.

"In general, the movies are long, and there are several of them, [. . .] so we have that much material," says Holderness. "It's just a lot of fodder for memes. It's fun, it's interesting, the characters are complex but also funny at the same time. I think that kind of all builds out a great base for people to just riff on and make things out of."

That ability to explore such a large amount of content means that *The Lord of the Rings* memes can feasibly cater to everyone. You don't have to look far for a meme that fits what you're trying to convey—from the joys of drinking with friends to the aftermath of cleaning a messy room to simply a funny joke based on a specific scene. Not only does the vast material allow for constant meme creation, it also encourages continuous circulation;

TIMELINE
2001

⌐ OCTOBER **20**
Pursued by the Nine Riders, the party crosses the Fords of Bruinen and arrives in Rivendell.

⌐ OCTOBER **24**
Frodo wakes in the house of Elrond, at 10am.

After nearly four months on the road from Minas Tirith, Boromir arrives in Rivendell.

L OCTOBER **23**
After tending his wound for days, Elrond removes a splinter of the Morgul blade from Frodo's arm.

L OCTOBER **25**
The Council of Elrond

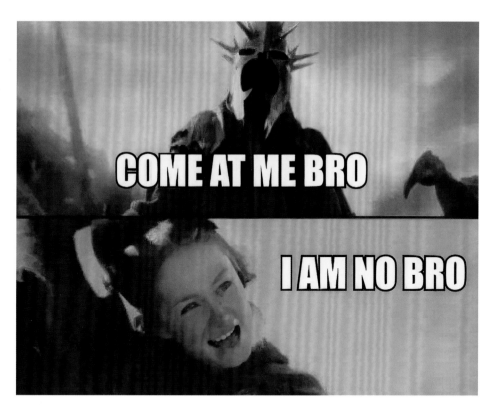

you can always find at least one *The Lord of the Rings* meme out there to relate to or that you find funny.

One does not simply use a *The Lord of the Rings* meme casually—there's a rich story behind every image and line, and at least part of it has to be understood in order for the joke to make sense. These memes level the playing field, though; those who only vaguely know the stories because of their cultural importance can enjoy the memes just as much as those who harbor a deep passion for the story behind them.

In the same way that the series is so profoundly embedded in our culture, the memes that come from it have garnered their own kind of fame. At this point, for example, the Boromir meme is a living legend. It was created in a time of image macros—memes that consist of an image with top and bottom text in the Impact font—and it survived the transition into what we consider memes today.

Thanks to dedicated digital fans and a constant adaptability in the changing internet landscape, *The Lord of the Rings* memes have been circulating for 20 years, squarely situating themselves as a major part of internet culture. These memes have so much to be enjoyed, and to be, and to do, and—like Samwise Gamgee—their part in the story of *The Lord of the Rings* will certainly go on.

If you want to read more about...

> LOTR *memes, turn to page 62*—"The Lord of the Rings *Comes from a Time When Fans Were Online, but Hollywood Was Not*" *(December)*

> *Or to page 135*—"The Lord of the Rings' *Twenty-Year-Old DVD Set Is Absolutely Thriving on TikTok [If revision of numerical style or capitalization style is stetted, retain introduction of midcap in TikTok.*" *(May)*

IN PRAISE OF ARAGORN, THE MOST WELL-ROUNDED SEX SYMBOL ON MIDDLE (OR ANY) EARTH

A DEEP APPRECIATION OF A TRUE KING, THE BABE OF THE WEST

Joshua Rivera

It is not particularly novel to note that Aragorn, son of Arathorn, the Dunedán, Elessar, the Elfstone, is hot. One may as well announce that elves are old, or that hobbits have large feet. But consider, if you will, the enduring nature of that hotness: its versatility.

The film adaptations of *The Lord of the Rings* do a lot of things across the 10-plus hours it takes to experience them, but when you focus on Aragorn, it becomes an episode of *Planet (Middle) Earth* about the many unexpected ways he can be hot.

One can almost hear Sir David Attenborough narrating: *Observe, in a dark corner of the Prancing Pony, a man crosses his legs, smokes his pipe, and a generation of viewers swoon, helpless. But what did we swoon over? His artful tobacco indulgence? His fierceness on Weathertop? His filthy nailbeds, affectionately closing the eyelids of the fallen Boromir? The valor of a man who should be king, but refuses the call?*

Aragorn occupies a unique position in the canon of formative crushes in blockbuster cinema in that he's absolutely a sex symbol, while the actor who portrays him is absolutely not. This is not a judgment of

Viggo Mortensen's attractiveness (for the record: hot), but an observation of how his career trended before and after he played Aragorn. In years prior, Mortensen was a regular supporting player with a career stretching back to the mid-'80s, and few breakout roles. After *The Lord of the Rings*, Mortensen eschewed blockbusters almost entirely. With the exception of *Hidalgo*, the actor almost unilaterally preferred arthouse films like *A History of Violence* or *Eastern Promises*, and starred in fewer and fewer movies going into the 2010s.

Compared with say, Orlando Bloom—who went on to be a go-to heartthrob in the early 2000s as Will Turner in *Pirates of the Caribbean* (ironically once again competing for attention with a grimy man nearly 20 years older than him) and in romantic dramas like *Elizabethtown*—the attractiveness of Mortensen's characters was not a recurring theme in his career. Aragorn's attractiveness, however? It has endured, smoldering on like the fires of Mount Doom.

Interested in this formative figure of millennial youth, I asked a bunch of people over the internet what, specifically, makes Aragorn hot, and I was delighted to find that fans weren't merely interested in

There's a VIBE.
Like do I want to take him to bed or
do I . . . want to BE him???

discussing his personal magnetism, but his journey.

"I think it relates to how he tends to embody a kind of perfect (to me) masculinity," wrote Polygon contributor Chris Eddleman. "He is both rugged and gentle, humble and capable, affectionate but fierce in the face of adversity. It's great!"

"He has all the 'traditional' masculine attributes like strength, protectiveness, bravery but he's not a bully," said Aragorn fan Kiki Intarasuwan across multiple tweets and DMs. "He's also kind, compassionate, not afraid to show his emotions and he respects women's choices. When I think of Aragorn, I think of the scene where he consoles Boromir as he dies and then kissing him on the forehead. That and the battle of Helm's Deep were really turning points for him because he initially wasn't ambitious and didn't want to be king. But his compassion and vulnerability make him a good leader and he naturally stepped up in that role."

Intarasuwan also noted how that compassion also seems to radiate from Viggo himself in interviews and public appearances out of character, something *Observer* entertainment editor Eric Vilas-Boas also notes.

"There's layers to the hotness: on-screen external physicality but also the meta-notion/fan-maxim that Viggo left it all on the field for them." Ask a fan for their favorite "little known" fact about the production and, paradoxically,

it will often be that footage of Mortensen breaking his own toe was used in *The Two Towers*.

Vilas-Boas, like a lot of people, also mentioned a specific moment emblematic of Aragorn's all-encompassing Noble Hotness. For him, it was answering the king of Rohan's despairing question "What can men do against such reckless hate?" with the challenge to ride out with him and face the orcs.

For journalist Linda H. Cordega, that key moment was one of Aragorn's first, at his introduction in the Prancing Pony.

"I saw *LOTR* when I was 11 and the entire course of my life shifted when he put out a candle with his bare hand. I literally went home and tried it and had a blister for a week," they told me. "I have had Extensive Conversations about this with me and my friends and we are (for the most part) p. Gay and also p. Asexual but like . . . there's a VIBE. Like do I want to take him to bed or do I . . . want to BE him???"

Of course, when talking about incredibly hot Aragorn scenes, one towers above them all: his arrival at Helm's Deep, aka the Door Scene. "Scene" is perhaps generous—it's really a single shot of Mortensen pushing a pair of heavy double doors open; he emerges from the gap between them, mouth slightly parted, hair swinging in front of his face, it's in slow motion for some reason. Nevertheless. I got *a lot* of messages about the Door Scene.

And a few that just get at a very essential truth about Aragorn: He just looks good dirty.

"He's the king of the specific niche that really only works in fiction & not life, which is 'looks better covered in an artful layer of dirt & grime than clean,'" wrote Lauren Sarner.

This brings up an interesting corollary to Aragorn's hotness: He is sexy, specifically, as Strider, the man on the road, and less so (but not by much) when he is the cleaned-up king of Gondor at the conclusion of *The Return of the King*. Both versions, my colleagues at Polygon note, exude powerfully admirable levels of Wife Guy, a term with a number of definitions but here is used to mean a man whose pure, earnest, and reciprocated love of a woman totally out of his league makes him kind of a weirdo in spite of everything.

Of course, not everyone who watches *The Lord of the Rings* is moved by Aragorn's brand of hotness. Some, as Sangeeta Singh-Kurtz wrote for *The Cut*, are not Aragorn Girls, but Legolas Girls. Others, as Polygon has shown, have plenty reason to find its many orcs hot. Some may just be in it for an enduring tale of friendship and perseverance, and quietly wish that we perverts would also diminish, and fade into the West.

To them, I must apologize, because to me? Aragorn is the one to rule them all, and in the darkness bind them . . . if you know what I mean.

If you want to read more about...

> *Aragorn's unique masculine appeal, turn to page 90*—"The Lord of the Rings *Revived Hollywood's Soft Masculinity with Boromir's Tender Death*" (February)

> *Even more on Aragorn (with horses), turn to page 122*—"The Lord of the Rings *Wasn't a Horse Girl Story Until Peter Jackson Made It One*" (April)

How Wētā Pulled Off (and Won Oscars for) Return of the King's Fantastic Beasts

A CREATURE FEATURE WITH WĒTĀ DIGITAL DIRECTOR JOE LETTERI

Karen Han

"We went 11 for 11 that night," Joe Letteri says of *The Lord of the Rings: The Return of the King*'s clean sweep (the highest in history) at the 2004 Academy Awards. *Return of the King*'s final Oscar haul tied it with *Ben-Hur* and *Titanic* for most Academy Awards won by a single film.

Among the awards was the statue for Best Visual Effects, accepted by Letteri, Jim Rygiel, Randall William Cook, and Alex Funke. Letteri, the director of Wētā Digital, spoke to Polygon in celebration of the 15th anniversary of *The Return of the King*'s big night at the Oscars, especially about the Army of the Dead.

"We had a couple of things to do there," says Letteri. "One was obviously the look of them when you saw them, and that was just some great makeup, and then we treated the imagery to give you that [ghostly] look, especially on the king.

"One of the big things we had to deal with was the battle itself. The way Tolkien writes it is, they're kind of invincible, and that doesn't make for much of a battle when they're just going through everything. So Peter was actually very judicious in how and when he deployed them; you'll see he kind of saves them for the end and uses them for the big payoff when you sort of already expect them to win. He just sort of brought that out in a few different stages until you just saw them swarming and taking over everything.

"As for how they move, in the caves, you're seeing them awakening for the first time. They're sort of assembling. There actually wasn't a lot of room to float around so much because there were so many of them, but out in the battlefield, something more fluid was the idea. They were sort of running, but you needed them to be ghostlike, so they had a floatiness on top of it. We did work with that for a little while, because sometimes that could just look wrong; it

could just look like things slipping. We played with that timing a lot to get something that still felt like they were running, but running in their own dimension that was allowing them to go faster than a normal run, and you get that ghostly kind of floating that goes with it.

"There was some difficulty in having them in daylight, because glowing things work better in dark caves than they do out in the sunlight. But again, our compositor spent a lot of time manipulating the images, popping the highlights here and there to make sure they still had that feeling of glowing and adding a little bit more contrast in the daylight scenes, that kind of thing.

"And then I remember Peter wanted us to come up with an effect for when they're released from their bond, and so we tried several different ideas of how they might dissolve and break up and float away until we hit on the one that he liked. It was just playing with different ways of doing it: How big do you make the particles? Do they look flaky or do they look smoky? Ultimately, we stuck with the idea that there was something ghostly even as they were coming apart, because anything else felt like it was too physical. That's not what they were supposed to be.

"I think we tried a couple of different colors for them, just because you always try to explore the different possibilities. But I think in the original concept art, it was a little bit greenish, and in the end, that's where we landed. It seemed to fit better, especially once we got to the outdoor scenes. There was so much grass and natural colors around them. Orange wouldn't have made sense for a ghost, and blue doesn't quite work when you're out in daylight, so we came back to the green. That seemed to be the best way to go."

GIMLI'S UNCREDITED BODY DOUBLE PUT IN THE WORK, AND HE HAS THE TATTOO TO PROVE IT

BRETT BEATTIE SPEAKS ON HIS PIVOTAL WORK IN PETER JACKSON'S TRILOGY

James Grebey

Peter Jackson and the creative team behind the *Lord of the Rings* trilogy assembled a fellowship on screen, and on set. The experience of nearly two years of filming was so deeply felt by the ensemble that, after completing filming, most of the actors of the fellowship got matching tattoos to cement the bonds they'd forged together in New Zealand. Only one member of the core cast doesn't bear the elvish "nine" on his person: John Rhys-Davies.

Since bringing Gimli the dwarf to life, Rhys-Davies has joked that he doesn't have the tattoo because "whenever there's anything dangerous or that involves blood, I sent my stunt double to do it," and professed a general aversion to needles and tattoos. But the true story is much more complicated and impressive: Another actor spent a great deal of time playing Gimli alongside the other actors of the Fellowship, albeit without much credit. Stunt double and size double Brett Beattie has never spoken to the media about his time playing Gimli in the *Lord of the Rings* films until now, but in his own humble way, he's ready to share the full extent of how

much he put into the role, recall some old battle wounds, and reveal why he was chosen to become a member of the tattoo fellowship.

THE GO-TO GIMLI

Beattie was about as green as they come when he stepped into the blockbuster world of Middle-earth. Although he had done, as he says, "a wee bit" of high school drama while growing up in Canterbury, on New Zealand's South Island, he had no serious acting experience to speak of. What he did have going for him, however, was a black belt in martial arts, plenty of horse-riding experience, and a height of 4-foot-10—helpful for a movie in which many main characters are dwarves or hobbits.

"I'm a country boy. I come from a rural environment," Beattie tells Polygon. "From having no experience, I couldn't have gotten kicked more in the deep end, let's put it that way."

Initially, Beattie was hired to do horse stunts. ("I did that for two weeks and out of everything I've done, my God, that was dangerous.") However, casting soon picked him up because he was an

able scale double and could stand in for Rhys-Davies—despite playing a dwarf, at 6-foot-1 (186 centimeters), Rhys-Davies was the tallest member of the main cast. But once it became clear that the facial prosthetics needed to bring Gimli to life triggered a nasty allergy in Rhys-Davies' skin, Beattie became the go-to Gimli.

"I am aware that a lot of the people, even hardcore *Lord of the Rings* fans, assume that a lot of the shots are some tricky sort of camera angle or some CGI shrinking John Rhys-Davies down," Beattie says with a good-natured laugh. "I don't want to burst anyone's bubbles, but I can only think of a couple of shots where CGI was used to shrink Rhys-Davies down."

Viewers can't really tell when Gimli is Rhys-Davies and when he's Beattie—that's the whole point—but Beattie can. He recalls watching a YouTube video of a minute and a half of Gimli fight scenes and realizing that all but four seconds of the montage were him. Beattie says he spent 189 days—some 2,300 hours—as Gimli, all told.

THE ENDURANCE OF DURIN

Beattie's time on set was not without incident. Just last month, he got his third knee-reconstruction surgery, a consequence of having blown both knees while filming the movies. "The surgeon was asking me how I got those injuries, and I was, like, 'Well, I was battling Uruk-hai at Helm's Deep,'" Beattie says as he lists off other close calls like a sinking canoe, dodging horse hooves, and taking an axe to the head. The latter incident happened while he was holding one of the heavier, more detailed prop axes for a close-up shot of Gimli running, and Beattie attempted to toss the weapon from one hand to the other.

"I clipped my brow on the way past. Because I was wearing a prosthetic mask,

the blood couldn't get out. So the blood built up and built up under the mask until, eventually, an eye bag which was glued on actually ruptured, and the blood just started spurting out," he recalls. "It looked a lot worse than it actually was."

"The blood built up and built up under the mask until, eventually, . . . the blood just started spurting out."

Even when they weren't becoming blood-filled balloons, those facial prosthetics were a lot to endure. The scale doubles playing the hobbits had full rubber masks they could just pull on and off, and there was an unwritten rule that they couldn't be in the masks for more than an hour at a time on set. Beattie, meanwhile, had nearly half a pound (more than 2 kilograms) of silicone and foam rubber glued to his face for a minimum of 12 hours a day, sometimes more.

"A lot of guys couldn't do it," Beattie says, not trying to brag so much as just earnestly convey what a hardship those prosthetics were. "I'd actually seen a guy ask to put it on, and he was getting claustrophobic and had to take it off."

Toward the end of filming, Beattie was running on fumes—figuratively and literally, when you consider that he was essentially sweating out the chemical adhesives used to attach the Gimli prosthetics. He and prosthetic artist Tami Lane were frequently the first people on set in the early hours of the morning to get him ready to shoot, and then he'd have trouble sleeping due to an onset of insomnia. He took to taking naps, in costume, while filming.

"I'd get woken up—'Brett, you're on!'—and the next thing I knew, I'd be running through Fangorn Forest or the Mines

of Moria getting chased by goblins," he recalls. "I wasn't awake, I wasn't asleep; I just ended up in this really crazy state of consciousness."

ONE OF THE NINE

Beattie was doing far, far more than he ever imagined he would be when he first got involved with the *Lord of the Rings* films, and he was certainly going above and beyond what one might expect from a typical stunt performer. The rest of the cast knew it, too. This is where the tattoo comes in, as well as some of the more unsavory aspects of moviemaking.

With the encouragement of his seasoned movie star cast members, Beattie, who did not have an agent or any movie-business experience, asked to get a screen credit befitting the amount of time and effort he'd put into Gimli. The producers agreed, saying that he was going to be listed in the credits as Gimli's stunt, scale, and photo double. But a week later, he says, he was told that he actually couldn't be given the screen credit, due to "movie politics" and "concerns about preserving the illusion that is Gimli." Beattie is listed in the credits, but just as a stunt performer. (Sean Astin's book about his time filming *Lord of the Rings*, *There and Back Again: An Actor's Tale*, confirms that Beattie almost got co-credit for playing Gimli.)

Beattie is hesitant to tell this story. As crushing as the bait and switch was, he says he holds no grudges, understands the impulse to protect Gimli as a character, and doesn't want to rock the boat or cause a controversy in the *Lord of the Rings* world. Still, the lack of a proper screen credit was a disappointment after everything he'd put into the movies. The cast picked up on this. While Rhys-Davies is often quoted as saying he sent Beattie to get a tattoo in his stead, Beattie says—and *There and Back Again: An Actor's Tale* corroborates—that it was actually the rest of the cast who reached out to him.

"I remember Elijah Wood actually approached me first and invited me. And to tell you the truth, my biggest concern at the time was John Rhys-Davies. I knew that this wasn't supposed to be for me to be asked to get this tattoo. So I said I had to think about it," Beattie explains, adding that he relented when Viggo Mortensen and Orlando Bloom asked him again the following day.

So, on a Sunday afternoon, Beattie, Mortensen, Bloom, Wood, Astin, Ian McKellen, Billy Boyd, and Dominic Monaghan (Sean Bean was already in England, according to Beattie's recollection) headed to a tattoo parlor in Wellington to get elvish numerals engraved on their bodies. It was an honor for Beattie—"No doubt about it," he says.

Beattie's only regret is what happened afterward. "After we got the tattoos, Elijah says to me, 'Myself and a few of the cast members are going into Peter Jackson's armory today, um, to play with machine guns. Come.'" Still utterly exhausted from the rigors of the shoot, he declined.

"I almost feel like I owe the cast some sort of an apology for not digging deeper and making that effort," Beattie admits. "I spent a lot of time on set with the cast as a professional working. I spent a lot of time with mainly Viggo and Orlando socializing and fishing, but I didn't have much to do with the [hobbit actors] or Peter Jackson. It was all very professional, and that was an opportunity to get to meet them and to get them to meet me without a mask glued to my face."

Despite missing out on some bonding over machine guns, Beattie is still forever a member of this special fellowship. He's not in touch with the other actors anymore, though Bloom made a special effort

to track him down and catch up when they both worked on Peter Jackson's Hobbit films. Nowadays, Beattie, who worked with EA Games on the *Lord of the Rings* video games after filming and still takes the occasional stunt role now and then, spends most of his time operating a native-tree farm in the Canterbury region of New Zealand's South Island. He doesn't show off his tattoo much or get any recognition, really, for what he put into the *Lord of the Rings* films.

"I knew I'd done something harder than I'd ever done in my life, and I knew I'd never work that hard again."

Despite being thought of—if he's thought of at all—as merely "Gimli's stunt double," Beattie is proud of what he accomplished during the making of the films. "I knew I'd done something harder than I'd ever done in my life, and I knew I'd never work that hard again," he says, adding that he also feels he did something good for his country, considering the tangible ways in which the trilogy benefited New Zealand's filmmaking and tourism industries.

Playing Gimli was a life-changing experience, for more reasons than just getting some permanent ink to quietly honor his unsung contributions. Beattie ends our interview by telling the story of his last day of filming: He'd been up until early in the morning for the home birth of his first child, then hopped on a plane to film the *Two Towers* scene where Gimli gets pinned by a dead warg and snaps an orc's neck. Within 24 hours, he was back home holding his baby in his arms.

"There aren't too many people who have been jumped by a warg, killed an orc, and delivered a baby all in the same day," Beattie says with a smile.

If you want to read more about...

> *The mixed performances of LOTR, turn to page 71–"Andy Serkis' Gollum Is a Singular Performance Without a Single Author" (January)*

> *The secret stars that made* The Lord of the Rings *a masterpiece, turn to page 23–"The First Note in* The Lord of the Rings *Has an Ancient History" (September)*

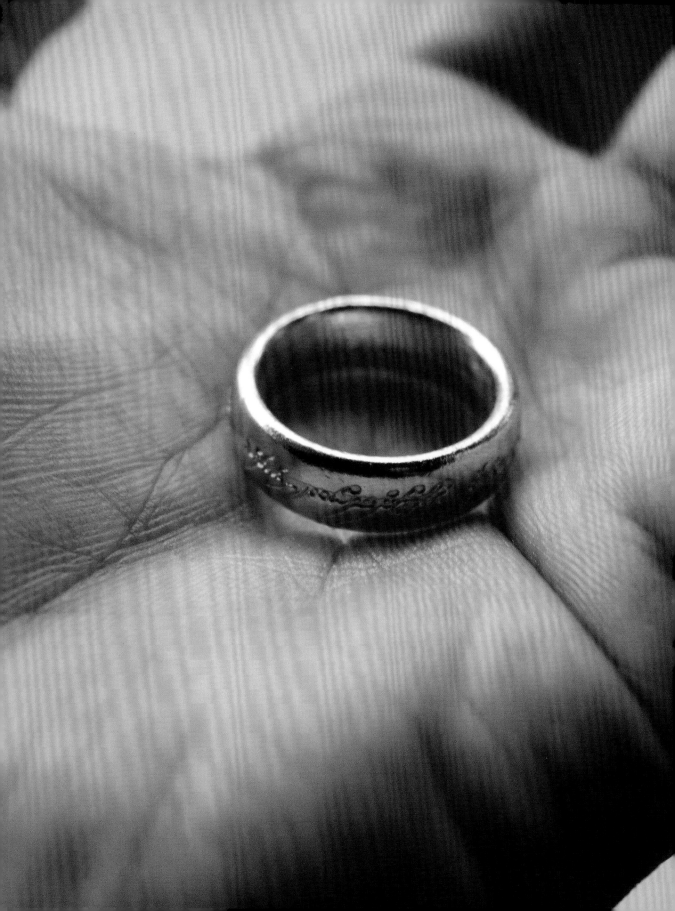

CHAPTER THREE

NOVEMBER: WATCHING *THE LORD OF THE RINGS*

EVERYBODY LOVES THE LEAST DEFINITIVE VERSIONS OF THE *LORD OF THE RINGS* MOVIES

THE EXTENDED EDITIONS ARE NOT PETER JACKSON'S FAVORITES

Susana Polo

I've got a lot of opinions about media that other fans of it might find controversial. I love *Rogue One* and *The Last Jedi*. I can't stand Damian Wayne. I think *The Silmarillion* is more readable than *The Hobbit*.

But if there's one controversial opinion the most likely to elicit a shocked gasp and an immediate accusation of being no real fan at all, it's this one: I prefer the theatrical versions of the *Lord of the Rings* trilogy to the Extended Editions in the deluxe boxed set.

The Extended Editions of the *Lord of the Rings* movies are legendary, and rightfully so. They boast "deleted scenes" fully integrated with the films themselves (which are delivered in files so big you have to swap discs halfway through, like a VHS copy of *Titanic* or a video game from the 1990s), complete with fully treated special effects and a restrung score. Finished with the movie? There are dozens of hours of cast and crew interviews about the techniques used to make the film and the friendships forged on set—enough behind-the-scenes adventures for their own trilogy.

But when I sit down to watch *The Lord of the Rings*, I want to watch it the way it looked in the theater. The way Peter Jackson really imagined it.

THEATRICAL *LOTR* IS ALL KILLER, WAY LESS FILLER

There isn't a wasted shot in the theatrical edition of *The Fellowship of the Ring*. It's a near-perfect movie. The first act is perhaps the greatest example of seamless exposition in filmmaking ever produced, as the production covers 6,000 years of history, a textbook's worth of world-building, and the introduction of a dozen immediately compelling lead characters.

Would I have liked it if there had been room for the scene where Galadriel gave the Fellowship gifts in Philippa Boyens, Peter Jackson, and Fran Walsh's adaptation? Sure, she's one of my favorite characters. Would I have liked to catch a glimpse of Gildor and his band of elves on their long pilgrimage to Valinor? See Aragorn visit his mother's grave? Yeah, of course! Do I want those scenes to cut in to the delicate pacing of *The Fellowship of the Ring*, jarring the exquisitely balanced flow of the movie? I do not.

The Two Towers is baggier than *Fellowship*, with a few detours that have

never felt justified to me. Aragorn falls off a cliff and has a psychic conversation with his girlfriend, Faramir whiffles back and forth about the Ring, and it never quite matters. It's still a great film, and is my go-to pick whenever someone asks, "Wanna watch a *Lord of the Rings* movie?"

I am only human, and a giant *The Lord of the Rings* nerd. Do I want to see what Jackson and his collaborators thought Treebeard's house should be like? Yes! What about that bit where Aragorn admits that he's nearly 90 years old? Obviously!

But when I'm sitting down for an all-day marathon, I want the tighter, better version of the movie, the one that's engineered as a cohesive cinematic story rather than a collection of translated scenes.

THE EXTENDED EDITIONS BROUGHT *LOTR* HOME

The extended versions of *Fellowship*, *The Two Towers*, and *The Return of the King* came out when it was still astonishing that a broader public would invest monetarily and emotionally in something that was historically niche, lowbrow, and, for lack of a better word, nerdy. They also offered a way to bring an "exclusive" version of the *Lord of the Rings* movies into more intimate, fans-only spaces, where we could pause and rewind, and gush and cheer without fear of judgment (or just fear of bothering other people).

Every year, my friends and family would see a *Lord of the Rings* movie just before Christmas. And the following year, the Extended Edition DVD would hit stores around Thanksgiving break. For three years, we would pop the disc in and dive back into Middle-earth just in time to ignite hype for the next installment.

The Extended Editions also fostered a sense of intimacy through hours and hours of filmed interviews on how the movies came together. There are Wētā designers I can still recognize on sight today. Talking about how Viggo Mortensen breaks his toe on screen in *The Two Towers*—something you'd only know if you watched the special-edition DVDs—is a meme now.

But the Extended Editions are not better movies.

AND PETER JACKSON AGREES WITH ME

"The theatrical versions are the definitive versions," Jackson told IGN in 2019. "I regard the extended cuts as being a novelty for the fans that really want to see the extra material."

To Jackson, things like Treebeard's home and Galadriel's gifts are indelible parts of the *Lord of the Rings* books, and he didn't want the footage lost forever. The Extended Editions preserve that work, and are made with the understanding that fans want to see it. But, Jackson said, every addition has a detrimental effect on what he set out to make.

"Every time [I add something in] I think I'm spoiling the film, but I'm doing it because people want to see it and they'll see it in their home."

There isn't a wasted shot in the theatrical edition of **The Fellowship of the Ring.**

The difference between adaptation and translation is that the former is in ultimate service of the new format, and the latter is in ultimate service of preservation. And perhaps it's natural for fans of a beloved story to look to accuracy before art. But a novel is not a movie, and adaptations have to make choices—and not just about what something that used to exist only in readers' imaginations looks like when it must be embodied by a living, breathing, costumed actor.

The theatrical editions of the *Lord of the Rings* movies made great choices. The Extended Editions chose completionism, at least partially to please fans rather than the creatives behind the work itself. The shape of *Lord of the Rings* movie fandom would be entirely different without the extended DVD releases. But even to the director himself, those versions of the movies are a novelty, not his artistic intention.

I don't want to keep anyone from enjoying the Extended Editions—I just wish people wouldn't speak of them like they're the "real, true" versions of Jackson's trilogy. Not even he talks like that!

That said, there is one *Lord of the Rings* movie that I think is better in the Extended Edition, and that brings me to my next controversial opinion: *The Return of the King* is actually kind of a mess, and the Extended Edition is necessary to complete vital character arcs and create emotional underpinning for the movie's best moments. But that's a story for another time.

If you want to read more about...

> *Yet another version of Peter Jackson's LOTR, turn to page 210—"What Peter Jackson's Original Two-Movie The Lord of the Rings Almost Looked Like" (October)*

> *Never-ending fan arguments, turn to page 158—"The Eagles Are a Plot Hole, but Also an Us Problem" (June)*

NOVEMBER **1–30**

Elrond sends his sons, Aragorn, and many scouts in search of the Nazgûl, to be certain they have fled back to Mordor. Meanwhile, the Fellowship rests and recuperates in Rivendell.

TIMELINE
2001

ARE THE *LORD OF THE RINGS* MOVIES BETTER AT CHRISTMAS OR AT THANKSGIVING?

THE ANSWER TO AN AGE-OLD QUESTION

Jeremy Gordon, Daniel Dockery, and Susana Polo

A recent internal poll of Polygon employees found a split editorial edifice: The office was deeply divided on whether Peter Jackson's *The Lord of the Rings* trilogy was best watched as a Thanksgiving movie marathon or a Christmas movie marathon.

The only answer was to dig deeper, weigh the arguments, and then decide in our hearts which late-year extravaganza was truly in the spirit of *The Lord of the Rings*. Is it the trilogy's themes of fellowship and cooperation that speak to your turkey-loving heart? Or is it the elves, trees, and bearded old men that really capture your Christmas spirit?

Or is there a third, galaxy-brain answer that blows the previous two out of the water and infuriates everyone who reads it?

Polygon assembled a panel of three experts to decide the issue for once and for all.

[*Ed. note:* The findings of Polygon's experts are nonbinding on any person reading this now and on all future holiday seasons. If you really have a dog in this fight, we encourage you to share it politely, although you should log off and watch the *Lord of the Rings* movies at some point.]

CASE #1: THE *LORD OF THE RINGS* MOVIES ARE THANKSGIVING MOVIES
Presented by Jeremy Gordon

Perks of attending a fancy-pants magnet high school: Every Thursday, my normal class schedule was swapped for two 90-minute seminars covering an array of specialized subjects, taught by teachers thrilled to cast aside the pedantry of standardized-test prep and dive into a subject they really gave a shit about. In my freshman year, the first seminar I signed up for was on J.R.R. Tolkien.

The Fellowship of the Ring had hit theaters just before last Christmas, and though I hadn't read the books, the saga—of good and evil, of men and elves and orcs, of Magneto recast as my wise wizard grandpa—immediately sucked me in. This seminar seemed like an excellent way to accentuate the knowhow I'd picked up from the original text (a last-minute Christmas gift, wolfed down in a few days) and message board forums.

Only the teacher, a middle-aged woman who dressed like a librarian Stevie Nicks, did not want to titillate our minds

with adventure. Instead, we were to make our way through *The Silmarillion*, Tolkien's dense collection of stories about the greater Middle-earth mythology stuffed with proper nouns and plotless exposition. I was a never-been-kissed nerd who owned all of the needlessly obscure Star Wars action figures, but this was too much.

For Tolkienites like my teacher, that kind of lore was the real treasure of *The Lord of the Rings*—an epic and rich tapestry upon which Tolkien's explorations into invented language and allegorical religious conflict unfurled. For newcomers like me, and the millions who would see *The Lord of the Rings* in theaters over the next few years, all this was beside the point. Not that the concept of Ents isn't awesome; I would love to talk to you about the Ents. But the resonant appeal of the trilogy had nothing to do with the fleshing out of Middle-earth, which is why the Hobbit trilogy was a small failure.

We cared about the *Lord of the Rings* trilogy because we cared about the characters, and the ways their relationships developed as they progressed along this journey to defeat true evil. *The Lord of the Rings* wasn't the only 21st-century action blockbuster adapted from a series of popular novels—there's Harry Potter, Twilight, and the Hunger Games, to name a few—but it offered the most poignant demonstrations of how this action actually changes people. This is just basic storytelling, but success is often a perfect execution of an established formula.

Notably, this change is oriented around friendship and loyalty as experienced by adults. These relationships are familiar, even though we're ostensibly watching a movie about the fictional races of hobbits and elves and dwarves. Frodo and Sam are best friends. Pippin and Merry are Frodo's cousins, and best friends. Gandalf is Frodo's uncle, basically.

Aragorn, Boromir, Legolas, and Gimli are some guys they all meet, and while they don't get along at first, they learn to. Their brotherhood is invented, but it's no less meaningful for that. At the end of the first movie, Aragorn, Legolas, and Gimli *should* join the war efforts against Sauron . . . only they have to find their homies first. "We will not abandon Merry and Pippin to torment and death," Aragorn declares, and have you ever been more roused to the cause of friendship in a franchise film? NO!!!!!!!

Thank God they have each other, because no one comes back the same. Boromir—a gigantic prick, at first—sacrifices himself for the gang. Legolas and Gimli, who initially can't stop being racist toward each other, realize they have more in common than not. Aragorn, a generational shirker of responsibility—suck it up and be the king, man!—accepts his role as everyone's big brother, and also the king. Sam abdicates his own personhood to make sure Frodo reaches Mordor, but in doing this he becomes his own man. (He's the only character we see as a parent, which is to say that, canonically, Sam fucks.) Pippin and Merry cut the shit and find meaning in the twin cities of Gondor and Rohan. Frodo is the rare hero whose life is ruined by his heroism; he can never shake the wounds of what has happened to him, no matter how many years go by.

To satisfy the prompt of whether *The Lord of the Rings* is a Thanksgiving movie, I will point out that the films take place in fall climates and the food is excellent and some cousins get stoned. But Thanksgiving is a holiday where you are supposed to reflect on the things in your life, and the people around you, and the gratitude you might feel for all this. Life changes people. Life changes *you*. We can all use a moment to pause and breathe and note the passage of time

and all its breathtaking and quiet revelations—preferably in the fall, the season of change, surrounded by good food and potentially some weed breaks with the cousins. So I will resist the impish urge to contort myself into some whimsical argument about Why *The Lord of the Rings* Is Actually a Thanksgiving Movie because the dynamics I have described so clearly sync up with the holiday, and are why I, and millions of others, remain touched upon repeated viewing. (Even if I do also watch the movies around Christmas, when there's more free time, because I always go for the Extended Editions.)

CASE #2: THE *LORD OF THE RINGS* MOVIES ARE CHRISTMAS MOVIES
Presented by Daniel Dockery

When picking out Christmas movies, there's the obvious family-friendly fare (*How the Grinch Stole Christmas*, *Elf*, *It's a Wonderful Life*), the "This is actually a great Christmas movie" internet darlings (*Die Hard*, *Batman Returns*), and the stuff that just seems to fit for some reason. More than one person has told me that, around the holidays, they like to nestle in and put on Peter Jackson's *The Lord of the Rings* trilogy, which definitely slots nicely into that last category. I should know, because I, too, like to enjoy the near twelve-hour experience that is the Extended Editions in the days leading up to Christmas.

The method by which I gorge myself on these films has changed, but for over five years, the base tradition hasn't. What once was a marathon session to fit them all in on Christmas Day (adjusted because exposing my two-year-old to the deliciously spooky Mines of Moria and Shelob sequences would get me arrested in most states) became a sort of Six Days of Christmas affair, where each night, my wife and I settle into half of one of the films.

This is made extremely easy because even with the magic of technology, Jackson's films are so long that they're split over two discs. It might seem like a callback to J.R.R. Tolkien's splitting each book into two sections, but the timing doesn't quite line up. And with little exception, each provides a satisfying little conclusion to cap off the night, (The only outlier is *The Return of the King*, which ends with the introduction of Grond, the giant, flaming battering ram that's certainly rad, but "Oh, man. GROND'S HERE" just doesn't carry the weight of, say, the conclusion of the Council of Elrond.)

So, what makes the trilogy work as Christmas films? They're obviously feel-good movies, but I think the warm satisfaction you get from them is particularly of the Christmas variety, one where the power of the spirit overcomes that of greed or malicious decadence. *Elf* ends when James Caan decides that he shouldn't be so cutthroat in the world of, um, children's book publishing, and accepts the magic of Santa and/or family. *It's a Wonderful Life*

concludes when Jimmy Stewart learns that it was pretty solid for him to be so nice all the time. These moments of triumph are littered throughout *LOTR*, whether it's Frodo deciding that he has to be the one to take the ring to Mordor, or something as grand as the treelike ents marching on Isengard, a stronghold of industrial terror and the demise of nature.

It also doesn't hurt that there's something inherently communal about *The Lord of the Rings*. You get the sense that when Saruman falls, it isn't just because he's a conniving old weirdo, but because he's a conniving old weirdo who has no friends. Christmas, or at least most Christmas movies, tends to be about that feeling of family, and how special it is that even if it's just once a year, you can gather together with people you love and kinda wallow in it all. It's a reason that they form a Fellowship to take the Ring rather than Aragorn and a platoon of jacked dudes. And when Aragorn kisses Boromir's forehead or Frodo and Sam hold one another on the lava-drenched side of Mount Doom, there's real love and open admiration untethered to any self-aware sense of masculinity. Comfort in the presence of another that you adore.

The fact that *The Fellowship of the Ring* basically begins with a big party (after all the epic, sweeping battlefield shots and Cate Blanchett exposition) makes it a good kickoff game for Christmas. There's something holiday-ish about Bilbo's birthday party, with everyone eating and pouring ale and lighting fireworks. The hobbits' need for feasting while their clothing looks like something from a Charles Dickens adaptation gets me in the mood for copious amounts of eggnog and sleeping after eggnog.

Meanwhile, the sheer amount of promise that in the end, it's all going to be okay means that when Christmas begins to wrap up, hope for what lies ahead still remains. It seems that every few minutes, a character in *The Lord of the Rings* pauses to basically affirm that life isn't totally terrible, whether it's Gandalf looking at Frodo in his little travel garb and smiling at his naive enthusiasm or later reminding Frodo that even when all seems dire in "the time that is given," we still decide what to do. Sam has two separate moments in *The Two Towers* where he speaks of the stories that will come through the characters just holding on and even Gandalf's description of death and passing on in *The Return of the King* feels hopeful. There is a new year ahead.

Lastly, and perhaps most importantly, there are elves in *Lord of the Rings*. Santa has elves. That's gotta be something, right?

The *Lord of the Rings* trilogy is easily applied to the constructs of Christmas flicks without constantly reminding us of Christmas itself, and that's key for allowing it to remain fresh. Existing during the holidays means being inundated with Christmas as a brand name, a driver of merchandise and movies. So by the time you pop in a Christmas movie, it can be a little tiring to pray at the red-and-green altar when you've just spent hours fighting your way out of the checkout line at Target. *LOTR* is devoid of this kind of hustle, and becomes the best choice for anyone that likes watching the good guys succeed without feeling like they're trapped in a commercial.

CASE #3: THE *LORD OF THE RINGS* MOVIES ARE NEW YEAR'S EVE MOVIES
Presented by Susana Polo

If you hit Play on the theatrical version of *The Lord of the Rings: The Return of the King* at exactly 9:13 p.m. and 24 seconds, the Eye of Sauron explodes at midnight.

I figured this out while exploring ways to see off the year 2020.

Knowing I'd be spearheading Polygon's Year of the Ring anniversary coverage through all of 2021, I thought a New Year's marathon with a friend would be both fun and edifying. On a sort of whim, I thought I'd time *The Return of the King* to put Sauron's demise at midnight. All it took was pulling up the movie on whichever streaming service it was then housed, scrubbing to the moment, checking the time stamp, and using an online calculator to work backward through the films' runtimes to make sure I got everything right. We would kick off in the early afternoon and even have time for a half-hour intermission between each film and at the midpoints of *Fellowship* and *The Two Towers*.

It seemed a bit silly at the time, but fun. Whimsical, perhaps. One last middle finger to 2020. I expected it to be moving. I didn't expect sheer, unbridled catharsis.

What I hadn't realized was that the span of time from the moment Gollum disappears beneath the lava of the Crack of Doom to the moment the tower goes boom is actually over two minutes' worth of movie. After a full day of movie-watching, snacking, and relaxing, Gollum falls, and you know that midnight is nearly here. But it's not here *yet*.

First, Sam has to implore Frodo to reach for his hand, and choose life over the thrall of the Ring. After what feels like an eon, the Ring finally sinks beneath the molten waves. Orcs and trolls hesitate and flee at the Black Gate. Aragorn, Gandalf, and the rest of our heroes look up in renewed hope, and they realize exactly what we've realized: This whole long fight is about to end, and here, in the darkest dark, a new era is starting in spite of all expectations.

The tower begins to shift and crumble, tears well up in Ian McKellen's eyes, and then . . . *POW*, the Eye of Sauron explodes and takes the year with it.

I don't think I'd do it every year—only on years that really, really deserved it. And I can't say that *The Lord of the Rings* is *more* of a New Year's marathon than it is a Thanksgiving or Christmas one.

But let me tell you: as a dark horse challenger in this clash of holiday titans, it deserves an honorable mention.

If you want to read more about...

> *How to watch the* LOTR *movies, turn to page 118–"A Definitive Guide to Being the Most Annoying Person to Watch* The Lord of the Rings *With" (April)*

THE ECSTASY OF SEEING
THE LORD OF THE RINGS
IN THEATERS IN 2021

"IF I TAKE ONE MORE STEP, IT'LL BE THE FARTHEST
AWAY FROM HOME I'VE BEEN SINCE 2020"

Chris Plante

*Adventure!
Togetherness!
Drinking grog
inside small
rooms without
fear of a virus
that could kill
you and those
you love!*

Every day we make a thousand small decisions that steer the direction of our lives. Only now and then—and only with the power of hindsight—can we point to a single moment and say, with full confidence, that it changed us.

In 2021, as the global pandemic down-shifted into a global endemic, I left my house, donned a high-grade medical mask, and returned to the movie theaters to see *The Lord of the Rings*. The analogue wasn't lost on me: one man afraid of stepping far from home to watch another man journey outside his comfort zone. I chose a dark room with a few dozen like-minded locals. Frodo chose Mordor. A little different, I guess.

The audience—a small group, lots of empty chairs to allow for social distancing—wasn't prepared for the 3.5-hour emotional earthquake. We laughed, we cried, and most of all we cheered like we were at the World Cup. Every little thing warranted applause. We were feasting on a story with all the nutritious elements that had been so hard to come during quarantine. Adventure! Togetherness! Drinking grog inside small rooms without fear of a virus that could kill you and those you love!

I wrote about the experience that week, hoping to pin down the memory like a deceased butterfly. It would never be quite as beautiful or vibrant, I thought, but it wouldn't be forgotten.

But I couldn't have predicted how that experience would shape me. I had liked going to the movies a couple of times a month, but all those emotions of *The Fellowship of the Ring* had made my appetite insatiable. I returned to see both sequels. And then to see whatever else theaters were willing to show to keep the doors open as Hollywood spun up production. I moved to California to help take care of my in-laws and I sought out an indie movie theater. In that awkward post-move phase—no friends, a bit of extra time—the theater became my home away from home, the place where I could talk to strangers or just be near other humans for a few hours each week.

This year, I began to volunteer with the movie theater. And this past week, we hosted a daylong screening and put a button on this journey from there and back again: a back-to-back-to-back showing of the *Lord of the Rings* trilogy. Extended Editions, of course.

There were fewer masks and the clapping was loud, though not thunderous. But the venue was sold out, a community of people brought together by one story. As the credits rolled, it hit me: The opening minutes of this trilogy brought me back to the theaters, and the final minutes cemented a hobby into a life's passion.

What follows is my original story from 2021, from the perspective of someone who doesn't yet know they're at the beginning of a wonderful quest.

The half-capacity audience couldn't stop applauding during a recent screening of *The Lord of the Rings: The Fellowship of the Ring* in Austin, Texas. The lights went down in the theater. Applause. The title card appeared. Applause. Sam took the farthest step he's ever been from home. Some giggles and a couple of knowing claps from the crowd's more meme-savvy members.

Should I really be surprised that, in 2021, folks are ecstatic to be watching movies together again? Of course not. Movie theaters are therapeutic. For a couple of hours, we can sit in a dark and air-conditioned room, have a beer or a decaf coffee, and share a communal experience without having to actually do the anxiety-inducing labor of chatting with strangers.

Skipping movie theaters for the past year has been a minor sacrifice in the grand scheme of the pandemic, but that never prevented me from fantasizing about a return to my local Alamo Drafthouse. Now, new data on vaccines and Centers for Disease Control and Prevention guidance have begun to illuminate the shape of our increasingly vaccinated future. So, this week, with my vaccinated cells on full defense and my wife and kid on a road trip, I felt comfortable spending a few hours sporting an N95 mask in an enclosed but socially distanced space.

I ventured to see my first movie at the theater since watching *The Invisible Man* in early 2020. I chose *The Fellowship of the Ring* because, frankly, it's what happened to be playing, thanks to a recent reissue of the trilogy in 4K resolution. Though in hindsight, I can't imagine a more fitting film to mark the downslope of this miserable 12 months and change.

A story about average people (because hobbits are more human than the humans in *LOTR*) forced into a long, arduous, potentially deadly, and profoundly isolating journey is even more relatable in 2021. Lines like "and my axe" got cheers and laughs, but I felt the room vibrate during the film's more unintentionally timely moments, like a conversation between Frodo and Gandalf that was (rightfully) on every nerd's lips in 2020.

Stuck in the Mines of Moria, internalizing the gravity of his quest, Frodo says to Gandalf, "I wish none of this had happened." Gandalf is soft but stern. "So do all who live to see such times," the wizard says. "But that is not for them to decide. All we have to decide is what to do with the time that is given to us."

The guy a few seats over from me, previously sneaking popcorn under his handmade cloth face mask, wiped tears from his eyes. So did I. Being back inside a movie theater tuned my heart like a return to church on the holidays. My quibbles with moviegoing inverted.

In the past, I ground my teeth when seat neighbors loudly murmured to one another or checked their smartphones, somehow always set to maximum brightness. But at this screening, I felt grateful for every little reminder that I wasn't alone, whether it was the pungent odor of hot wings wafting from the row behind me or

the group of friends in front of me debating who was hotter, Viggo Mortensen or Orlando Bloom? (The answer is Viggo, but only barely.)

Back in March 2020, I subscribed to the Criterion Channel, and for a moment, the streaming service became my "media therapy" (not to be confused with my therapy therapy). I'd struggled with getting a full night's sleep, so around 5 a.m. each day I'd start a Japanese noir film or a '70s horror flick and enjoy the serenity. I watched better movies, it cost less money, nobody munched popcorn with their mouth open or unwrapped candy, and I didn't have to think about waiting for a urinal in the theater bathroom. I liked it.

Then the pandemic kept rolling, and something about these mornings with the iPad felt—slowly and then all at once—lonely. I went from watching French existential dramas to living French existential drama. *J'en regrette ce bon vieux passé.*

Back at the Alamo Drafthouse, I confess I saw myself in those lovable hobbits, leaving behind the comfort of their homes and joining together with strangers for something bigger than themselves. Watching a movie with other people isn't the same as stopping an all-seeing evil from destroying life as we know it. But it's been a long pandemic. Baby steps.

The screening was part of the Alamo Draft-house's Support Local Cinemas series, in which classic films are being screened in theaters across the globe alongside new Q&As with cast and crew. The entire *Lord of the Rings* trilogy is screening week by week, each with its own virtual panel hosted by Stephen Colbert with all the names you'd expect, like Elijah Wood and Peter Jackson. As pleasant as the virtual reunion can be, however, the decision to follow the film with a glorified Zoom session spoiled my high.

At the end of the Q&A, the prerecorded Colbert called for a round of applause for the theater employees, and one more time the room erupted with claps. The lights came up, and we waited our turn to file out of the theater in a socially distanced single-file line. I got into my car and drove back home. And then it hit me: For the first time in ages, home wasn't the place I must stay, but a sanctuary to which I could return.

If you want to read more about...

> The Lord of the Rings *as food for the soul, turn to page 223*—"The Lord of the Rings *Faithfully Adapted Tolkien's Unrelenting Belief in Hope" (Second November)*

> *Another personal story of* LOTR *and community, turn to page 30*—"I Wore Arwen's Dress to Prom Thanks to a Welcoming Lord of the Rings Fandom" *(October)*

All we have to decide is what to do with the time that is given to us.

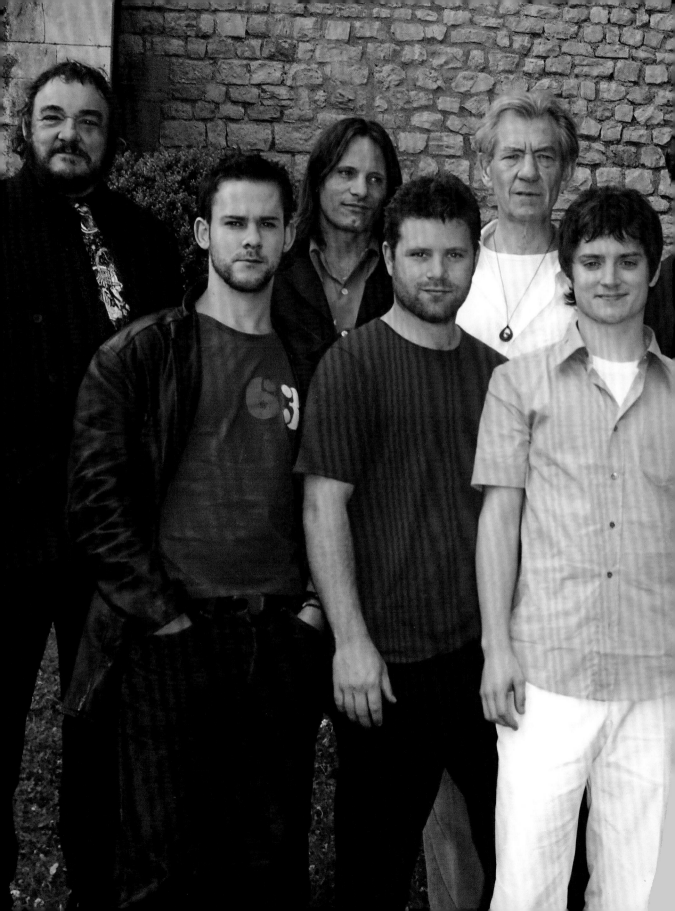

DECEMBER: THE FELLOWSHIP SETS OUT

THE LORD OF THE RINGS COMES FROM A TIME WHEN FANS WERE ONLINE, BUT HOLLYWOOD WAS NOT

LET'S OVERANALYZE A PRANK CALL

Joshua Rivera

Have you ever heard Elijah Wood laugh? Like, really laugh? Straight-up bust a gut in shock and delight? It's *great*. He doesn't really do it much in the *Lord of the Rings* trilogy, but you can still see him do it on the *Lord of the Rings* DVDs if you dig carefully through the scene selection menus on *The Return of the King* to find one of two hidden Easter eggs there. That's how you'll find one of the best jokes in the entire film adaptation of *The Lord of the Rings*.

It's a prank call by Dominic Monaghan, posing unseen as German radio interviewer "Hans Jensen," asking Elijah Wood increasingly ridiculous questions in a remarkably consistent German accent. It's a great goof, but it's also a good reminder of just how *different* fan and internet culture was when these films were released—of how if these movies had come out today, we might already be tired of them.

If you've never seen the interview before, it's now much easier to see than it was in 2004, thanks to YouTube and modern social media. Wood, as he notes in an introduction recorded after the fact, completely buys Monaghan's schtick. And for the next eight minutes he is absolutely taken for a ride, as "Hans Jensen" asks him about his beautiful eyes and, in the best exchange in the video, "Do you vear vigs?"

"Uh, no, I do not," Wood responds.

"Have you vorn vigs?" Monaghan persists.

"No, I have not," Wood says, the corners of his mouth beginning to twitch.

"Vill you vear vigs?"

". . . maybe!" Wood admits with a skeptical shrug, as if giving in to the nonsensical request of a toddler.

"Vhen vill you vear vigs?"

After a half second of mental processing, a scream of unleashed laughter breaks out of Wood's mouth, as Monaghan does his best to keep his own sniggering chuckles inaudible. The moment is universally appealing even when removed from context, as in 2022, when user jonahpedro remixed audio from it alongside "Under the Sea" from Disney's *The Little Mermaid* and spawned a whole TikTok trend.

(It's also worth noting that this prank call is a bit of a product of its time—both

because it's a prank call and because Monaghan uses his German character to make blunt statements about his co-star's sexuality. It's not terribly egregious, but the joke plays on a discomfort that speaks to the commonplace homophobia of the early aughts, which was not that long ago!)

The video is a delight partly because it's very funny—effortlessly flowing from absurd to cringe to a wicked non sequitur about Wood's former dolphin co-star from 1996's *Flipper*—but it's also steeped in the meta-narrative around the *Lord of the Rings* movies, and how the cast that played its core Fellowship became best friends over the course of the trilogy's filming. This friendship was a big part of the movie's folklore—most got tattoos of the Elvish character for "nine," a bit of trivia that comes up often enough that the actors are still asked about it today (page 42).

What's interesting about this backstory is the way that it's been preserved and remembered, occasionally surfacing when people, for example, recall on Reddit the time Viggo Mortensen and Karl Urban bought Gunpla together while doing press in Japan. When the *Lord of the Rings* films were coming out, online fandom was very much there, but social media was not—fans gathered on an internet that feels prehistoric in retrospect, sharing news and posting away on siloed message boards and fan sites. A lot of them are still around! And together with the more traditional press stories about the films released at the time, a hybrid text is formed, as modern fandom reprocesses the fascination of a previous generation.

The Lord of the Rings isn't the only movie celebrated in this way, but it is one of the biggest blockbuster phenomena to come along at a time when fans were online and movies were not. Now, something like Dominic Monaghan pranking

Elijah Wood wouldn't be tucked away on a DVD for only the biggest fans to find; it would be shared on the movie's Instagram account. It would be one of many orchestrated stunts for viral publicity—one appearance on *The Masked Singer*, pulling a giant mascot head off before C-list judges; another on *Hot Ones*, to sweat through a question with each spicy chicken wing; a shoot with *Wired*, answering the web's most searched questions in a blank white void; a Jimmy Kimmel segment, reading tweets that are either hateful or horny, according to the actor's vibe—a long charm offensive that might start to make people question if anyone on the film *actually* liked each other. (Or, possibly, give those questions an obvious, and un-fun, answer.)

These modern media blitzes can have great moments—Tom Holland promoting *Spider-Man: Homecoming* by upstaging Zendaya by performing Rihanna's "Umbrella" in drag on *Lip Sync Battle* is a classic of the form—but they're also a great way to ruin what was previously kind of fun. Now, the press tour *is* the story, a battery of interviews and viral games that contort actors into pretzels of performative authenticity. We're at a point that when celebrities start to do things people *actually* do, like, for example, when Paul Bettany makes a sly joke about getting

DVD Easter Egg

· First, load up disc 1 of *The Return of the King*. Go to "Select a scene." Go to scenes 33–36. Hit down until the cursor selects the One Ring icon next to the words "New Scene," and hit Enter/OK.

· Or just google something like "prank interview Elijah Wood wigs," which'll get you in the right place.

It's fitting that a trilogy of movies about wonderful and frightening myths rising up from the shadows for one last hurrah would also generate its own mythology that feels like one of the last of its kind.

to work with an actor he's always wanted to work with (himself, he meant, when his character Vision battles an evil duplicate), a tidbit snowballs into rampant fan speculation about a mystery *WandaVision* villain played by . . . Al Pacino? In a world like this, the only way to win is to troll. Which Bettany did, reminding everyone that this is all performance, and we're all part of it.

These lines weren't so cleanly drawn while the *Lord of the Rings* movies were happening. And that's what the trilogy felt like, like it was actually *happening*, and not being projected for attention. Algorithms weren't so instrumental in deciding who saw what, social media didn't yet gamify outrage and speculation, and online fandom was still mostly a spectator sport—studios were *absolutely* not looking to court or engage with online forums. So fans spun their wheels in relative obscurity, and now when we remember those films, we're also remembering that fandom—which is, of course, an extension of a very long line of people who adore the world of Middle-earth.

It's fitting that a trilogy of movies about wonderful and frightening myths rising up from the shadows for one last hurrah would also generate its own mythology that feels like one of the last of its kind. That distance between the internet as it was and the internet as it is makes *The Lord of the Rings* feel like a piece of the past, in a way that the subsequent *Hobbit* trilogy and Amazon's *Rings of Power* TV series never will.

Something that happens on the internet now is always happening, always present, all shared on the same social networks. But with *The Lord of the Rings*, all we have are the stories, and one really good prank call.

If you want to read more about...

> *How the internet changed fandom, turn to page 132*—"The Lord of the Rings *Movies Heralded the Final End of 'Nerd Stuff'"* (May)

> *How Hollywood has changed since LOTR, turn to page 86*—"The Return of the King *Won the Prize, but It Was* Fellowship *That Changed the Oscars Forever"* (February)

DECEMBER 18

Gandalf and Elrond choose the final two members of the Fellowship of the Ring.

DECEMBER 25

Bilbo gifts Sting and his mithril shirt to Frodo.

The Fellowship of the Ring leaves Rivendell.

TIMELINE
2001

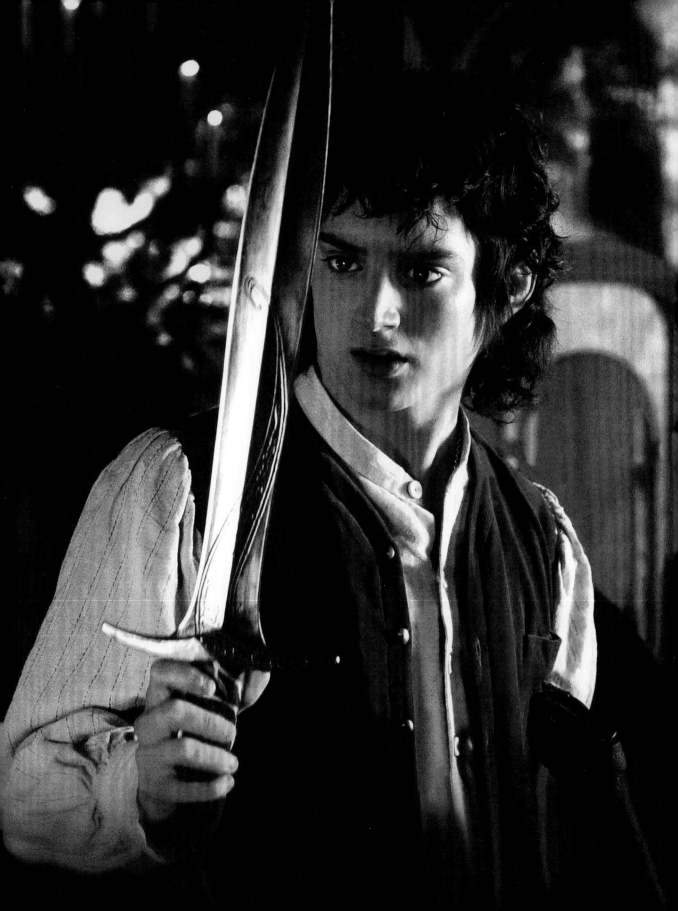

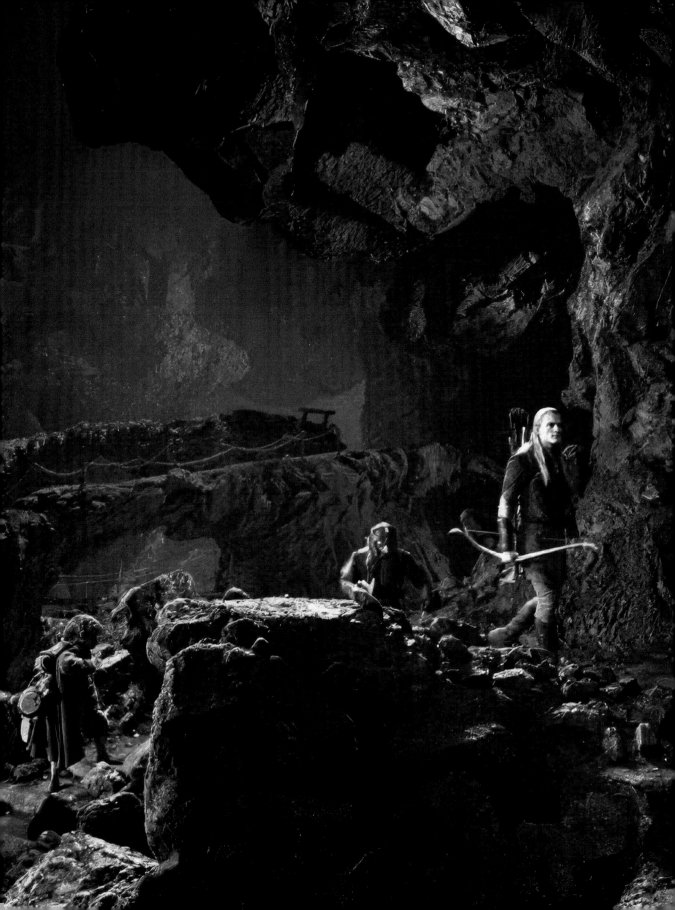

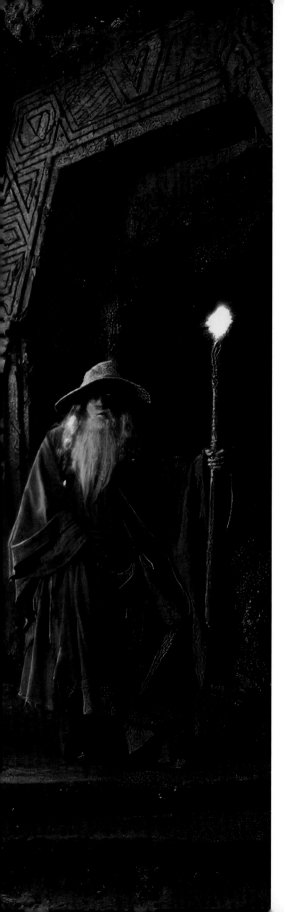

CHAPTER FIVE

JANUARY: MORIA AND LOTHLORIEN

LET'S CALL *THE FELLOWSHIP OF THE RING* WHAT IT IS: A HORROR MOVIE

THE FIRST FILM'S SCARES ARE KEY TO ITS SUCCESS

Austen Goslin

The *Fellowship of the Ring* is our introduction to Peter Jackson's version of Middle-earth. It sets the stage for the trilogy's epic journey, helping us take our first steps into a world that had never been so effectively imagined on screen before. It's got a harder job to do than *The Two Towers* or *The Return of the King*, and it does it with aplomb.

But there's something else that sets *Fellowship* apart from its successors, two action-adventure fantasy epics that span the world of Middle-earth and focus on half a dozen different characters. Unlike *The Two Towers* or *The Return of the King*, *The Fellowship of the Ring* is a horror movie. And that's exactly why it's great. Both fantasy and horror require you to believe in monsters for a few hours at a time—and scaring viewers can be the fastest way to make them believe in heroes.

Fellowship's divergence in tone comes by virtue of its uniquely limited perspective, mostly focused on Frodo or the hobbits. While we may literally see events that Frodo does not, it's through his eyes and naivete that we're watching it all unfold, instead of hopping around to the journeys of several different characters. The other movies occasionally get spooky when we're

back with Sam and Frodo, like when Shelob is hunting them, but *Fellowship* spends almost every moment in that creepy mode.

Horror is all about the unknown . . .

This kind of perspective is integral to what makes a horror movie scary. Horror is all about the unknown, and the dangers that lurk in the dark. While many of the characters in *The Lord of the Rings* have some familiarity with the more dangerous parts of Middle-earth, everything we're seeing is brand-new and terrifying from Frodo's point of view.

Fellowship's horror elements start almost as soon as the One Ring appears in the Shire. We see Bilbo go from a kindly old hobbit to a ghoul at the thought of giving it up. He only snaps out of it when Gandalf betrays a hint of his full terrifying power, bellowing at Bilbo not to mistake him for a "conjuror of cheap tricks." We see the same thing from Galadriel, the kindest and most gentle-seeming of the characters in the movie, when she, too, is tempted by the Ring.

In fact, most of the movie is just the hobbits and their companions moving

from one monster to the next. When they arrive at the gates of Moria—a haunting place in its own right—they're forced inside by the Watcher in the Water, a massive tentacled monster that's straight out of the work of H.P. Lovecraft. Once inside, they're faced with skeletal corpses, orcs (which bear a resemblance to the undead horrors Jackson's previous movies were known for), and a troll. Finally, their journey in Moria ends with encountering the Balrog, who resembles a fiery demon who pulls Gandalf down to hell in the kind of the-killer-wasn't-really-dead fakeout fit for any slasher movie. Even the Uruk-hai are shot to emphasize that they are horrific, decidedly inhuman, and monstrous.

Unlike the rest of the trilogy, *The Fellowship of the Ring*'s battle sequences are largely assembled with a sense of panic. Unstable, quick-cutting shots give us a sense of the chaos that the helpless hobbits feel during the fights. In contrast, in the few moments toward the end of the movie where we see characters like Aragorn battling foes with no hobbits in sight, he's shown in wide, stable shots as he defeats multiple Uruk-hai at once.

But the movie's most harrowing scenes involve the Nazgûl. When Gandalf discovers that the One Ring is at Bag End, *Fellowship* takes on an entirely different color palette, as if the Ringwraiths' arrival has darkened the entire world. The wraiths themselves are also shot in closeups of their features—their hands, their hoods, and the mouths of their frothing horses—like horror-movie monsters like Nosferatu or the Xenomorph from *Alien*, rather than the villains of action or fantasy movies. We tend to see Saruman with his full face and upper body in-frame, for example. It takes Jackson hours to show the Nazgûl in their full strength and numbers, only offering glimpses of them shrouded in shadows, their metal

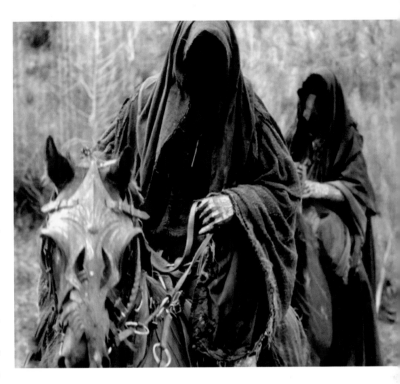

gauntlets, their shadowy-hooded faces, or their cloaks as they ride off screen.

This is even more true when the Ringwraiths track Frodo and his friends down and begin their pursuit. As soon as Frodo realizes the Nazgûl are chasing him through the forest, Jackson makes his inspiration clear by employing a zoom dolly shot to create an eerie sense of visual distortion—a signature trick of Alfred Hitchcock that he first used to unease viewers in *Vertigo*, and a horror-movie staple. From there, everything with the Ringwraiths is pure terror.

During the pursuit, we spend far more time with closeups of the hobbits as they hide—covered in bugs and trying not to scream—rather than on the monsters that are hunting them. Instead, the Nazgûl lurk at the edges of the frame, looming and threatening, always just one wrong move or small sound away from catching them. It's a move straight out of slashers like *Halloween*.

Ringwraiths are definitely horror material.

Jackson even uses bits of this when he introduces Strider. It's easy to bask in the familiar glow of Viggo Mortenson's confidence as Aragorn and the memory of all the fearless things he'll do in the next two and a half movies. But if you watch the scene the way Jackson presents it, Strider—in keeping with Tolkien's own descriptions—seems like yet another threat for the hobbits. And to be fair, all they've found outside of the Shire is terror. Frodo is our portal into this world, and for him (and us) it's full of danger.

If it wasn't so tightly connected to some of the best fantasy and action-adventure movies ever, the entire Nazgûl section of the movie, from the moment they're introduced until Arwen and Frodo are safely across the river, would be more widely recognized as full of masterful horror sequences. You could watch it without any context and instantly feel a connection to the charming hobbits, and terror at the faceless creatures chasing them.

But then, horror is especially good at introducing fantasy worlds. *A Nightmare on Elm Street* has to make you scared of a man with knife-fingered gloves who can kill you in your dreams, *The Exorcist* has to make you believe that a girl is possessed by a demon, and *The Omen* has to convince you that a 5-year-old is the devil. So why shouldn't Peter Jackson use some of the same techniques he used in his time as a horror filmmaker to sell you on a world of goblins, elves, dwarves, and hobbits?

Horror is a genre of purposefully heightened emotions, and everything of the horror movie has to match. You like the charming characters more quickly, laugh with them more easily, and accept otherworldly ideas with fewer questions—which makes it all easier to tell a fantasy story with nearly a dozen main characters.

By the time you've rewatched the *Lord of the Rings* for the dozenth time, it's easy to think of the series as just one big movie. But that's not exactly right. The *Fellowship* is, by design, a much spookier movie than you might remember.

If you want to read more about...

> *The impact of* The Fellowship of the Ring, *turn to page 86–*"The Return of the King Won the Prize, but It Was Fellowship That Changed the Oscars Forever" (February)

> *The quiet horror of* The Lord of the Rings, *turn to page 171–*"The Moral of Denethor's Story Is, Stop Doomscrolling" (July)

TIMELINE
2002

JANUARY 11
Overnight, the Fellowship becomes snowbound on Caradhras.

JANUARY 13
Gandalf deciphers the password and opens the West-gate of Moria.

From his hiding place in Moria, where he fled after escaping Mirkwood, Gollum senses the Ring, and begins to follow the Fellowship.

JANUARY 12
After the Fellowship escapes the mountain only to be hounded by wargs, Gandalf and Aragorn decide they must chance Moria.

JANUARY 14
Pippin drops a stone in the well.

ANDY SERKIS' GOLLUM IS A SINGULAR PERFORMANCE WITHOUT A SINGLE AUTHOR

HOW AN UNKNOWN STAGE ACTOR AND 18 ANIMATORS CHANGED CINEMA

Isaac Butler

Motion capture is the biggest techno-logical advance in the field of screen acting since *The Jazz Singer* ushered in the era of synchronized sound in 1927. But it's unclear where the field would be without the performance of Andy Serkis as Gollum, in Peter Jackson's *The Lord of the Rings: The Two Towers* and its follow-up, *The Return of the King.* Jackson was not the first to use motion capture in a feature film, but he was the first to use it well, and Serkis' work as Gollum is so persuasive that it would help birth a new kind of acting and filmmaking. And yet, two decades in, it's a bit difficult to describe, or under-stand, what it even means to talk about this new not-quite-live but not-quite-animated form of performance.

Serkis first tried to explain his job in the making-of documentary that came bundled with *The Two Towers*' DVD release. Initially, all we see of Serkis in the documentary is a manic blur wrestling Elijah Wood's Frodo and Sean Astin's Sam. We spy on Jackson as he shoots Gollum's entrance into the film. Gollum has been tracking Frodo and Sam, and is now attacking them in hopes of finally getting his distended hands on his precious, precious Ring. Serkis jumps all over the stage, pulled and pushed by Wood and Astin. He's dressed in an all-white, skintight suit, complete with a hood. He looks like a discount Moon Knight, or perhaps an angry larva.

"I'm playing the character of Gollum," Serkis says in the doc. "Now, the charac-ter of Gollum does tend to belong to a lot of different departments, obviously, as a computer-generated character. But I guess what I'm doing is really providing

JANUARY **15**
The Fellowship discovers Balin's tomb.
Gandalf falls in battle with the Balrog.

JANUARY **17**
The Fellowship reaches Caras Galadhon.

JANUARY **25**
Gandalf casts down the Balrog from the highest peak above Moria, and dies.

JANUARY **16**
After insisting they be blindfolded in solidarity with Gimli—to Legolas' dismay—the Fellowship travels through Lothlorien.

JANUARY **18**
Saruman hears of the Fellowship and sends a company of Uruk-hai to seek and waylay them.

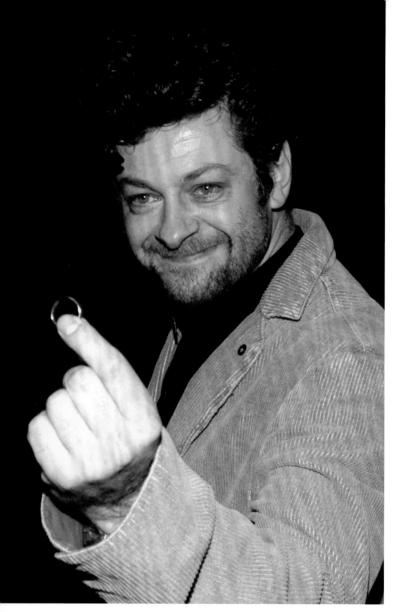

In a way, while on set, Serkis sketched out an outline that he, Jackson, and the animators at Wētā could embellish later. Since motion capture technology was still in its early phases, nothing Serkis did during principal photography for *The Two Towers* would wind up in the final product. In order to make Gollum, Serkis and the animators at Wētā Digital (now Wētā FX) broke down "the acting side of it" into its component parts, then stitched them back together like Frankenstein's monster. That the end result is so believable, so deeply felt and human, is miraculous given the complicated, piecemeal nature of its construction.

That the end result is so believable, so deeply felt and human, is miraculous . . .

Jackson shot each Gollum sequence twice: once with Serkis doing the movements of the character, and once without him. Later—many months later—Serkis re-created his blocking in a motion-capture studio. Surrounded by 25 cameras in an entirely blue studio so pristinely maintained that crew members were barred from bringing water bottles into the room for fear that their reflections would muck up the shot, Serkis wore a special costume that enabled his movements to manipulate a digital Gollum puppet, and a special visor that showed him what his movements would look like in the already-shot footage. He then re-created his physical movements and performance, so that they could serve as the basis for the eventual animated creature.

By today's standards, the "puppet" was rudimentary. Far less of Gollum is an exact rendering of Serkis' movements than most people today remember. As Bay Raitt, one of the 18 animators who

the acting side of it, the emotional drive behind the character, the physicality, and, I suppose, most importantly, the voice."

On one level, Serkis is only describing what all actors do: using their physicality and voice to embody, and communicate the psychology and emotional drives of, a character. But most actors do all of those things simultaneously by themselves. Serkis would need to do all of those things separately, and he wouldn't do them alone.

created Gollum, explained to Animation World Network in 2003, "There is no facial motion capture data, at all, on Gollum. The only motion capture data is for his torso, legs, and arms."

The hands, feet, and—most importantly—facial expressions of Gollum were all animated later, using Serkis' performance as reference footage. Gollum's face is made up of 875 shapes that animators manipulated using 64 controls to create his many expressions. At times, the animators revised Serkis' performance, altering the physicality or even the facial expressions, to better suit Jackson's needs. Serkis additionally dropped by Wētā's offices to help the animators, modeling gestures or facial expressions they were struggling to realize.

We've all seen these movies so many times over the last 20 years that it can be hard to really grasp the achievement of the end results. Previous attempts at using motion capture gave the world Jar Jar Binks and *Sinbad: Beyond the Veil of Mists*, performances so off-putting and soulless that one could not help but long for the heyday of Jim Henson's Creature Shop. Gollum is the opposite—vividly alive, and essential to the success of Jackson's *The Lord of the Rings* adaptation. He is the story's lone multidimensional character, and the battle for his soul, a soul that has long since been lost to the Ring of Power, buttresses the stakes of Frodo's own struggle. We see, through looking at the pathetic, emaciated body of the former Smeagol, what could become of Frodo if he's not careful.

The action of *The Lord of the Rings* also hinges on Gollum. As Gandalf says in *The Fellowship of the Ring*, Bilbo's choice to pity Smeagol and spare his life "may rule the fate of man." This, in turn, sets up Frodo's declaration in *The Two Towers* that "maybe he does deserve to die, but

now that I see him, I do pity him." Frodo and Sam's journey to throw the Ring into the fires of Mount Doom is guided by Gollum, and it is Gollum who ultimately destroys the Ring and dies in the process. Frodo survives his journey with the Ring because of the mercy he shows Gollum, even as that mercy nearly costs him his life on more than one occasion.

This whole arc only works if the audience understands and sympathizes with multiple characters' refusal to kill Gollum when they have the chance. Gollum is untrustworthy, vicious, cruel, violent, manipulative, and weak. In a George R.R. Martin novel, he'd have the life expectancy of a dependent clause. In *The Lord of the Rings*, his survival evokes our struggle to cling to our better natures in the darkest and most urgent of times, a struggle we were in the process of failing as a nation embarking on the War on Terror.

Serkis and the team at Wētā made Gollum pathetic by emphasizing his divided nature. He looks grotesque, and moves like a feral beast, but his facial expressions are deeply human. He is simultaneously repugnant and adorable. He's both conniving and childlike, a pining lover and a vicious killer, a victim of his own worst impulses. He often hunches in a full-body cringe, so disgusted with himself and afraid that he can barely look at who he's talking to. Serkis' voice work, particularly, is a marvel. His vocal choices for Gollum are extreme, but within them he finds a huge range, filled with little microtonalities and grace notes. It is by far the most sophisticated and successful performance in the film, even if that performance is constructed by 20 different people.

When he was cast as Gollum, Serkis was virtually unknown to most audiences. He had been a journeyman stage actor in England, touring the country in productions of Brecht and playing a drag version

of the Fool opposite Tom Wilkinson's King Lear. He had only appeared in a few films, most notably Mike Leigh's *Topsy-Turvy*. His stage training and experience are vividly recognizable in his physical and vocal expressiveness, as well as his willingness to stretch his performance beyond the stylistic limits of naturalism.

The clarity and size of his choices make him ideally suited to the expressive needs of animation in a way that other actors are not. Robert Zemeckis' 2004 film *The Polar Express* contained a motion-captured version of Tom Hanks that was so off-putting, it helped popularize the concept of the uncanny valley. Meanwhile, Serkis went on to become nearly synonymous with motion capture acting, taking roles as apes and bears and the villain of a couple of Star Wars movies. One of his greatest performances came in Ninja Theory's flop *Enslaved: Odyssey to the West*, one of the first video games in which characters communicate with sophisticated, visible subtext. In 2011, Serkis founded The Imaginarium, a production company that specializes in projects that use motion capture. Today, if you google "Andy Serkis" and "motion capture," one of the questions that comes up is about whether the actor invented the technology in the first place.

Motion capture evolved right alongside its greatest muse, becoming sophisticated enough that it is now often referred to as performance capture. By the time Serkis starred as Caesar in 2011's *Rise of the Planet of the Apes*, animators were able to capture facial expressions of actors, and the film pioneered a new system for on-set motion capture so actors didn't have to fully re-create their performances in post. A new real-time playback system enabled Serkis and his castmates to see how their ape characters moved while filming.

The performances—and the animation of them—grew so sophisticated that by 2014's *Dawn of the Planet of the Apes*, A.O. Scott of the *New York Times* declared Serkis' Caesar "one of the marvels of modern screen acting." Each of the three films in the series brought widespread speculation about whether Serkis would be nominated for an Oscar, and a wave of impassioned writing on why he should. But the nominations were never to be.

Even before the advent of more immersive motion capture technology, New Line Cinema mounted an Oscar campaign for Serkis during *The Lord of the Rings*. Although the Academy ruled that motion capture acting was eligible, no nomination was forthcoming. Parsing the authorship questions raised by performance capture proved too difficult, and Serkis' somewhat self-interested attempts to clarify the matter only got him into trouble. In a 2014 interview with io9, referencing the various advances in animation technology since *The Lord of the Rings*, Serkis said, "The way that Wētā Digital [. . .] have now schooled their animators to honor the performances that are given by the actors on set, [. . .] that's something that's really changed. It's a given that they absolutely copy [the performance] to the letter, to the point in effect what they are doing is painting digital makeup onto actors' performances."

Animators were understandably furious at having their contributions dismissed. Serkis is undeniably *an* author of Gollum, Caesar, Monkey, Snoke, and his other motion capture roles, but he is hardly the only one. As Randall William Cook, the animation supervisor for the *Lord of the Rings* films, put it to Cartoon Brew while responding to Serkis' comments in io9, "Gollum was a synthesis, a collaborative performance delivered by

*"Gollum was a synthesis,
a collaborative performance delivered by
both Andy and a team of highly skilled
animation artists."*

both Andy and a team of highly skilled animation artists." The staging, facial expressions, and interpretation of the role were often altered by animators in postproduction without Serkis' involvement. Gollum's most memorable scene—the one in which he debates with himself about betraying the hobbits at the end of *The Two Towers*—was significantly altered by animators from Serkis' original movements, according to Cook.

But screen acting is *always* a synthesis of sorts, with many components of what we think of as cinematic acting lying beyond an individual actor's control. Actors don't choose which takes their directors use in a film, or what happens with those takes in the editing room. Dialogue can be cut or added after the fact, drastically changing how an audience views a character. The pitch, timbre, and resonance of an actor's voice can be altered with software. The musical score, the lighting, the other actors' performances—the list of things outside an actor's control that impact how we evaluate their work goes on and on. If motion capture makes us question what it means to be a screen actor, it is only summoning up long-buried questions we frequently like to ignore.

Filmmaking is a collaborative art, with every creative job impacting every other in ways both perceptible and not. Perhaps, then, the problem is our desire to assert authorship for what should be a collective achievement. Gollum is one of the great screen characters of the aughts and a groundbreaking technical achievement at the same time. He is, if anything, as interesting, complicated, and compelling as the films taken as a whole. Perhaps, even for those of us who are scholars of acting, that should be enough.

If you want to read more about...

> *Gollum's tricksy ways, turn to page 105—"Frodo and Sam's Bread Fight Is Objectively Dumb but Admittedly Crucial" (March)*

> *The mixed performances of LOTR, turn to page 42—"Gimli's Uncredited Body Double Put in the Work, and He Has the Tattoo to Prove It" (October)*

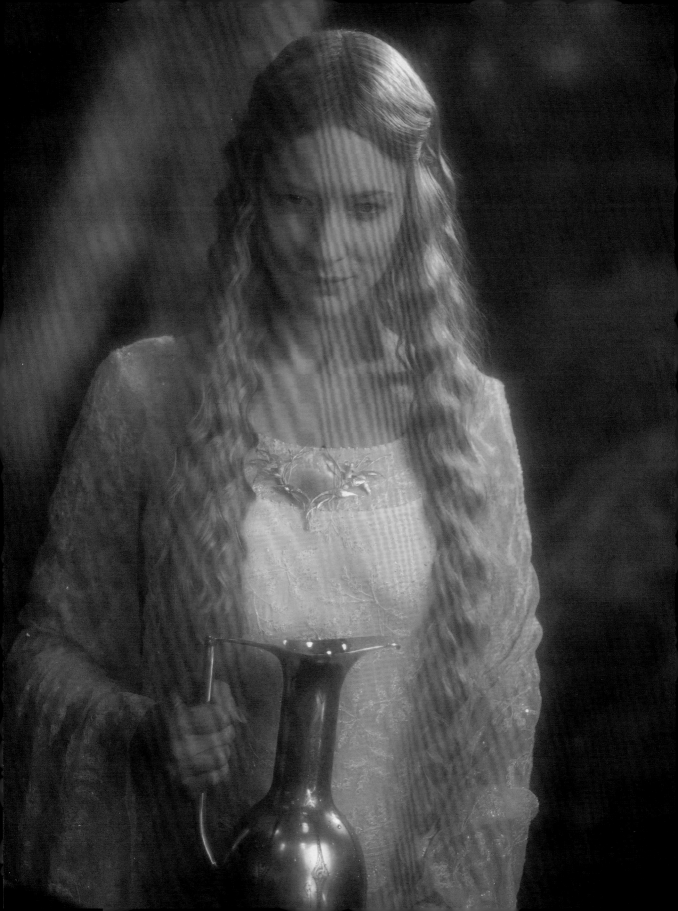

PETER JACKSON KNOWS EXACTLY WHEN TO BE "TOO MUCH"

YES, GALADRIEL WOULD MAKE A GREAT DRAG QUEEN

Kyle Turner

The *Fellowship of the Ring* scene in which Galadriel is tempted by the Ring radiates a transgressive, intoxicating camp aesthetic in an immediate way. Cate Blanchett, whose ethereal beauty transcends mere humans, rises up into the air, her figure transformed by the light bending around her, her cheeks turned sallow and masculine, complicating her gender presentation. Her voice becomes deeper and modulated, roaring, "In place of a Dark Lord, you would have a queen, not dark but beautiful and terrible as the dawn!"

It is terrifying to see this avatar of kindness and power mutate and shriek, "All shall love me and despair!" It is also kind of funny—and very campy.

When I watched *The Lord of the Rings* with my mother growing up, it was a sincere, real transportation into the world of Middle-earth. The ents and oliphaunts were tactile and fantastical, its elves and hobbits beyond reproach. The universe created by Tolkien and brought to life by Peter Jackson had no stitching that I could see.

Revisiting the trilogy as an out queer adult made the seams more apparent. But rather than detracting from the films, it makes them deeper and more interesting, more complex movies about artifice and

openness. The abstract idea of power itself has a visual language to play with, and the stranger and more unusual aesthetic moments of the films makes them better movies. The *Lord of the Rings* movies are campy, and that makes them great.

Recognizing [camp] and being fluent in its signifiers makes you feel like you're in a secret club of like-minded Others.

There's not an easy consensus on what is and is not "camp" (it tends to be a "you know it when you see it" kind of deal), but it's predicated on a subjective engagement with a piece of work and an awareness and love of excess and artifice, which coalesces into a sensibility and aesthetic that is transgressive or outside the realms of conventional taste in some way. It's not always unintentional or "naive," as Susan Sontag wrote in the 1964 essay that popularized the term, but can take pleasure in a kind of "too muchness," an extreme quality in the aesthetic that the work can't really hold without showing its own lack of realness. Recognizing it and being fluent in its signifiers makes you

feel like you're in a secret club of like-minded Others.

For Galadriel's moment of temptation, Blanchett (and Jackson and his VFX crew) transform her into a bit of a drag queen, an outsized persona meant to be off-putting cross over straight or general audiences. (And, yes, drag queens can be scary too!) It's a conscious undermining of the idea of Galadriel we've had prior to this moment in the film, a Titania-like beauty who maintains a hyperawareness of the control she has on herself and holds over others. (Also, Cate Blanchett *did* do drag at a charity drag show at the Stonewall Inn in 2017, donning a beat face and bustier to lip-synch to Dusty Springfield's cover of "You Don't Own Me" alongside local queens.)

Evil Galadriel is a loss of that control, but also an acknowledgment of the artificiality of the films themselves, a moment of magic that reveals that it's a magic trick. Galadriel comes back to herself, shaken, but also like she just got off a roller coaster at Disney World. "I have passed the test," she says, catching her breath. That's funny.

Of course, camp as an aesthetic is heavily tied to the history of queer art and queer engagement *with* art, and much has been written, too, on the way the trilogy explores homoerotic desire, particularly between Sam and Frodo. *The Lord of the Rings* has never exactly been a stranger to queer readings (page 202), with slash fanfic (LibraryofMoria.com, a *Lord of the Rings* slash-fiction repository dating back to 2002, has literally thousands of examples) and scholarly analysis having proliferated since the 1970s. But camp is also primarily a subjective understanding and way of relating to a piece of work. It's not, at least in the case of the *Lord of the Rings* films, an objective fact of the style, compared to something like *Pink Flamingos*, directed by John Waters, or *But I'm a Cheerleader*, directed by Jamie Babbit, both of which use camp as a deliberate filmmaking choice—but it does open up the film in an interesting way to different audiences.

The films' camp sensibility, though it doesn't cover the entire surface of the cinematic universe of Tolkien's world, does feature significantly in specific beats of the films. Besides Galadriel's temptation, scenes of the Ring seducing and taunting Frodo crossover into the same territory. While they're probably intended to resemble something more akin to a struggle with addiction and relapse, Elijah Wood also looks as if he's about to orgasm.

Before their journey has even really started in *The Fellowship of the Ring*, Frodo, Sam, Pippin, and Merry find themselves tracked by a group of Ringwraiths (whose shriek sounds like the squawking of excited gay men, for the record). They hide within the nook of a tree, and as the Ringwraith bends over, sensing the Ring and ready to capture whomever has it, Frodo begins to feel the Ring taunting him and taking over his sense of desire. Wood's eyes roll back into his skull and he closes his eyelids, his breathing gets heavier, and his nose quivers. He holds the Ring with its orifice open using his right hand, about to put it on his left pointer finger. The erotic imagery feels a little blatant and self-aware.

It's a scene of incredible tension, sure, but it also feels like a sly wink on the part of Jackson, an awareness of the multifaceted images and metaphors that can be found in Tolkien's story, turned up to 11 to shed light on what images of desire and temptation look like, especially when power is the object. Jackson himself is not a stranger to using camp aesthetics, having employed them earlier in his career with the gonzo splatter films *Bad*

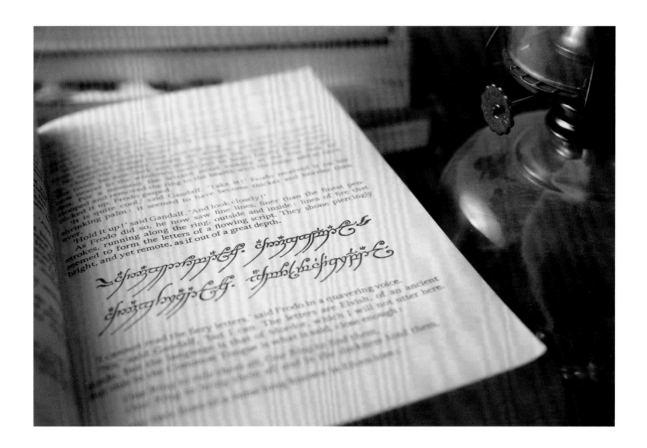

Taste and *Meet the Feebles* as well as the queer-inflected fantasy drama *Heavenly Creatures*, which starred Kate Winslet and Melanie Lynskey as a pair of young girls with a very complicated friendship. It's these traces of those artistic experiments found in the *Lord of the Rings* films that make them so stunning and interesting.

Jackson has a willingness to consider the other genres and styles of storytelling that informed Tolkien's work and how those styles and genres were shaped by Tolkien. The *Lord of the Rings* films are not just grand fantasy blockbusters, but intelligent films invested in the nuances and tropes of action, melodrama, romance, horror, and, yes, even camp. You just have to open up your lidless eye.

If you want to read more about...

> *How Jackson also knew when a little could go a long way, turn to page 14*— "The Fellowship of the Ring *Redefined Movie Magic with a Single Line* (September)

> *Strong acting choices in Jackson's* The Lord of the Rings, *turn to page 127*— "Legolas' Dumb, Perfect Faces Are the Key to His Whole Character" (April)

THE TRUTH ABOUT GALADRIEL

FROM TOLKIEN TO CATE BLANCHETT TO MORFYDD CLARK

Susana Polo

"All shall love me and despair!" The line from Peter Jackson's *The Fellowship of the Ring* is the apex of Cate Blanchett's striking turn as the elven sorceress Galadriel. In an instant, all hell seems to break loose. "In place of a Dark Lord, you would have a queen!" she cries, as the colors of the film seem to invert, her clothes billow around her, and she shakes as if possessed by a force beyond mortal reckoning. But a moment later all is well, leaving millions of movie viewers to wonder, "What the heck was that all about?"

There's a story behind Galadriel's triumph over temptation, and her journey to this pivotal moment in Frodo's journey to Mordor. Morfydd Clark, the 33-year-old Welsh actress, was eager to explore the rich potential of the character in Amazon Studios' *The Lord of the Rings: The Rings of Power*. Before stepping into Galadriel's shoes for the production, Clark told Polygon that she knew Galadriel "as the very serene and wise lady of Lothlórien." But now?

"The elves of [*The Lord of the Rings*], they've gone through a lot to achieve that serenity and wisdom, it's been hard-earned. They've been very messy throughout many of the ages of Middle-earth," Clark said, putting it mildly.

To Frodo, Galadriel is a helping hand. But in Tolkien's legendarium, Galadriel had a life of ambition and adventure, in which she spurned the gifts of the gods to seek power, justice, and a realm of her own to rule. To Tolkien, the elf was among the most exemplary figures of his opus—and she may be the only character he ever wrote who nakedly desired power but didn't turn evil. He also never finished writing her story.

We know, from often-contradictory notes, personal correspondence, and his son's recollections—some published posthumously in volumes like *The Silmarillion*—Tolkien had intended to make Galadriel superlatively wise and skilled. In the version of *The Silmarillion* he didn't live to write, she was a ruler of elves, a rider in great hosts of war, a survivor of immense hardships, a scion of virtue, and a legendary beauty. And she was a character who walked the most difficult of mythological tightropes: defying the gods and living to tell the tale.

"DREAMS OF FAR LANDS AND DOMINIONS THAT MIGHT BE HER OWN"

To put it simply: Galadriel was born in paradise. Her hometown of Valinor, the capital city of Middle-earth's far realm of Aman, was crafted by the gods as the elven promised land. But even for a woman raised in elven Valhalla, she was exceptional. Years before she actually left Valinor, she considered the place too small for her ambitions.

As Christopher Tolkien summarized in *Unfinished Tales*, based on one of his father's "partially illegible" notes, Galadriel "did indeed wish to depart from Valinor and to go into the wide world of Middle-earth for the exercise of her talents; for 'being brilliant in mind and swift in action she had early absorbed all of what she was capable of the teaching which the Valar thought fit to give the [Elves],' and she felt confined in the tutelage of Aman."

Tolkien also wrote about Galadriel in an essay that was otherwise about Middle-earth linguistics, saying "Galadriel was the greatest of the Noldor, except Fëanor maybe, though she was wiser than he, and her wisdom increased with the long years." That is: Galadriel is the greatest of her tribe, which contained many, many heroes of the war against the dark god Morgoth, except perhaps for her kinsman Fëanor, the greatest craftsman and worst elf in history, the guy who started that war in the first place. Anyone who assumed a warrior Galadriel was an invention of modern, "liberal" sensibilities might be surprised, or disappointed, but hopefully well pleased, that Tolkien got there first.

The war against Morgoth offered Galadriel her chance to leave Valinor and journey to Middle-earth to find her own dominion. When Fëanor swore vengeance against Morgoth for stealing his precious Silmaril jewels and rallied the Noldor to sail from Aman to destroy him, Galadriel joined him. Tolkien wrote (as compiled from his drafts and notes by his son in *The Silmarillion*) that she was "the only woman of the Noldor to stand that day tall and valiant among the contending princes. [. . .] No oaths she swore, but the words of Fëanor concerning Middle-earth had kindled in her heart, for she yearned to see the wide unguarded lands and to rule there a realm at her own will."

Galadriel and her older brother Finrod joined up with the Noldor but opposed and abstained from the historically significant crimes the rest of their tribe committed to leave Aman. In response, Fëanor gave them a pretty tough time of it, stranding them and their people in the Arctic without ships. They survived and made it south on Middle-earth's main continent via a grueling overland march that Tolkien described in superlative terms. "Few of the deeds of the Noldor thereafter surpassed that desperate crossing in hardihood or woe," he wrote.

In some of his notes, Tolkien showed intention to establish that Galadriel had never been very impressed by Fëanor in the first place, but in all versions of her story, she arrived in Middle-earth with very little desire to rejoin his forces—but also no desire to return to Valinor. In the aforementioned philological essay, Tolkien chalks this up to pride (not wanting to beg the gods for forgiveness) and revenge. "She burned with desire to follow Fëanor with her anger to whatever lands he might come, and to thwart him in all ways that she could."

And so, while Galadriel stood against Morgoth, she also very much distanced herself from what I'm going to call Several Centuries of Awful Fëanorian Drama. Her brother was not so lucky, perishing in the dungeons of Sauron, even as he killed his opponent (a werewolf) with his bare

She burned with desire to follow Fëanor with her anger to whatever lands he might come, and to thwart him in all ways that she could.

hands. (*The Silmarillion* is . . . rawer than most folks realize). Still, the gods banned Galadriel from returning to Aman along with all the other Noldor who'd followed Fëanor, and when that ban was lifted for all who helped defeat Morgoth, Galadriel declined to return home. From his notes, it seems Tolkien explored several reasons for this over time, including her own pride, her desire to remain with her husband, or that she was handed a specific ban from returning to Aman for reasons unrelated to Fëanor.

In the age after Morgoth's defeat Galadriel finally got her dominion. After befriending the dwarves of Moria she and her followers settled in the forest near its eastern entrance, which became known as Lothlórien. And following Sauron's creation of the One Ring, she was given possession of one of the three Elven Rings for safekeeping, in recognition of her incorruptibility. In the Third Age, she was instrumental in the formation of the White Council, which united Gandalf, Saruman, and the wisest elves against the growing threat of Mordor, and during the events of *The Hobbit*, she assisted when the members of the council drove Sauron himself from southern Mirkwood. As Aragorn et al. battled orc armies at Minas Tirith in *The Return of the King*, Galadriel's power drove several waves of Sauron's forces from Lothlórien, and upon his final defeat she tore the dark fortress of Dol Guldur to the ground with her magic.

But none of those dangers compared to the Fellowship's visit to her realm. Not knowing anything about her story, but in awe of how immensely her power and wisdom overshadowed his own, Frodo offered Galadriel the One Ring. All she had to do was ask, and she could make all of Middle-earth into a dominion that might be her own. The proposal provokes her darkest (and to some, bewildering)

moment. Depending on which scraps of Tolkien's notes you look at, this was either the ultimate test she had to pass for her pardon, or the moment she realized that she had finally faced every challenge worthy of her might, and had no reason not to return to Aman.

"I PASS THE TEST, AND REMAIN GALADRIEL"

Galadriel walked out of heaven because she was bored of paradise and wanted power. She is the only character Tolkien ever created for Middle-earth who desired power simply for the sake of enacting her own will, and yet never became corrupted. According to Morfydd Clark, accessing that unbruised self-confidence was the hardest part of the job.

"The elves in particular," she told Polygon, "are so physically powerful. A big part of me [. . .] is that I feel quite physically weak, no matter how fit I become. And so shaking off what that would mean, to be a being that has never felt that they are weak, never felt that they could be overcome. That was a big journey, which at times is quite emotional to imagine, *What if I'd never felt any of those things?* What comes with that is a fearlessness and a type of arrogance."

And Clark doesn't just mean a physical confidence, the kind that makes it to the screen in graceful fight scenes and feats of endurance—although she says that her favorite physical challenge of the production was getting to ride horses for the first time. The actress says she puzzled over how to portray a younger version of an immortal. An elf could be "young" and still centuries upon centuries old—they wouldn't exactly be more *naive* than their older selves.

The answer Clark found was, "If they were going to be naive, it would be arrogance. That's how it would manifest. At

some point [Galadriel] talks about how with gaining wisdom, there's a loss of innocence. So there's an innocence to her arrogance, which I don't think is particularly something that I associate with women in our world."

In Tolkien's lore, Galadriel has plenty of reason for innocent arrogance. The writer often underscored that she clocked the secret dark hearts of some of Middle-earth's greatest betrayers—like Fëanor and Saruman—years before their betrayals. Galadriel's hunch is correct—anyone who's seen *The Lord of the Rings* knows that Sauron will rise again. But what *The Rings of Power* explores is whether Galadriel's hunch comes from intuition, or simply from having been blinded by centuries of war and hatred.

Clark stubbornly defended her character: "What [other characters have] got wrong is, you can't ever sit back on your laurels with peace, and you can't ever think that you've achieved it." She referred to a quote from activist Mariame Kaba, "Hope is a discipline," by way of explaining. "I think Galadriel senses that everyone's sitting back and relaxing, and even if Sauron wasn't coming, you have to protect peace constantly. And hope. They're not things that survive through being inert."

When readers and viewers meet Galadriel for the first time, it's in a story where the burden of practicing hope and protecting peace lies most heavily on the shoulders of others, an era when the wise lady of Lothlórien's role is to maintain her bright borders against encroaching darkness, not to take the fight to darkness itself. For some, the first photos from the set of *Rings of Power*, featuring Galadriel in full armor and carrying a sword nearly as long as she is tall, surely seemed like a misapprehension of her character.

But as Cate Blanchett's Galadriel put it in the opening scene of *The Fellowship of the Ring*, "The world is changed [. . .] and some things that should not have been forgotten were lost." The Galadriel of Tolkien's heart, pieced together by his son and others, was a fair and terrible adventurer, a reader of mortal souls, a prideful and learned leader who considered the gods no more or less fallible than her. And a woman who knew exactly who she was, even in the face of the ultimate evil.

"I was playing someone that if they chose a path of evil, the destruction they could cause would be so immense," Clark mused. "And I think about that a lot. I think that lots of female pop stars, for example, with huge followings—I'm a bit, like, *Yeah, and you're lucky that they're nice, because they literally have an army behind them*. And I think there's something so wonderful about Galadriel that she rejects a type of power that most—well, we know that *all*—the human men of Middle-earth would grab and use to destroy instead of build."

If you want to read more about...

> *The deep lore of Middle-earth, turn to page 152—"The Truth About Elven Immortality" (June)*

> *Or turn to page 96—"The Truth About Gandalf" (March)*

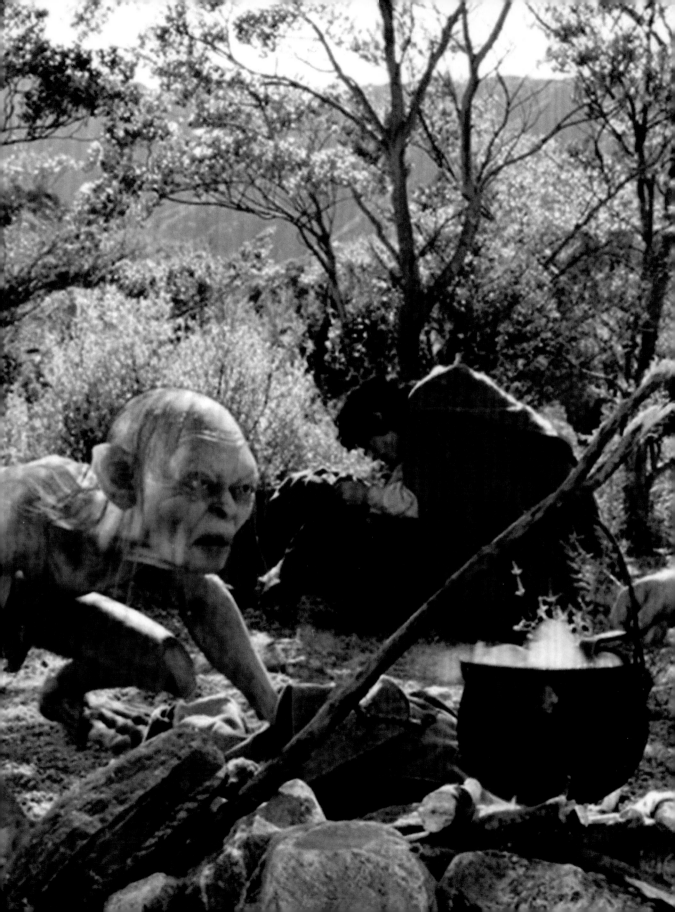

FEBRUARY: THE BREAKING OF THE FELLOWSHIP

THE RETURN OF THE KING WON THE PRIZE, BUT IT WAS *FELLOWSHIP* THAT CHANGED THE OSCARS FOREVER

THE LORD OF THE RINGS FORCED THE ACADEMY
TO RECKON WITH MODERN BLOCKBUSTER FILM

Chris Feil

When we talk about the *Lord of the Rings* movies and the Academy Awards, *The Return of the King*'s triumphant Oscar tally and Best Picture win from 2003 dominates that conversation. The Peter Jackson film is the ceremony's biggest clean sweep, winning in all 11 of its nominated categories, tying *Titanic* and *Ben-Hur* for most wins in the ceremony's history. But by that point, the series had become something of an award inevitability. But the real groundwork was laid when *The Fellowship of the Ring* netted a historic 13 nominations and broke through the Oscars' genre-film ceiling.

When the franchise launched in 2001, adapting J.R.R. Tolkien's beloved series wasn't an obvious candidate for an Oscar run. As Russell Schwartz, the president of theatrical marketing for New Line Cinema, put it to *Vanity Fair* in 2014: "The question about the Academy campaign was, was it worth doing?[. . .] The biggest problem—and this started with *Fellowship*—was we had the dreaded *F* word." And that word was *fantasy*.

Until this point, the Oscars had had a tenuous relationship with fantasy, horror, and science fiction films, unless they had Steven Spielberg's name attached. Spielberg would earn buckets of nominations for films like *E.T.* or *Close Encounters of the Third Kind* (which still failed to show up in Best Picture despite eight other nominations), but his films were the exception to an unspoken rule.

Even films that made huge technological advances such as *The Matrix*, *2001: A Space Odyssey*, and *Terminator 2: Judgment Day* could rack up multiple nominations (and wins) in craft-focused categories without breaking the barrier into the big prize. While Best Visual Effects was naturally the most welcome home to genre movies, there would be occasional wins like *Batman* (1989) for Art Direction or *Bram Stoker's Dracula* for Costume Design. Sigourney Weaver's Best Actress nomination for *Aliens* was seen as a landmark anomaly.

The most notable exception of a high-fantasy movie landing in Best Picture was 1977's *Star Wars*. But like *Fellowship*,

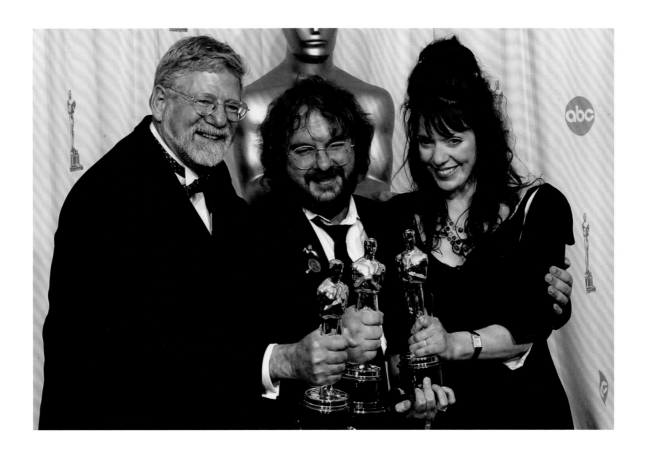

Barrie M. Osborne,
Peter Jackson,
and Fran Walsh at
the 76th Annual
Academy Awards,
February 29, 2004

Star Wars missed out on the biggest prizes of the night for screenplay, acting, director, and Best Picture, which went to *Annie Hall*. (Not counting for special-achievement Oscars and including the *Hobbit* films, both franchises have earned a total 37 nominations each. For franchise comparison, the entire Marvel Cinematic Universe has 19.)

Much of this struggle for recognition is rooted in the industry's and the Academy's perception of what makes an Oscar-worthy movie. While the presence of major filmmakers and movie stars never hurts, the Academy Awards have always responded to prominent literary adaptations, true stories, and films that deliver something timely. The Academy voters' patterns suggest they want films that can reflect our time and our history in a "serious" way, even if it looks like a

flimsy prestige veneer. The decade leading up to The *Lord of the Rings'* Oscars coup favored historical dramas (*Titanic*, *Dances with Wolves*) and bona fide movie stars and star directors (*Forrest Gump*, *Unforgiven*) even more than today. What helped set *Fellowship* apart was Jackson's ability to produce something that delivered what the voters' gravitated toward, regardless of genre distinction.

As soon as critics began invoking names like David Lean and Francis Ford Coppola to describe Jackson's achievement, the series was recontextualized from its blockbuster purpose. Jackson hadn't just made an adventure with goblins and elves, he had made something on the wavelength of Oscar legends like *Lawrence of Arabia*. Best Picture was already trending toward favoring large-canvas films, with a previous decade

Barrie M. Osborne,
Peter Jackson,
and Fran Walsh at
the 76th Annual
Academy Awards,
February 29, 2004

of wins that included *Titanic*, *Schindler's List*, *The English Patient*, and *Braveheart*. *Gladiator* was praised for reviving the corpse of swords-and-sandals epics like *Ben-Hur*, cementing Oscar's nostalgia for big-picture filmmaking of a certain scale. With *Fellowship*, Jackson and his collaborators unleashed that grandeur.

The film's scope had an effect both timeless and timely for audiences—and voters. Despite perceptions on the limits of the genre, *Fellowship* was the Oscar film that spoke to the moment. Just as *The Exorcist* was interpreted through a lens of post–sexual revolution anxieties in an increasingly secular American society (resulting in 10 nominations), *The Lord of the Rings* subtextually ignited a culture reeling with the aftermath of 9/11. Audiences wanted escapism and clearly defined heroes; as the AV Club observed in its review, Jackson offered a vision "where the forces of good and evil are as boldly demarcated as on the Fox News network." Even though it was set in a land of wizards and orcs, *Fellowship* spoke to something larger that we were going through at the time. Jackson had, as Roger Ebert put it in 2001, "made a work for, and of, our times."

It also helped that voters had another popular fantasy franchise to which they could compare *Lord of the Rings*. *Harry Potter and the Sorcerer's Stone*, which opened in the same holiday season, kicked off the Potterverse by handing the reins to Chris Columbus. Jackson and New Line Cinema filmed an entire fantasy series at once, a higher risk that Hollywood was more likely to reward if it paid off. The reviews were hosannas for Middle-earth and passive respect for Hogwarts. The *Wall Street Journal* noted the difference: "Giving *Lord of the Rings* to an idiosyncratic filmmaker like Mr. Jackson was surprising corporate behavior, to say the least, in contrast to the resolutely conventional choice for another recent film involving wizards." *Sorcerer's Stone* earned three nominations to *Fellowship*'s 13, and went on to never win an Oscar. Other Potter movies earned nominations, but never won.

The Fellowship of the Ring was also perfectly placed in 2001's Best Picture lineup to diminish potential fantasy-film pushback. Opposite the idiosyncratic observation of Robert Altman's *Gosford Park* and the claustrophobic intimacy of *In the Bedroom*, *Fellowship*'s massiveness was undeniable. But Baz Luhrman's *Moulin Rouge!*, a highly divisive film whose audacity and strangeness positioned *Fellowship* as the safe option in line with the Academy's stodgier taste, was also nominated.

The only thing that could beat the film was typical Hollywood politicking and Oscar strategy, manifested in 2001 by the Ron Howard–directed biopic *A Beautiful Mind*. Before Ben Affleck was famously shut out of Best Director for *Argo*, Howard was known as one of

FEBRUARY **15**

Gandalf returns to life.

Frodo beholds the Mirror of Galadriel.

FEBRUARY **17**

Carried on the back of Gwaihir the Windlord, Gandalf arrives in Lorien.

TIMELINE
2002

FEBRUARY **16**

The Fellowship receives Galadriel's gifts and leaves Lothlorien.

the more notorious snubbed filmmakers, having been shockingly overlooked for 1995's *Apollo 13*. Recent memories of that snub bolstered Howard and *A Beautiful Mind*'s chances throughout the season, cementing an "overlooked and overdue" narrative in the film's favor. The Academy has always favored honoring industry legacies, and Peter Jackson was still considered an outsider, despite already having an Oscar nomination for *Heavenly Creatures*' screenplay.

Mind weathered several hurdles to nab its win, from mixed reviews, controversies of obscuring its subject's anti-Semitism and possible queer history, and its star Russell Crowe aggressing the director of the BAFTA ceremony. But *Fellowship* faced a single, more formidable obstacle: inhabiting a genre the Academy didn't yet take seriously. *A Beautiful Mind* ended a decade that awarded timeless epics and began one that mostly awarded films by legacy directors. (Or had *Gladiator* been the final death knell? Either way, blame Russell Crowe.)

Fellowship would still win four Oscars, and the following year's underwhelming showing for *The Two Towers* (six nominations, with Jackson shut out of Best Director) would be blamed on the Academy already eyeing the trilogy's finale as the cue to honor the entire series. In 2003, *The Return of the King* proved such theories correct with its historic Oscar showing, shattering conceptions of the genre's limitations. As the *New York Times* wrote, "It seemed to represent Hollywood's soaring ability to create fantasy for the screen, but also seemed an emblem of a time when a conflict-ridden world was being reflected in Hollywood movies, as the original books seemed a reflection of the last world war and what followed."

In the years since, Oscar has yielded such Best Picture nominees as *The Shape of Water* (which tied *Fellowship*'s 13 nominations for the most for a fantasy film), *Black Panther*, and *Avatar*. Even if all genre biases haven't been broken, *The Fellowship of the Ring* changed the Oscar landscape forever.

If you want to read more about...

> Jackson, et al.'s better screenwriting side, turn to page 146–"The best Easter eggs in the Lord of the Rings Movies Are in the Dialogue" (June)

> The secret crafts behind the LOTR movies, turn to page 23–"The First Note in The Lord of the Rings Has an Ancient History" (September)

FEBRUARY **25**

The Fellowship passes the Argonath.

The first Battle of the Fords of Isen: Orcs clash with riders of the Mark near Isengard, slaying Theodred, the son of Theoden.

FEBRUARY **26**

Breaking of the Fellowship.

Frodo and Sam pass across the Anduin to the Emyn Muil.

Merry and Pippin are captured by orcs. The Three Hunters, Aragorn, Legolas, and Gimli, vow to rescue them.

Boromir is slain.

In the absence of the King's son, Erkenbrand, commander of Helm's Deep, assumes command of Rohan's West-mark.

Eomer hears of an orc patrol passing through northern Rohan.

THE LORD OF THE RINGS REVIVED HOLLYWOOD'S SOFT MASCULINITY WITH BOROMIR'S TENDER DEATH

HOW PETER JACKSON'S TRILOGY SOLD A BROTHERLY KISS TO AN AUDIENCE ALLERGIC TO MALE INTIMACY

Zev Chevat

It's one of the most striking moments in *The Lord of the Rings: The Fellowship of the Ring*: Boromir, impaled by three enormous arrows, lies dying in the forest. When Aragorn finds him, Boromir sobs, confessing that he tried to take the Ring from Frodo, and that he fears the worst. Aragorn helps Boromir bring his sword to his chest, giving him the repose of a warrior slain in battle. And then, in an intimately framed shot, the heir of Isildur cradles his fallen companion's face, and kisses his brow.

Boromir's death sticks with viewers new and old, unforgettable in its performances and its deep wells of emotion. The first time I saw the scene in an enraptured midnight-premiere audience, I remember my surprise that no one laughed or quipped in embarrassment. It was gratifying, and shocking, to see that level of masculine tenderness depicted on screen, let alone in one of the biggest films of that decade.

It would have been easy, following the lead of other early 2000s blockbusters, for the *Lord of the Rings* trilogy to have catered to the times, and taken a turn for the self-aware, self-embarrassed, and glancingly to overtly homophobic. But with the quiet power of Boromir's death scene, Jackson and company gave the hardened mainstream audience of 2001 a different idea of what masculinity could look like—an *older* idea. Drawing on a potent mix of Arthurian legend, Tolkien biography, and the on-screen mannerisms of the Golden Age of Hollywood, the filmmakers crafted one of the most heart-wrenching moments in the *Lord of the Rings* series. More than that, they delivered an expression of profound masculine vulnerability and, well, fellowship, that had become all but extinct in the surrounding big-budget landscape.

THE MAKING OF AN ACTION HERO

While there are many reasons for the shifts in masculine representation coming out of the 20th century, one seems the most glaring and obvious. A shadow and a threat to the mainstream had been growing in Hollywood's mind for decades: homosexuality. As awareness of queer existence rose in the cishet public consciousness—owing in no small part to the AIDS crisis of the 1980s and 1990s, and the increasing visibility of queer activism—Hollywood became more and more skittish about

representing closeness, physical touch, and emotional vulnerability between male characters of *any* sexuality.

The box-office-topping action movies from the years around *Fellowship*'s release—including the first installment of the Fast and the Furious franchise, the first of the Raimi Spider-Man films, and *The Mummy Returns*—give an overview of how adult masculinity existed in the popular consciousness. Masculinity meant male heroism, and the heroism of a solitary man. He might be the de facto leader of a team, but if he had equals, they were coded as antagonists, rivals, or, at the very least, sources of gruff, in-group

To truly be a hero—to be a man, the movie says— you cannot bear your burdens in the poisonous cloud of solitude.

tension. The hero probably had a female love interest (likely to be the only top-billed woman), but no close male friends with whom he shared his interior life, and certainly none who he'd touch for longer than a fist takes to make contact.

On its surface, the *Lord of the Rings* trilogy seems to fit the picture of what could sell to an early-2000s audience. In contrast to the fairytale meandering of *The Hobbit*, the *Lord of the Rings* series is very much a war story, and War Stories are traditionally full of the camaraderie and rivalries of men. But the movie trilogy, as a text, if not as a production, is as untethered from 2000s Hollywood concerns as New Zealand is from any mainland.

THE HANDS OF A KING ARE THE HANDS OF A HEALER

In building an alternative Anglo mythos, Tolkien drew heavily on the imagery of masculinity as it exists in ancient and medieval sources. He also took conscious inspiration from his time as a soldier in World War I, embellishing the storybook knights and warriors of past ages with the friendship and close bonds he witnessed in real fields of battle. This fusion creates a complex update to a well-worn arche-type, and, as interpreted by Jackson & Co., gives us a variety of heroic types in *Fellowship* alone. But it is Aragorn and Boromir who adhere most closely to the blueprint of chivalric knight.

More than any other pair of mascu-line characters in the trilogy, the two are a study in contrasting equals. They're both of the race of men, and experienced warriors. Aragorn is the soulful, poetic knight, valiant but melancholy, respectful of history, gallant and chaste with women. Boromir looks the part, laden with the props of a Round Table champion, and is more brazen, propelled by the knightly desire to protect his homeland. Both are suspicious of the other. The quality in question is not whether the other is a *man*, but whether he is noble and worthy enough to be the leader of Gondor, the figurehead nation of men.

From their first tense introduction in *Fellowship*, Boromir and Aragorn are reflections of each other, reflections that contain valor as well as darkness. Aragorn, an outsider raised by elves, doubts he should assume his kingly birthright, while Boromir's princely confidence and pride in his homeland make him prey to the Ring's promises. In their own ways, they are seeking a redemption that only the other can understand, and give. But in order to receive it—and for Boromir's death to be cinematically effective—they must first have bared their flaws to the other. Aragorn and Boromir have to be physically and emotionally close, without the self-reflexive flinching their audience might expect.

FEBRUARY **27**

Pippin manages to drop the brooch of his elven cloak.

News reaches Edoras of the death of the king's son and the peril of the Westfold. Grima manipulates Theoden into delaying reinforcements to Erkenbrand. Against Theoden's orders, Eomer and his riders set out to pursue the Uruk-hai.

FEBRUARY **29**

Merry and Pippin escape from the Orcs, and meet Treebeard. The Taming of Smeagol. At dawn, Eomer's men slaughter the company of orcs. The Three Hunters meet Eomer, and reach the site of his battle with the Uruk-hai.

THE LEGACY OF
THE WAR FILM

Whether it was deliberate planning, or unconscious association by Jackson and his collaborators, much of *The Lord of the Rings* echoes the same on-screen language as Golden Age Hollywood—where masculinity is gentler, but its credentials unimpeachable. The classic War Picture is a direct ancestor to the framing, sincerity, and unashamed touchingness of Boromir's death scene, and others like it. It's a cinematic invocation that lets the films bridge the gap between early-2000s audience expectations and Tolkien's more archaic references and tastes. By signaling that what's being shown is part of the cinematic and literary past, the film provides space for an audience to engage with the scene on its own terms, not 2001's.

It was in this breathing space that an audience was able to take in the scene's many layers and lessons. Eminently flawed but noble masculine characters in the *LOTR* trilogy are known by their actions toward others. *Tenderness is an action*, the scene seems to say. *Forgiveness is an action.*

The *Lord of the Rings* trilogy resolves the rivalry between its two classically masculine members of the Fellowship not through manly contest, but through careful reveal of their mirrored doubts, worries, and fears for the future. To truly be a hero—to be a man, the movie says—you cannot bear your burdens in the poisonous cloud of solitude. That's how the Ring seizes you. You must be brave enough to share your doubts, to hold each other close, to see and be seen in turn.

Grasping Boromir's hand as he dies, Aragorn takes his first real step toward claiming his birthright: "I swear to you, I will not let the White City fall." With a look not unlike relief, Boromir responds in affirmation, "I would have followed you, my brother. My captain. My king." This simple declaration says it all: I accept you, I recognize you in turn, thank you.

You are not alone.

If you want to read more about...

> *Tender masculinity in* LOTR, *turn to page 202—"Queer Readings of* The Lord of the Rings *Are Not Accidents" (Second September)*

> *Aragorn's masculine appeal, turn to page 38—"In Praise of Aragorn, the Most Well-Rounded Sex Symbol on Middle (or Any) Earth" (October)*

└FEBRUARY **30**[*]

The Entmoot begins. The Three Hunters meet Eomer, and reach the site of his battle with the Uruk-hai.

[*]In Middle-earth, all months have 30 days.

CHAPTER SEVEN

MARCH:
THE WAR OF
THE RING

THE TRUTH
ABOUT GANDALF

A LOOK AT THE ORIGIN, POWERS, DEATH, AND REBIRTH OF
A MYSTERIOUS-BUT-BELOVED CHARACTER

Susana Polo

The theatrical version of Peter Jackson's *The Lord of the Rings* trilogy clocks in at nine hours and 18 minutes, yet there's so much of J.R.R. Tolkien's *The Lord of the Rings* that was left on the cutting room floor.

That's a good thing. Movies and books are different beasts, and the former can only support so much exposition. The lack of an origin story didn't stop audiences from falling in love with Gandalf as portrayed by Ian McKellen, who studied Tolkien himself in perfecting his award-winning performance, fixing himself in the hearts of millions of fans. Gandalf, the wise, mercurial, mysterious, and occasionally terrifying wizard, is arguably more the face of the *Lord of the Rings* films than Frodo, its hero, or Aragorn, its long-lost king.

The real power of McKellen's performance is that you believe wholeheartedly in Gandalf despite how his role in the movies is full of ambiguity. Is he, like, human . . . or what? What happened when he died? What's the difference between Grey and White? What can wizards *do*, anyway? And who appointed Saruman president of wizards?

I can provide answers to all these questions, because I'm a giant Middle-earth nerd who thinks *The Silmarillion* is a more enjoyable read than *The Lord of the Rings*, and pillaged Tolkien's *Unfinished Tales* to enhance the accuracy of my own *Lord of the Rings* Twitter account (page 48). Read on for everything you were always afraid to ask about everyone's favorite weed-smoking magic grandpa.

IS GANDALF HUMAN? CAN ANYONE BE A WIZARD?

No. And also, no.

Gandalf is a divine spirit clothed in a mortal form. In Middle-earth parlance, he's a creature known as a Maia (plural: Maiar). They are sort of like demigods, in that they serve a higher order of godlike beings, the Valar. And they're sort of like angels, in that they are fully divine in origin (not half-human, like a lot of Greek demigods) and can change their form at will.

Other Maiar who appear in the *Lord of the Rings* movies include Saruman, Sauron, and the Balrog. (Yes, the monster and Gandalf are the same species.) Also, Elrond's great-great grandmother is a Maia—his family tree is *very* complicated.

The Valar, Middle-earth's cohort of caretaker gods, retreated from the world thousands of years before the time of *The*

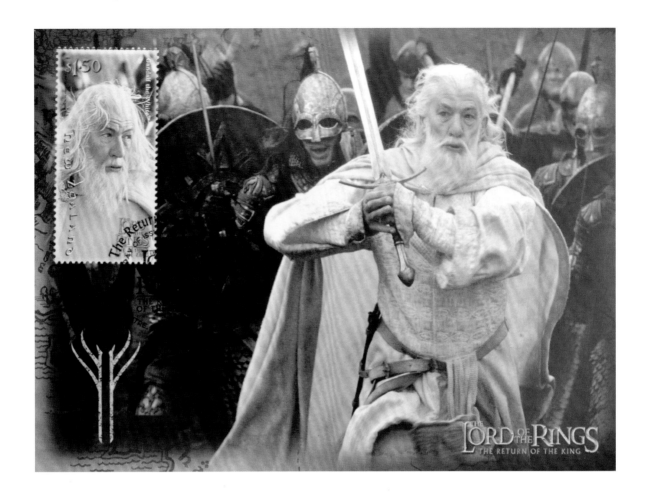

Lord of the Rings, and they took all of their Maiar with them. But in the Third Age (that is, sometime after Isildur got his hands on the Ring in the prologue of the Jackson movies), Sauron began to amass power again. And since the Valar nearly had to destroy the world to stop Sauron the last time he rose to power, they decided to send some emissaries to Middle-earth to make sure he was kept in check this time around.

So with the blessing of Middle-earth's creator god, the Valar assembled a small group of Maiar to secretly send to Middle-earth. Those emissaries were known as the Istari, and the Valar sent five particularly high-ranked ones—Tolkien calls them "chiefs"—to the northwest of Middle-earth in particular, because

that was deemed the place where it was mostly likely that men and elves could be rallied to oppose Sauron.

Those five Istari were Saruman the White, Gandalf the Grey, Radagast the Brown, and the two "Blue Wizards." Those two went east of Mordor and were never seen again, and Tolkien declined to give them names or even explain what happened to them, since they had nothing to do with the War of the Ring.

Tolkien also never quite settled on all the details of what Gandalf was like as a Maia before he died. But we do have some hints from his notes, as compiled and published by his son and archivist, Christopher Tolkien. It seems clear that Gandalf's Maia name is Olórin, and

"In shapes weak and humble [they] were bidden to advise and persuade Men and Elves to good . . ."

possibly that he was reluctant to take up his Istari responsibility and was the last of them to arrive in Middle-earth.

IF WIZARDS ARE GODS, WHY DO THEY ALL LOOK LIKE CRUSTY OLD DUDES?

By the time the Valar were sending their Istari emissaries out, Middle-earth had already suffered through several waxings and wanings of its two great Dark Lords, and you could say that the Valar had seen the error in leading men and elves to expect gods to solve their problems instead of sorting them out themselves.

So, instead of being sent in their full divine majesty, capable of taking whatever form they wished, the Istari were fixed in the forms of unremarkable old men. This forced them to better understand those whom they were sent to protect, but it had the drawback of making them corruptible. It dimmed their power, and subjected them to mortal fears and worries—but that would be worth it to gain the trust of elves and men.

That was important because of another rule that was placed on the Istari: They were forbidden to use force or fear—the favorite tools of the corrupted Maia, Sauron—to dominate men and elves. No bending societies under their rule, no political scheming or hoarding of power, even to accomplish honest goals. They'd have to get people to trust them instead.

"In shapes weak and humble [they] were bidden to advise and persuade Men and Elves to good," Tolkien wrote in an essay on the Istari published after his death, "and to seek to unite in love and understanding all those whom Sauron, should he come again, would endeavor to dominate and corrupt."

Most people in Middle-earth who ran into a wizard had no idea that they were interacting with an angelic being—but there were a few powerful individuals who figured it out, like Elrond and Galadriel.

HOW DID GANDALF GET ONE OF THE ELVEN RINGS?

It is not mentioned in the movies, but just in case you've heard about it from some *The Lord of the Rings* nerd, yes, Gandalf has one of the three Elven Rings.

He got it from an elf, naturally.

The three bearers of the Elven Rings are Elrond and Galadriel, who you know from the movies, and Cirdan the Shipwright—who appears on a blink-and-you'll-miss-it basis. Cirdan's domain was the Grey Havens, the coastal launching point of all the elven boats going West to the elven afterlife/homeland (which itself would take a whole separate essay to unpack).

As the guardian of that location, Cirdan got to meet all the Istari as they arrived in Middle-earth, and he gave his ring to Gandalf for three reasons: One, he liked Gandalf better than any of the other Istari. Two, he foresaw that Gandalf would

TIMELINE 2002

MARCH 01

The Three Hunters meet Gandalf in Fangorn and set out for Edoras.

Erkenbrand's troops reach the Fords of Isen.

Frodo, Sam, and Gollum reach the Dead Marshes.

Faramir leaves Minas Tirith to return to his forces in Ithilien.

MARCH 02

The Entmoot explosively concludes. The Last March of the Ents reaches Isengard in the evening.

Saruman's army marches forth from Isengard and clashes with Erkenbrand's troops at the Second Battle of the Fords of Isen.

Frodo, Sam, and Gollum reach the end of the Dead Marshes.

Gandalf and the Three Hunters come to Edoras, heal Theoden, banish Wormtongue, and ride west against Saruman.

face "great labours and perils." Three, he wasn't doing much with it anyway. He lived about as far away from Sauron as you can possibly get without leaving Middle-earth, and he wanted the ring to be on the hand of somebody who was actually going to need it.

WHAT EVEN ARE GANDALF'S POWERS?

Tolkien never really elucidated the specific powers of wizards. After all, it's not like he was building a cohesive game system or writing a series of novels about a wizard school. He didn't have to.

But it seems that there are some things all wizards can all do. They all use staffs to focus their magic, for example. Gandalf and Radagast can both speak to animals; Gandalf and Saruman both have some level of ability to mystify using only their voice. And being a wizard seems to come with some power over the physical world around you, as when Gandalf orders a door to stay shut in Moria, summons light, or shatters Saruman's staff simply by commanding it to.

But it also seems like wizards have specialties. Tolkien says that the Valar deliberately did not mandate that the Istari work together, and in part chose them for their different and separate powers and inclinations.

In the books, Saruman was known for the power of his voice to beguile and convince, as well as for his "great skill in works of hand"—his inventiveness. Radagast the Brown, who was featured in Jackson's *The Hobbit* movies, developed an obsession with Middle-earth's beasts and birds, which distracted him from the Istari mission, much to the exhaustion of his colleagues Gandalf and Saruman. (Ultimately, Tolkien says, Gandalf the Reluctant Maia was the only one of the Istari who remained faithful to the Valar's goals.)

Gandalf's specialty was fire. Which might seem odd for a guy whose biggest magic moments in the movies involve summoning great white beams of light or fighting another wizard with invisible waves of force.

To Tolkien, Gandalf embodied the fire of creation in the forge, the fire of warmth in the hearth, and the torch fire that keeps the darkness at bay. "Warm and eager was his spirit (and it was enhanced by the ring Narya)," Tolkien wrote in his Istari essay, "for he was the Enemy of Sauron, opposing the fire that devours and wastes with the fire that kindles, and succours in wanhope and distress."

It's a connection that explains why a demigod would take so much enjoyment from making fireworks for hobbits.

WHAT HAPPENED TO GANDALF WHEN HE DIED?

When Gandalf died, his divine being left its physical form, and about 20 days later, he was returned to life. "Darkness took me;" he says to Aragorn, Legolas, and

Gimli in *The Two Towers*, "and I strayed out of thought and time, and I wandered far on roads that I will not tell. Naked I was sent back—for a brief time, until my task is done."

He was re-embodied and sent back to Middle-earth by an entity or entities who gave him his task in the first place—either the Valar, or Middle-earth's supreme creator god himself, Eru Ilúvatar. And, of course, he was sent back changed.

In his essay on the Istari, Tolkien stated that it took each Istari some time to learn mortal ways after they arrived, which might account for Gandalf's memory lapses just after he was resurrected—and for how Gandalf the White is more formal and disconnected than his previous incarnation.

WHY DID GANDALF TURN WHITE?

To a generation of folks who grew up on *Avatar: The Last Airbender* or *Mighty Morphin Power Rangers*, or, heck, even the coded lightsaber colors of Star Wars, it's tempting to assign the same kind of weight to the color language of Tolkien's wizards. But from his own writings, it's clear that Tolkien's color connotations were personal, rather than universal.

If Gandalf's specialty is fire, you'd think he'd be a red wizard, but Tolkien wrote that Gandalf's gray robes and hair represented the color of ash that concealed his divine fire, just as his wizened form concealed his identity as a Maia. In his essay on the Istari, Tolkien linked Gandalf's white robes and hair to fire as well, saying he was "clothed then in all white, and became a radiant flame (yet veiled still save in great need)."

Tolkien didn't say much about what white represented for Saruman, though we can infer a few things about what taking on Saruman's color meant for Gandalf. But let's get one thing straight first: Saruman is "the White" for only a few chapters of *The Fellowship of the Ring*. The moment he does his big villain reveal to Gandalf, he also reveals a change of wardrobe, crying "I am Saruman the Wise, Saruman Ring-maker, Saruman of Many Colours!"

As Gandalf tells the Council of Elrond:

I looked then and saw that his robes, which had seemed white, were not so, but were woven of all colours, and if he moved they shimmered and changed hue so that the eye was bewildered.

"I liked white better," I said.

"White!" he sneered. "It serves as a beginning. White cloth may be dyed. The white page can be overwritten; and the white light can be broken."

"In which case it is no longer white," said I. "And he that breaks a thing to find out what it is has left the path of wisdom."

It might be worth mentioning here that even Tolkien's own biographer, Humphrey Carpenter, felt the need to comment on how boring his clothing was. Even for an Englishman *and* an English professor, Tolkien dressed to be forgotten, partly as a conscious rejection of the academic philosophy of aestheticism, according to Carpenter. Among Tolkien's only indulgences once his books made an unlooked-for amount of money, Carpenter writes, was to buy the occasional brightly colored waistcoat to go along with his drab suits. To Tolkien, flashy colors were in the neighborhood of decadence.

It's also important here to remember that although we know Saruman as a villain, his reputation as the wisest of the Istari was based on thousands of years of behavior. He's one of the most prominent of *The Lord of the Rings'* many examples of how even the most principled people can be corrupted by fear and disillusionment.

So, when Gandalf becomes "the White," it's about showing that he's here to take Saruman's place and make up for Saruman's mistakes. "Yes, I am white now," Gandalf tells Gimli. "Indeed I *am* Saruman, one might almost say, Saruman as he should have been."

For Tolkien, Gandalf's and Saruman's white robes may also have connected them to the color of starlight, which is a big force for magical protection in Middle-earth—think of Sam forcing Shelob to cower before Galadriel's light. One of the biggest things that the Valar did for Middle-earth was to bring light to it, through the stars, sun, and moon (and, at one point, some special glowing trees). Protecting, fighting over, or maintaining the light of the Valar is a big recurring theme in *The Silmarillion*.

Sending Gandalf back as Gandalf the White, "a radiant flame" in a dark time, is a Big Valar Mood.

WHAT WAS GANDALF ALWAYS SMOKING?

sigh

Everybody who smokes in *The Lord of the Rings* smokes pipeweed. It's supposed to be tobacco. It's tobacco.

It's *tobacco.*

"But what if . . . heheheh . . . What if it wa—" I cannot stress *enough* that Tolkien's own biographer devoted a whole chapter to enumerating all the ways in which he was exceptionally boring, even for a professor of Old English at Oxford who was raised during the Victorian era.

You can think pipeweed is whatever you want. Tolkien meant it to be tobacco.

Why is this so complicated?

Gandalf is not the kind of wizard we get from other wizard-involved stories, like Dungeons & Dragons, Harry Potter, The Magicians, Diane Duane's books, or even Marvel comics. In *The Lord of the Rings*, wizards aren't men who study magic, or people born with magical talent; they're not human, they're not strictly mortal, and they're the same species as Sauron himself, which is to say, they're kind of angels.

And it's even more complicated because wizards were never supposed to be a part of Middle-earth. Technically, they were retconned in, comic book style.

We think of *The Hobbit* and *The Lord of the Rings* as a single coherent narrative these days, but Tolkien never imagined continuing the story of Bilbo Baggins when he wrote *The Hobbit* as a fairy tale for his children. The true creative work of his life would be *The Silmarillion*, the mythological epic of world-building and romance that he had begun before his children were even born.

The publishers who'd seen the success of *The Hobbit* thought that a multi-thousand-year history of elves and men (and only elves and men) was too different to serve as a satisfying sequel. It wasn't until Tolkien was about a dozen chapters into writing his *The Hobbit* sequel that he realized he could set the entire story after the events of *The Silmarillion*, turning the project into an excuse to play around in his pet universe, Middle-earth.

There was only one problem, which, for Tolkien, probably felt like an irresistibly enjoyable puzzle: He'd have to find a way to reconcile all the weird stuff in *The Hobbit* with the extensive and exquisitely balanced world-building he'd done for

The Silmarillion. That weird stuff included but was not limited to hobbits, trolls, giant talking eagles, whatever Gollum was, and, of course, old men with magic powers.

In a very literal sense, the author would spend the rest of his life in pursuit of this goal. Most of what we know about the origins of the wizards comes from unfinished posthumously published work in *The Silmarillion,* and from other books of Tolkien's notes and essays compiled and annotated by his son. In some cases, what we have is really just a note Tolkien jotted down in the margins of a student paper as he read it, and we have no way of knowing if it was an idea he later discarded.

Due to the nature of how Tolkien's books were licensed for film, screenwriters Philippa Boyens, Peter Jackson, and Fran Walsh were prohibited from using content from books other than *The Lord of the Rings.* And while it's fun to explore the unfinished nooks and crannies of Middle-earth in Tolkien's writing, leaving things vague certainly didn't stop people from falling in love with Gandalf on-screen. It just goes to show that you don't necessarily need to spell out a character's whole origin story to make them the face of a franchise.

If you want to read more about...

> *The mysterious magic of wizards, turn to page 14—*"The Fellowship of the Ring Redefined Movie Magic with a Single Line" *(September)*

> LOTR's *most mysterious characters, turn to page 80—*"The Truth About Galadriel" *(January)*

That One Soup-Eating Gondorian Guard Tells His Story

VFX SUPERVISOR AND *MORTAL ENGINES* DIRECTOR CHRISTIAN RIVERS LOOKS BACK AT HIS CAMEO

Karen Han

Do you have what it takes to be a Gondorian?

While working as the visual-effects supervisor on the Lord of the Rings trilogy, Christian Rivers—who'd later go on to direct the Peter Jackson–produced *Mortal Engines*—mentioned to Jackson that it'd be nice to have a cameo somewhere in the films. As it turns out, the casting department already had something in mind.

"I was a lot fitter-looking back then, and I had long, black hair, and a black beard," Rivers recalls, describing how he got the casting department's attention simply by walking across Stone Street Studios every day to get to work. Years after the fact, they told him, "When we'd see you, we'd suddenly point out and go, 'That guy! See that guy? Gondorian. That's what the Gondorians should look like. That guy.'"

And so, Rivers was cast as "the soup-eating Gondorian guard" in one of *The Return of the King*'s most dynamic sequences: the lighting of the beacons of Gondor to call for Rohan's aid. ("That was great, because you just know it's a cameo that's never going to be cut," Rivers jokes.)

The pyre that Pippin (Billy Boyd) lights is real, which meant that the stakes of the shoot were high. "They

actually lit it, and the idea was that we'd look up, and then quickly put the fire out," Rivers explains, laughing as he remembers the process. "We were up there, up at the top of a quarry, and it's a shot that's shooting past us as Pippin lights the beacon. I was actually really nervous, and so I was really getting into character and I was eating my soup."

As should be relatable to almost everyone, Rivers was so nervous that he flubbed the moment. "The guy goes, 'Guard,' meaning, 'Guard, look up!' And I thought [feigns being dejected], 'Oh, he's not talking to me.' Of course, who else would be talking to? And so I keep eating and I hear, 'Guard!' So I look up at the camera, and they're, like, 'Well, what?' And then I just hear this guy go, 'Can we cut?!' The thing that actually caught fire, the whole pyre, was about to go up."

It's a light-hearted anecdote that belies just how dramatic the sequence is—and adds a touch of earnestness to watching the scene, and picking Rivers out.

"I was a real idiot," he says, as self-effacing as possible. "It was alright, though. We did a second take—and I somehow made it into the film!"

How Wētā Created Shelob

Joe Letteri, currently the director of Wētā Digital, spoke to Polygon in celebration of the 15th anniversary of *The Return of the King*'s big night at the Oscars. Here, he breaks down one of the great creatures that made the leap from page to screen:

"Peter has always had an intense fear of spiders, and so he wanted a big, scary spider. It was Christian Rivers who was with us at the time as one of our art directors [...] he actually found [these things] called trapdoor spiders. They live in little holes in the ground; they cover themselves with a little flap of dirt, and when prey goes by, they pop up and run out and grab it. He happened to find one in his garden one morning and just photographed it, and that was our reference—that was what we used. We got other pictures as well, but that was the main one.

"The biggest thing to remember about her design was trying to come up with what her eyes should look like. Spiders have eight eyes, but if you put them where real spiders' eyes are, it doesn't make for an interesting shot, because you don't know which one you're supposed to look at. So what we did is we moved the eyes around to have the two that you would recognize as eyes on a face. Those were the main ones and the other ones became less important around it.

"And then Peter, of course, wanted the sense of history, the scarring of the eyes and the sense that she'd been in a battle and had to be in lots of fights, whether for defense or prey, for all of her life. We did a lot of revisions of that to try to work all of that out, and then the look of the fur. At that scale, you get that translucent fur, but it's almost like the beer-bottle effect; when you get those big hairs that are that big in size, they get very refractive. That was something that was new for us, but we had to figure out how to make it look that way, so that when you backlit it, you got that nice kind of amber quality covering each of the furs.

"We spent quite a long time on her, getting the articulation right, getting the joints pretty close to a spider, but we took liberties because we wanted her to have a little bit more flexible motion than what a spider could do—just little changes here and there as we kind of worked out what she needed to do for animation. You can do the basic locomotion of all eight legs, you can study spiders and see what they're doing, but you always need to come up with something interesting. Especially in the battle, when Sam is running around her and they're fighting, you need to choreograph it so that each one is doing something to either hold the weight or be adjusted for the move, or to be striking out or moving in a direction she needs to move. With eight legs, you always have to be thinking about it because you don't want any of them to look like they're not engaged because then you lose the excitement, but you also don't want them just flailing around for no reason at all, because then it just looks wrong. The animators spent a lot of time just trying to find that right level.

"What we did for the fight was actually pretty cool. We had a stunt person on set in a blue suit, with this big extension with two fangs at the end. He did a lot of the fighting with Sam that way. Sean [Astin] actually reworked all of the animation, in a way, backwards for us, because he would grab the fangs and kind of fight with them and puppeteer it, and because we had to fit all that action to his hands, those became what her fangs were doing, and then we fit the body performance around that.

"The thing that really drove the scale was the scene where she needed to wrap up Frodo. She needed to be big enough to do that believably, because if you watch spiders doing that with insects, they can do them with insects that are fairly large compared to their body size, but we wanted something that felt a little bit more easy for her to handle to make it really look scary, so that relationship is kind of what drove the final pick on size.

"That scene was a combination between some live-action elements that we shot with Elijah [Wood] and then going to a digital double of him as he's getting wrapped up in the wide shots when you see her spinning him around. We created this sort of silken, clothlike texture that came out of her spinners and that she wrapped around him."

FRODO AND SAM'S BREAD FIGHT IS OBJECTIVELY DUMB BUT ADMITTEDLY CRUCIAL

THANK YOU FOR COMING TO MY TED TALK

Jeremy Mathai

One does not simply claim that *The Lord of the Rings* "contains multitudes" and leave it at that. There's more than enough heart, drama, and spectacle (not to mention meme fodder and Eagle-sized controversies) to appease any casual fan. But for those of us who identify as J.R.R. Tolkien purists, our relationship with Peter Jackson, Fran Walsh, and Philippa Boyens' three-part adaptation could best be described as . . . *complicated*.

You can trust the most passionate (insufferable) among us, burdened with book-learned knowledge, to host annual trilogy marathons and debate ourselves in disturbingly Gollum-like fashion. Between effusive praise (nothing but respect for MY *The Fellowship of the Ring* prologue front-loaded with all that world-building and historical lore) and head-scratching disbelief (they did WHAT with Faramir in *The Two Towers*?), we can spin ourselves into knots trying to reconcile these two wolves within us—and within the films themselves, too.

It's in this spirit that we take a microscope to one particular sequence I've obsessed over since I was an impressionable hobbit-lad in 2003, bursting with anticipation in my theater seat as

The Return of the King unfolded before me. The parting of Sam and Frodo, where the bond between our two lovable leads shatters due to irreconcilable differences (assisted by a third-wheeling Gollum), best represents the singular dichotomy at the heart of these cherished adaptations. Again and again, bold swings of blockbuster filmmaking crash against Jackson's B-movie storytelling quirks.

The end result is uniquely fascinating.

The entire affair between Frodo, Sam, and Gollum on the Stairs of Cirith Ungol *seems* straightforward at first glance. The possessive and consuming nature of the Ring has almost completely overtaken Frodo, leaving him susceptible to manipulation and whispered suspicions. Gollum's treachery compels him to chuck the last of their precious lembas bread and frame Sam for the crime. And poor Samwise, well-meaning to a fault, bumbles right into Gollum's trap by offering to bear Frodo's burdensome Ring himself. Cue the fraught confrontation, Sam's ineffectual defense, and Frodo's two harsh words that broke all our hearts: "Go home."

But a cursory look at this scene unearths the strands fraying just below the surface. Author/video essayist Lindsay Ellis

once amusingly coined the phrase "Forced Peej Conflict," which describes a specific kind of plot contrivance Peter Jackson frequently relies on when adapting aspects of Tolkien's work that (theoretically, at least) won't translate smoothly on-screen. The go-to method, apparently, is to inject otherwise frictionless storylines with character conflict—like, say, our hero banishing his best friend thousands of miles from home over misunderstandings about bread, choosing to remain alone with a loathsome creature very obviously up to no good—and hope that playing up the momentary, visceral sensations will compensate for any gaps in narrative or emotional logic.

Reader, it does *not*.

As big a departure as this is from Tolkien's book—and it is, in case non-book-readers haven't caught on—the real pitfall of this scene is how very little of it makes any dramatic sense. Instantly, Frodo's likability takes a debilitating and almost unrecoverable hit. (Siding with Sméagol's small redemptive potential over Sam's well-established devotion will do that!) Meanwhile, the inherent tension in the Sméagol/Gollum duality is completely sapped, as his betrayal turns into a foregone conclusion. Suddenly, at the most crucial juncture, the main thread of the trilogy feels hamstrung.

The biggest casualty, however, is none other than our favorite bodyguard/ gardener. This seemingly reverse-engineered outcome requires Sam to remain inexplicably passive in the face of Gollum's obvious villainy, act uncharacteristically violent to justify Frodo's reaction, and, most egregiously, look really slow on the uptake. (Even Elijah Wood and Sean Austin poke fun at this in the cast commentary track.)

Sam knows he's innocent, but he meekly goes along with Frodo's commands even if it means breaking his promise to Gandalf, the focal point of one of *The Fellowship of the Ring*'s most moving scenes. Extremely questionable! He begins his long journey home only to stumble across their missing food lying down the mountain where Gollum tossed it, theatrically swelling with rage and motivation to save his dear Frodo because he . . . now has visual proof that he did not, in fact, mistakenly eat their own food and forget about it? . . . Sure.

So why isn't this a bigger deal-breaker than it is? Why didn't audiences revolt en masse and chain themselves in front of LA's Dolby Theatre to prevent *The Return of the King* from sweeping all those Oscars? It's simple, really: Peter Jackson's repeated efforts to drum up tension through utter nonsense—on some lizard-brain level of human consciousness—*work anyway*.

As illogical, noncanonical, and awfully strained as the setup to these payoffs

MARCH **06**

Merry swears himself to the service of Theoden, king of the Mark.

Frodo, Sam, and Gollum pass into the woods of Ithilien.

MARCH **07**

Frodo and Sam are captured by Faramir's Rangers and taken to Henneth Annun. Faramir refuses the Ring.

At Dunharrow, Aragorn refuses to allow Éowyn to ride the Paths of the Dead to Minas Tirith with his company.

TIMELINE
2002

Sent by Galadriel, Aragorn's Dúnedain—accompanied by the sons of Elrond—find him in Rohan, delivering council and a standard of his house, crafted by Arwen.

Gandalf and Pippin come briefly to Edoras on their flight to Minas Tirith.

may be, Jackson, Walsh, and Boyens sure as hell know how to deliver. Pippin's insipid "plan" in *The Two Towers* (which, oops, renders one of the oldest beings in Middle-earth a gullible fool) is easy to forget because the subsequent March of the Ents delivers tenfold. Likewise, King Théoden's weirdly self-defeating attitude toward helping Gondor (and his inexplicable reversal in *The Return of the King*) is but a blip on the radar in the face of the majestic lighting of the beacons.

It'd be convenient to dismiss these as missteps stemming from changes to the source material, but it's not quite that straightforward. Throughout the trilogy, Jackson and his co-writers prove they intuitively understand that shortcuts and trade-offs are sometimes necessary in translating novels to visual language. One could argue that the figurative cost-to-benefit ratio doesn't come out in Jackson's favor at times, but what makes art so wonderfully complex is how striving for greatness commingles with the inherent flaws of the artist(s).

However much we roll our eyes at blatantly padded action sequences or contrived attempts to raise stakes, these foibles are precisely what makes this fantasy epic as distinctive, idiosyncratic, and downright *weird* as it is. The *Lord of the Rings* trilogy is still fostering discussion and withstanding scrutiny today, nearly 20 years after it arrived in theaters. The results speak for themselves.

Nothing diminishes Sam's crowd-pleasing hero moment, returning with Frodo's sword Sting and the Phial of Galadriel in hand, ready to save his best friend from the arachnid incarnation of evil itself. It's precisely the kind of triumphant, heart-on-its-sleeve catharsis we come to this trilogy for in the first place.

And that's the ace in the hole that the *Lord of the Rings* movies always carry. For as tempting as it is to fixate on unforgivable departures from the text, it's through these creative gambles that Jackson & Co. leave their indelible marks on a nigh miraculous adaptation. This one bizarre scene, nestled within a much larger saga, serves as a microcosm of the most rewarding adaptation we could've hoped for, teaching a downright Tolkien-esque lesson—however unintentionally—in appreciating the occasional stumble in the pursuit of success.

So why isn't this a bigger deal-breaker than it is?

If you want to read more about...

> *Jackson et al.'s better screenwriting side, turn to page 146—"The Best Easter Eggs in the* Lord of the Rings *Movies Are in the Dialogue" (June)*

> *Gollum, turn to page 71—"Andy Serkis' Gollum Is a Singular Performance Without a Single Author" (January)*

MARCH 08

Faramir's scouts find Mordor silent and waiting. He releases Frodo, Sam, and Gollum.

Aragorn and the Grey Company travel the Paths of the Dead, calling upon the Dead army.

MARCH 10

The Witch-king leads his army from Minas Morgul, bound for Minas Tirith.

Frodo, Sam, and Gollum ascend the Straight and Winding Stairs.

Faramir returns to Minas Tirith from Ithilien.

MARCH 09

Gandalf and Pippin reach Minas Tirith, where Pippin swears himself to the service of the steward.

Theoden and his riders reach Dunharrow, where the armies of Rohan are mustering.

The Dawnless Day: Dark clouds issue forth from Mordor, covering the skies. The sun will not rise on Gondor and Rohan for six days.

The Mustering of Rohan, in which Theoden and his armies set out for Minas Tirith. Merry is forbidden from riding with the Rohirrim, but a soldier named Dernhelm offers to bring him into battle with him in secret.

PHILIPPA BOYENS REFLECTS ON ÉOWYN'S "I AM NO MAN!"

A LOOK BACK AT ONE OF THE *LOTR* TRILOGY'S GREAT QUOTES

Karen Han

"The truth of storytelling, and I think female audiences especially prove this, is that you don't need 'strong female characters,'" Philippa Boyens told Polygon about writing the scripts for the *Lord of the Rings* movies with Peter Jackson and Fran Walsh. "I mean, you write strong female characters because they're authentic to the story and they are real, and they reflect something that young women can relate to."

In the years since *The Lord of the Rings: The Return of the King* debuted in theaters, one frequently cited scene persists for the reasons that Boyens describes: Éowyn (Miranda Otto) slaying the Witch-king of Angmar during the Battle of the Pelennor Fields.

Though commanded not to join the battle by her uncle Théoden (Bernard Hill), king of Rohan, on the basis of her gender, she enters the fray by disguising herself as a man—and finds herself face to face with the Witch-king of Angmar, the Lord of the Nazgûl, when she comes to her uncle's aid. Mounted on a fell beast, the Witch-king hisses at her to get out of his way, citing the elf Glorfindel's prophecy that he could not be killed "by the hand of man." Freed from his grasp by the intervention of the hobbit Meriadoc Brandybuck (Dominic Monaghan), Éowyn removes her helmet, revealing her face for him to see.

"I am no man!" she says before plunging her sword directly into his face.

"It's one of the great lines," says Boyens, though she adds, with a laugh, "[Fran and I] were female screenwriters who had to write for all these male characters, and then we finally get this woman to write for, and she has to pretend to be a man."

She feels real, rather than standing in for an archetype or simply ticking a box.

Given the power of the moment, it's no surprise that it has become one of the film's breakout scenes, and it's not just the fact that Éowyn is one of only a few major female characters in the franchise that explains why it has such an impact. It's that she feels real, rather than standing in for an archetype or simply ticking a box.

"If you set out to write a 'strong female character,' quote unquote, they're going to smell it a mile off," Boyens says. "And they

do smell it a mile off. It's always presumptuous, I think, that people believe—and it's not just that they believe this for women, it's also that they believe it for young men—that they cannot relate to a story where the main character is not the same sex as them. Of course they can."

As for whether or not that truthful approach to storytelling worked, one need only look to the film's enduring popularity, not to mention how often Éowyn's triumphant moment is used as a rallying cry for women.

"It was like, 'Wow, this is hitting, this is resonating with young women,'" Boyens notes, then adding, "I think it was that audience that lifted *Rings* into another place."

If you want to read more about…

> *The women of* The Lord of the Rings, *turn to page 80—"The Truth About Galadriel" (January)*

THE JEWELER WHO FORGED
LORD OF THE RINGS' ONE RING
NEVER GOT TO SEE IT ON FILM

THE LATE ARTIST JENS HANSEN,
REMEMBERED BY HIS CHILDREN AND THE *LOTR* CREW

Sara Murphy

Practical. Strong. Ageless. Unadorned, until heated to reveal the Tengwar script of the Black Speech of Mordor. Able to morph to fit its wearer without losing integrity of shape.

These are Peter Jackson's "Rules of the One Ring," recalled by Dan Hennah, supervising art director on the *Lord of the Rings* trilogy, from his home in Nelson, New Zealand. "It was a reasonably simple brief, but it was very specific."

Hennah knew exactly who had the skill and aesthetic to forge the most famous piece of jewelry in Western literature: Danish-born artist Jens Høyer Hansen. A physical giant of a man with a larger-than-life personality, Hansen already had a reputation as one of the most influential contemporary artists in New Zealand. Trained as a jeweler but a smith and sculptor at heart, Hansen had been making bold, clean statement pieces since the 1960s.

"He was capable of understanding [the brief] without needing to put his own stamp on it," Hennah explained. Plus, "he was never mean with his gold." (Unlike some dragons we know.)

But Hansen never got to see his tiny creation on the big screen. Not long after he began work on the One Ring in 1999, he was diagnosed with pancreatic cancer. The condition took his life four months later when he was 59.

As Halfdan Hansen, Jens' eldest son and current manager of Jens Hansen Gold & Silversmith, told Polygon, seeing his father's design on-screen without him "was definitely a moment of bittersweetness for my brother and I."

The films' success introduced a global audience to Hansen's work, and customers around the world now purchase the official licensed prop replicas his workshop produces for Wētā Workshop. However, the Ringmaker deserves appreciation for more than this one piece. Called "the grandfather of modern jewelry-making in New Zealand" by the country's own *WildTomato* magazine, Jens Hansen reshaped the idea of what jewelry could be.

"He was making this work that was kind of bold, big, organic, sculptural surfaces," said Halfdan, "which in hindsight meant that he was a logical person to make a ring such as the One Ring."

As a scholar of Old English, Old Norse, and other Germanic languages, J.R.R. Tolkien would have been delighted to

know that the trilogy's Ringmaker hailed from Denmark.

"My family tree is very monoculturally Danish for the last couple of hundred years," said Halfdan. "[My father] would have had innately in his soul and upbringing some exposure to Viking and Nordic mythology."

Tall, bearded, and boisterous, Jens Hansen appeared to many Kiwis like a Nordic god himself.

"Jens, to me, was very much a Viking," Hennah said.

Born in the town of Gram in 1940, Hansen sailed east to Auckland with his parents and three sisters in 1952, one of many families who left the war-scarred lands of Europe for better opportunities.

Never fully comfortable in the classroom due to the language barrier, Hansen left school at the (then) legal age of 15 to begin a jeweler's apprenticeship in 1956. Four years and 8,000 working hours later, Hansen returned to Denmark as a journeyman for the jeweler firm A. Michelsen.

"He would have cut his teeth on diamond engagement rings and wedding rings and other stuff that he personally didn't have an aesthetic taste for," Halfdan said. To satisfy his growing artistic sensibility, Jens studied at Copenhagen's School of Applied Arts and Industrial Design. He returned to Auckland with his wife, Gurli, in 1965, and immersed himself in the bold, simple, geometric designs that characterized postwar Danish jewelry. In 1968, the picturesque New Zealand town of Nelson, where the mountains meet the beach on the northern tip of the South Island, came calling. Local leaders, eager to woo artists, offered Hansen financial help to set up shop.

Dan Hennah had relocated to Nelson around the same time in his work as an architectural draftsman, and he soon crossed paths with Jens. "He was a very capable, big guy," Hennah remembered. "Larger than life."

Just like his pieces. During our conversation, Hennah pulled out a necklace he and his wife, Chris bought from Hansen in the '70s: a convex half-sphere of New Zealand greenstone mounted in silver. It's nearly as big as his palm.

Hennah pointed out the gentle curve of the clasp and held up the round-linked

Dan Hennah displays his wife's Jens Hansen pendent and chain.

chain reminiscent of one owned by the Baggins family. (Hensen's workshop designed the Ring's chain as well.)

"The detail in his stuff was evident," he said.

The necklace looks like it weighs a ton, reflecting Hansen's commitment to substance as a style. Justine Olsen, curator of decorative arts and design at the Te Papa Tongarewa/Museum of New Zealand, told Polygon via email that "his practice was founded on a love of materials and process. But form defined his work."

"I use a hammer to bend metal where a jeweler would use pliers," Jens himself explained in a 1999 jewelry-exhibition catalogue. "This process is in itself a creator of bigger work with more fullness of form."

The One Ring he designed has that fullness, too. "It's needlessly heavy," Halfdan said. "But what it means is that when you hold it in your hands and feel the weight of it, or look at it on the screen, it has this big reflective surface, and it just has this brooding sense of power."

Of course, there was never just "one" Ring for the films. The first to appear on camera, in fact, didn't come from Hansen at all: It belonged to co-producer and additional unit director Rick Porras.

You can see it in the "Bag End Set Test" featurette from the extended edition DVD of *The Fellowship of the Ring*. The hobbit home's plywood shells had just been completed, and Peter Jackson wanted to check the set dimensions and test camera angles.

VFX cinematographer Brian Van't Hul was behind the camera, with Porras as Frodo, Jackson as Bilbo, and VFX producer Charlie McClellan as Gandalf (using a puppet head on a stick). But of the four men at this impromptu taping, Porras alone had a wedding ring, having married in March 1999. Bought in Wellington, the gold band had markings designed by Alan Lee, one of the trilogy's main conceptual artists and a longtime illustrator of Tolkien's work.

Porras told Polygon that it was actually the first time he'd ever taken the ring off, which he found "a little disconcerting" in the moment. All the same, he recognized the need for it. "It was a character," he said. "In those scenes, it's not just someone pulling it out of a pocket, but it's also holding it to camera, it's dropping it, it's then cutting to a close-up of it on the floor."

Close-ups of Porras's ring (now kept in a safe deposit box at an undisclosed location) from the set test show a ring almost identical in shape to that used in the films proper. While movie lore has presented Porras's ring as the original prototype for the One Ring, the timeline complicates this narrative.

In the extended edition extras, Jackson dates the Bag End set test to about a month before shooting began, or September

TIMELINE
2002

MARCH **11**
Dol Guldur assaults Lothlórien.

Denethor orders Faramir back to Osgiliath in a suicidal mission to shore up its defenses.

MARCH **12**
In the late evening hours, Gollum leads Frodo and Sam into Shelob's lair.

MARCH **13**
Aragorn captures the corsair fleet at Pelargir with the help of the Army of the Dead and releases them, their oath fulfilled.

With the close of Sauron's forces around the city, the Siege of Minas Tirith begins.

Riding in the retreat from Osgiliath, Faramir is wounded by a Nazgûl dart and brought to Minas Tirith in a state near death.

Shelob attacks Frodo and Sam, but Sam takes up the Phial of Galadriel and Sting and mortally wounds her. Thinking Frodo dead, Sam takes the Ring to bear it to Mount Doom alone. Frodo is captured and taken to Cirith Ungol.

1999. In the same commentary, Hennah confirms that he borrowed Porras's ring to show Jens during the design process. Yet Jens died on Aug. 10.

"It was definitely all done and dusted before our dad passed in August 1999," Halfdan confirmed via email after speaking to his brother Thorkild, who worked with his father at the time. Whatever the correct timeline and genealogy, two things are true: Porras's wedding band made a unique contribution to the history of the One Ring, and Jens himself developed the final version.

The production was lucky to have Hansen's direct involvement at all, since he lived only four months after his diagnosis. "His one big regret was that later in his life, he really felt like he was becoming a competent landscape painter in watercolors and oils," Halfdan remembered.

However, Hansen's lifelong generosity with his time and tools ensured that his jewelry artists—led by Thorkild—could execute his vision. "I choose to train people not necessarily to think like me but at least to understand what I am after," he explained in some literature accompanying a 1972 exhibition. (Halfdan worked overseas as an engineer until his father's illness required his return to manage the shop.)

The workshop produced approximately 40 different rings for the films. Most expensive were the 18-carat solid gold "hero" rings, sized 10 for Frodo's hand and 11 for the chain.

Tolkien's "*pure and solid gold*" description (my emphasis) in *The Fellowship of the Ring* works on paper but not in real life, as Halfdan explained. "Practically, 18k gold has probably got the right balance between the richness of the golden color and the durability," he said. In technical terms, the One Ring is closest to a comfort or court wedding band with rounded outer and inner surfaces.

To save money—though not time—the workshop used gold-plated sterling silver for most of the rings. Unlike the solid-gold heroes, though, these rings kept losing their luster. "We had to keep sending back the plated ones when they got scratched on rocks and things like that," Hennah said.

For many fans, the ring used in close-ups—like the scene where the Ring slips away from Frodo to lure Boromir in the snow at Caradhras, or when arguing participants in the Council of Elrond are shown reflected in the Ring's surface—is the real hero ring. In order to capture the ring's sheen in high definition, that prop was a full eight inches wide—too big even for Hansen's tools.

Instead, a local machine shop made and polished the shape that Hansen's team then plated. The polishing alone took about three days. "You have to have it highly polished, because gold plating is not like gold paint," Halfdan said. "It will show up any surface underneath." Aside

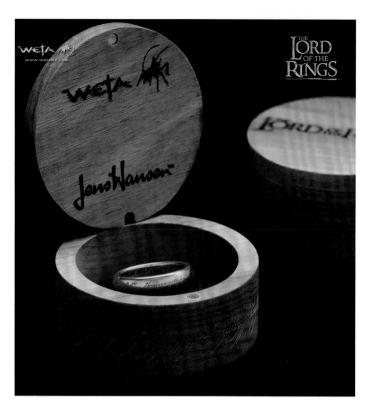

One of the many replicas of the One Ring available from the Jens Hansen workshop

used a lead ring to get that loud, hard thud.

Jens Hansen died before anyone had an inkling how successful the trilogy would become.

"Hindsight is 20/20," Halfdan said. "After we achieved the final thing that we wanted to make and we went with that, all of the other ones [the prototypes] were basically put into the shop, and half of them had sold by the time anybody stopped to think."

In the beginning, multiple companies sold unofficial ring replicas, and some still do. When Wētā regained the license for the One Ring from Warner Brothers in 2010, however, they asked Jens Hansen Gold & Silversmith to produce their official prop replicas.

Available in 18k gold-plated tungsten, sterling silver, 10k solid gold, and made-to-order 18k solid gold, these replicas contain the Tengwar markings. (Tungsten was chosen for its heft and for safety; in an emergency, it shatters easily for swift removal.) They come housed in a unique wooden box that displays the One Ring verse, the logos for Wētā and Jens Hansen, and the trilogy's title font.

Halfdan brought up a couple of common questions about the replicas to put them to rest. Customers often wonder why their rings have an "S10" stamp on the inside: that's the licensing symbol, not the ring's size. In addition, many wonder how the ring will look on their finger. No matter

from appearances at film premieres, the Big Ring sits in a display case in the Jens Hansen showroom, where visitors can hold it if time and COVID protocols permit.

As for the purported magnetized ring that Bilbo drops onto a magnetized floor, that rumor appears to have come from Dominic Monaghan, who mentions a magnetized floor in the Extended Edition's cast commentary. In his voiceover, though, VFX artist Brian Van't Hul insisted they just

MARCH **16**

The Last Debate of the Captains of the West: They resolve to draw the eye of Sauron to the Black Gate with their lives if necessary.

MARCH **18**

The Army of the West marches from Minas Tirith, bound for the Black Gate of Mordor.

Mistaken for deserters in their orcish clothing, Frodo and Sam are driven miles along with an orc company.

MARCH **17**

Frodo's cloak and mithril shirt, taken in Cirith Ungol, are brought to Barad-dur.

At the end of a three-day battle, the forces of Sauron besiege the citizens of Dale and Erebor within the Lonely Mountain. Kings Brand and Dain Ironfoot are slain.

the size, the width stays the same: 7mm. Halfdan likens it to buying two different sizes of the same shoe: "A lot of those identifying features—the size of the eyelets, the laces, the logos—they're all the same."

While the One Ring may be Jens Hansen's global legacy, evidence of his broader artistic impact on New Zealand art and culture appears throughout the island nation. "He introduced emerging jewelers and silversmiths to workshop methods and forms of modernism through the Danish lens," Olsen told Polygon. In 2004, the national museum Te Papa added some of his early pieces to their permanent collection.

Hansen also recruited and taught many next-generation jewelers and artists, through summer painting and sculpture classes at the local polytechnic, local workshop demonstrations, and offering bench space to any jeweler who asked. "During a period when formal [higher] education in jewelry was non-existent, Hansen's workshop became an attractive training ground," Olsen added.

As Hansen told the *Otago Daily News*

in 1995, "Most contemporary jewelers in the country have had some involvement with this place."

To keep Jens Hansen's personal vision alive, the workshop now produces the Legacy Collection, based on some of his earliest designs. "Once upon a time, we found a box of old 6-by-4-inch index cards that had all the original maker's notes," Halfdan said. "Every year, around about the anniversary of his birthday, we release a new piece."

"I think he was a singular artist," Hennah said. "New Zealand was very privileged that he came here."

If you want to read more about...

> *The secret crafts behind the* LOTR *movies, turn to page 23—"The First Note in* The Lord of the Rings *Has an Ancient History" (September)*

> *How the* LOTR *movies affected New Zealand, turn to page 221—"How Hobbiton Changed Life in Matamata, New Zealand" (Second October)*

MARCH **20**
Faramir and Éowyn meet in the Houses of Healing.

MARCH **24**
Sam and Frodo reach the foot of Mount Doom.

MARCH **27**
Sauron's forces are driven from Dale, breaking their siege on the Lonely Mountain.

MARCH **22**
Frodo and Sam leave the road and head overland on the final stretch to Mount Doom.

MARCH **25**
The Army of the West challenges Sauron at the Black Gate.

The Ring is destroyed.

Gandalf rescues Frodo and Sam from the slopes of Mount Doom.

MARCH **28**
Galadriel throws down the walls of Dol Guldur for the armies of Lorien.

CHAPTER EIGHT

APRIL:
FOOL OF
A TOOK

A DEFINITIVE GUIDE TO BEING THE MOST ANNOYING PERSON TO WATCH *THE LORD OF THE RINGS* WITH

FROM EXPERTS IN BEING ANNOYING TO WATCH *THE LORD OF THE RINGS* WITH

Susana Polo, Toussaint Egan, Austen Goslin

How do you share your love of all things Lord of the Rings? You could gently entice your friends and loved ones to watch the films with you, or read aloud the books. You could schedule cozy marathons with friends who are already hooked on the story of Frodo Baggins and the One Ring.

But even then . . . how will you ever know that they're enjoying the movies on the same level that you are? Will they know how much Sean Bean hated helicopters? Will they know how long it took to film the scene where all the hobbits say goodbye? I ask you, *Will they know that Viggo Mortensen really broke his real toe kicking that helmet for real?*

They will if you are constantly spouting facts about the movies during their runtime. This is Polygon's guide to being a very annoying person to watch the *Lord of the Rings* trilogy with, compiled by Polygon's Toussaint Egan, Austen Goslin, and Susana Polo, all of whom admit to occasionally being very annoying to watch the *Lord of the Rings* trilogy with. We've arranged our facts in the

order they come up in the movies, and even provided suggestions of things to say for *maximum annoyance*. (Which version of the movies? The Extended Editions, obviously.)

Frankly, we even annoyed ourselves putting this together. We're not proud. This article is a cursed object, and should be handled with care. Look, if this is how you watch *The Lord of the Rings*, that's *fine*. But you should probably only watch it with people who are also like this.

People like us.

THE FELLOWSHIP OF THE RING

"They did this scene with forced perspective." The first good example is Frodo sitting on the cart with Gandalf, but you can bring this up almost any time a short-looking person is on-screen with a tall-looking person.

"Hey, those are Peter Jackson's kids!" Those are Peter Jackson's kids.

"Watch, Gandalf hits his head on Bilbo's ceiling beam." Ian McKellen actually hit his head on the ceiling beam.

Extra Christopher Lee Facts

Feel free to pepper these in whenever Saruman appears:

✵ Christopher Lee was so confident he would be cast as Gandalf that he was a little miffed to be asked to play Saruman.

✵ Christopher Lee helped the makeup department to make sure everything looked right.

✵ Christopher Lee read the *LotR* books once a year.

✵ Christopher Lee corrected people on set when they made minor mistakes.

"Christopher Lee was a huge *Lord of the Rings* **nerd."** Christopher Lee was the only member of the cast who had personally met J.R.R. Tolkien, and he could recite the Ring poem from memory in the Black Speech of Mordor, just so you know.

"That's Peter Jackson." The guy in the streets of Bree with the carrot is Peter Jackson.

"Daniel Day Lewis was the first choice to play Aragorn." When Aragorn shows up in the Prancing Pony, well, that could have been Daniel Day Lewis.

"Viggo Mortensen actually threw that apple." Viggo was actually the one throwing apples at Billy Boyd's head.

"Can you believe this is the first scene Viggo Mortensen filmed?" The Weathertop Battle against the Ringwraiths was the first thing Viggo filmed.

"Arwen's double actually owns that horse now." Arwen's riding double loved that horse so much that Viggo Mortensen bought him for her at the end of production so she could keep him (page 122). Liv Tyler also accidentally stabbed herself during this scene in one of the outtakes.

"John Rhys-Davies is actually that much taller than the hobbit actors." John Rhys-Davies is so tall and all the hobbit actors are so short that in wide shots of Gimli and the hobbits (which are admittedly few), they didn't need to size doubles or CGI.

"Hey, that's the name of the movie." Elrond says, "The Fellowship of the Ring."

"Composer Howard Shore used a lot of leitmotif in the soundtrack." Leitmotif, or the use of specific musical phrases to accompany recurring characters or themes, was popularized by the composer Wagner, which is ironic because Tolkien bore a personal grudge against Wagner for creating a very popular adaptation of one of his favorite subjects, Norse mythology, which he considered to be inaccurate.

"Look, Legolas is walking on the snow." When they're crossing the Pass of Caradhras, Legolas walks on top of the snow while everyone else is in it.

"Did you know that Sean Bean hates helicopters?" Sean Bean hated riding in a helicopter so much that he would get

up extra early to go through makeup and costuming and then hike to mountain locations every day in his full Boromir getup.

"Look really closely at Galadriel's eyes, though." They set up a special light rig just for Cate Blanchett's closeups to give her the appearance of having stars reflected in her eyes.

"Gosh, this scene is so sad, but did you know they had to break for lunch in the middle?" Viggo Mortensen and Sean Bean filmed Bean's death scene twice, to catch each side of their closeups, with a lunch break in between.

"Viggo Mortenson is really good with swords." The knife that Lurtz throws at Viggo is real and Viggo really deflected it with his sword. Viggo wore his sword with him everywhere during filming and was apparently one of the best people the movie's sword master ever trained.

THE TWO TOWERS

"Every single actor in this scene is injured." When they filmed the shots of Aragorn, Legolas, and Gimli chasing the orc company, Orlando Bloom had a broken rib, Viggo Mortenson had a broken toe, and Gimli's size double Brett Beattie had chronic knee problems.

"Brad Dourif had to shave his eyebrows to be Wormtongue and he hated it." Brad Dourif had to shave his eyebrows, and he hated it.

"Most of the Riders of Rohan are played by women." When the production put out a call for extras who could bring their own horses, the majority of the applicants they got were women, so most of the Rohirrim in any given scene are actually ladies with spirit gum beards.

"Did you know that Viggo Mortensen broke his toe here?" Viggo Mortensen broke his toe filming this scene. Peter Jackson wanted him to kick the helmet close to the camera, but he kept missing. In the final shot he kicked a real metal helmet instead of the prop one and fell over screaming. Peter Jackson was, like, "Wow, Viggo really got into that one," but he'd actually broken his toe. The shot was so good, they kept it in the movie. We just watched Viggo Mortensen break his toe for real.

"If you think Aragorn's age is weird, look up Frodo!" Bring up a character's age that isn't stated in the movie. Denethor is only one year older than Aragorn. Boromir is 41. Frodo is 51, Sam is 39, and Merry is 37. Hobbits come of age at 33, so Pippin, at 29, is technically a teenager. Gimli is 140. Eomer and Éowyn are 28 and 24, respectively.

"They had to use CGI to put Legolas on that horse because Orlando Bloom was injured." Orlando Bloom fell off a horse and cracked a rib, and was unable to perform a stunt of leaping onto a running horse, so the production substituted a CGI double doing a bizarre flip.

APRIL **06**

Celeborn and Thranduil meet at the center of Mirkwood to commemorate cleansing the forest of Sauron's corruption for good. They rename it Eryn Lasgalen, the Wood of Greenleaves.

APRIL **08**

The Ring-bearers awake, and are honored on the Field of Cormallen.

TIMELINE
2002

"**Treebeard and Gimli are played by the same guy.**" John Rhys-Davies voices Treebeard.

"**That's screenwriter Philippa Boyens' kid.**" When Aragorn tells that blonde kid that he has a good sword? That's screenwriter Philippa Boyens' kid.

"**Did you know it was originally going to be Arwen, here?** Arwen was originally going to lead the elf forces at Helm's Deep, not Haldir.

"**That's Peter Jackson's kid.**" That kid in the Helm's Deep caves who looks just like one of those hobbits played by Peter Jackson's kids? That's Peter Jackson's kid.

THE RETURN OF THE KING

"**Christopher Lee knew what it sounded like when you stab someone in the lungs.**" Peter Jackson asked Christopher Lee to yell when Wormtongue stabbed him, and Lee, who served in Royal Air Force intelligence during World War II and was for some time tasked with tracking down and interrogating Nazi war criminals, explained that when you stab a man in the lungs he cannot scream.

"**That's Jed Brophy's son.**" When Arwen has a vision of her and Aragorn's son, he's played by the kid of orc-stuntman (and the actor behind the dwarf Nori in the Hobbit films) Jed Brophy.

"**Those are Peter Jackson's kids.**" The sad kids watching Faramir leave who look just like the hobbit kids in Fellowship are Peter Jackson's kids.

"**That's Peter Jackson.**" The pirate that Legolas shoots is Peter Jackson.

"**Did you know that Peter Jackson is terrified of spiders?**" Peter Jackson is terrified of spiders and disliked having to design Shelob.

"**The design of the destruction of Barad-dûr was influenced by 9/11.**" The destruction of Barad-dûr, the sick-lookin' fortress of the dark lord Sauron with the giant honkin' fireball eye at the top, was deliberately designed to not invoke comparisons to 9/11, going so far as to have the tower being destroyed by a magical shockwave from the middle of the tower instead from the top down and simulating the sound of the tower's destruction with broken glass.

"**Viggo Mortensen composed this melody himself.**" The lyrics are a quote from Elendil, the first king of Gondor, that Tolkien wrote in The Lord of the Rings, but Mortensen set it to music himself for Aragorn's coronation scene.

"**The hobbit actors had to cry for three days for this scene.**" Because of a series of on-set accidents (cameras going unfocused for a whole shoot and Sean Astin forgetting to put his waistcoat back on after a lunch break), the hobbit actors had to film their entire goodbye scene three times—three straight days of crying for the camera.

"**That's Sean Astin's daughter.**" Sam and Rosie's oldest kid is played by Sean Astin's daughter.

If you want to read more about…

> *How to watch the Lord of the Rings movies, turn to page 48—"Everybody Loves the Least Definitive versions of the Lord of the Rings Movies" (November)*

> *The joy of rewatching LotR, turn to page 56—"The Ecstasy of Seeing The Lord of the Rings in Theaters in 2021" (November)*

THE LORD OF THE RINGS WASN'T A HORSE GIRL STORY UNTIL PETER JACKSON MADE IT ONE

DON'T DE'NEIGH THE TRUTH

Susana Polo

J.R.R. Tolkien's *The Lord of the Rings* built the foundation of the modern fantasy genre. Dwarves, elves, orcs, wizards, kings, warriors, quests, dungeons, and yes, even dragons. But you know what it doesn't have?

Even one single goddamn unicorn.

Though the three books in the *Lord of the Rings* trilogy have some fancy horses, and even a very prominent horse-loving girl, it never quite puts the pieces of a Horse Girl story together—because Horse Girl stories aren't just about horses and girls.

They are a romantic fantasy genre of their own, about unbreakable, tantamount-to-psychic bonds between a wild or unruly or simply misunderstood animal and the one special person who takes the time to earn its trust.

Unfortunately, J.R.R. Tolkien was no Horse Girl. Fortunately, Philippa Boyens, Peter Jackson, Fran Walsh, Viggo Mortensen, horse trainer Jane Abbot, and a small legion of local New Zealand equestrians changed all of that forever.

THE LORD OF THE RINGS IS NEITHER HORSE-Y NOR GIRL-Y

It may seem strange to say that *The Lord of the Rings* lacks sufficient horse content, considering the actual text. Yes, it is indisputable that Shadowfax is a cool-ass horse. He's descended in a direct line from Felaróf, the steed of Eorl the Young—the first king of Rohan—who, legend tells us, was able to understand the speech of men. That makes Shadowfax one of the Mearas, an ancestral line of Rohanian equines who are said to be like to horses as elves are like to men, and may only be ridden by a king of Rohan.

On top of all that, even the greatest of Rohan's riders considered Shadowfax to be untamable, until Théoden (under Grima's manipulations) ordered Gandalf to take any horse in the kingdom if he would only leave Rohan as soon as possible—no one expected the old wizard to trot away on the best horse in the country.

But here's how Tolkien has Gandalf describe the most sacred tenet of the Horse

Girl story, the golden and beautiful moment when a wild horse bestows a priceless gift—its trust—on a special person:

"Never before had any man mounted him, but I took him and I tamed him . . ."

That's it. That's the whole description.

Shadowfax is extremely cool—but he is really just a very fancy, wizard-only fast-travel system, an answer to the problem Tolkien faced when he realized that Gandalf needed to get from one end of his carefully planned map to the other in a completely unrealistic time frame.

So, Gandalf is surely no Horse Girl, but what about Éowyn? Éowyn is a girl, and as the princess (OK, the niece of a king) of an entire Horse Girl nation, she is closely associated with horses. However, the books do not show her in a strong bond with any particular equine, making Éowyn's Horse Girl status a purely semantic one. Windfola, the steed she rides to the Battle of the Pelennor Fields, went mad with fear the moment the Witch-king of Angmar arrived, threw both his riders, and bolted not just away but out of the story entirely.

The biggest Horse Girl Energy in *The Lord of the Rings* is Sam's relationship with Bill the Pony, who he nurses back to health after Frodo purchases Bill from a cruel master for much more than his actual worth. The underestimated and undervalued horse who just needs a special person (i.e., the main character) to reveal their true talent is perhaps the second-most-common trope of the Horse Girl story. (Why, yes, you *can* view most Horse Girl tropes as Gothic Romance on training wheels.) But while Bill and Sam do reunite in the end, the Fellowship sets him free before they enter Moria and he isn't seen again for hundreds of pages.

There simply aren't enough horses or enough people who form strong bonds with them in *The Lord of the Rings* for it

to truly be Horse Girl culture. But that's not to say that folks who were *both* Horse Girls and *Lord of the Rings* fans weren't excited about *The Two Towers* hitting theaters in 2002. If memory serves, I stitched a white horse to a green tank top to wear to the theater, a sartorial interpretation of the banner of Rohan.

And the people in the center of the Horse Girl and *The Lord of the Rings* Venn diagram were rewarded. The transformative power of cinema made Tolkien's masterpiece into Horse Girl catnip.

ARAGORN ♥ BREGO 5EVA

The Two Towers served up a great horse/human romance: Aragorn and Brego.

You won't find a horse called Brego anywhere in Tolkien's *The Lord of the Rings*. In the books, Eomer loans Aragorn, Legolas, and Gimli two horses, but the steeds are named Hasufel and Arod. Aragorn gives Hasufel back to the Rohirrim a book later, when Elrond's sons show up shortly after the Battle of Helm's Deep with (among other things) Aragorn's actual horse, Roheryn.

Aragorn and Brego were an invention for the screen, a bit of plot logic necessary to one of the trilogy's weirder detours from the actual story of the *Lord of the Rings* books. *The Two Towers* has a tangent in which Aragorn is presumed dead after a fight with some warg riders and drifts down a river on his back while either vividly hallucinating, or psychically conducting, a conversation with Arwen. When he reaches shore, he is found by loyal Brego, the only creature in the world who had faith that he was still alive. Brego gently, tenderly lies down next to him, encourages him to mount up, and then ferries him back to the plot.

Now, in the scope of Horse Girl Media, Aragorn and Brego are at the

same level as Sam and Bill the Pony—it's definitely *there*, but it's not the driving force of the experience. However, Peter Jackson's *The Lord of the Rings* isn't just about what's in the movies. It's about what's in the Extended Editions. It's about who *made* the movies.

This isn't just about Aragorn and Brego. It's about Jane and Florian. It's about Viggo and Uraeus. It's about women wearing beards and deleted scenes of horse romance.

This is the most important thing that the *Lord of the Rings* films taught Horse Girls:

Viggo Mortensen is a giant Horse Girl.

Fans who were drawn in by Horse Girl Aragorn and the opportunity to ogle many, many pretty horses running fast—whether it was Arwen's steed, Asfaloth, horses made of water, or the steeds of the Rohirrim—did what any fans of the *Lord of the Rings* movies did.

They dove into the extensive and entertaining suite of special features on the DVD editions of the movies, and discovered a hidden treasure trove of information that retroactively imbues the *Lord of the Rings* movies with Horse Girl Content.

Here's the thing to know about this: Actor Viggo Mortensen is absolutely gaga for horses, and it is obvious in every single scene he shares with the animals. Find any shot in the movie where Aragorn is looking at his horse and you'll find Mortensen playing him like he is one hard cut away from making out with it.

The Extended Edition of *The Two Towers* only double down on Aragorn's relationship with his steed, by revealing Brego's *tragic backstory*. In the Extended Editions, we meet Brego in the stables of Edoras, absolutely wilding out on the two hardened Rohirrim trying to bring him

under control. Yet it only takes Aragorn a few gently whispered sentences of Elvish to calm the savage beast.

That's when Éowyn drops the Brego exposition: He is the steed of her cousin Theodred, the prince of Rohan, who was killed just days ago in a clash with Saruman's forces. That's why Brego is flipping out! This horse has trauma! He is GRIEVING!!!!!!

But rather than claim Brego for his own, Aragorn knows that if you love something, you'll set it free. He tells the warriors to turn Brego out on the beautiful plains of Rohan, saying, "He"—meaning the horse whose young master was cruelly slain—"has seen enough."

The very next time we see Brego, he's nudging Aragorn back to consciousness as the king-in-waiting washes up on a pebbly shore. How did Brego know where Aragorn was? How did he even know he was in danger? Psychic Horse Girl connection, baby!

Just like his character, Mortensen apparently had something of a way with horses on set. Asking a half-ton animal to lie down inches from the actual face of your film franchise's face isn't any crew's idea of a good time. But as the folks behind the camera sweated their way through the scene where Brego coaxes a wounded Aragorn onto his back, Mortensen's trust was rewarded with the shots we see in *The Two Towers*.

The actor so adored the horses he worked with on set that he bought three of them, and became friends with Jane Abbott, stunt rider and horse trainer on the production. As a part of the Horse Department, Abbot was tasked with helping to turn a handful of inexperienced animals purchased for bargain prices into actors that traveled well, wore odd costumes, and could execute commands

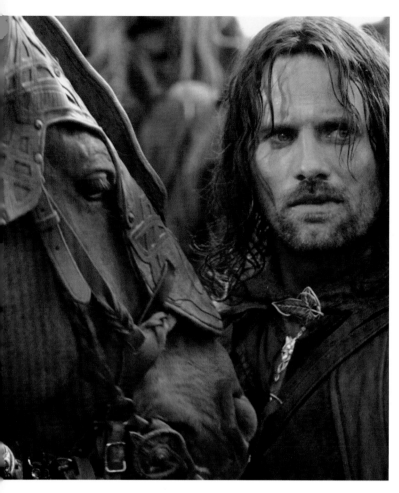

actor, he was now worth more money than she could afford to give. That is, until Viggo Mortensen purchased Florian and gave him to her. The person who forms a strong bond with a horse they cannot afford and then through deus ex machina gets to own that horse anyway? This is also a quintessential story arc of the Horse Girl canon.

So Viggo Mortensen isn't just an honorary Horse Girl. He's a Horse Girl ally.

HORSE GIRLS BUILT THE *LORD OF THE RINGS* MOVIES

Did you know that when you put out a casting call for New Zealand extras who own their own horses and are willing to camp out overnight for the chance to be in a *Lord of the Rings* movie, you wind up with a lot of women?

Boom. Hey, *The Lord of the Rings*–loving Horse Girls? Basically any horse-riding Rohirrim extra is more likely to be a Horse Girl than not. Given the amount of time that waves of Rohirrim pour over the screen during *The Two Towers* and *The Return of the King*, that's a significant increase in girlyness compared to Tolkien's original work.

Just like *The Lord of the Rings*, a Horse Girl story uses a hefty dollop of fantasy to get going. But it took real horses and real horse-loving people on the production of the movies to transform Tolkien's text into a pillar of Horse Girl culture.

in the face of yelling crowds, heavily costumed riders, smoke, rain, flaming torches, and every other strange thing that might crop up on a film set.

She was also one of two riding stunt doubles for Arwen, and in the process fell head over heels in love with Florian, the Andalusian/Lipizzaner–mix stallion that played Asfaloth in *The Fellowship of the Ring*. "He's the dream horse," she told New Zealand's *Scoop Independent News* in 2001, "every little girl's dream horse to play with and have fun."

Unfortunately, she knew she would have to part with him at the end of production, since, as a fully trained animal

If you want to read more about...

> *Horses, turn to page 216—"An Investigation of How Legolas Got on That Horse That One Time" (Second October)*

> *Aragorn's ineffable appeal, turn to page 38—"In Praise of Aragorn, the Most Well-Rounded Sex Symbol in Middle (or Any) Earth" (October)*

LEGOLAS' DUMB, PERFECT FACES ARE THE KEY TO HIS WHOLE CHARACTER

GIVE ORLANDO BLOOM AN OSCAR

Susana Polo

It's easy to find screenshots of Orlando Bloom making strange facial expressions in the *Lord of the Rings* trilogy. In fact, it's practically a meme. And even if you strip out all the examples that are fleeting mid-movement expressions, or that are actually from Orlando Bloom goofing around in his Legolas gear in behind-the-scenes footage, you still wind up with a lot of very strange expressions from our blond elf friend.

Then there are the line reads. Sentences like "A red sun rises. Blood has been spilled this night," delivered with intensity and a straight face. The Legolas of Peter Jackson's trilogy gives off the vibes of That One Weird Kid, someone who seems perpetually surprised by whatever is going on around him—but also with a layer of curiosity, perhaps even amusement. He projects a sense that he's aloof from whatever is going on, and that he has absolutely no idea what is going on.

Many would argue that this was just Bloom's natural bewilderedness, from being cast in his first major film production two days after graduating from drama school. That read might be true, but it's also a perfect read on J.R.R. Tolkien's

Legolas, who is paradoxically very old and very young, and has never been anywhere or met anyone in his life.

LEGOLAS IS A NICE COUNTRY BOY

In one of the earliest shots we see of Legolas, he's hopping off a horse in Rivendell, looking around like he's never seen fancy elves before. This is because he hasn't. He's from a society of, in a nutshell, the least fancy elves on Middle-earth.

This might sound strange, because of how Peter Jackson's *The Hobbit* movies showed us that Legolas' dad wears gold brocade and rides a fully pointed elk into battle, but the elves of Mirkwood are the least ethereal variety you can find in the time of the War of the Ring. Elrond and Galadriel's people have lived a life much closer to Middle-earth's gods than Legolas', and it shows in their manner, dress, and architecture.

On top of that, Legolas' father, Thranduil, is an isolationist ruler. His people are sequestered in a dangerous forest, and they simply do not get out much or welcome many visitors. Legolas is the elven equivalent of a kid who grew up without cable TV, pop music, or meeting anyone his

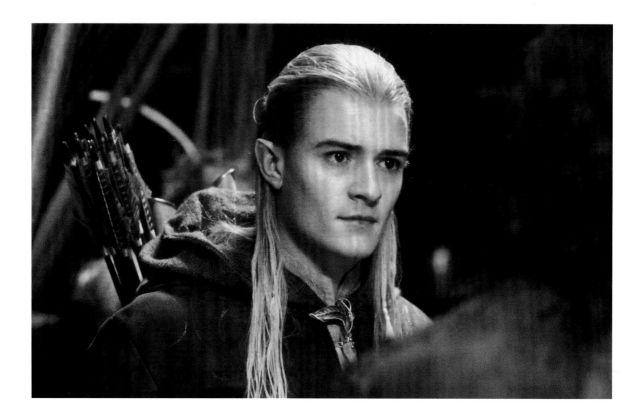

parents didn't know by name. Like the rest of the Fellowship, he joined the Ring Quest mostly because he was a capable person who happened to be in Rivendell when the group was being assembled, not because he was already a great hero.

LEGOLAS IS BABY

Another of Legolas' most-memed lines is when he walks into an obviously very old forest and says with confidence and relish that . . . it's old. Contrast this moment with the full line from Tolkien's *The Two Towers*: "[Fangorn] is old, very old. [. . .] So old that almost I feel young again, as I have not felt since I journeyed with you children."

Legolas, you see, is accustomed to being the youngest guy in the room. Tolkien was never specific on his age, but since Legolas has never been to Lothlórien before the Fellowship visits, we can say he was probably born after

the shadow in Mirkwood grew so dangerous that travel was cut off between Thranduil's and Galadriel's kingdoms. That was about two thousand years ago. For context, Legolas' dad was alive during the First Age, which could make him up to *ten* thousand years old.

This is the dichotomy of Legolas: To humans, he is unfathomably old. But for an elf, he is a teeny, tiny baby with no life experience who has never left home before. And he is *always* going to be a teeny, tiny baby—a prince who will never be a king—because elves don't die.

LEGOLAS CANNOT BE KILLED IN A WAY THAT MATTERS

Orlando Bloom's line reads for Legolas might make you feel like everyone around him should be looking at each other with the international facial expression for "Is this guy for real?" But when the tomb in

which his friends' bones are buried is rendered to sand by the elements, Legolas will still be sitting on that beach, drinking wine.

In a very real way, almost nothing that occurs around Legolas carries any weight for him. Elves can be killed, but they cannot *truly* die. Death neither cuts an elf off from their loved ones forever, nor prevents them from returning to Middle-earth (page 152).

Legolas has absolutely no personal experience with death, and this arena is where the choices Bloom made for Legolas become pitch-perfect. When the Fellowship exits Moria and, to a man, collapses in tears, weeping for their fallen leader, Legolas just looks *confused*. He wanders among his sobbing companions like one on an alien planet, almost smiling nervously.

This is a man who has *literally* never known someone who died before. He has no idea what the people around him are doing, much less whether he should be doing it too. In a reaction shot of Legolas coming upon Aragorn and Boromir's touching final moments together, his face takes on a cast of sadness, but it's more like he's watching a parent comfort a kid with a skinned knee than someone observing a dying friend. It's almost as if he's playing along with a cultural practice not his own—"Ohhh, they're doing that thing humans do, what's it called . . . ? 'Dying?'"

The most heightened emotion Legolas shows in the whole trilogy might be when he argues with Aragorn about the wisdom of making a stand at Helm's Deep. "Three hundred against ten thousand? Aragorn, they cannot win this fight. They are all going to die!"

It bothers him deeply that all these already short-lived people—including his closest friends—would accept their mortality. It's as if he wants to grab Aragorn by the collar and go, "Don't you know that if you die in real life, you'll die in real life?????"

From sheer confusion over Gandalf's demise to Helm's Deep to the moment in *The Return of the King* when Legolas smiles at the idea of dying side by side with a dwarf, his education on the nature of mortality might be the closest thing he has to a not-Gimli-related story arc.

Philippa Boyens, Peter Jackson, and Fran Walsh didn't have time to unpack any of this—the workings of elven immortality, Legolas' upbringing, his age—in the script of the *Lord of the Rings* trilogy. There's too much to do, and the elf is too minor a character. (Even Tolkien himself passingly noted, in an essay otherwise entirely about wizards, that Legolas "probably achieved the least" of the nine members of the Fellowship. Devastating.)

But they didn't leave it on the cutting room floor, either. Peter Jackson depends almost entirely on Bloom's acting—his disoriented facial expressions and earnest intonation—to communicate all of these ideas. Bloom's face conveys a paradoxical attachment and detachment. He's attached to the mortals he's grown close to, but fundamentally detached from the mortal world as they understand it. Sometimes, the best way to play an aloof, ethereal being is to just look like a total weirdo.

If you want to read more about...

> Legolas' appeal, turn to page 138—"Confessions of a Former Legolas Fangirl" (May)

> THAT Legolas moment, turn to page 216—"An Investigation of How Legolas Got on That Horse That One Time" (Second October)

CHAPTER NINE

MAY: ONLINE CULTURE AND "NERDS"

THE *LORD OF THE RINGS* MOVIES HERALDED THE FINAL END OF "NERD STUFF"

AND WHEN EVERYONE'S NERDY . . . NO ONE WILL BE

Susana Polo

It was still the age of the webring . . .

In December of 2002, I knew one thing: The things I liked were not cool, and almost nobody wanted to hear about them. Star Trek? Not cool. Batman? That's for babies. Which is why it was so personally terrifying when a girl—a, like, normal girl with deliberately chosen clothes, hair, and makeup—stuck her head around the changing room lockers after gym and yelled in my direction "HEY! That new *Lord of the Rings* movie coming out this week?"

I must stress that she and I had never spoken before—my high school had a couple thousand students in it—and we never spoke again. She had simply looked at me and thought: "*That* girl knows the release date of *The Two Towers* off the top of her head." I stammered an affirmative response and she disappeared around the lockers, leaving me alone and half-clothed, in the wreckage of an instant, precise, and devastating read on my *entire deal as a person.*

I've never really gotten over it, but it serves as a perfect encapsulation of how deeply Peter Jackson's *The Lord of the Rings* trilogy penetrated the mainstream consciousness, and how quickly—despite everything else going on in the world at the end of 2001. The movies' $3 billion gross (in early-2000s money) served as a first and unheeded warning that "niche" interests could dominate mass entertainment, a death knell for the nerd as subculture rather than simply "culture."

The *Lord of the Rings* movies were a decade too early to be the final nail in the coffin, not because of anything wrong with them, but because of a lack of cultural infrastructure. Middle-earth was ready for the big time, but nobody else was. Not nerds, and especially not normies.

A TIME WHEN *THE LORD OF THE RINGS* WAS INDISTINGUISHABLE FROM POKÉMON

It can be difficult to remember how obscure J.R.R. Tolkien's *The Lord of the Rings* was before the Peter Jackson trilogy, but here's an example:

On a November 1999 episode of *Who Wants to Be a Millionaire?*, contestant Toby Moore was asked, for $500,000, to pick which of four choices was not a Pokémon. After much deliberation, and using his 50/50 lifeline, he chose to forfeit rather than risk his $250,000 pot, ending his run. The correct choice and only non-Pokémon name was "B: Frodo." Three

years later, a complete stranger was casually yelling at me about *The Two Towers*.

Even during its early-2000s rollout, when poor Toby's Pokémon question would have been worth $2,000 at most, the *Lord of the Rings* trilogy was shockingly inaccessible compared to today's nerd blockbusters, because the cultural infrastructure that underpins those blockbusters didn't yet exist. If a movie fan wanted to know a bit more about Gandalf—or even how many movies were on the way and when—it's not like they'd see the answer pop up in Google News.

It was still the age of the webring, with Google Inc. getting its free, ad-supported search engine off the ground as the trilogy went into production in New Zealand. When *The Fellowship of the Ring* hit theaters, Wikipedia was less than a year old. YouTube didn't exist; if you wanted to rewatch a trailer, you went to apple.com/trailers and waited for a Flash-based Quicktime movie to buffer.

In more ways than one, you could not simply walk into Mordor. It's not that today's mainstreamed nerd interests are more engaging than the *Lord of the Rings* trilogy—it's that everything about them is more accessible. Jackson's films arrived just as the internet and mobile tech were *starting* to make it more possible than ever to get into stuff. But it was still the era of panicking when you accidentally pressed the button that made your flip phone open its—and I use this term loosely—"internet browser."

Indeed, "nerd stuff" is now almost impossible to escape, as the internet becomes a gateway to answering the questions of the girl in the locker room. Google aggregates countless assiduously maintained fan wikis. Entertainment media outlets play to the almighty algorithm to bolster their own audience. Fan communities are no longer insular pockets you have to go find, but trending social media hashtags surfaced to you whether you're looking for them or not. The "niche" now dominates the mainstream so completely that the fact that Netflix advertises its genre content with an event called Geeked Week feels quaint and cringe. Who would call someone a geek for watching *Stranger Things*?

AND IT'S BETTER THIS WAY

When I was reading Tolkien's work for the first time, there were no wikis, no meme culture to engage in, no communities that I wasn't far too shy to engage with. As far as I was aware, the things I liked were not cool, and nobody wanted to hear about them.

Fandom via social media has a lot of problems, but accessibility is not one of them. Easier access to fan communities has given a far greater diversity of people a voice in fan discussions, allowed more people to discover art that truly moves them, and normalized the love of genre fiction.

That accessibility has led to its own rise in gatekeeping—accusations of "fake nerd girl" or "casual" as a way of denigrating those who are perceived as having only jumped on the bandwagon now that a thing is popular, or have had an easier path to their interests than those who came before. Which is bullshit, of course. People should be able to read *The Silmarillion* and then immediately go on Tumblr and discover the thriving community of fanartists who like to draw Morgoth and Sauron kissing. It's a better way.

If there's any cultural point to glean from the impact of the last 10-plus years of Marvel Cinematic Universe storytelling, it's that "nerd" stories are actually universal stories, and their relegation to niche entertainment is rooted in format, not their fantastical focus and silly costumes.

The story of Spider-Man is the story of Spider-Man is the story of Spider-Man, and so long as it is told well and earnestly, it will find an audience.

A decade before the MCU explosion, Jackson's *Rings* trilogy took that assumption as given. He and his collaborators never winked, shrugged, or made jokes at the expense of their own theatricality, despite their commitment to the spirit of Tolkien's work nearly costing them the job (page 210). The saga simply unfolded itself in front of an unready audience, and Jackson was confident that the operatic romance of J.R.R. Tolkien's series was enthralling enough on its own. The production refused to hold the viewer's hand, never explaining exactly what a wizard is, or how elven immortality works, and leaving wide-open "plot holes."

If you weren't up for that reality, well, the theater exit was right over there. But if you were, there were very few avenues available if you were not already inside existing fan spaces. After all, when the standard way to buy movie tickets is to dial up the Moviefone robot on a touch-tone phone, yelling at a nerdy-looking kid across the room also seems like a pretty efficient option.

When "niche" culture goes mainstream, you don't have to find people to talk about it anymore—the modern internet will find *you*. The *Lord of the Rings* trilogy was ready-made for the new accessible fandom of the new mainstreamed geek. We just weren't quite ready for it.

The death of the "nerd" has been a long time coming, but it didn't come fast enough for that girl in my high school locker room. I hope she got to see *The Two Towers* on opening week. I hope she still likes the *Lord of the Rings* movies. But I can rest assured that cool girls no longer have to use my nerd ass as their own personal Siri.

They can google it and find one of my articles instead.

If you want to read more about...

> Online culture in 2001, turn to page 62—"The Lord of the Rings *Comes from a Time When Fans Were Online, but Hollywood Was Not*" (December)

> Tolkien fandom in 2001, turn to page 30—"I Wore Arwen's Dress to Prom Thanks to a Welcoming Lord of the Rings Fandom" (October)

┌ MAY **01**

Elrond and Arwen set out from Rivendell for Minas Tirith.

In Minas Tirith, Aragorn is crowned Elessar, the first high king of the Reunited Kingdom.

┌ MAY **08**

Eomer and Éowyn depart Minas Tirith for Rohan.

TIMELINE
2002

THE LORD OF THE RINGS' 20-YEAR-OLD DVD SET IS ABSOLUTELY THRIVING ON TIKTOK

THE EXTENDED EDITIONS STILL DRAW 'EM IN

Liz Anderson

The Fellowship of the Ring hit theaters on Dec. 18, 2001. But there might be an even more important anniversary for fans who love the movie: Nov. 12, 2002. That, of course, is when the *Fellowship of the Ring: Special Extended Edition* DVD box set hit stores.

Followed by the *Two Towers* and the *Return of the King* box sets, the *Lord of the Rings* trilogy's catalog of extra content mirrored the films themselves: a massive effort by hundreds of creatives, finally getting the thorough documentation they deserved. The final tally marked a full 43 documentaries, nine image galleries, 12 commentary tracks, dozens of interactive maps, featurettes, original art, and anywhere from 30 to 50 minutes' worth of additional footage added to each Extended Edition cut of the films.

That was 20 years ago, but the story of the making of Peter Jackson's *The Lord of the Rings* trilogy is still being told. On TikTok, sketches, memes, and viral audio clips reference content you would only find if you spent long hours poring over every cast interview and armor schematic available on the Special Edition discs. Right down to "Do you wear wigs?" memes on your For You Page. And as prolific creators

of TolkienTok—that is, the Tolkien-loving TikTok community—tell Polygon, the audience's relationship to the Extended Edition DVDs is changing the way the Tolkien fandom communicates.

Ultraspecific content delivery is, of course, TikTok working as intended. But in an ironic way, that community-based targeting can sometimes be quite isolating. What appears to be trending audio may actually just be 20 videos that TikTok has hand-delivered to you and only you, pushing you ever deeper into the hole in the social media mountainside that's just your size.

But "*Lord of the Rings* Watch Party Hotline," a video by Don Marshall (aka "Obscure *LotR* Facts Guy") is a bona fide TikTok success, in and outside of TolkienTok. In it, Marshall acts as a kindly representative of a collect-call service that gives *LotR* superfans a safe place to spew fun facts about the films to him instead of their unsuspecting normie friends.

"You want to tell them?" Marshall pretends to say comfortingly into a phone, pausing for response from a fictitious caller. "Yeah, we get calls like this all the time. Let me walk you through this, don't worry, I've handled this a bunch [. . . .]

Here's what you can do. You can either tell me, or we can walk through this together on why you shouldn't say it; it's a practice in self-control."

Marshall recalls originally writing the bit with a specific scene in mind: the classic "Did you know?" fun fact from *The Two Towers*, which includes actual footage of Viggo Mortensen breaking two toes after kicking a helmet in acting out Aragorn's grief. The impulse to announce "Viggo actually broke his toe there" is well-memed within the fandom, to the point where Marshall actually rewrote the original idea to make it not so specifically about Mortensen's injury. This ultimately made the video much more shareable—some duets made with it have racked up views in the millions. With dozens upon dozens of enthusiasts quoting different film facts into Marshall's careful pauses, the video became a collective nerd release valve in action.

The best thing I think about TikTok is how universal something can be, even if it is so specific.

"I think my family and I spent collectively more time watching the behind-the-scenes of those movies than any other medium of entertainment in the 2000s," Marshall recalls. He notes that the Extended Editions, in a way, are perfectly suited to TikTok's quick-bite-info/storytelling sensibilities: "So many people look at things like the costumes, and say, 'They're so intricate,' but half of the things you don't even see." You don't need to be an existing fan to be interested in intimate details.

"The best thing I think about TikTok is how universal something can be, even if it *is* so specific."

An infamous video of Dominic Monaghan pranking Elijah Wood during the press tour for *The Return of the King* is something of a niche joke among film fans, available only in a hidden button on the Extended DVD set. But when "Do you wear wigs?" was uploaded to TikTok for modern fans to enjoy, the audio morphed into a meme format, used generally as shorthand for "Do you ___?" "No I do not." (Or just cosplayers showing off their wigs.) The results yielded 3,000+ videos, with millions of views.

On TikTok, communities are built with engagement, not just views. User Knewbettadobetta, a Tolkien megafan, joined TikTok just as something to do, and was surprised that he couldn't find many *The Lord of the Rings* creators at first. It took creating his own Tolkien content to teach the algorithm to take him to TolkienTok: "I was looking for [Tolkien fans], and it didn't put me on to the algorithm; but once I started talking about it, and people started talking about it to me, and they were sharing my stuff with the people in TolkienTok, then, boom, I got locked in."

Knewbettadobetta's TikTok draws significantly on book lore, and he sees his content as a gateway for film fans to come into the fold of the Tolkien fandom. He specifically recalls how even the smallest bits of Extended Edition content can reveal a creator's devotion to being book-accurate, including minute moments found only if you have the subtitles on.

In September, TikTok user @Cavatica discovered something interesting watching *The Fellowship of the Ring* with the subtitles on: "They're going over Caradhras, and you see Saruman reciting spells to create the storm, and Gandalf is trying to counter the spell. [The subtitles say that] Gandalf is speaking Sindarin, and you see Saruman is speaking Quenya." Knewbettadobetta wasted

no time in duetting with his own theories. "That's huge—they don't say they're just *speaking Elvish* . . . Saruman is high and snooty and is trying to speak the language of the more powerful elves, while Gandalf is more the everyman, speaking the language of the people. Stuff like that is amazing."

The way the Tolkien fandom consumes content goes hand in hand with the way the fandom itself has changed over the years, and some TolkienTok creators that become popular by helping other fans see themselves in the work. WizardWayKris, who uses *she* and *they* pronouns, is a TolkienTok creator focusing mainly on elves and the Elvish language. To them, Extended Edition content bolsters their devotion to the language and lore of Tolkien, as well as giving her the opportunity to create moments of inclusivity.

"Art is created by those who consume it; we as the consumers bring our own lens. When we experience fandom and canon, we pull things out that may not have been important to other people," WizardWayKris told Polygon, noting in particular a scene from the *Fellowship* Extended Edition commentaries: Sir Ian McKellan relates the story of how he emphasized to Elijah Wood and Sean Astin that Tolkien's inclusion of Sam holding Frodo's hand while bedridden was very important to certain gay readers, and that it was vital to make sure that moment was seen on-screen. As a non-binary trans creator, WizardWayKris says that "me even existing as a creator in this space helps open it up to those people who would say 'this is all just subtext, no one is actually saying these things.'" To many, subtext is increasingly text in the modern Tolkien fandom.

An element of Extended Edition TikTok that can't be ignored is the myriad of videos that are just ripped uploads of the documentaries themselves. And while it may not be in keeping with the standards of copyright law, it can't be ignored that for many young, non-DVD-player owning fans, TikTok may be the only place they would ever see this content.

While the Extended Editions are considered to be gospel among fans, the passing of physical media has been a death knell for the bonus-feature industry. The all-access pass viewers had to the creation of the modern blockbuster seemed doomed to become a fond memory. (Fortunately, the Extended Editions are now available to stream and will hopefully escape becoming victims to the oncoming digital-archiving crisis.)

For his part, Don Marshall told Polygon he intends to launch a Snyderverse-style grassroots push to get an even longer version of the Extended Editions released. Whether this sub-subsection of TikTok will grow or just continue as a hyperspecific personal internet blip remains to be seen.

But either way, TolkienTok gives users a validating feeling that only the best kind of nerd spaces provide—that the knowledge that is important to you, no matter how niche, is valuable and relatable to someone. And thanks to TikTok, it may be easier to find that someone than ever.

If you want to read more about...

> *The Wigs video, turn to page 62—*"The Lord of the Rings *Comes from a Time When Fans Were Online, but Hollywood Was Not" (December)*

> *LotR memes, turn to page 133—*"One Cannot Simply Separate the Lord of the Rings *Movies from Meme Immortality" (October)*

CONFESSIONS OF A FORMER LEGOLAS FANGIRL

THE LIMITS OF THE 2000S-ERA INTERNET MADE A SAFER SPACE FOR STANNING

Kendra James

In late 2002, right after *The Lord of the Rings: The Two Towers* was released, a message board of Orlando Bloom fans compiled a care package to send to Orlando Bloom himself. Assuming that everything that was supposed to make it inside did indeed make it in (and there were questions—and ensuing drama on the board—as to whether that happened), the package contained an assortment of trinkets, tokens, and gifts that the board members had surmised he might appreciate, based on various interviews and teen-magazine profiles.

The box was sent to his representation in London, with no guarantee it would ever actually reach him, no expectation of a response, no specific hopes attached to its mailing or its recipient. Later, some participants would claim to take issue with one piece of the box's contents, finding it a bit gauche to include a card with the message board's URL, "just in case he wants to visit." Why would he want to? And, more importantly, why would they want him there?

It was hard enough to exist as a Legolas fangirl online, after all. Scrutiny from men wasn't hard to come by. Why invite a burgeoning heartthrob into your pervy fan community dedicated to him when you could just visit any early-aughts film site's comments section and be embarrassed and ridiculed for much less effort? That was the beauty of curated spaces like message boards (often hosted through places like EZBoards or Yahoo Communities) or websites with titles like OrlandoBloomFans.net, where groups of women and girls could gather to celebrate, lust after, and—very importantly—*create* around their fascinations without judgment from others.

The streams of fangirl and celebrity crossed so rarely back then that the internet of the early 2000s felt like a much safer space to be a fangirl than the internet of 2021. When I (a high school freshman with too much unsupervised internet access) donated toward the transatlantic shipping costs of the Box Endeavour, I wasn't thinking that this was some sort of Hail Mary play to meet and fall in love with Orlando Bloom. The package was simply about trying to gain that tentative thread of connection with a crush. An act that—thanks to social media—is now as simple as pressing Send to access the star of your favorite film, television show, or TikTok. But we weren't conditioned to expect that sort of access then.

Which is in part why, when Bloom *did* respond a few months later, I was titillated, of course. What teen girl wouldn't have been? But also? I was kind of *extremely* freaked out.

It took until *The Two Towers*, but when I finally decided that I was indeed a Legolas Girl—approximately 2.5 seconds after he used his shield as a skateboard during the Battle of Helm's Deep—I went all in. We're talking a full redecorating of my bedroom to make room for a wall entirely dedicated to Orlando Bloom. We're talking hours spent on fan message boards and many dollars spent on the UK versions of our teen magazines, which covered him far more regularly than American publications. We're talking about a cardboard Legolas standee in my sophomore-year dorm room that concerned teachers occasionally inquired about. We're talking *one hundred thousand words* of an RPF romance novel about a thinly veiled version of myself

falling in love with a very explicit version of Orlando Bloom. This right here? *This* was a parasocial relationship.

I put a lot of work into my crush on Orlando Bloom. And it *was* work—a different sort than I had to put into my crushes on fictional characters (which made up 99% of my crushes at the time), where I would largely make up my own details while waiting for, say, J.K. Rowling to adequately fill in the details of Remus Lupin's Marauders-era life.

But IRL crushes meant IRL facts. Wikipedia wasn't particularly prevalent, so creepily committing details of Orlando Bloom's life to memory meant poring through magazines, watching every red carpet appearance, and using up all of my parents' bandwidth for the month because I had to download every one of his international chat show segments. It was knowing facts off the top my head—things like his sister's name, details about his dog, being able to recount from memory multiple

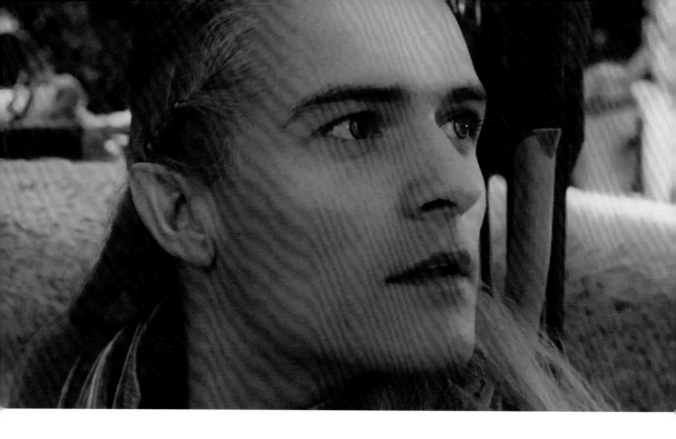

stories about the time the Fellowship actors had spent in New Zealand, or recall the events around the time he'd broken his back—that made me, and the fans I connected with online, feel closer to him.

Those details were our currency. They were how we knew what to put in our package in the first place. Items in the tightly packed box included, but were not limited to, blank journals ("for him to write his thoughts in," one of the package organizers said), the books *The Hitchhiker's Guide to the Galaxy* and *The Internet for Dummies* (the latter because he'd once described himself as akin to a Luddite), a Superman T-shirt, a stuffed puppy named Maude (because he'd had to give up his own dog named Maude), a handcrafted ring, and a spray bottle labeled "Crazy Fan Repellent" (ironic, given the circumstances).

Care package aside, the idea of trying to communicate with Bloom through any medium seemed slightly outlandish. I knew my parents would think so, especially since it involved working with adults I'd met online—stranger danger and all that. I was online enough too, even then, to recognize the stigma directed toward women who showed any interest in *LoTR* vis-à-vis the men who populated the Fellowship. I read the boards at Ain't It Cool News every single day, after all. Even if you were a "legitimate" (as deemed by men) *Lord of the Rings* fan, admitting a sexual attraction always seemed to work to diminish the legitimacy of your broader fandom experience in others' eyes.

So, in addition to not wanting to come off like a Stalker Sarah prototype, crushing at a distance was also about maintaining cred in the more "serious" corners of Film Internet. Places where knowing the basics of Quenya got you

cool-nerd points, but knowing the basics of Quenya specifically for the purposes of enhancing the sex scenes you were writing about Legolas and the new lady-elf character who happened to look and sound a lot like you absolutely did not.

All of this—the good, the bad, the lack of social media, and the sexism—worked to create an environment for adolescent crushing that I remain somewhat thankful to have grown up in. For me, lusting after celebrities was like being a dog chasing a car: I wouldn't have known what to do with any of my crushes if I had managed to catch them, and at age 13, that was more than appropriate. I've long advocated for people (especially parents and teachers) to understand that things like unattainable crushes and writing steamy fanfiction about the objects of those affections are some of the safest ways for young girls to explore their budding sexualities. These hubs of fan activity were safe spaces, semisecretive corners of the internet that have existed since the early days of listserv Star Trek slashfic.

It's the fantasy of these crushes, my own on Bloom included, that makes them both special and safe. But in 2021, that veil of fantasy feels moth-eaten. With daily looks into people's everyday lives granted via Instagram, streams of consciousness available minute-to-minute on Twitter, and the straight-up stalker content that accounts like DeuxMoi provide, there's simply a lot less fantasy about the idea of celebrity as a whole. And the same is true in the reverse. Fandoms are loud now; some might argue that the hives surrounding certain celebrities are even louder. It's as easy for celebrities to find us now as it is for us to find them—just a hashtag away.

It's certainly quaint, now that being incredibly Horny on Main is more acceptable, to think of shocking a celebrity with the mere existence of lusty message board posts being written about them—as Graham Norton did to Orlando Bloom on his show in those early years of his burgeoning fame. I mourn the privacy the early 2000s allowed the various Hive factions; I long for a smaller internet.

While I was probably the earliest adopter of being Extremely Online within my group of school friends, those digital interactions still felt very insular. The Graham Norton incident could be seen as a blip rather than something that might happen at any given moment. In the same way that I never thought the creatives behind my favorite shows would ever stumble across my fanfiction, I never *really* worried about the romance novel–length story I'd written making its way to the story's real subject.

I often wonder what it's like to write real-person fanfiction in a world where you know people are so much more internet literate than ever before. There was no mechanism for snitch-tagging then, thank God. I would have been mortified if someone had slid a hashtag or an @ into the comments of one of my chapters.

Funnily enough, it was in the fandom I entered soon after my Orlando crush began to wane—I sobbed through the credits of *Pirates of the Caribbean: At World's End*, despite being fully 19 years old—where I first noticed the veil begin to fray. I was a lot less Horny on Main about *Supernatural* (that is, I kept it mostly to a locked account on InsaneJournal.com), because it began to feel like the people in charge of *making* the show were also Extremely Online. I wasn't super comfortable with that. Not out of prudishness, as I hope is obvious by now. I simply enjoyed that fundamental separation of fandom church and state.

I've always been that way, to some extent. When it came time to participate in that first care package, and at least two

subsequent birthday-package attempts, and several more months of drama after each, I happily donated a few allowance dollars to the cause—for the trip to Michael's for decorations for a bottle of Crazy Fan Repellent spray, for example—but I never saw the need to buy or make anything myself. I liked the idea of making an ocean length's distance of contact, but never wanted to fly too close to the sun.

Six months or so after it was sent, Orlando Bloom thanked our message board for the gift.

In addition to including the message board's URL, the woman who ultimately mailed the package out had also (and I'm still not sure *how*) gotten her phone number to Orlando's *mother*. And so, when he wanted to thank us for our very strange box of gifts, he simply picked up the phone late that spring and called her from England. It was 4:49 a.m. Eastern.

After speaking for a moment, he asked her to record a message for the board. "I just wanted to say a big thank-you to everyone at the site just for the box, the care package. It was really sweet. I'm really touched. It was very thoughtful. And I'm sorry that the response has been so long. I've been so busy with work and I'm not very good at responding to everything. I'm sort of figuring out ways of responding to fans and to the sites and stuff. But that is something that got to me. And I'm really and truly appreciative and all the best. Thank you."

As asked, the call's recipient recorded the message. She then transferred it to her computer, and painstakingly uploaded it to a personal server (this was *not* a simple

Creating the Oliphaunts

The current director of Wētā Digital, spoke to Polygon in celebration of the 15th anniversary of *The Return of the King's* big night at the Oscars about creating one of the movie's largest creatures:

"We started with drawings from [illustrator and lead concept artist] Alan Lee, as did most of the creature designs, and really just took it from there. They're based on elephants, of course, so there was a lot of study for that, and especially for *Return of the King*, because they have so much battle action and had those big battle towers on top of them.

"[The sense of scale] was really based on needing to get those towers on them for the battle, and to make that as big as possible but still make it look like these were creatures that could bear that weight. There was a lot of work that went into just trying to understand the physics of doing all that to get the weight right, and the muscle movement, and

to get that big, shifting basket up on top, moving back and forth.

"When you're doing it digitally, you tend to cheat those things. There would tend to be a fairly big sway. We would restrict the movement, so it didn't move that much, because otherwise it looked like the actors were getting thrown around too much. But you didn't want to stiffen up the oliphaunt's walk, because that would've looked wrong as well, so we just kind of absorbed a little bit of the motion in the padding underneath the tower.

"There were some insert shots of the basket that were done practically on the stage with people on them, and then we would take those and put the elephant underneath them. Sometimes we only saw them in wide shots, like that big charging shot—those would all be digital."

process back then), so that she could post a link on the board, accompanied by a lengthy list of instructions to members on how to download it to their own computers. In 2021-speak, they amounted to little more than "right-click + Save As."

I burned my copy onto a CD-RW and took it to school to show off to all my friends. But the fallout from that first package marked the beginning of a steady decline in participation. A bout of arguing had ensued after the fact, all based around one faction's belief that the wrong organizer had been awoken by the predawn call. Typical of early-aughts fandom/hive in-fighting. But what really soured the taste in my mouth was the knowledge that Orlando Bloom's *mother* could very well be aware of our message board—the place where I posted sexually explicit fanfiction about her son.

That URL, now shared, was no longer a safe space to explore what it meant to be a teen girl with a crush and a wild imagination, and I began my migration back to LiveJournal and its magical feature—the ability to lock your posts. By the time I sent my final message, I'd posted on that Orlando Bloom fan message board nearly 300 times. But the package organizers had flown too close to the sun.

If you want to read more about...

> *Female fandom in 2001, turn to page 30—"I Wore Arwen's Dress to Prom Thanks to a Welcoming* Lord of the Rings *Fandom" (October)*

> *Orlando Bloom's acting choices, turn to page 127—"Legolas' Dumb, Perfect Faces Are the Key to His Whole Character" (April)*

CHAPTER TEN

JUNE: TOLKIEN'S WORLD

THE BEST EASTER EGGS IN THE *LORD OF THE RINGS* MOVIES ARE IN THE DIALOGUE

DESPITE CUTTING SCENES AND CHARACTERS, JACKSON FOUND WAYS OF INCLUDING TOLKIEN'S MOST ARRESTING WRITING

Kenneth Lowe

How do you adapt something as seminal, as beloved, and as dense as *The Lord of the Rings* into film? The easy answer is to cut liberally, but that presents its own problems. The richness of all the background that J.R.R. Tolkien crafted for Middle-earth is what drew generations of fans to the material in the first place.

Of all the tasks before Peter Jackson, Fran Walsh, and Philippa Boyens in bringing the epic trilogy to the screen, preserving that essence may have been the most challenging. But the adaptation worked because the trio didn't stop at translating Tolkien's concepts; they also took his prose word for word. Even scenes that were cut for time made it into the final cut through dialogue.

Tom Bombadil, who appears early in the novel version of *The Fellowship of the Ring* and baffles lore experts, and Quickbeam, one of the distinctive ent characters of *The Two Towers*, are two characters who wound up cut from the movies. But Boyens, et al. honored them by slipping their dialogue into the mouth of Treebeard, another guardian of nature. In addition to singing Quickbeam's song ("O rowan mine!"), Treebeard also speaks aloud some narration from Tom Bombadil's chapter, with his line about the "destroyers and usurpers!" who go about biting, breaking, and burning the pristine wilderness.

Tricks like that highlight just how much restructuring Jackson had to do as a director to keep the story in the shape of a film trilogy rather than a novel trilogy. Tolkien's books made use of few perspective characters and the occasional chapter of heavy exposition, an approach that just couldn't work in the movies. Accordingly, a lot of great lines from the books couldn't occur at the same point in the narrative, even if the characters who said them were still included. The writers overcame this challenge in a number of interesting ways, but always by showing love toward the language itself.

In some cases, Boyens, Jackson, and Walsh chose quiet moments where Tolkien's prose could breathe, and better evoke the books' bittersweet tone. Frodo's lament to Gandalf about wishing he were not the one to live to see such times has become a memetic touchstone, especially during this past year of constant doom and gloom. Jackson plucked it out of an exposition-heavy chapter of *The Fellowship of*

the Ring and found a quiet moment for it, as Gandalf and Frodo rest in Moria, a lull before a major swell of action. It's not unlike another lull during the movies' climactic siege of Minas Tirith, when Gandalf and Pippin take a breather and Gandalf soothes the hobbit's fears about death. He actually sneaks in a line of narration from the very end of *The Return of the King*, describing the last thing Frodo sees aboard the ship as it bears him to the shores of Valinor: "white shores, and beyond, a far green country under a swift sunrise."

Jackson and his co-writers also made a valiant effort to preserve the many songs and poems that pepper Tolkien's work but that would have absolutely torpedoed the pacing of the movies. On his way into the Shire in *The Fellowship of the Ring*, Gandalf sings the song that is so often reprised throughout the series, "The Road goes ever on and on . . . ," for instance. Particularly dramatic, too, is a poem of Rohan that begins, "Where now are the horse and the rider?" originally recited by Aragorn in *The Two Towers* as he, Legolas, and Gimli arrive in the land of the horse lords. In the movies, Théoden delivers a portion of it in solemn voiceover over a montage of characters gearing up for the siege of Helm's Deep. It's a change that shows a deep understanding of the text, tying Théoden's character to his culture, and in a way perfectly in line with its fatalistic theme.

Moments like that highlight both how the filmmakers changed character arcs and how they used those same sorts of callbacks to the books to evoke what couldn't make it in. Aragorn's arc in the movies, in particular, is different than in the books. On the page, he's already accepted his destiny to become king of Gondor and defeat Sauron by the time the Fellowship leaves Rivendell. But since so much of that backstory is hidden in an appendix at the back of *The Return of the*

King, working it into the movies without clunky flashbacks required some finesse.

The extended edition of *The Fellowship of the Ring* includes one short scene that sets up a major callback to the novels for Aragorn's character. In an early scene in Rivendell, he visits his mother's grave. Readers would know that Aragorn's mother lived a hard life, hiding from a dark lord bent on killing her son. And so, when Elrond visits Aragorn at the end of *The Return of the King* to deliver the sword Anduril (a scene that does not happen in the books in the same way or at the same time), it means even more than some viewers may know when he says, "I give hope to men" and Aragorn answers, "I keep none for myself."

Those two lines are a paraphrasing of the poem Aragorn's mother spoke to him the last time he saw her alive. Put in context with the Extended Edition scene by the grave, Elrond's visit isn't just handing off a plot device: He's admonishing Aragorn to remember his duty.

It's a triumph of the film adaptations that scenes like this sometimes feel like improvements on the original work. Even with all of the cutting, reshuffling, and repurposing of scenes and characters, the filmmakers found so many different ways to reference some of the best parts of what they had to otherwise leave out. That they did so using Tolkien's own words shows the same genuine love for the source material that fans have had for nearly 70 years.

If you want to read more about...

> *Screenwriting the LotR movies, turn to page 108—"Philippa Boyens Reflects on Éowyn's 'I Am No Man!'" (March)*

> *How LotR adapted Tolkien most directly, turn to page 14—"The Fellowship of the Ring Redefined Movie Magic with a Single Line" (September)*

WHICH TWO TOWERS
ARE **THE** TWO TOWERS?
THE ANSWER IS INFURIATING

JOHN RONALD, WE NEED TO TALK

Susana Polo

There is a mystery at the heart of the second installment of *The Lord of the Rings*, from Peter Jackson's 2002 adaptation all the way back to Tolkien's 1954 original. The title, *The Two Towers*, has plagued many a reader who missed the one line of the books that gives the answer, and many a movie watcher who has thought to themselves: "Wait . . . what does the name of this movie even mean?"

The mystery, of course, is, which towers are *the* two towers?

In another setting, perhaps, this would be easy to answer, but the geography of Middle-earth practically bristles with spires of one kind or another, from Saruman's tower at Isengard to the steeples of Minas Tirith, capital city of Gondor to Barad-dûr, the perch of the Eye of Sauron—and all of them play large roles in *The Lord of the Rings*.

But it's a valid question, one that even J.R.R. Tolkien waffled on for the majority of the time he was writing *The Fellowship of the Ring*. And it came back to plague Philippa Boyens, Peter Jackson, and Fran Walsh when it came time for them to convert *The Lord of the Rings* into three movies.

When you really get down to it, *The Two Towers* just isn't a very good name for the middle installment of *The Lord of the Rings*. But then, it was never *supposed* to have a name at all.

ONE BOOK TO RULE THEM ALL

Tolkien envisioned *The Lord of the Rings* as a single book told in six named sections, not a trilogy. But his publishers were wary of the high price of paper in postwar England and thought that readers would balk at the sight of a thousand-page tome, so they mandated that it be split into three parts with two sections each.

This meant that Tolkien had to come up with names for the three parts. The second book in the trilogy, containing sections III and IV of the six-section epic, proved to be a challenge. Section III followed linearly from the first book, covering about a week of the adventures of Aragorn, Legolas, Gimli, Gandalf, Merry, and Pippin in Rohan. But Section IV leapt back in time a week to pick up with Frodo and Sam, and then continued with them for over two weeks. The two sections never intersected.

Eventually Tolkien settled on *The Fellowship of the Ring*, *The Two Towers*, and *The Return of the King* so that the titles of all three books could be included in an endnote in the first printing of *The Fellowship* to entice the satisfied reader. According to his biographer Humphrey Carpenter, he initially wrote to his publisher, Allen & Unwin, that the towers the title referred to should be left ambiguous.

Then, he wrote that he was attempting to decide on specific towers, but was waffling between three different options. Perhaps the events of the book were best represented by Orthanc and Barad-dûr, the strongholds of Saruman and Sauron, respectively, as the major antagonistic forces of *The Lord of the Rings*? Or, perhaps it was Minas Tirith and Barad-dûr, representing the last refuge of the forces of good, and the fortress of the highest evil? *Or*, perhaps it was Orthanc, the location of the final conflict of the first half of the *Two Towers*, when Gandalf strips Saruman of his wizardly powers, and the tower of Cirith Ungol, the location of the cliffhanger climax of Sam and Frodo's *The Two Towers* arc, where Frodo is captured by orcs and Sam is left to bear the One Ring to Mount Doom alone.

I wish I could tell you it was any of these, but unfortunately, a month after that, Tolkien settled on none of those combos.

WHICH TOWERS ARE *THE* TWO TOWERS?

As he was finishing *The Fellowship of the Ring*, Tolkien decided that the two towers of *The Two Towers* would be . . . Orthanc and Minas Morgul.

Minas Morgul? Are you kidding me, professor?

Odds are that right now you are thinking, "If it's not Saruman's tower, or Sauron's tower, or the tower that Frodo gets captured in, then what the fuck is Minas Morgul?"

Minas Morgul—formerly a Gondorian city, hence the "Minas," as in "Minas Tirith"—is the fortress of the Witch-king of Angmar, leader of the Nazgûl. It appears in just *one* scene in Tolkien's *The Two Towers*, in which Sam and Frodo cower as the Witch-king leads his armies out of a spooky castle, bound for Minas Tirith and the Battle of Pelennor Fields. That's it!

And here's the fun part: Minas Morgul doesn't appear in the movie *The Two Towers* at all, because of the particular pickle that the book's non-novelistic structure presented to Boyens, Jackson, and Walsh. If you follow the timeline of the overlapping events of *The Lord of the Rings'* plotlines, by the time Frodo and Sam sight Minas Morgul, Gandalf, Aragorn, and the rest of the crew have run across Rohan twice, healed Théoden, defended Helm's Deep, sacked Isengard, broken Saruman's staff, and walked

the Paths of the Dead, and Gandalf and Pippin have reached Minas Tirith.

By the time of the Battle of Helm's Deep, the moment that Boyens, Jackson, and Walsh chose to button the end of their *The Two Towers*, Frodo, Sam, and Gollum have yet to even met Faramir yet. So, to avoid packing a lot more content into *The Two Towers* than was really feasible, the trio fudged Sam and Frodo's timeline a bit, created a narrative arc for them to overcome, and left a lot of Sam and Frodo's book plot for 2003's *The Return of the King*.

Creative demands of the adaptation meant that Minas Morgul only appeared in *Return of the King*, as a sickly green castle that fires a giant eldritch light into the sky before spewing forth the armies of Mordor. So on top of the monumental task of translating Tolkien's work to screen, Jackson and his team had to come up with their *own* two towers for *The Two Towers*. In trailers for *The Lord of the Rings,* sequel, Galadriel's voice helpfully explained that the title referred to Barad-dûr and Orthanc, the strongholds of the villainous Sauron and Saruman. But . . . it's not mentioned in the movie itself.

And this may have been too much for an American psyche already grappling with the legacy of towers. And through no fault of their own, the mainstream success of *The Fellowship of the Ring* invited some comparison-making for its much-anticipated sequel.

OH NO, IS THIS ABOUT 9/11?

It sure is!

Months in advance of *The Two Towers*' December 2002 release, a man named Kevin Klerck used the now-defunct PetitionOnline.com to create the petition "Rename 'The Two Towers' to Something Less Offensive." His manifesto read, in part:

"Peter Jackson has decided to tastelessly name the sequel [to *The Fellowship of the Rings*] *The Two Towers*. The title is clearly meant to refer to the attacks on the World Trade Center. In this post–Sept. 11 world, it is unforgivable that this should be allowed to happen."

Unlike many of the post-9/11 reactions to the *Lord of the Rings* movies (page 198), Klerck was not serious, but the petition still attracted thousands of signatures and enough news coverage that some of it is still available to read with a quick Google search. The same search results indicate that Klerk's work may not have been the only one of its kind, though as I poked around them, I couldn't say whether other efforts were sincere or likewise satirical.

Regardless, it speaks to the core problem with *The Two Towers* as a title: It's very hard to know what the hell it means. It's an idea Tolkien produced under editorial mandate and then—like a surprisingly large number of things in *The Lord of the Rings*—worked backward to find a solution to (one that made more sense to him than anyone else).

JUNE **25**
Gandalf leads Aragorn to a sapling of the White Tree in the mountains above Minas Tirith, a good omen for the future of his reign.

JUNE **30**
The wedding of Aragorn and Arwen on Mid-Year's Day.

TIMELINE
2002

Fell Beasts

Karen Han

Joe Letteri, currently the director of Wētā Digital, spoke to Polygon in celebration of the 15th anniversary of *The Return of the King*'s big night at the Oscars:

"The Nazgûl's flying mounts were fairly straightforward. The designs didn't change too much from Alan's drawings. Peter homed in pretty quickly on what he wanted for the design, and then Alan would pop in and give us some detailed sketches for—especially areas around the face—what that would look like.

"[The skin] had sort of a lizard quality to it. We went with that right off the bat and it seemed to work, so we stuck with it. We had that sort of purplish-black skin on them. We really tried to play up the translucency of the wings; because we had gotten subsurface scattering working for Gollum, we thought that was another good place to use it, so that was helpful to have on those big wing flaps to see the light bleeding through. I know we played around a little bit with the armor and how the rider sat on them, but they kind of were what they were.

"I would say we spent most of our time just in the execution of the flight, just making sure that they looked appropriately big and scary, but could still do things like, there's a shot where they rise up above the city and you're almost coming up on a thermal, in a way—the way they just ride up and sort of hover there with the wraith on its back. It was a lot about the animation and the character that we put into them—that's, I think, where we spent most of the time on those guys.

"[They were] a combination of bats and, really, eagles. Eagles are big birds, and they're great flight reference when you're doing big creatures, but of course the wings were more like bat wings. So we studied the two and tried to put the two together."

There are many diehard fans of the books who, 20 years on, still seethe at how Faramir had to get turned into a bad guy for the movie version of *The Two Towers*, in order for Sam and Frodo to have something to do while their buddies were off at the much more dramatic Battle of Helm's Deep. But as a fellow pedantic book fan, I think we should all rally behind a new take on the film:

Peter Jackson's *The Two Towers* actually improves on Tolkien's, because it at least knows which two towers it's about.

Minas Morgul, my ass.

If you want to read more about...

> *The strange ways that Tolkien wrote* The Lord of the Rings, *turn to page 19—"Tom Bombadil Is the Stan Lee of the* The Lord of the Rings" (September)

> *Even more towers, turn to page 168—"Sauron Is So Much More Than an Evil Eye—He's Also an Evil Everything Else" (July)*

THE TRUTH
ABOUT ELVEN
IMMORTALITY

OOOOH, (ELF) HEAVEN IS A PLACE ON (MIDDLE-)EARTH

Susana Polo

The opening of *The Fellowship of the Ring* finds an elven war-leader ordering his archers to fire, with arrows aimed so precisely, they clip his exquisitely braided hair on their way past. We don't see Elrond, the lord of Rivendell, again for another hour—and while it's been several thousand years, he hasn't aged a day.

Jackson & Co. had to leave many details of Tolkien's mythos unexplained for the *Lord of the Rings* movies, but the brilliance of the production is that they never passed up an opportunity to depict the *effects* of these details. We don't *need* to be told that elves live a very long time, because Hugo Weaving looks exactly the same in a multi-millennia flashback.

The elves become a fascinating embodiment of this less-is-more approach to exposition. Elves *can* die—Jackson & Co. give outsize weight to elven deaths during the battle of Helm's Deep, making sure Aragorn has a good chunk of a moment to honor Haldir's sacrifice. Elves are strange— they are oddly detached, even campy, in their relations to men, dwarves, and hobbits. Elves remember—the great elf-lord Elrond seems to hold a grudge against

Aragorn for a weakness he witnessed in the man's distant ancestor, and puts up a mighty resistance to Aragorn marrying his daughter.

Jackson's elves are alien in ways that are difficult to articulate, but utterly compelling nonetheless. They seem indifferent *and* helpful, wise *and* overly judgmental. And for those who want to know more (and there is so much more), the context for these contrasts—the lore that informed the dialogue, acting, even cinematography of the elves of *The Lord of the Rings*—is all found in Tolkien's books, often beyond the main trilogy.

> *The real key to understanding elven immortality is understanding that elven heaven is a place. Like, on a map.*

See, elves *can* die. When they do, they get to go to heaven. They can also come back from heaven any time they want to. The real key to understanding elven immortality is understanding that elven heaven is a *place*. Like, on a map.

It's called Valinor.

WHAT IS VALINOR?

In the far west of Middle-earth, there is a continent called Aman (or at least there used to be, but we'll come back to that), that was shaped by Middle-earth's gods, the Valar, as the best place in the world for elves.

At the dawn of time, Middle-earth's supreme creator god, Eru Ilúvatar, created the Valar to be the caretakers of the world, and to shape its form into one that would be good for Ilúvatar's next creations, Elves. (Men were also in the blueprints for Middle-earth, but not for some eons later.) The Valar were not powerful enough to turn all of Middle-earth into a paradise, so after they made all the birds, and fish, and animals, and the mountains, and valleys, and rivers, and oceans, and most of the stars . . . they focused on crafting an elven homeland in the far west.

And when they found the first elves, they spent a long time gaining their trust and guiding them to Aman, with some factions of elves choosing to stay behind at various pinch points like mountain ranges and ocean shores—leaving a tidy trail of different elven cultures for Tolkien to play with during the course of *The Silmarillion*, his history of the pre-*Lord of the Rings* Middle-earth.

On the continent of Aman, the elves and the Valar founded a nation called Valinor. Valinor is Asgard, and it is Valhalla; it is Heaven, and it is, in some ways, Eden. And within Valinor is the domain of Mandos, Middle-earth's god of the afterlife. The Halls of Mandos are a system of great caverns and underground halls lined with god-woven tapestries depicting all of history. When elves die, their spirits travel to the Halls, where they rest for a time as disembodied shades. Most of them are then returned to corporeal form and rejoin all the other elves living in Valinor.

Most elves "return to life" without much drama, but Mandos has the power to deny an elf corporeal form if they were a particularly bad person in life. And if an elf lacks the will to live again—which has happened at least a few times—they remain as a sad, disembodied shade in the Halls of Mandos until the end of time or until they feel better, whichever happens first. Their families and friends can visit them, but it's not very fun.

So yes, if an elf is killed in battle, her death will separate her from any loved ones she has on Middle-earth as her spirit travels to Valinor to be re-embodied. But her elven friends and family know they'll see her again eventually. And "eventually" means something different when you literally live forever. Any amount of time you spend apart from your loved one is, by definition, a blip on the road of infinity.

Human spirits also travel to the Halls of Mandos upon death, but they do not get to stay, and nobody knows where they go except Mandos and Ilúvatar himself. Spooky! And very interesting that Tolkien's own mythology is one in which even though god demonstrably exists, humanity is asked to take the afterlife on faith.

Many elves traveled to Aman in the early days of Middle-earth and made it their home—some elves, like Galadriel, were simply born and raised in the realm of the gods, which is part of the reason she's such a stand-out badass compared to the other elves in *The Lord of the Rings* (page 80).

But whether they've been to Valinor before or not, all elves go there when they die, and all elves can leave Valinor and sail to the rest of Middle-earth if they want—though that hasn't happened particularly often in Tolkien's work, and when it has it's usually a big deal.

SO YOU CAN JUST . . .
SAIL TO ELF HEAVEN?

Not anyone. Not *anymore*. In the time of the War of the Ring, Middle-earth was a globe. But when Eru Ilúvatar created Middle-earth, it was flat. What happened in between starts with an island country called Númenor.

Thousands of years before the War of the Ring, the human kingdom of Númenor was founded in the ocean between Aman and the rest of Middle-earth, under the leadership of Elrond's twin brother, Elros. See, Elrond and Elros were descended from such mixed parentage—multiple half-elven ancestors and one literal demigod—that the Valar threw up their hands and allowed the twins and their parents to choose their own fate: immortality or mortality.

Elros was the only member of their family who chose to be human, and he was the first king of Númenor, from which Aragorn's family line and the people of Gondor descended. (This is why Aragorn looks so good for an 87-year-old: It's the power of elvish blood.) But many generations later, Númenor fell under the sway of a black sorcerer who encouraged many on the island to spurn the Valar and worship a dark god instead.

Yes, it was Sauron, back in the days when he could take physical form. The Dark Lord had suckered the last king of Númenor, Ar-Pharazôn, in a web of lies and manipulations, convincing him that if he built an armada to invade Valinor he could plunder the secrets of the gods and win immortality for humanity.

As the first soldiers of Ar-Pharazôn's fleet set foot upon the continent of Aman, the Valar called on Ilúvatar to stop the invasion, as they were forbidden from harming his children. And boy, did Ilúvatar stop it.

Middle-earth's creator god cracked the plate of the world in two, snapping the continent of Aman off like the end of a Kit-Kat bar and drowning Ar-Pharazôn's fleet and the island of Númenor beneath the churning seas. The remaining majority of Middle-earth was bent into a sphere, and any humans who tried to sail to Valinor again . . . well, I'll let Tolkien say it, as he does in *The Silmarillion*:

> Those that sailed furthest set but a girdle about the Earth and returned weary at last to the place of their beginning; and they said: "All roads are now bent." [. . .] yet the [elves] were permitted still to depart and to come to the Ancient West [. . .], if they would. Therefore the loremasters of Men said that a Straight Road must still be, for those that were permitted to find it. And they taught that, while the new world fell away, the old road and the path of the memory of the West still went on, as it were a mighty bridge invisible that passed through the air of breath and of flight [. . .] and traversed Ilmen which flesh unaided cannot endure [. . .] to Valinor.

"Ilmen" is the elven word for the upper atmosphere of Middle-earth, through which light from the stars, the sun, and the moon pass. So, thanks to Sauron, the elven afterlife is technically in space now.

FRODO AND BILBO SAILED WEST WITH THE ELVES. DOES THAT MEAN THEY'RE IMMORTAL?

Tolkien wasn't really explicit about that, but probably not. Immortality is a characteristic of Elves as a species, not something conferred by Valinor itself. It's probably better to think about Frodo and Bilbo (and Sam and Gilmi)'s invitations to board a boat at the Grey Havens as the gift of a very, *very* nice retirement in recognition of services rendered to the goals of the Valar.

WHAT DO THE GREY HAVENS HAVE TO DO WITH ALL OF THIS?

The Grey Havens are in a region of Middle-earth called Lindon. In the map at the beginning of *The Lord of the Rings*, it's a coastal region all the way on the western side of the map.

But in the map of Tolkien's *Silmarillion*, which largely takes place before the destruction of Númenor, Lindon is a tiny wedge of space beyond the map's last *eastern* mountain range. Ilúvatar's wrath drowned all of the lands that feature in *The Silmarillion*, turning Lindon into beachfront property overnight—and into the closest ocean shore to Valinor.

So, shortly after that cataclysm, some surviving elves in Middle-earth—a faction who had originated in Valinor and traveled back to the main continent thousands of years before for reasons that pretty much make up the core plotline of *The Silmarillion*—founded the Grey Havens as an ocean port specifically for sending ships over the Straight Road back to Valinor.

Still, many of those elves hung around for a long time afterward. At that point, they'd spent a lot of time struggling for peace in Middle-earth, and they felt tied to the land and their allies there. But on an immortal's timescale, nothing lasts forever except your own lifetime. By the era of the War of the Ring, many of the elves in Middle-earth were starting to feel a little obsessed with the western sea.

Even Legolas, born in an elven society where no one had ever actually been to Valinor, talked about feeling an instinctual calling to travel there in *The Return of the King*. Well, actually, he sang about it, but that's elves for you:

> Grey ship, grey ship, do you
> hear them calling.
> The voices of my people
> that have gone before me?
> I will leave, I will leave the
> woods that bore me [. . .]
> Long are the waves on the
> Last Shore falling,
> Sweet are the voices in the
> Lost Isle calling,
> In Eressëa, in Elvenhome
> that no man can discover,
> Where the leaves fall not:
> land of my people for ever!'

WHY DOES ARWEN HAVE TO GIVE UP HER IMMORTALITY TO MARRY ARAGORN?

We've covered how Tolkien's elves are functionally immortal because their souls go to another country and get new bodies. But here's the other important thing about them: Tolkien's elves are monogamous. And I don't mean culturally. If *The Lord of the Rings* were a science fiction setting, we might call it a biological imperative.

Elves mate for life and do not remarry. (With the exception of literally one elf, one time, and—this sounds like hyperbole but you have to trust me because it would

take another two thousand words to properly explain—he was also the worst guy in the history of elves.) Once an elf engages in reciprocated love with someone, that's it. If he cannot be with that person, he will lose the will to live, die, and become a forever-shade in the Halls of Mandos. Elves *do not move on.*

Elves and humans have fallen in love only a handful of times in Middle-earth's history, and it's always a big deal, because all humans die. Arwen and Aragorn's romance was greatly enlarged in the movies from its frankly minuscule presence in Tolkien's novels, and it makes Elrond seem like a harsh dad who disapproves of his daughter entering an interracial relationship.

But elven monogamy provides the context for the way he cruelly forces Arwen to confront the idea of Aragorn's eventual death. If she loves him, he will eventually die, and she will pine for him forever as a shade in the Halls of Mandos. If she loves him and is separated from him, the exact same thing will happen. But if she doesn't *really* love him, there's still a chance she won't die.

Elrond, whose twin brother chose mortality, is the rare elf who has actually experienced the grief of losing a family member—and he needs to know if he's going to lose his daughter, too. Elrond's insistence that Aragorn seize his kingly destiny isn't just about making sure his son-in-law can provide for his daughter in a manner worthy of her. It's because no daughter of his is going to give up *eternal life in a god-crafted paradise* for a sweaty ranger in the woods.

But she might give it up for the heir to his brother's legacy and the king of all good men.

Peter Jackson's *The Lord of the Rings* did not devote time to unpacking the exact nature of elven immortality, or of elven romance, but that doesn't mean those details were ignored. Take Arwen and Aragorn's reunion scene in *The Return of the King.*

Once you notice Hugo Weaving's face as Liv Tyler steps away from him and into Viggo Mortensen's arms, you will never look at anything else during this moment. It's not the look of a father giving a child away in marriage, but the look of a father losing an eternity in paradise with his daughter.

If you want to read more about...

> *Elven history, turn to page 80—"The Truth About Galadriel" (January)*

> *The Valar, turn to page 96—"The Truth About Gandalf" (March)*

THE EAGLES ARE A PLOT HOLE, BUT ALSO AN US PROBLEM

FOR THE LAST TIME, EVERYBODY SHUT UP ABOUT THE EAGLES

Susana Polo

Peter Jackson's *The Lord of the Rings* trilogy contains one of the great mysteries of our modern age. It's a question that has been asked among friends, on Reddit, on Quora, on Stack Exchange, and on the dearly departed Yahoo Answers. It's been googled, and memed, video-essayed, and even immortalized in stop-motion Lego. It will never die.

Why didn't the Fellowship just ride eagles to Mordor?

That is, if Gandalf can ask a moth to bring him a giant eagle to rescue him from Saruman in *The Fellowship of the Ring*, or pick Sam and Frodo up from the lava fields of Mount Doom in *The Return of the King*, why couldn't he summon some giant eagles to carry the One Ring to Mordor itself, shortening the Ring Quest by months?

This question haunts me. Nay, it tortures me. So I'm going to answer it, and prove once and for all that it doesn't fucking matter why they didn't just ride eagles to Mordor.

GANDALF ISN'T JUST BURNING A SPELL SLOT ON SUMMON NATURE'S ALLY

(I.e., a Dungeons & Dragons spell that, at higher levels, allows you to summon a roc, or giant eagle. This is a very cool reference.)

The giant eagle that Gandalf calls up in *The Fellowship of the Ring* is sentient, one of an entire race of giant eagles that's as old as the dwarves or the ents. This is one of the many bits of Tolkien lore that Philippa Boyens, Peter Jackson, and Fran Walsh decided would stay on the cutting floor of a trilogy that's already over nine hours long.

Gandalf's particular eagle friend is Gwaihir the Windlord, who owes Gandalf for some service the wizard paid to him in the past—possibly a life-debt, but *The Hobbit* and *The Lord of the Rings* are contradictory on this. When Gwaihir gives Gandalf a ride in *The Lord of the Rings*, he's doing the wizard a favor. And he doesn't do requests.

Gwaihir noticed Gandalf on top of Saruman's tower and agreed to rescue him, but would only take him as far as Edoras in Rohan. Then, he noticed Gandalf on top of the peak of Zirakzigil above Moria after he'd defeated the Balrog and returned to life, and agreed to take him on another short trip to Lothlórien. When Gandalf asked Gwaihir to help rescue Sam and Frodo from Mount Doom, it was with a promise to never ask him for anything else ever again. "Twice you have borne me, Gwaihir my friend, [. . .] Thrice shall pay for all, if you are willing," he said to the Windlord in *The Return of the King*.

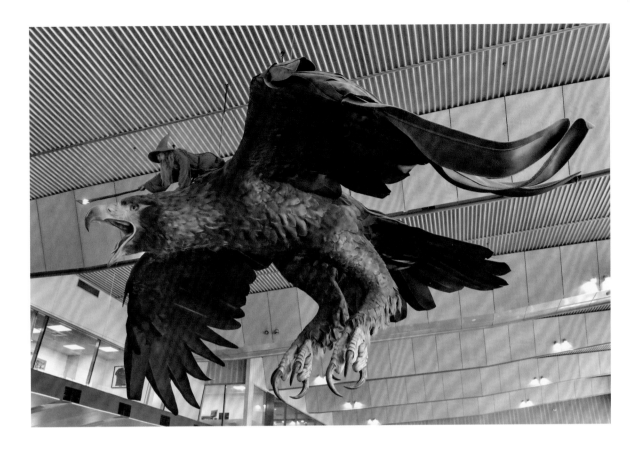

Like most of how Gandalf flexes power in *The Lord of the Rings*, it's not about magic, but about politicking. The giant eagles of Middle-earth aren't beasts to tame, like Shadowfax; they have their own society and concerns. And just like literally everyone else in the story, it takes a lot of work to get them to care about all this Dark Lord stuff until it affects them directly. The eagles can't carry the Fellowship to Mordor, because Gandalf can't simply summon a squadron of birds to dive-bomb Mount Doom.

Without any explanation from Boyens, Jackson, and Walsh, it's reasonable for movie fans to wonder why the Fellowship can't ride eagles to Mordor. But the real problem is that book fans are always there with the answer.

Back in my *World of Warcraft* days, I saw it demonstrated that the best way to get useful tips out of a disinterested zone-wide chat was to ask your question about the location of that quest NPC, and then have a buddy reply with something you knew was not the right answer. Previously apathetic players would leap to "correct" your friend and demonstrate their *far superior* knowledge of Ashenvale Forest or *whatever*.

This is the real reason the eagles question will never die: It's too appetizing for *The Lord of the Rings* fans. *The Lord of the Rings* doesn't have plot holes. *How dare you suggest!* Movie viewers will keep asking, and book readers are going to keep answering, and we will never escape the "Eagles, Explained" cycle.

I myself fell prey to this trap for many, many years, before I realized that the book explanation of the eagles question isn't the real answer.

Gandalf riding a great eagle, Wellington International Airport, Wellington, New Zealand

MOVIE FANS SHOULD BE ABLE TO FIGURE IT OUT ON THEIR OWN

Perhaps Jackson's *The Lord of the Rings* trilogy didn't underline this enough, but everything the Fellowship does on the Ring Quest is meant to hide their existence from Sauron for as long as possible. The moment the Dark Lord realizes there is a plan to destroy the Ring rather than use it, he would turn his entire operation into a Find Frodo Free-for-All. That's why Gandalf and Elrond assemble a small group to sneak into Mordor in *Fellowship*. It's why Gandalf and Aragorn actively mislead Sauron into thinking the Ring is in Minas Tirith in *The Return of the King*.

The eagles plan is cool, but it's not secret. The Fellowship can't ride eagles to Mordor, because of the giant, flying snake-dragon monsters ridden by One-Ring-sensing warrior-kings and their half-mile-wide aura of fear. The moment the eagles swooped in, the Fellowship would show its hand, and if the plan failed, Sauron would recover the Ring and instantly reunite with a power he hasn't held in 6,000 years. If the Ringbearer dies in Moria, or on top of a mountain, or unseen in the Dead Marshes, or is slain by squabbling orc kidnappers, then the Ring would be lost once again, to the forces of good *and* evil.

The eagles can't carry the Fellowship to Mordor, because that's actually a shitty plan.

But here's the thing. That's *also* not the real answer.

PLOT HOLES AREN'T ACTUALLY ABOUT PLOT

If Buzz Lightyear believes he is actually a space ranger, why does he freeze with all the other toys when a human walks into a room? How is it possible for an Apple PowerBook 5300 to download a virus into the alien mothership in *Independence Day*? Is it really easier for the folks in *Armageddon* to train offshore drillers as astronauts than it is to train astronauts as offshore drillers? Why didn't Jack get on the door with Rose in *Titanic*? Why doesn't Batman just kill the Joker?

Chances are that, with at least one of the above examples, the thought of a person seriously demanding that the movie provide an answer exhausts you. And chances are that you *also* have a movie or two that leaves you with a brain-tweaking question every time you see it. And I can hear you saying, right now, "Well, the things that bother me are *real* plot holes. But those other things . . . people need to just relax and enjoy the movie."

The thing about plot holes is that they're not just about the movie. They're *mostly* about the viewer. If you can't stop thinking about a logical inconsistency, it could be because the movie failed to engage you in believing in it, and that can be a legitimate problem. But it's just as likely that you just . . . weren't that into it, in a way that's nobody's fault. And the line between those two states is *incredibly* blurry.

Maybe you're not a science fiction buff, and these laser swords bore you, so you find yourself focusing on how the ships make sound in space, which is impossible. Maybe you're not into romantic drama, so you find yourself focusing on why nobody in this movie just talks about their feelings, which would really help Elizabeth and Mr. Darcy work this out.

Every story has *something* that *someone* could consider a logical inconsistency. But stories are a contract between the teller and the listener. The listener will engage with the teller's story, and the teller gets to tell the story they made. If you have to ask, "Why didn't the story do X," when the story is clearly about Y, you're not engaged in it. And the answer

is always the same: It's a made-up story. And they made it about Y.

The real answer to why the eagles couldn't just fly the One Ring to Mordor is that flying Frodo and Sam to Mount Doom is a completely different story from their long, lonely struggle against impossible odds. You might as well ask why Elrond and Gandalf didn't raise an army to invade Mordor, and *then* throw the Ring into Mount Doom. You might as well ask why they didn't just *take the Ring's power for their own.*

Tolkien invented the eagles for *The Hobbit*, and used them sparingly as a fast-travel system for his wizard in *The Lord of the Rings*. Boyens, Jackson, and Walsh brought them to the big screen in all their feathered glory. The eagles have an explanation, but they don't really need it. The plot of *The Lord of the Rings* is the story Tolkien, Boyens, Jackson, and Walsh wanted to tell. A story with *occasional* giant eagles.

If you want to read more about...

> *More ways to be annoying about* The Lord of the Rings, *turn to page 118—"A Definitive Guide to Being the Most Annoying Person to Watch* The Lord of the Rings *With" (April)*

> *More things left out of Jackson's* The Lord of the Rings *trilogy for good reason, turn to page 19—"Tom Bombadil Is the Stan Lee of* The Lord of the Rings" (September)

The Great Eagles

A CREATURE FEATURE WITH WĒTĀ DIGITAL DIRECTOR JOE LETTERI

Karen Han

"In those days doing feathers was really hard; we spent a lot of time on those eagles. The feathers are very thin and they're all layered together, and they break off into what is essentially fur, and it becomes very complicated to put all those things together.

"To really do it properly, you need to just run big simulations. You need to lay out all the feathers and let the computer run through all the calculations of what piece is colliding with what other piece. We've gotten better at the software that we need to do that and computers have gotten a lot faster, so we can rely on them more. In those days, you really couldn't, so we had to guide it a little bit more by hand. There was a lot of just going in and fixing everything by hand to make sure that all the feathers layered properly.

"Because they were eagles, we followed real birds as much as possible: the layout of the feathers, the guide feathers, the tail feathers, the way it's all layered, from the beak and around the eyes and back onto the neck. We tried to be as faithful as possible, and then really just scaled the whole thing up.

"I think the only time we cheated that was on the close-up shots where you saw [characters] riding on their backs. We would bring the size of the feathers down because they're big birds, and if you see them in a wide shot—you expect them to look like eagles, but if you think about that, it means they've got these really huge feathers. If you scaled them down and made more feathers, then it wouldn't look like an eagle anymore. But when you put the riders on their back for those close-up shots, those really big feathers looked out of place. It made everything look miniature.

"We would scale the feathers down so they looked more correct to the riders, because you never saw both, really. You'd see them in a wide shot, and then you weren't paying attention so much to the scale of the riders or the feathers, but when you went in for the blue-screen shots where you saw the riders who were on the buck we use to put the bird underneath them, that's when we would kind of adjust the size."

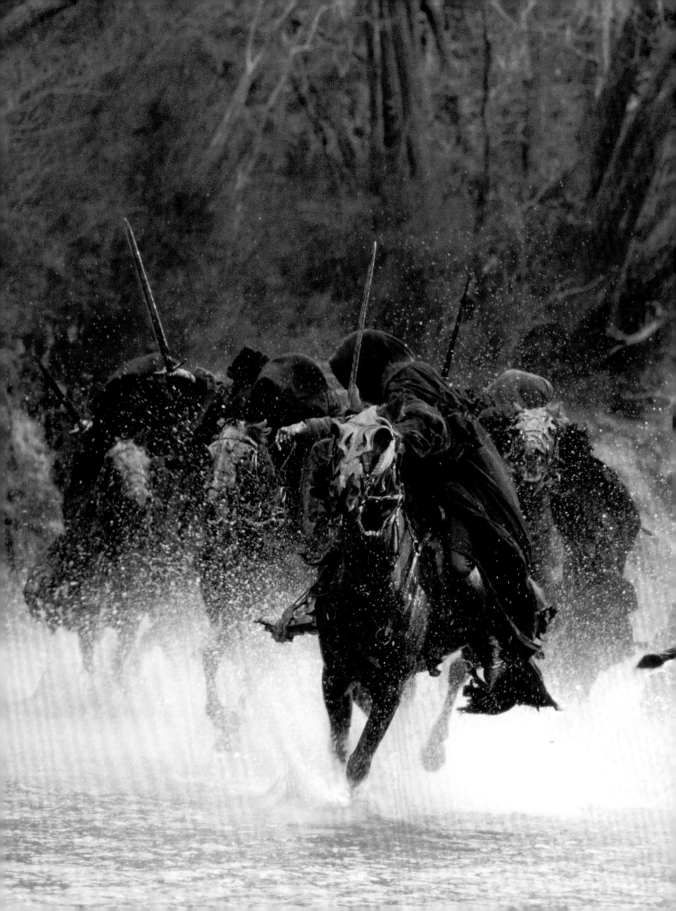

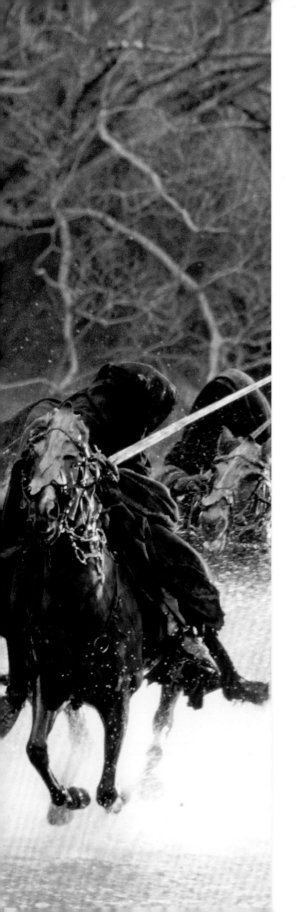

CHAPTER ELEVEN

JULY:
THE FORCES
OF EVIL

HOW TO INVENT ORC RESTAURANTS

SO, WAS MEAT **PREVIOUSLY** ON THE MENU?

Susana Polo

The promise of fantasy fiction like *The Lord of the Rings* is that the reader will be shown another world. A world with strange creatures (most of the time), magic (usually), and heroes—a palate cleanser, if not simply an escape, from everyday life.

But with one line of dialogue, the movie trilogy raises a question that can easily jolt someone back to real life: Does anybody in *The Lord of the Rings* have a job?

Regardless of whether you're asking about the books or the movies, Frodo and Bilbo don't have jobs. They've been living off of Bilbo's family wealth and the haul from one freelance assignment (burglary) he took about 60 years ago. Merry and Pippin likewise. Legolas, Gimli, and Boromir are scions of political families, essentially. Gandalf is basically an angel. Aragorn is a king, sure, but that's not a job; it's a responsibility.

It might not seem like a serious question, but it's one that can lead us to one of the most fundamental challenges of building a fantastical world that still feels familiar. Because there *are* definitely people in the *Lord of the Rings* movies who have jobs.

Orcs have jobs.

MIDDLE-EARTH'S GAINFULLY EMPLOYED

Tolkien nods to employment in a few places in *The Lord of the Rings*. Sam is Frodo and Bilbo's gardener, after all. Some Shirefolk are farmers, and they all pay for services and goods with earned currency, as at the Prancing Pony, which employs multiple people. But there are many places where Philippa Boyens, Peter Jackson, and Fran Walsh expanded on Tolkien's work in order to translate it to cinema, and occupations are one of them.

In the Jackson film trilogy, orcs have jobs. Because orcs have restaurants. Boyens, Jackson, and Walsh invented orc restaurants in a brief scene in *The Two Towers*, when the orc company carrying Merry and Pippin pauses for rest.

"I'm starving," an orc complains. "We ain't had nothing but maggoty bread for three stinking days!"

In a tweaked approximation of an argument in Tolkien's *The Two Towers*, the orcs bicker over whether they're allowed to torture and kill their prisoners, with hunger as the motivation. A large Uruk-hai insists that Merry and Pippin are not for eating. The company grows restless and menacing, but just as a smaller orc seizes the hobbits for "just

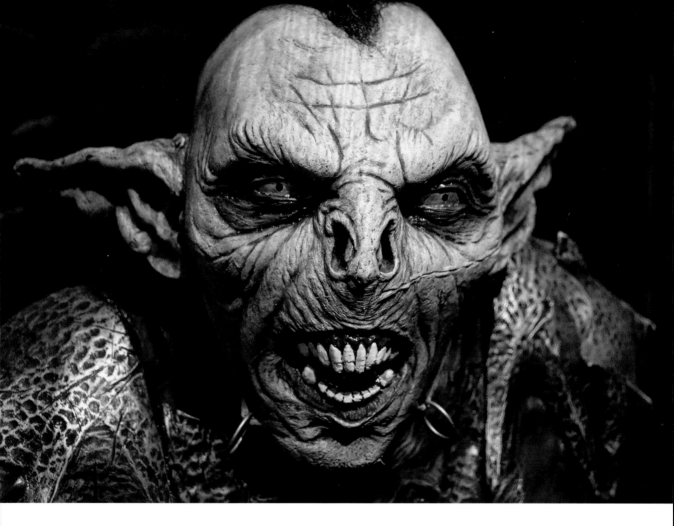

a mouthful," the Uruk lops off his head with a single stroke, declaring those infamous words:

"Meat's back on the menu, boys!"

The rest of the orc company takes this as a sign to descend on the corpse and consume it raw, intestines wriggling through the air like so much chaff.

Follow the logic: If orcs know what menus are, then they know what paying for food that someone else made is. And maybe that means there are just orc cafeterias where soldiers can chow down. But it invites the imagining of orc bars, orc barbecues, perhaps even *orc bistros*.

Orcs have restaurant jobs.

HOW *THE LORD OF THE RINGS* GOT A MOSS-TROLL

OK, OK, orcs don't have restaurants; this is an anachronism. Well, the "chron" in *anachronism* comes from the Greek for "time," so perhaps this is more of an *anacosmism*, from the Greek word for "world."

We accept and enjoy that menus are a salient concept for orcs because it's fun.

And because the alternatives are difficult, and can result in a more detached, less relatable setting. But obviously, this can spin out in unexpected leaps of logic. Writer Sarah Monette (*The Goblin Emperor*) called this "the Moss-Troll Problem" in a short essay for the Science Fiction and Fantasy Writers of America in 2010.

You might not have ever read a story with a moss-troll, but you've probably heard of a womp rat. Luke Skywalker conjured them into existence in the Star Wars universe when he said, "I used to bull's-eye womp rats in my T-16 back home. They're not much bigger than 2 meters."

And you can find fan-made plushies of an animal never actually seen in an episode of Star Trek, thanks to lines like "I can see it in your eyes. You can barely resist the urge to leap up and start jumping around like a Tarkassian razorbeast."

"The advantage of writing urban fantasy or world-crossing fantasy," sci-fi/fantasy writer Marissa Lingen wrote on her LiveJournal in 2006, "is that when the sea serpent has eyes the color of NyQuil, you can say so rather than spending time trying to come up with settlement-era Icelandic-ish equivalent having something to do with moss-troll ichor." Once invented for a single line, moss-troll ichor becomes a brick in the edifice of the author's fictional universe, one that needs remembering so that it doesn't become inconsistent or contradict anything they write later. And, as Lingen said, "You can pretty well guarantee

The "Moss-Troll Problem" . . . [is] a habitual challenge for anyone building a fictional world that is radically different from our own.

that's going to come back and bite you in the butt in another book or two."

Monette expanded on Lingen's idea in her piece for the SFWA, calling it the Moss-Troll Problem after Lingen's hypothetical example. And to her, it's a habitual challenge for anyone building a fictional world that is radically different from our own.

"You can't, for instance, say something is as basic as the missionary position in a world without missionaries," she wrote. "What about saying something is as swift and sharp as a guillotine's blade? Well, did Dr. Joseph-Ignace Guillotin exist in this world? You will find moss-trolls again and again whenever you start describing the imaginary people, places, and things of your imaginary world."

Boyens, Jackson, and Walsh's solution to the Moss-Troll Problem was "Meat's back on the menu, boys!" The line is objectively great. Actor Nathaniel Lees' delivery is impeccable, even through the heavy orc makeup. It's much better than saying, "Meat's back on the list of our options!" or "Insubordinates get eaten!"

Tolkien would opt for a mundane reference in his work as well. While there are

JULY **15**
Arwen offers Frodo her place at the Grey Havens.

JULY **22**
The funeral escort of King Theoden sets out from Minas Tirith, and with it, the Fellowship begin their long procession home.

TIMELINE
2002

very, very few anacosmisms in *The Lord of the Rings*, there is one that escaped the editorial pen in its very first chapter.

This is how Tolkien describes the imaginary climax of Gandalf's fireworks show at Bilbo's birthday party:

> The lights went out. A great smoke went up. It shaped itself like a mountain seen in the distance, and began to glow at the summit. It spouted green and scarlet flames. Out flew a red-golden dragon— not life-size, but terribly life-like: fire came from his jaws, his eyes glared down; there was a roar, and he whizzed three times over the heads of the crowd. They all ducked, and many fell flat on their faces. The dragon passed like an express train, turned a somersault, and burst over Bywater with a deafening explosion.

So you see, if orcs have restaurants, then hobbits have trains.

If you want to read more about...

> *The* Lord of the Rings' *trilogy's considered dialogue, turn to page 146—*"The Best Easter Eggs in the Lord of the Rings Movies Are in the Dialogue" *(June)*

> *Orcs and their legacy, turn to page 175—* "The Lord of the Rings *Movies Declined to Address Tolkien's Greatest Failure" (July)*

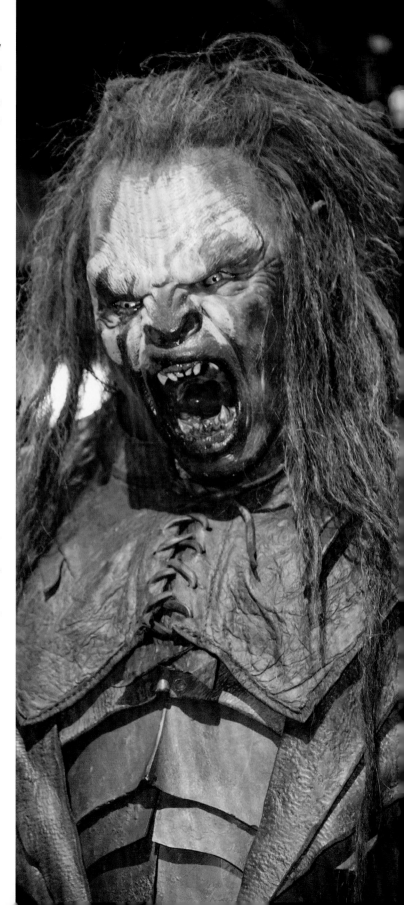

SAURON IS SO MUCH MORE THAN AN EVIL EYE—HE'S ALSO AN EVIL EVERYTHING ELSE

THIS IS THE REST OF SAURON'S BODY ERASURE

Leon Miller

When you think of *The Lord of the Rings'* baddie Sauron, chances are a big, flaming eyeball comes to mind. Why wouldn't it? The Eye of Sauron is one of the most iconic symbols associated with J.R.R. Tolkien's trilogy—it's even plastered on the cover of several editions of the books. The Great Eye also features heavily in Peter Jackson's blockbuster big-screen adaptations, an ever-watchful flaming orb atop a massive stone obelisk.

So, it makes sense that when the average Middle-earth fan thinks of Sauron, they think of him as a honking great peeper made of fire—but that's not what Tolkien originally intended. Jackson and his collaborators made some significant changes to Sauron for the *Lord of the Rings* films, and they've colored how we've all pictured the Dark Lord of Mordor ever since.

THE EYE OF SAURON IS A METAPHOR

If Sauron is more than the evil eye to end all evil eyes depicted in Jackson's movies, just what the heck is he? Did Tolkien ever describe Sauron's appearance in the books? And where does the Great Eye come into it?

Like a lot of Middle-earth lore, it's complicated. Tolkien makes it clear that when Isildur cut the Ring from the Dark Lord's hand, only his physical body died. His spirit lived on, and (according to Middle-earth's meticulously detailed timeline) he spent the next thousand years or so recovering until he was able to manifest a new form. From here on out, Sauron is literally a shadow of his former self, but crucially, he's also decidedly humanoid.

Of course, Tolkien injected a hefty dose of lyricism into *The Lord of the Rings*, and there are allusions to Sauron appearing as the Great Eye in the books. One particular passage in *The Return of the King* suggests that there really *is* a flaming eye perched atop Barad-dûr tower, at least temporarily.

However, just because Sauron occasionally goes full "flaming eye" mode, that doesn't mean the Great Eye is the Dark Lord's only form—and it's certainly not the only one he can take. In *The Two Towers*, Gollum even recalls seeing Sauron's four-fingered hand, which kinda shoots down the whole "just an eyeball" argument.

So how did the "Eye of Sauron" become such a big deal? Think of it as

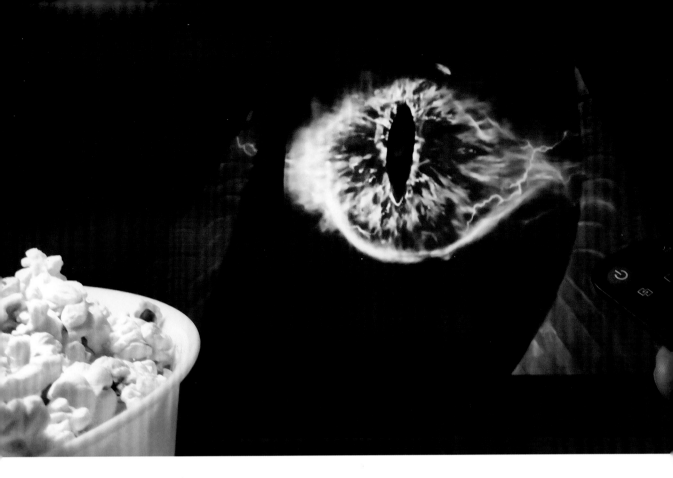

Middle-earth marketing. The Great Eye is the image the Dark Lord uses to brand himself and his armies, projecting an aura of omniscience. As propaganda, the Eye of Sauron is the most potent symbol in Middle-earth—and its effectiveness is built on the genuine power of Sauron's gaze, literal and otherwise. But ultimately, it's just that: a symbol.

WHO NEEDS SYMBOLISM?

The same doesn't apply in the *Lord of the Rings* movies. Here, Jackson portrays Sauron almost exclusively as a flaming eyeball (save for the odd Second Age flashback), and there's nothing metaphorical about it.

In Jackson's *The Fellowship of the Ring*, Saruman proclaims that Sauron flat-out can't take physical form (even a shadowy, finger-deficient one). This statement alone makes it pretty clear that Jackson believes the best Sauron can do for a body is a quasi-ethereal eyeball, and he clears up any remaining doubt in the commentary included with the Extended Edition home release. There, Jackson talks openly about his literal interpretation of the Eye of Sauron, lamenting that Tolkien lumped him, a filmmaker, with a villain "[who] is in the form of a giant eye and can't really participate in the story to any great degree."

Yet this misreading of Sauron's true nature does little to hurt Jackson's movies. As realized by Wētā FX, the Eye of Sauron still radiates exactly the level of menace Tolkien describes. One look at that cruel cat-eye pupil wreathed in fire and crackling with lightning, and you know you're

dealing with a dangerous, demonic presence. And if nothing else, the Great Eye makes for a more distinctive, less generic "dark lord" visual than the shadowy figure that Tolkien describes in the books (and which appears in certain sequences in Jackson's later *The Hobbit* films)—not to mention one that's infinitely more memorable.

Jackson's take on Sauron does have its shortcomings. The most infamous of these is what disgruntled fans call the "Lighthouse Sauron" effect: a handful of shots in *The Return of the King* where the Eye of Sauron projects a beam of light that scans the plains of Mordor far below. It . . . it looks goofy. Even when the beam finally lands on Frodo and Sam, they still manage to get away!

Reducing the archvillain of the saga to an ineffectual spotlight should have been enough to sink the entire Jackson trilogy. Yet many fans of the movies—even fans who know the original books inside out—seem cool with the director's less-than-accurate spin on Sauron, lighthouse and all.

So how did Jackson get away with such a radical departure from Tolkien's text?

WITH SAURON, THERE'S MORE THAN MEETS THE EYE

In the end, it doesn't really matter what form Sauron takes in *The Lord of the Rings*, as long as the Dark Lord plays his role in the story effectively. Whether Sauron is a dark phantom, a flaming eyeball, or something else entirely, his function remains the same: to provide an overarching threat to drive the narrative. In a sense, he's as much of a McGuffin as the One Ring itself.

As far as the story itself is concerned, Sauron's not there for our heroes to confront directly (although that nearly happened in previous versions of the film), even if his true form means that they actually could. Instead, he's a perpetual, ominous presence in every scene. His menace, as a villain, lies primarily in the danger he could pose—that he *could* regain his power through the One Ring and become unstoppable—and that's something a fiery eyeball can represent just as easily, perhaps even better, than a sinister shade.

All we need for Jackson's Sauron-as-eyeball interpretation to pay off is to believe in the threat of Sauron's relentless hunt for the Ring. And for the majority of the trilogy's runtime, we do—so much so that, for most of us, even the Dark Lord's embarrassingly half-assed search efforts late in the game are easy to ignore. Flawed or not, the unique aesthetic of Jackson's Sauron is too great to resist, and the appearance of his incandescent eye bopping about atop an ebony pillar in other media—including parodies in *South Park* and *The Lego Batman Movie*—is a testament to how deeply ingrained it is in our collective pop-culture consciousness.

Tolkien purists may argue that the changes Jackson made to Sauron do the original story an injustice, no matter how successful the films were and still are. But then, the beauty of being part of Middle-earth fandom is that not everyone has to see eye to eye.

If you want to read more about...

> *Big towers, turn to page 148—"Which Towers Are the Two Towers? The Answer Is Infuriating" (June)*

> *A sillier take on the 'Great Eye,' turn to page 133—"One Cannot Simply Separate the Lord of the Rings Movies from Meme Immortality" (October)*

THE MORAL OF DENETHOR'S STORY IS, STOP DOOMSCROLLING

WHAT THE LORD LACKED IN PARENTING SKILLS, HE MADE UP FOR IN SETTING A BAD EXAMPLE

Luke Ottenhof

As Sauron's vast orc army faces off against a shaky coalition of human nations in the most consequential battle of the entire *The Lord of the Rings* film trilogy, Lord Denethor II burrows himself deep within the burial grounds of the mountainside city of Minas Tirith. Portrayed chillingly by *Fringe* actor John Noble, the ruler of the declining and kingless nation of Gondor abdicates his role mid-conflict and prepares both himself and his definitely- not-dead son for self-immolation.

"Better to burn sooner than late, for burn we must," he mutters. In the book, his dialogue expands the vision behind this rhetoric: "Soon all shall be burned. The West has failed. It shall all go up in a great fire, and all shall be ended." In the film and in the book, he encourages Pippin to piss off and die in whatever way seems best to him.

The steward's submission offers a textbook guide for What Not to Do in a Siege, but the tragedy of Denethor transposes well onto modern conditions. Considered today, the arc gives us an operatic and useful glimpse into the social-media-driven Doomer movement:

a millions-strong cohort driven by current-event horrors to believe that humanity is, uh, irrevocably doomed. The steward of Gondor shows us that despair can be even more destructive than apathy.

ALL SHALL SOON BE ENDED

Denethor's personal rationale is simple: The fight is doomed, evil will win, and survivors will endure worse than the slain. Aside from the death of his beloved son, Boromir, the movie doesn't make explicit the reasons behind Denethor's macabre jadedness, but the book offers a critical revelation: Denethor, using a palantir, has seen visions manipulated by Sauron that compel him to despair and hopelessness. Imagine Frodo's vision in *The Fellowship of the Ring*, in which the Shire is burned and the hobbits enslaved and tortured—but that it was available for Denethor to gaze at whenever he felt compelled.

Where Denethor was a man overcome with dread, the doomer movement—referred to or described as being "doompilled"—is one fueled by social media feeds filled with global horrors and news reports on the climate crisis rather

"Denethor is the essential despair figure in this story of people refusing despair,"
says Tolkien expert and author John Garth

than a magical speaking-stone. The core belief is that since humans have irreparably damaged the Earth, our lives will continue to get worse and worse until an extinction event mercifully wipes us out.

It's a legitimate response: White-supremacist extraction capitalism had already battered the globe before a pandemic arrived to exacerbate its worst tendencies. It's easy to see why folks are being doompilled even with the fastest disease-discovery-to-vaccination period in human history and record levels of concern on climate change.

But Denethor was ultimately wrong in his suggestions, and his death (and attempted murder of his son) was in vain. His commitment to despair and rejection of hope exacerbated his community's situation and harmed his comrades. So what can we and doomers, grappling with the twin-engine churning of late-stage capitalism and imperialism under the shadow of a waning global pandemic and waxing climate crisis, learn from Denethor's downfall?

DESPAIR, OR FOLLY?

In his book *The New Climate War,* Michael Mann, director of Pennsylvania State University's Earth System Science Center, quips that at least in the film adaption of *The Return of the King*, Gandalf was present to crack Denethor in the face and halt his campaign of surrender. (Later, Shadowfax boxes him up pretty

good, too.) "Sometimes I feel that way about doomists who advocate surrender in the battle to avert catastrophic climate change," he writes.

Mann argues that the "too late, we're screwed" rhetoric has been co-opted by extraction industries to continue their work unhindered, and that we have an obligation to rail against the "doom and gloom that we increasingly encounter in today's climate discourse." The central problem, Mann says, is that "doomism and the loss of hope can lead people down the very same path of inaction as outright denial."

Mann cites research backing up his claim that fear doesn't motivate people to action, while worry, interest, and hope—a supporting cast of Tolkien motifs—reliably do. Quoting the University of Colorado's Max Boykoff, he reminds readers that "if there isn't some semblance of hope or ways people can change the current state of affairs, people feel less motivated to try to address the problems."

But how and why did Tolkien write Denethor 75 years ago as an impossible pessimist set against an inherently optimistic tale? "Denethor is the essential despair figure in this story of people refusing despair," says Tolkien expert and author John Garth, likening him to Boromir's succumbing to temptation amid refusals to do so. "The whole story would not work without that."

As Garth explains, pieces from the author's past can help illuminate Denethor's

tragic arc. The Tolkien expert and author says that Christopher Tolkien's History of Middle-earth book series evidences when Tolkien wrote certain passages. The character of Denethor emerged during World War II, when two of Tolkien's sons were involved with the British military. The death of Boromir was written in 1942, and Frodo's rendezvous with Faramir was written in 1944. According to Christopher, his father finally wrote Denethor's plot in 1946. By then, he'd consoled and mourned with the parents of two of his closest friends, killed in World War I, and fretted over his own sons' possible deaths.

"He was really intimate with these experiences of parental loss or fear of loss on a personal level and as an observer of friends' parents," says Garth. Set against a backdrop of potential fascist invasion, these experiences were likely to have coalesced into the sort of intense melancholy that characterizes Denethor. "Coming up with these ideas in the middle of the Second World War when there was no obvious victory on the horizon, it was obviously an intensely felt process, a working out of anxieties and convictions."

Garth says that Denethor's connection to 21st-century doomers can also be read through Tolkien's environmental bent. "It's not just a war," Garth says of *The Lord of the Rings*. "It's about the Earth being under threat of complete destruction by industrialists." Garth notes that even though Tolkien was believed to have hated allegory, the symbolism of an older man's despair causing him to betray his own child is also pertinent given the generational implications of boomers legislating in disregard of certain disaster in the future.

The Denethor of Jackson's *The Return of the King* is a relatively nuance-free character, a miserable, hapless prick rather than a respected, prestigious leader. Tolkien fans have taken issue with

Peter Jackson, Philippa Boyens, and Fran Walsh's interpretation of Denethor; one 2003 review of the movie called it a "caricature" of "a snarling and drooling oaf rather than a noble pessimist."

But faithful or not, the film's Denethor has become one of the trilogy's most enduring pop-culture phenomena. To prepare for the part, actor John Noble has said, he immersed himself in Denethor's circumstance.

"I did understand everything, everything about him, how he got where he was," Noble said in 2016. "It required quite a bit of research, a bit of understanding about the human psyche, the human condition." Even Denethor's manic munching was a considered piece of a human teetering on the abyss' edge. "That's what that was—obsessive eating," Noble said. "That's sad. Again, if you're looking at where the character would be at that point, that's what you do. That's what he did."

In a 2018 interview, Noble expressed empathy for his character: "This depression, an abject depression, can happen to people—we know this," he told Dove.org. "Basically, he lost faith and hope."

Garth admits he sometimes considers whether Denethor's worldview is indeed correct. "I've often wondered why it is that we have stories that have happy endings and uplifting moments. Is it an abdication of realism?" says Garth. "But no, I think that it's really bound up with the human spirit, and what the human spirit requires for its survival."

The problem with Denethor's doomism and the contemporary doompill movement is the community impact of their myopia. It is a very real and legitimate thing to be terrified by the climate crisis, but recoiling into inaction is consequential for all, and disproportionately so for citizens in developing countries most likely to feel the effects of the climate

"Basically, he lost faith and hope."

crisis hardest and fastest. Even the most striking of arguments in favor of stepping back from the fray, like Jenny Odell's smash 2019 book *How to Do Nothing: Resisting the Attention Economy,* advocate not for total disengagement, but for rationing our engagement according to what is most important.

As climate crises close in and the pandemic continues to keep us apart, the doomer movement has as much reason as ever to despair. Denethor shows us why we can't afford that, and why we must organize against it to work toward solidarity, care, and hope, even in the harshest of conditions. Gandalf wasn't able to stop Denethor in the end, but his pleas to the steward are still instructive: "You think, as is your wont, my lord, of Gondor only. Yet there are other men and other lives, and time still to be."

If you want to read more about...

> *Tolkien and hope, turn to page 223—* "The Lord of the Rings *Faithfully Adapted Tolkien's Unrelenting Belief in Hope*" *(Second November)*

> The Lord of the Rings *movies and social movements, turn to page 198—* "*Evangelicals Saw Their Foes in Harry Potter and Themselves in* The Lord of the Rings" *(Second Septermber)*

THE *LORD OF THE RINGS* MOVIES DECLINED TO ADDRESS TOLKIEN'S GREATEST FAILURE

SO IT'S UP TO US

Susana Polo

In his final years, Tolkien struggled to work on *The Silmarillion*, his unfinished magnum opus, which would be published incompletely and posthumously. According to his biographer, he would sit awake until the wee hours, trying to write, playing endless games of solitaire, and despair the next morning that he'd accomplished nothing. He felt keenly that he would not finish before old age caught up with him—a reality that he prophesied in his 1945 short story "Leaf by Niggle," about an artist who makes it his life's work to paint a tree, but whose perfectionism, procrastination, and resentful self-isolation keeps him from having finished more than a single leaf before he dies.

It wasn't just perfectionism and procrastination that preoccupied Tolkien. It was orcs.

Among the many details of Middle-earth he considered and reconsidered in his later years was the origin story of orcs. First they were elves corrupted by the dark god Morgoth, then beasts deformed into humanoid shape (also by Morgoth), then corrupted men (guess who? Morgoth).

Whether these changes represented Tolkien's late realization of the ethical contradiction in creating an obviously sentient kind of people that were nevertheless heroic to exterminate, or just his dry perfectionist desire for internal consistency in Middle-earth's metaphysics, we'll never know for a certainty. And ultimately, it doesn't matter what he meant to do. He could have written and rewritten their origin story for an eternal elven life, and would never have found an explanation that was not essentially one of the same stories that humans have always invented to moralize their brutality toward those they deem other.

Tolkien created the unsolvable puzzle of the "monster race," the concept of a people defined by inherent and universal cruelty, suitable only for extermination by the righteous. Fantasy fiction inherited it. Peter Jackson's *The Lord of the Rings* trilogy translated it to screen. And lately, fantasy role-playing games, an ever-growing medium in which it is perhaps most entrenched, have begun the long-overdue work of reckoning with it.

THE RACIST ORIGINS AND PERPETUATION OF ORCS IS INARGUABLE

Tolkien took a facet of his beloved English folklore and recast it in a physical guise of Orientalist tropes. In the

Men like
Boromir can
fall and be
redeemed,
men like
Théoden can
be corrupted
and cleansed,
but the only
good orc is
a dead orc.

version of their origin most known, he writes that orcs were made in "envy and mockery of the Elves," an inverse reflection of Middle-earth's most noble and divinely touched people. Over time, and through subsequent creators who set out to build their own Tolkienian worlds, the form of orcs has shifted to follow whatever qualities of the human form were the racist signifiers de rigueur of predatory strength, viciousness, ugliness, and brutal ignorance. Their only defining quality is that they are as evil as the heroic force is good, and they look like it.

But even if orcs looked like your next-door neighbors, everything else about them would still represent permission to take a certain kind of people and deem them "not really people." After all, Tolkien presents orcs as irrefutably sentient—they have military ranks and allegiances; they argue among themselves, grumble about their orders, and crack jokes; they take disciplinary action against deserters, which is to say, they are not mindless tools. Yet his work presents them as fully irredeemable. To kill an orc is not merely a moral good but also a moral imperative, and a self-evident one at that. Men like Boromir can fall and be redeemed, men like Théoden can be corrupted and cleansed, but the only good orc is a dead orc.

Jackson's trilogy prided itself on its faithfulness to Tolkien's text, a frame that presents it as preservation or translation rather than adaptation. (Needless to say, the Jackson movies did make significant changes to thematic and narrative elements of *The Lord of the Rings*.) It's also a frame that, whether intended or not, can both shield the films from some criticism of their choices and present those choices as the one and only true way to imagine *The Lord of the Rings*. For proof of that you've only got to look at 2001-era

paperback printings of the book series, featuring the film actors prominently on their glossy covers.

"Everyone really liked those movies and they were this cultural phenomenon, and we don't *think* of them as perpetuating orc racism," says James Mendez Hodes, a cultural consultant and games writer who has written extensively on the history of orcs in fantasy fiction. "And if we *do* think about them as perpetuating orc racism, we can't speak to that without saying, *Well, it started with Tolkien, and he's really the one who's culpable for this; if we're holding anybody responsible, Jackson was re-creating something that somebody else started.*"

Mendez Hodes likens this argument to a social media company that pleads innocence of the results of its own recommendation algorithm. "*We just made an algorithm. And the algorithm did it by itself.*" Accuracy presents a safe moral position for creators and those who would defend their choices—or build upon them.

"Anything bad that happens, anything bad that you inherit from the original, you get to get away with. You're saying, *I'm not making this, I'm telling you what Tolkien said, and it's our job to make a movie of what Tolkien said. So, anything that we do, we're just quoting somebody else.* The Jackson movies set up an algorithm—they set up a mode of adapting older work, adapting older tropes, that is now a refuge for anybody who wants to re-create something that might have something bad in it. If you want to re-create that old thing, and you don't want to engage with like anything in there that might be harmful, it's actually safe to do so because Jackson did it, and everyone really liked those movies."

Accuracy is a double-edged sword anyway. One person's "Tolkien intended hobbits to represent working-class English people—of course they're all white; that's simply accurate" is another person's "What's accurate is that Tolkien described Sam's hands as brown compared to Frodo's, so there's no reason Sam can't have been played by a brown or Black actor."

Writing here in 2023, this is a tack that some more recent adaptations of Tolkien's material have taken, with Amazon Prime's *The Lord of the Rings: The Rings of Power* casting multiple actors of color as human, elven, and hobbit characters; and with Magic the Gathering's *Tales of Middle-earth*, featuring illustrations that depict Aragorn, Gandalf, Merry, and others as characters of color. This flexibility of interpretation is a necessary iteration on Tolkien's text, and it can certainly represent a career boost for overlooked actors of color. But much like the hypothetical scenario in which orcs just look like regular guys, it still lacks a reckoning with the "monster race" as a concept.

DEEP DUNGEONS, POWERFUL DRAGONS

The monster race runs deep in the fantasy genre of tabletop role-playing, a realm where Dungeons & Dragons is the undisputed king. In D&D, adventure stories are imagined and told among participants who represent characters of their own creation.

There are many ways in which Dungeons & Dragons has reinforced the monster-race concept over the years, like listing a moral alignment for each kind of creature or person in terms like "usually" or "always" evil or good. But the monster race has also been tangled with the basic functioning of the game itself in a way that's harder to excise than, say, some suggested cultural details for half-orcs.

In D&D, tension is provided via an element of chance (the fabled 20-sided die) to determine the outcome of character actions, with the odds modified this way or that based on elaborate rules systems that apply simple numbers to traits like intelligence or strength. And, at least until very recently, Dungeons & Dragons' system applied the factor of a character's "race"—that is, whether they were human or orc, elf or dwarf—to that arithmetic by assigning immutable physical and mental advantages and deficiencies to a character based on the player's choice of their origin.

But rather recently, that has started to change.

Mendez Hodes points to early 2020 as his first inkling that Wizards of the Coast (the Hasbro-owned parent company of Dungeons & Dragons) was beginning to take the matter of orcs, and the game's locked-in "race" mechanics quite seriously. Following his publication of two articles—which he affectionately refers to as his "Orcticles"—on the progression of orcs and

their own algorithm for presenting the evil other, Wizards invited Mendez Hodes to give a talk for company employees on the topic.

Over the course of 2020 and continuing to the time of this writing, Wizards has gradually decoupled specific, innate advantages and disadvantages from a character's race in new D&D materials, and hired cultural consultants to help the company to retrofit old lore and create new lore with more care and awareness. In late 2022, Wizards announced that it would be additionally striking all use of "race" as a mechanical category from its future materials in favor of *species*.

This was work that had already been done by many in smaller and/or more independent fantasy-gaming circles—like Mendez Hodes' Orcticles—and Wizards brought many of those ideas (and those who'd voiced them, like Mendez Hodes) into the circle. Slowly, in the inch-by-inch manner of a corporation with many moving parts and capitalistic concerns, Dungeons & Dragons has started to reckon with its role in the monster-race trope, proving that even the most Tolkien-influenced fantasy settings can iterate on his worldbuilding without falling apart.

THE ROAD GOES EVER ON AND ON

So perhaps the "monster race" is less of a puzzle and more of a Gordian Knot, in that once you have thought outside the box and cleaved it in twain, you're still left with a couple piles of cord in serious need of detangling. It's one thing to change some rulebooks for a roleplaying game—it's another to materially change a central, near-century-old pillar of a vastly popular genre of storytelling. It's up to us, as creators and fans of fantasy, to build on our foundations with care, love, and open eyes.

There are creators and fans of color who find the idea of an unfairly demonized people as a point of identification, and find power in telling stories in which orcs can be triumphant, multidimensional heroes. In this way, some have adopted orcs in the same way that marginalized communities have so often adopted slurs in order to reclaim them. Mendez Hodes takes a more proactive and defensive stance on playing as an orc in the collaborative medium of tabletop RPGs:

"If I don't know the people at the table, if I don't totally trust the DM of my D&D game, I'm going to play the character at the table who has the most potential to be most offensive, because I want to control that narrative," Mendez Hodes says. "This isn't just because that's engaging and interesting to me—it's because if I play an orc, then if you start saying shitty things about orcs, I have power to deal with that."

For this writer's own part, I would argue that if we love Tolkien's work, we are under obligation to fix the problems he created for a simple reason: It's what his own writing tells us to do.

"Leaf by Niggle," Tolkien's own prophecy of failure, doesn't end with the artist's death. After an interminable time in a kind of bureaucratic purgatorial penitentiary, Niggle finds himself in his true afterlife: the world of his painting. Here, the sanctuary of imagination he was never able to realize or share to his satisfaction is real. The central tree is bursting with life, the forest beyond it can be walked through; the mountains on the horizon can be explored. And he's not the only one who has made their way there.

His neighbor, with whom he never got along in life, arrives. The two learn a new appreciation for each other as they work together to improve upon the artist's vision, with the neighbor adding his

expertise. They build a cottage by the tree that the artist hadn't himself imagined, and the neighbor prepares for his wife's afterlife, anticipating that she'll add her own welcome touches as well. Satisfied as he never was in life, Niggle eventually travels on from his painting-world to the faraway mountains and beyond them, to what lies beyond the bounds of his imagination.

His art, unfinished in his lifetime, lives on for others to make their home there. It becomes a chief location of heaven, offering healing, peace, and succor to the weary and endless adventure and discovery for the rested, who find it easy to trade pleasant effort for satisfying achievement.

For a guy who resisted the idea that *The Lord of the Rings* was about any specific aspect of his actual life, "Leaf by Niggle" is like Tolkien shouting into a bullhorn about his creative anxieties, existential dread, and most fervent hopes and his opinion on the purpose and value of art.

What "Leaf by Niggle" says is that Tolkien didn't think art was for worshipping under glass or repeating by rote. He hoped that his art would be for others to explore, for others to find rest and fulfillment, and for others to build homes in.

Tolkien never stopped working on Middle-earth, and we don't have to stop working on it either.

If you want to read more about...

> Tolkien's non-*Lord of the Rings fiction*, turn to page 19—"Tom Bombadil Is the Stan Lee of The Lord of the Rings" (September)

> Orcs' big personalities, turn to page 164—"How to Invent Orc Restaurants" (July)

His art, unfinished in his lifetime, lives on for others to make their home there.

AUGUST: CONS AND COLLECTORS

REVISITING *THE LORD OF THE RINGS*' SHOCKINGLY CHILL PANEL AT SAN DIEGO COMIC-CON 2001

FROM THE ONERING.NET'S QUICKBEAM

Clifford S. Broadway

I wanted the team working on these films to feel the fan love...

"The heirs of Elendil do not forget all things past," said Strider. Neither does Ringer fandom—that gregarious, hypercreative global collective that puts literature and legacy first. Not only do we have oliphaunts in our stories, we have their memory, too.

From the age of 8, I have been on the front lines of a fan phenomenon that has taken me from the gatefold covers of my brother's treasured Led Zeppelin albums to distant Kiwi lands where the stars are strange. But nothing, and I mean nothing, can reach the level of unique fan chaos generated at San Diego Comic-Con.

With the exception of these two recent summers affected by COVID-19, I have attended SDCC yearly since 2000 as a panelist, emcee, and host for our fandom, and Lor' bless me, Master Frodo, surely we've witnessed changes we should have seen a-coming (if you'll forgive my inner Samwise speaking out).

In 2001, the leviathan (and legendary) Hall H was yet only an architect's fever dream, so it was the task of the newly minted Ballroom 20, adjacent to the Exhibit Hall, to house the big-ticket studio presentations. These huge blowouts in a ballroom were the newest craze.

New Line Cinema was ready to unspool that Mines of Moria escape footage it had just screened at the Cannes Film Festival (earning pivotal early buzz in the world press and delight from the studio's foreign market investors).

Ringers were salivating. I was fit to explode with eagerness. *The Fellowship of the Ring* was five months from wide release, and the most anticipated meal ever was about to be served in that Ballroom. Assuredly we were all ignoring Gandalf's famous advice that "those who have laboured to prepare the feast like to keep their secret; for wonder makes the words of praise louder." It was too late for that.

I wanted the team working on these films to feel the fan love—I genuinely did. Giving direct acknowledgment to these intrepid artists was my main goal. They told me how isolated they felt "way down there" apart from the larger apparatus of filmmaking in Los Angeles, and it made me want to share more energy with them so that these wonderful craftspeople could know, in their hearts, we had their backs. Yes, naive and optimistic, but a little acknowledgment goes a long way. Try it sometime.

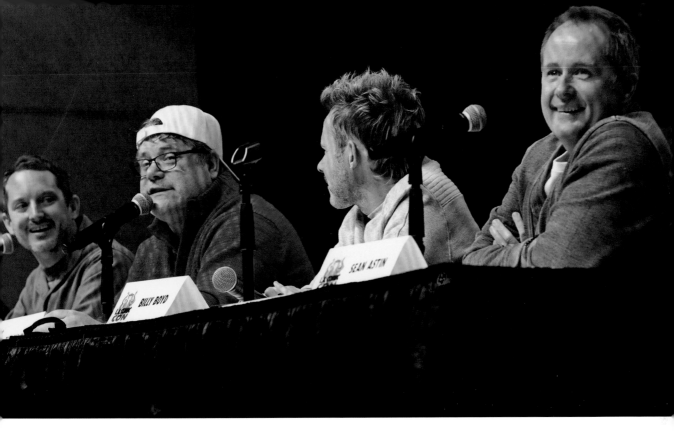

The *Lord of the Rings'* Wellington, New Zealand–based filmmakers were thrilled with the famous Spy Reports delivered by TheOneRing.net at the time, sparking buzz and speculation nearly weekly for a production doing something of which they were already immensely proud. Now, at SDCC, they were about to get their first taste of wild honey from a fandom ready to embrace it all, from the top down, yet still slightly wary of Peter Jackson's zombie-splatter-film past. Admittedly, interactions with everyone from the Wētā Workshop team signaled to me these artists were unprepared for the waves of adulation about to crash on their quiet shores. Attending SDCC 2001 was their first step toward receiving worldwide seismic acclaim.

Funny to see the tone I took back then, but I was indeed onto something when I observed the needle moving away from printed matter (illustrated fiction and actual comics) to film and TV promotions. I and many other pop-culture observers at the time had foresight, perhaps, that Hollywood would carefully calibrate its use of SDCC as a blunt marketing instrument for its biggest "genre IPs." At that time, being comic book–related or spun from fantasy, sci-fi, anime, or video games was the low-bar prerequisite your show needed to have some studio executive throw money at such a convention push. All things being equal, it was billed as "Celebrating the Popular Arts."

Unfortunately, the pattern grew and cemented its weedlike hold on the con: In eight more years, this metamorphosis would see studios and networks hawking their shows like any flimsy factory product even without it being genre storytelling. By the time the ABC network dragged Patricia Heaton into the ballroom for a

Elijah Wood, Sean Astin, Dominic Monaghan, and Billy Boyd, Los Angeles Comic Con, Los Angeles, California, December 2, 2023

pedestrian sitcom like *The Middle* (she famously exclaimed onstage, "I don't even know what we are doing here!"), I knew with fallen crest that the Golden Age of Genre Goodness was annihilated forever, erased from the landscape of San Diego.

A pity, that.

Nostalgia is powerful indeed: Even as Ringers of a new generation anticipate big things from Amazon Studios' billion-dollar foray into a Middle-earth adaptation, *The Rings of Power*, we still hearken back. We learn something from such golden-hued memories of a time when the internet was a little more innocent, a lot less jaded, and happy to celebrate J.R.R. Tolkien's works in boundless good faith. Over at TheOneRing.net, we still volunteer to keep those beacons lit, and welcome all generations of fans to join in fellowship.

What you're about to read is a little piece we published on TheOneRing.net out of San Diego Comic-Con 2001 (under the online pseudonym Quickbeam, a habit of '90s internet bloggers). Polygon has given me the delightful opportunity to look back and marvel at a behemoth of popular culture (observed from a safer distance) and to laugh at my own naivete, perhaps. Here's what we saw in 2001:

Greetings—Quickbeam here.
Last year all us Tolkien fans were just scratching the surface of the San Diego Comic-Con. In contrast, this year we hit the radar like never before!

It's a combination of things that makes this Con such a powerhouse event for people who love fantasy, illustrated fiction, great movies, games, and all the "Popular Arts." It ain't just comic books anymore, kiddo. In fact, today's *Los Angeles Times* had an article about how the movie industry is much more aware of how this type of gathering. This Comic-Con, in particular, is a unique promotional springboard for Hollywood's biggest "event movies." Peter Jackson's *The Lord of the Rings* included.

In this scenario you can't expect a studio to overlook its fans, and in San Diego it is the genre film that reigns supreme. Highlights included sneak previews of *Spider-Man*, *Planet of the Apes*, the new DVD release of Robert Wise's completed *Star Trek: The Motion Picture*, *Harry Potter*, and the crown jewel of all fantasy, *LotR*. Lowlights that left a bad taste in the mouth included the painfully trite *Smallville*, soon to premiere on the WB Network (beware, viewers, your beloved Superman has been turned into *Beverly Hills, 90210* drivel) and John Carpenter's *Ghosts of Mars*, which was ignored by a chilly audience.

The award for Most Eye-Catching Display goes to DreamWorks. They impressed many attendees with a massive floor exhibit from *The Time Machine*. The giant glass-and-brass apparatus was a marvel to see, nearly two stories high and about 3 tons of hardware, by the look

AUGUST **10**
The Funeral of Theoden, and the wedding of Faramir and Éowyn.

AUGUST **15**
Using the power remaining in his voice, Saruman convinces Treebeard to release him from Orthanc.

AUGUST **14**
The homeward procession leaves Edoras.

of it. My friend called it "a giant chandelier that was assimilated by the Borg." The whole thing looked like an exhibit from the Smithsonian.

And where was New Line Cinema? Evidently, they decided on a low-key approach, saving their big guns for the Saturday-evening showing of *Fellowship* footage. As we have reported, it was a mind-blowing event with so many thousands of people jammed into the huge converted ballroom. Even though they didn't pass out any free gifts or T-shirts (Tookish and I are quite fond of mathoms), you could not ask for more enthusiasm!

Remember last year, when Sir Ian McKellen sprung out on stage and surprised the heck out of everyone? This time, as the video footage from Cannes played on the giant screens, you could tell from the look on his face that he wanted to be with us all in person once more. You got the feeling he loved the passion behind the filmmakers' work, and equally the passion that Tolkien fans have brought to this new project—and he said as much in a more gracious manner than I ever could. I recall him saying, "If it weren't for you, and your love of these books, these films would never have been made." From the heart of the wisest wizard comes a wonderful acknowledgment for all of us.

One shining moment during the Hobbiton footage made us stop and laugh. There were tables set with piles of food, wine, and delicious frosted cakes, and as the banners went up and tents were raised under the Party Tree, a rustic old hobbit was caught on film addressing someone off-camera. He defiantly declared, "Say what you like about Mad Baggins, but he sets the most bountiful table in three farthings," or something close to that. Tookish and I both debated this mystery hobbit, and came to an early conclusion that it was the Gaffer himself! We shall see, we shall see.

Mr. Elijah Wood proved to be excellent and beyond patient. After the *LotR* footage, there were swarms of fans who piled up on him with flashbulbs, videocams, and pleas of "Could you sign this for me?" I happened to be one of the culprits, so I must deeply apologize to Elijah for instigating the crowd. I just couldn't help it. How often does one get the chance to meet the Ringbearer himself!? Later in the evening, the whole dining company was in good spirits, as Tookish has already related. Elijah's timing is quick and so are his wits; as the evening wore on he showed his gregarious side even in the late hours. No doubt it was great fun working with him in New Zealand for 18 months!

Last year we had lunch with Gandalf. This time it was dinner with Frodo. Who knows what might happen in 2002? The mind boggles.

But, seriously, no star shined brighter than Richard Taylor, president of Wētā, and his brilliant team of designers from New Zealand (and at least one of them from

Australia, or else I'm a ninnyhammer!). All people around them are touched by their generosity. All discussions turn to quiet listening and wide-eyed wonder when they speak of *LotR*. All doubts about these films wash away when you hear Daniel or David or Richard talk. We were thrilled to be part of their company and doubly lucky that Richard took part in our presentation. Here is a transcript of Richard Taylor's eloquent words before a packed house, all Tolkien fans eager to learn more of Wētā's role in the filmmaking process:

Hullo, and this is obviously a great pleasure to even have come to San Diego and come to the Comic-Con, but, ah, a few of our guys from the workshop have just been invited and had the opportunity to have a quick word to you. We started on the film five years ago now; we've been in the film industry for 14 years, so it's over a third of our working careers have been committed to bringing the world of Tolkien to the audiences of the world. We chose at the very beginning to look after the five departments under the one roof of our Wētā Workshop. We've looked after the special makeup effects, the creatures, the armor, the weapons,

and the miniatures, and in effect looked after all of the war and injury rigs as well. To look after the design, fabrication, and onset operation of so many departments on one film is obviously an unenviable task—but to be stupid enough to suggest that we could look after all three films was sheer madness. But there certainly is probably not a better audience in the world than those sitting before me now, who will appreciate likewise (applause) what I say about this.

Tolkien—any individual author—writes a singular vision of their creativity; likewise did Tolkien, and when we came to make this film and Peter (Jackson) offered us the decision on what departments we wanted to look after we knew that if we didn't take on as much as we possibly could and came to the world of Middle-earth with our own singular Tolkienesque brushstroke, there was the possibility that the project would become fragmented. There is no more important thing to this film project than an integrity and a realism to the vision of his writings.

At no time did we consider we were making a fantasy. We considered this a piece of English folklore; we believed we were trying to bring the writings of Tolkien in the way he tried to bring modern folklore to the world of England and our world to the screen. So to that end, we've invested a phenomenal amount of our time—our preproduction time—developing the cultures that you'll come to discover in the filmmaking. We've entered a huge amount of effort to create the graphic design of Middle-earth so that every culture has its own iconic realization. We were fanatical at a number of levels.

At all times I said to the guys in the workshop—we had 148 people working in the facility and another 38 on set—and I was absolutely adamant at all times that this wasn't filmmaking, this was legacy-making, and if all of us weren't in the mental position that we would want our grandchildren to sit on our laps and remember this project with them, then we weren't worthy of the project. (applause) At all times we had to approach this with a level of fanaticism some people bring to the Christian religions. (audience laughs) Yes!

Alongside Peter Jackson, obviously, we've had the most incredible five years of our lives. We've been blessed to have been given the opportunity to do this. We have been touched at a level that we could never have considered at the beginning. We knew it was going to be special, but it has been special beyond our wildest imaginations. I hope, when you all watch these three films, that you likewise will be touched again after reading the books for so many years: You'll be touched again by the visual imagery, the wealth and richness that we hope we've brought to your Middle-earth.

Thank you very much." (loud, raucous applause)

Again, we extend our gratitude to Sideshow Toys, Wētā, and Decipher Games for giving us a chance to share our Tolkien fanaticism. Congrats to all on an excellent four-day showing.

It was a long ride. It was also satisfying. Beyond the many people and events we experienced (or collided with) during the Con, we were impressed above all else with one grand, unavoidable thing: the building

wave of excitement! The Eyes of the World will soon be turning to *LotR*, and through the prism of our shared media, J.R.R. Tolkien will come under a brighter spotlight than ever before. This is the just the overture, as the sweeping arms of pop culture embrace the Professor and his works.

And with that, we bring the 2001 Comic-Con to a close. See you all next year.

Much too hasty,
Quickbeam & Tookish

If you want to read more about...

> *The last days of the* Lord of the Rings *being "niche," turn to page 132*—"The Lord of the Rings *Movies Heralded the Final End of 'Nerd Stuff'"* (May)

> *TheOneRing.net's effect on* Lord of the Rings *fandom, turn to page 30*—"I Wore Arwen's Dress to Prom Thanks to a Welcoming* Lord of the Rings *Fandom"* (October)

IT ONLY TOOK 13 FRODOS TO CHANGE ACTION FIGURES FOREVER

TINY TOYS, BIG IMPACT

Tim Hanley

From the day he leaves the Shire to the moment the Ring is cast into Mount Doom, Frodo Baggins changes his outfit three, maybe four times in the *Lord of the Rings* movies. And yet, between 2001 and 2005, Toy Biz managed to produce 13 clearly distinct and movie-accurate Frodo figurines. Thirteen different Frodo action figures is a lot of Frodos. Arguably, too many Frodos to have in one toy line based on one movie trilogy.

But that was very much the point. Those 13 Frodos redefined the action figure just in time for a new crop of toyetic blockbusters to dominate the minds of collectors and kids alike. That's right: *The Lord of the Rings* toys even taught Star Wars a thing or two about action figures.

Yet today, Toy Biz is gone, having shuttered years before *The Hobbit: An Unexpected Journey* graced screens in 2012 and the new trilogy's toy license fell to a competitor. The story of Toy Biz and *The Lord of the Rings* has DC Comics on one end, Marvel Studios on the other, and a middle filled with lasers.

SHADOW OF THE PAST

Before landing the *Lord of the Rings* movie license, Toy Biz was best known for superhero action figures, crafting some DC Comics toys in the late 1980s before entering into a long-term agreement with Marvel Comics in 1993. The two companies were closely connected, with infamous Toy Biz owner Ike Perlmutter serving on Marvel's board of directors. When Marvel faced bankruptcy in 1997, Perlmutter and his business partner, Avi Arad, kept the publisher afloat by merging the companies into Marvel Enterprises. Toy Biz served as Marvel's in-house action figure manufacturer from then on.

Handling Marvel's sizable catalog of characters proved to be an asset for Toy Biz when they pursued the *Lord of the Rings* license. New Line Cinema wanted an innovative toy line for their "incredible range of highly unique fantasy characters," said Toy Biz CEO Alan Fine in a 2000 news release, and Toy Biz had the necessary experience. The company had also developed a good relationship with New Line when they made action figures for the *Blade* movie franchise,

so despite strong competition from other toy manufacturers, Toy Biz won the rights to capture the "depth, spectacle, and appeal" of Tolkien's world, as Fine put it.

Everyone at Toy Biz took these words to heart, and embarked on a journey that many in the company would later call "the highlights of our careers." As development began in 2000, the action figure industry was in a state of flux. The biggest line in terms of sheer scope was Hasbro's Star Wars toys, but the small 3.75-inch figures offered little in the way of detail or articulation. Many manufacturers were moving to a 6-inch scale because of these shortcomings, with mixed results.

Some, like McFarlane Toys, with lines based on *Akira* and *Spawn*, had impressive detail but poor articulation. Others, like Toy Biz's own WCW wrestling line, were making strides in articulation but lagged behind in realistic detail, with obtrusive ball joints and painted-on costumes. For *The Lord of the Rings*, Toy Biz aimed to set new standards for scope, detail, and articulation, all at once.

THE MAKING OF THE FELLOWSHIP

To do so, Toy Biz partnered with Gentle Giant Ltd., a 3D scanning and modeling company, to get three-dimensional scans of all the *Lord of the Rings* actors, one of the earliest uses of this new technology. Gentle Giant had worked with Star Wars previously, but the small-scale figures didn't fully communicate what the machines could capture, and Toy Biz aimed to make the most of the enhanced level of detail.

Representatives from both companies traveled to New Zealand and met with every actor, in full makeup, leading them through an array of expressions as laser scanners revolved around their heads to capture their facial likeness. Toy Biz also worked closely with Wētā Workshop, and had access to their 3D scans of the film's intricate weapons, props, and costumes. All of these 3D images went into a highly detailed base model, allowing toy sculptors to craft action figures that were nearly true to life.

Toy Biz made strides in materials as well. Most action figures at the time were just hard, shiny plastic, with costume details molded into the figure core. For *The Lord of the Rings*, every figure had a hard plastic core base, but softer plastic pieces were layered on top to give more dimension. They were textured to replicate the look and feel of fabric, adding both realism and flexibility to coats, capes, and robes. Finishes were matte or glossy, depending on the fabric being replicated, to further enhance this realism.

At the time, action figure lines based on live-action movies were a negotiation of opposing needs: A more screen-accurate toy, appealing to the collector, would have to sacrifice mobility. But a more articulated toy, better for play and posing, would have to sacrifice accuracy. Toy Biz's line featured an array of joints that fit almost seamlessly within each figure, while accessories like sheaths and quivers were carefully crafted to fit each individual toy without inhibiting its articulation.

They had a wide range of movement without taking away from their lifelike appearance, allowing one toy line to offer both playability and collectability. Toy Biz also wanted the line to stand out in stores, and crafted unique half-moon packaging with a specific color scheme for each film. All of this effort and innovation was available for the same low price as any other action figure when the first wave of *The*

Fellowship of the Ring action figures hit stores in 2001.

The line focused on the main Fellowship initially, which immediately revealed one of the unique challenges of adapting the *Lord of the Rings* movies to toys: Hobbits are small. Frodo's first head sculpt was a bit severe and inconsistent from figure to figure, and the articulation was minimal, compared to his larger companions. But Toy Biz's second Frodo, released in the next wave a few months later, featured a new and improved head sculpt, along with additional elbow and knee joints that became standard for all of the small-scale figures moving forward.

From there, the line expanded quickly, improving with every wave as the company worked its way through *The Two Towers* and *The Return of the King*. They sold very well, and large online communities developed around the toys as fans discussed their collections, marveled at

the detailed work, and discussed their hopes for future lines. Toy Biz's sculpts grew more elaborate and the character choices became more creative, especially for Frodo. After making several variations of his standard costume, a translucent Frodo re-created his invisibility when he wore the Ring, while a Frodo in orc armor captured a scene that wasn't even in the theatrical cut, only the Extended Edition.

MANY PARTINGS

The close of a film trilogy would typically mean the end of the action figures based on it as well, but Toy Biz pivoted to the "Epic Trilogy" line, reissuing old figures alongside scores of new ones to fill in even the smallest remaining gaps, all in new, slimmer packaging. The company had already produced seven distinct Frodo figures, and in the two years after *The Return of the King* hit theaters it made six more, including a webbed-up Frodo who

was included as an accessory with Gorbag (one of over 20 orcs and Uruk-hai immortalized in action figure form).

Such was the scope of the line. Toy Biz went big, releasing a massive Treebeard in scale with the rest of the figures, and it went small, capturing the briefest of moments from the trilogy's epic runtime: A figure for Galadriel's dark form as she was tempted by the Ring during her "All shall love me and despair!" monologue. A figure for "Entranced Bilbo" that re-created the frightening split second when he lunged for the Ring in Rivendell. Even a figure for Theodred, prince of Rohan, and all he did in *The Two Towers* was die in a deleted scene. Nearly 150 distinct action figures were released over a five-year span.

And the standard set by those action figures, in detail, scope, accuracy, articulation, and technological innovation, still reverberates today. Larger, superposable figures became the norm at McFarlane, where toy designers now combine detail with articulation in series like their DC Multiverse line. Even Hasbro's Star Wars line got in the game in 2013, with their Black Series figures, using many of the same techniques Toy Biz pioneered. (The company has relegated the iconic 3.75-inch Star Wars figures to a specialized Vintage collection, and didn't even bother with a full line at that scale for *The Rise of Skywalker*.) Toy Biz's innovation is a new normal.

Unfortunately, Toy Biz didn't survive to see it. After taking over Marvel, Perlmutter and Arad set their sights on filmmaking, and Marvel Enterprises became Marvel Entertainment in 2005. Although Toy Biz had utilized the *Lord of Rings* line's innovations in their Marvel Legends figures, improving the collection, Perlmutter and Arad licensed the Marvel rights to Hasbro the following year. Hasbro continued Marvel Legends with the same style and techniques, and later applied those methods to the Star Wars Black Series. Meanwhile, Perlmutter and Arad had no use for their own toy division anymore, and Toy Biz was shuttered.

Bridge Direct landed the toy license for the *Hobbit* trilogy in 2012, but the new line offered only a handful of flat, lifeless figures that paled in comparison to the realism and breadth of Toy Biz's offerings, and it quietly fizzled out. There were no Bridge Direct Frodos, either, despite Elijah Wood's *The Hobbit* cameos. Toy Biz would've been all over that. Diamond Direct acquired Gentle Giant Ltd. in 2019 and launched a new *The Lord of the Rings* action figure series in 2021 that's garnering positive reviews, though they've only announced seven figures thus far—and just one Frodo.

Only 12 to go!

If you want to read more about...

> What the Lord of the Rings *movies evolutionized Hollywood, turn to page 86—*"The Return of the King *Won the Prize, but It Was* Fellowship *That Changed the Oscars Forever*" *(February)*

> How The Lord of the Rings *affected unexpected places, turn to page 221—*"How Hobbiton Changed Life in Matamata, New Zealand" *(Second October)*

THE LORD OF THE RINGS HELPED KEEP A 50-YEAR-OLD SHADE OF LIPSTICK ALIVE

THE STORY OF ARWEN'S BLACK HONEY LIPS

Maggie Lovitt

The early aughts were filled with a lot of questionable makeup choices for preteens and teenagers, from bold blue eyelids to flavorful Lip Smackers and sparkly lip gloss. But 20 years ago, there was another very specific lipstick that had a chokehold on anyone who found themselves thrown into an obsession with Middle-earth.

In 2001, *The Lord of the Rings: The Fellowship of the Ring* burst onto movie screens everywhere, and a cultural reset began. Liv Tyler's Arwen wore the perfect shade of lipstick in *Fellowship*. It was eye-catching, yet understated, and shockingly from a brand synonymous with Macy's department stores and the bottom of our mothers' purses. The brand? Clinique. The shade? Black Honey.

Now, 20 years after the release of *The Fellowship of the Ring*, Arwen is having a renaissance of sorts. In late June, a trend emerged on TikTok that led to users seeking out Clinique's Black Honey lipstick online and in stores, and once again trying to replicate Arwen's iconic look for themselves.

Arwen Undómiel first appears in J.R.R. Tolkien's *The Lord of the Rings* trilogy when Frodo Baggins arrives in Rivendell, but the majority of her story is told within the appendices of *The Return of the King,* which expanded the rich tapestry of lore in Tolkien's legendarium. While Arwen did not play a major role in the source material, Peter Jackson smartly chose to make her a more active participant in his film adaptation. By doing so, Jackson brought Aragorn and Arwen's love story to the forefront of the films, and that alone sparked a different kind of love story with the fans.

Arwen became an icon to a lot of young women who were looking for their place in Middle-earth (page 30), and she had a lasting impact on the audience at many levels. It isn't just cosplayers that are tracking down Black Honey lipstick to complete their costumes—TikTok is filled with regular, everyday people looking to incorporate it into their go-to makeup routines. Éowyn, with her "I am no man!" line, is undoubtedly the first character who comes to mind when you think of strong female characters from *The Lord of the Rings*. But it's Arwen that seems to be inherently bound to the cultural memory in such a way that people long to re-create her aesthetic.

On TikTok, the hashtag #Clinique BlackHoney garnered nearly 25 million

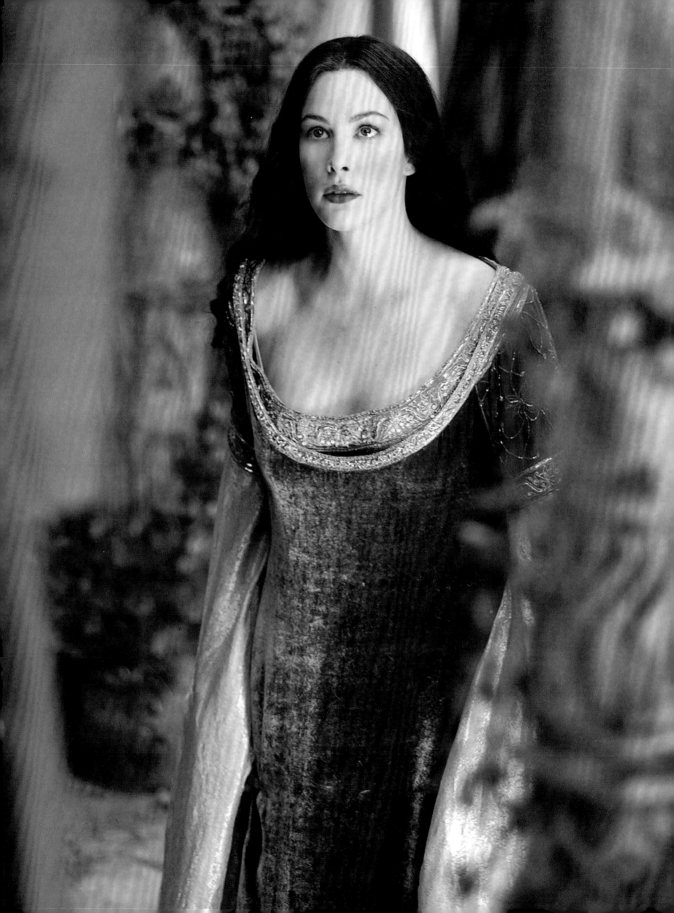

views in the span of a few months, with a number of users going viral with their makeup routines. Lauren, a cosplayer who goes by Lauren.Does.Cosplay, got over half a million views on her video where she tested out the product.

"Arwen has always been an icon to me since I watched *Lord of the Rings* when I was eight years old," she told Polygon. "Not only is she stunning and the embodiment of a woman who can also be a warrior, but her love for Aragorn and her willingness to give up her immortal life for him is such a wonderful love story." She went on to say, "I admire Arwen's courage to follow her heart, even in the face of the world's greatest evils."

Clinique introduced Black Honey lipstick in 1971, a mere five years after an official edition of *The Lord of the Rings* hit the US bestseller list. The raisin-colored lipstick stood in stark contrast to the bright colors that proliferate in the age of disco and psychedelics. While it might look dark before application, the lipstick, according to Clinique, is a blend of blue, red, and yellow pigments that works for every skin

tone—even Liv Tyler's pale complexion. At its debut, it was sold in a gloss pot, but Clinique relaunched Black Honey in 1989 in the same sleek tube that it's sold in today. Lauren agreed with this sentiment, noting that she had already incorporated the lipstick into an everyday routine because "it's the perfect lip for running errands."

Peter Swords King, hair and makeup designer on the *Lord of the Rings* trilogy, told Polygon that he chose Black Honey because it had "dark undertones, but at the same time it was sheer so [it] would look like the colour of her lips rather than lipstick." When asked about the fact that his makeup designs have endured as a go-to look for so many fans, King said, "I find it absolutely amazing that people are so influenced by something that I did so long ago. It is also very flattering as I am now working on my 50th movie in a design capacity. Long may it continue. "

A lot of information about the *Lord of the Rings* films has been passed down like folklore over the past 20 years. In that time, the internet has drastically changed—in some cases taking with it vital information that had been painstakingly curated and cataloged by dedicated fans, who spent their free time running fan sites and fostering a community. Other fans have done the work of preserving that information.

In 2001, *The Lord of the Rings* makeup artist Noreen Wilkie was interviewed by *InStyle* about her work on *The Fellowship of the Ring*. The interview included the first reference to the Clinique Black Honey lipstick that was used "to soften" Liv Tyler's lips. At one point, the article was uploaded onto TheOneRing. net (TORn), a site dedicated to everything a fan could need—scanned articles from magazines, information about community meetups, and vital links to other sites like AlleyCatScratch.com.

This is a great example of how

information has been passed along within the *Lord of the Rings* fandom over the years. The interview was first published in the print version of *InStyle* before appearing online temporarily for AOL and *InStyle* subscribers. For a period of time, both TolkienOnline.com (now TolkienEstate.com) and TORn hosted links to the *InStyle* article. At some point between 2001 and 2008, the article was deleted, but the information was preserved on one fan's personal site, Very-Faery.com. The person behind Very-Faery saved the article in Microsoft Word and then posted it on their own site. That site, though now also deleted, was fortunately captured and preserved by the Wayback Machine.

It takes dedication to ensure that vital fandom information remains accessible for future generations of fans. And it's a task that is growing more difficult for digital archivists trying to preserve significant fandom sites like GeoCities from mass data deletion.

Outside of pulling this information from the depths of the Wayback Machine, the only remaining evidence of Black Honey lipstick being used for Arwen exists in a post that was originally uploaded sometime prior to April 2008. The dedicated fans at AlleyCatScratch.com created a handy guide to Arwen's makeup, which listed both the screen-accurate palettes and less expensive alternatives to replicate the look.

Today, fans aren't necessarily looking for alternatives that are cheaper—they're seeking ones that can be found on shelves at all. Clinique's website claims that a tube of Black Honey lipstick is sold every three minutes, and that may not be bluster. The renewed interest on TikTok seems to have made the lipstick hard to find. Licensed cosmetologists like Jenn Aédo have been providing viewers with alternatives, including cruelty-free or vegan dupes such as Burt's Bees Tinted Lip Balm in Red Dahlia, ELF Sheer Slick Lipstick in Black Cherry, or Tarte's Quench Lip Rescue in Berry.

Aédo went viral in August with nearly 3 million views on a video in which she discussed the Black Honey trend. In an interview, she explained that the Sephora store where she works is completely sold out of the shade. While Aédo said that no customer has specifically mentioned Arwen when asking about the lipstick, she expected that upcoming comic conventions would only lead to more people searching for the shade.

No matter how far removed fans may be from the release of the *Lord of the Rings* trilogy and the initial fanfare that came with it, the franchise gave them characters that they still carry with them to this day. That may be wearing the Ruling Ring around their neck, or it may be applying a little Black Honey lipstick before heading out the door to face whatever battles wait for them. Arwen's look remains a classic for fans. As Peter King Swords said, "Long may it endure."

If you want to read more about...

> Arwen's immortal style, turn to turn to page 30—"I Wore Arwen's Dress to Prom Thanks to a Welcoming Lord of the Rings Fandom" (October)

> The Lord of the Rings and Tiktok, turn to page 135—"The Lord of the Rings' 20-Year-Old DVD Set Is Absolutely Thriving on TikTok" (May)

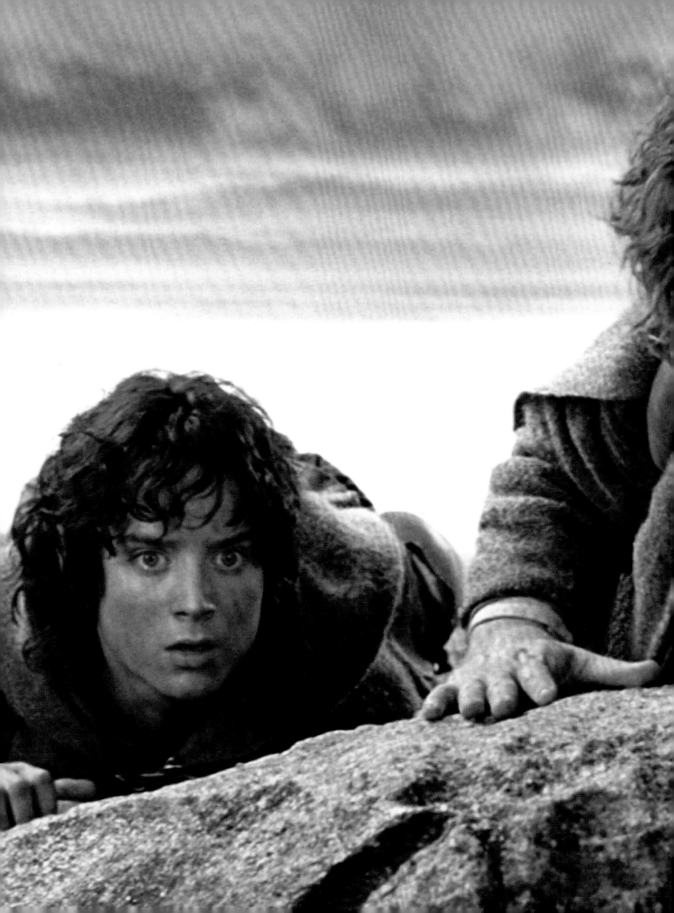

SECOND SEPTEMBER: MIDDLE-EARTH AND OUR EARTH

EVANGELICALS SAW THEIR FOES IN HARRY POTTER AND THEMSELVES IN *THE LORD OF THE RINGS*

HARRY POTTER WAS BAD, BUT TOLKIEN WAS GOOD, IN THE WAKE OF 9/11

Tom Emanuel

In 2001, my grandfather died. My parents announced their divorce. I hit puberty, developed my first crush. And in that same year, in anticipation of the incoming movie trilogy, I found *The Lord of the Rings*. It's impossible to overstate Tolkien's impact on my life, and I can't imagine becoming a minister in the progressive United Church of Christ without his work and the films based on it.

The Lord of the Rings made a believer out of me because it was the first story that taught me the power of story to give shape and meaning to our lives. And I saw it do the same for my conservative Christian classmates.

These are the kids who blasted Toby Keith's "Courtesy of the Red, White, and Blue" from their Walkman headsets and told me I was going to hell, because I obsessively reread *Harry Potter and the Goblet of Fire*. Yet their staunch Republican parents took us all to see *The Two Towers* when it came out, no questions asked. Why did the magic of Middle-earth get a pass from Christians who believed that "thou shalt not suffer a witch to live" (Exodus 22:18)?

One of the reasons I love *The Lord of the Rings* is its aura of tragic, heroic

finality, one that felt comforting and familiar to American conservatives who mourned the loss of a world they once knew. The difference is, conservatives and I are grieving for very different worlds.

A survey of ex-evangelical friends, colleagues, and Tolkien fans on Twitter—plus a search through the archives of *Christianity Today*, America's premier evangelical newsmagazine—suggests that while Peter Jackson's films may not have been met with the same kind of full-throated approval as films based on C.S. Lewis's The Chronicles of Narnia, many American evangelicals embraced them. This can partly be explained by the simple fact that J.R.R. Tolkien was, himself, a Christian (albeit the "wrong" kind, i.e., a Catholic). That doesn't explain why they damned J.K. Rowling, a self-professed Christian who incorporated Christian themes and symbolism into her work. What was the difference?

Fundamentalists argued at the time that Tolkien's moral vision was consistent with the Bible, whereas Rowling's was not. In a 2001 interview, the right wing polemicist Richard Abanes claimed that Tolkien's *The Lord of the Rings* exemplifies so-called biblical values "like integrity,

honesty, bravery, courage, forgiveness." Which, hey, fair enough. Moreover, it takes place in a secondary world, distinct from our own. Prosthetic ears and cosplay competitions notwithstanding, no child can actually become an elf like Galadriel or a wizard like Gandalf. (God knows we tried.) Not so with Harry Potter.

Abanes and the fearful parents who read his book *Harry Potter and the Bible: The Menace Behind the Magick* were concerned that young readers who wanted to imitate Harry and Hermione could "easily go into a bookstore or a library and get books on [divination and witchcraft] and start investigating it, researching it, doing it." If only they had waited a couple decades, they would have found in Ms. Rowling an unexpected ally in crusading against the basic human rights of transgender people.

I don't doubt that the reasons evangelicals gave for watching and enjoying the *Lord of the Rings* movies were sincere. But in my experience as a minister, our religious rationalizations often reflect deeper social and existential questions we may not even be aware of. In that light, we have to remember that Peter Jackson's trilogy was conquering the box office at the very height of the "War on Terror." Viewers who believed that the virtuous Christian West was locked in a deadly conflict with the wicked non-Christian East could interpret the films to reflect their odious politics.

Witness the Arab-coded Easterling soldiers marching in eerie lockstep through the Black Gate of Mordor in *The Two Towers*, or the dark-skinned Haradrim astride their mammoth Mûmakil at the Battle of the Pelennor in *The Return of the King. The Lord of the Rings* is a lot like the Bible: If you go looking for prooftexts to support your own xenophobia, imperialism, and Christian supremacy, you can find them.

I'd argue, however, that just like with the Bible, a fundamentalist reading of *The Lord of the Rings* is neither the only nor the most honest nor, indeed, the most faithful one. J.R.R. Tolkien once described the saga as "a fundamentally religious and Catholic work," but he doesn't bludgeon you with Christian allegories as nuanced as a cave troll's club. (I'm looking at you, C.S. Lewis.) Tolkien's Catholicism provides the spiritual matrix of Middle-earth without ever feeling the need to beat down your door and demand to talk about our Lord and Savior Jesus Christ.

And what distinguishes the War of the Ring from any real-world parallels is its profoundly elegiac quality. Even if we win, we are forced to acknowledge that much that is good and beautiful will pass away in the process.

Peter Jackson captures this bittersweetness brilliantly on-screen: the abandoned majesty of Moria; the burned-out watchtower on Weathertop; the Argonath, the monumental statues of ancient kings which featured so heavily in *Fellowship*'s promotional materials. The civilization that could hew such figures from the living stone is almost incomprehensible in its remoteness. Scenes of the elves of Rivendell departing Middle-earth, intercut with the action-packed battles of *The Two Towers* and *The Return of the King*, only deepen the sense that, win or lose, the Third Age of Middle-earth is on its way out. The elf-queen Galadriel calls it "the long defeat."

You can see how this might resonate with conservatives who long to retreat to the 1950s heyday of White American Protestantism, when church sanctuaries were packed to the rafters, crowds of children ran through new-built Sunday school annexes, and marginalized people were kept safely at the margins. This is what the Religious Right means when it claims to

want to "make America great again." Yet as early as 1998, Paul Weyrich, the man who coined the term "moral majority," observed, "I believe we have probably lost the culture war. That doesn't mean the war is not going to continue [. . . .] But in terms of society in general, we have lost."

More than two decades on, he's more right than ever. Christianity is increasingly seen as an irrelevant, oppressive anachronism, especially among young people. A 2021 Gallup poll found that for the first time in history, fewer than 50% of Americans are churchgoers. That trend shows no signs of reversing itself anytime soon. American Christianity is trudging through a Moria of its own making, drifting downstream past the crumbling feet of its own Argonath. Many churches stand empty; many that survive are hollow husks of their former selves. Even the liberal congregation I serve in Southern California, a formerly mighty "big steeple" church, reminds me of nothing so much as Minas Tirith at the beginning of *The Return of the King*: a once-thriving citadel now depopulated, a lonesome monument to a bygone era.

Perhaps this explains why the Religious Right prosecutes its culture war as if it were the War of the Ring itself. They know, at some unconscious level, that they cannot recover the past. But the prospect of admitting that is so traumatic, they'd rather fight an endless, unwinnable battle than face up to the reality that they've already lost. When I talk to Trump-voting Christians, the refrain I hear is "I hardly recognize my country anymore." Good! The conservative Christian political project spells disaster for the vast majority of the world's inhabitants. All the same, I can empathize with their sense of dislocation and abandonment.

I can empathize because when I found *The Lord of the Rings* in 2001, I hardly recognized my own life anymore. The events of September 11 shattered the sense of relative security I'd always known as a lower-middle-class white kid from a small town in rural South Dakota. Looking back, I can see that the story lodged itself so deeply in my psyche because I related to the poignant melancholy at its heart.

And I can empathize because in 2021, I hardly recognize my planet anymore. There is nothing original in comparing the ents drowning Isengard to the climate catastrophe, but metaphors don't need to be subtle to be true. Jackson's cinematic spectacle eerily presages a climate-changed future in which *our* towers will be the ones reclaimed by the vengeful Earth.

This universality is part of what made *The Lord of the Rings* so powerful upon publication in 1954, when Tolkien mourned the passing of his beloved English countryside. It was still powerful when Peter Jackson brought it to theaters in the early 2000s, when the blithe certainties of a pre-9/11 world could no longer contain 21st-century anxieties. It remains powerful today, when the UN's

TIMELINE 2002

SEPTEMBER **13**
Celeborn and Galadriel depart for Lorien as the homeward escort continues toward Rivendell.

SEPTEMBER **22**
Saruman arrives in the Shire.

SEPTEMBER **21**
Gandalf, the hobbits, and Elrond reach Rivendell.

SEPTEMBER **29**
Two years after the close of the Ring Quest, Frodo, Bilbo, Gandalf, Galadriel, and Elrond depart over the western sea.

climate report confirms that the ecological crisis is here to stay.

The Lord of the Rings and the *Rings* movies still grip us, not only because they look backward with longing but also because they look forward as well. Tolkien, and Jackson after him, capture the elegiac quality of life at the end of an age, even as it grants us courage at the dawn of another. In the face of the unknown, it teaches us to cling to one another and to the good we know: mercy, kindness, friendship, community. It inspires us to hope not because victory is assured but because without hope there can be no victory. It teaches us to be faithful not to a sectarian deity but to one another and to the world we share, because "even the smallest person can change the course of the future."

Are these Christian values? I suppose so—Christianity at its best. More importantly, they are *human* values that rang true in 2001 and ring true in 2021, no matter what you believe in or don't. It's why I read *The Lord of the Rings* aloud to my infant son and why we'll watch the movies together when the time comes: To teach him, in the words of Sam Gamgee, "that there's some good in this world, Mr. Frodo, and it's worth fighting for."

Amen to that.

If you want to read more about...

> *Tolkien's own faith, turn to page 233—* "The Lord of the Rings *Faithfully Adapted Tolkien's Unrelenting Belief in Hope"* *(Second November)*

> *How Jackson's movies failed to reckon with* The Lord of the Rings' *legacy of Orientalism, turn to page 175—*"The Lord of the Rings *Movies Declined to Address Tolkien's Greatest Failure" (July)*

This universality is part of what made
The Lord of the Rings *so powerful upon publication in 1954, when Tolkien mourned the passing of his beloved English countryside.*

QUEER READINGS OF *THE LORD OF THE RINGS* ARE NOT ACCIDENTS

FOLLOWING BREADCRUMBS TO FIND OURSELVES IN TOLKIEN'S HISTORY AND HIS FICTION

Molly Knox Ostertag

Ed. note: This essay contains discussion of homophobia and mention of suicide.

I was 12 in 2003, when *The Return of the King* was in theaters, and Frodo kissing Sam goodbye as he left Middle-earth made me sob like my heart was being ripped out, without understanding why. Outside of the safe darkness of the theater, in the Mordor-like wasteland of middle school, the movies were synonymous with the favored insult of the time—"gay."

Brokeback Mountain wouldn't come out for two more years, and none of us had seen a movie on the big screen where men hold each other, comfort each other, kiss each other's foreheads. Early-2000s preteen America was a time of gay jokes, of "no homo," of mocking voices and slurs, and secret, punitive violence enacted in the locker room against anyone who had a whiff of otherness. In that world, the *Lord of the Rings* trilogy stood out as deeply earnest, and therefore vulnerable.

I listened to *The Lord of the Rings* before I knew how to read. It's written on my creative DNA as the first book I really loved. But for a long time I avoided it, for the same reason that I learned not to talk about the movies at school: The accusations of queerness somehow tied into a story about elves, hobbits, and looming evil.

The essayist Italo Calvino defined a classic as "a book that has never finished what it has to say," and *The Lord of the Rings* is certainly a classic. Revisiting the book in the last year, as someone who has been out for many years and who is deeply engaged in making and consuming queer stories, I was amazed to find a same-sex love story at the heart of the narrative.

There are many relationships between men in the book, most of them platonic. Merry and Pippin are cousins, and banter like cousins. They fondly tease their other cousin, Frodo, and talk down to working-class Sam. Gandalf takes on a sometimes kind, sometimes frustrated grandfatherly role to the hobbits. Boromir and Faramir have an intense brotherhood, and have complex feelings about the loyalty owed to their king, Aragorn. These relationships are high drama, powerful examples of male friendship and family (page 90). But they do not read as intentionally romantic (and while fan interpretation is a diverse, wonderful thing, this essay is focused on authorial intent).

Frodo and Sam begin (as many great period-piece romances do) with a class difference. Frodo is Sam's employer, and

> *I was amazed to find a same-sex love story at the heart of the narrative.*

the distance between them in class and education is clear in early scenes. But as the story progresses, Frodo sees new sides of Sam in his impromptu poetry, his fascination with elves and stories, and his bravery. For his part, Sam is devoted to Frodo, discovering the depths of his devotion along the journey. He is flustered around Frodo, blushing when spoken to, holding "and gently stroking" his hands, face, and hair in various situations, and constantly expressing his loyalty.

As in any classic romance, through shared hardship they grow to become the most important people to each other. "Samwise Gamgee, my dear hobbit—indeed, Sam my dearest hobbit, friend of friends," Frodo says to Sam midway through *The Two Towers*.

Peter Jackson's excellent movies inject tension between the pair as Frodo is corrupted by the Ring—a choice that adds cinematic drama. But in the book, all the enemies exist outside the safety they find in each other, and a striking amount of description is devoted to their relationship. When Frodo is grievously injured, it is Sam (rather than any of Frodo's relatives present) who stays by his side night and day. Sam gazes at Frodo in Ithilien, noting his beauty, and thinks to himself, "I love him." They hold each other on the long trek to Mordor—Tolkien said in a letter that he "was [probably] most moved [. . .] by the scene when Frodo goes to sleep on [Sam's] breast." On a different night, Sam "comfort[s] Frodo with his arms and body." And they are pretty much constantly holding hands: in the Dead Marshes, through Shelob's lair, and while they sleep in Mordor.

Tolkien describes Sam as a "small creature defending its mate" when he protects Frodo from the monstrous Shelob. And when Sam thinks Frodo is dead, "all his life had fallen in ruin." When Frodo is

captured and imprisoned at the top of a tower, Sam finds him by improvising a song about hope and starlight that a naked, tortured Frodo weakly answers. When they wake after the quest is over, they're lying next to each other in the same bed. They kiss at least four times; another time, it's specified that they don't kiss, which has interesting implications. And when they return to the Shire, Sam moves into Bag End with Frodo—no longer a servant, but an equal and a constant companion.

The frame story Tolkien created for *The Lord of the Rings* was that the tale was simply translated from a much older historical document. This is established in the book's introduction, where the author describes how Bilbo's private diary (i.e., *The Hobbit*) was preserved and expanded by Frodo (and later Sam), becoming an account of the War of the Ring. That volume, *The Red Book of Westmarch*, was preserved and transcribed, and passed down as ancient history—"those days [. . .] are now long past, and the shape of all lands has been changed"—until it ended up in Tolkien's hands. This frame is evident through the book in bits of old lore scattered through the story, in footnotes on the quirks of translating languages like Elvish and Orcish into English, and in the

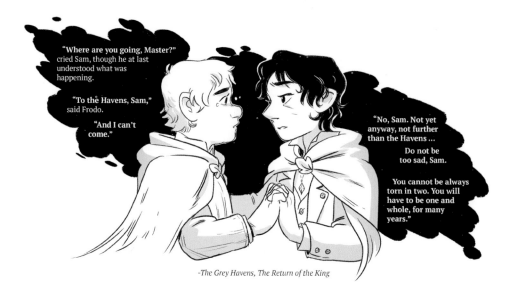

"Where are you going, Master?" cried Sam, though he at last understood what was happening.

"To the Havens, Sam," said Frodo.

"And I can't come."

"No, Sam. Not yet anyway, not further than the Havens ...

Do not be too sad, Sam.

You cannot be always torn in two. You will have to be one and whole, for many years."

-The Grey Havens, The Return of the King

extensive appendices that lay out Middle-earth's history before and after the story.

When a book is presented as a primary source rather than a work of fiction, it's an authorial invitation to look between the lines and search for hidden truths. The narrator becomes part of the fiction—history, after all, is recorded by specific people with their own motives—something that Tolkien, in his academic career as one of the world's foremost experts and translators of the Old English epic of *Beowulf*, would have intimately understood. It was a conscious choice on the part of "Frodo" and "Sam" to include the many moments when they express love for each other, and it reads much in the same way people from the past delicately referred to their same-sex relationships: wanting to acknowledge their truth while obeying the conventions of the time.

Heterosexual romance is sparse in the books, and discussion of sexuality between the characters is absent. (The One Ring can be seen as a metaphor for lust and temptation, but that's a whole other topic.) But Tolkien was not averse to romance. In a letter to one of his sons, he wrote about chivalric romance as the height of romantic love: "It idealizes 'love' [. . .] it takes in far more than physical pleasure, and enjoins if not purity, at least fidelity, and so self-denial, 'service,' courtesy, honor, and courage." This is the relationship between Aragorn and his elf-love Arwen and between Éowyn and Faramir" and it is, to a T, the relationship between Sam and Frodo.

It is also found in "The Tale of Beren and Lúthien," a high romance from Middle-earth's mythology, which Tolkien based on himself and his wife, Edith. Interestingly, there are many parallels between this story and Frodo and Sam's tale. Beren also has an impossible quest, and Lúthien also insists on accompanying him. Like Frodo, Beren is trapped in a tower by his enemies; like Sam, Lúthien sings to find him, and he answers her. Beren loses a hand; Frodo loses a finger. The Phial of Galadriel that Frodo bears was made with light from a star formed one of the legendary Silmaril jewels, the object of Beren's quest, something Sam notes—"we're in the same tale still!" For an author who was meticulous about world-building and mythology, the parallels feel intentional and pointed.

If you're a certain type of *The Lord of the Rings* reader, you're probably yelling, "Tolkien was a Catholic born in the Victorian era! He never would have written about gay people!" But there are examples of queerness in Tolkien's time and place, and any speculation is backed by historical context.

Three years younger than Tolkien, Edward Brittain was also a young, decorated soldier in World War I. He faced a court-martial in 1918 after one of his letters described "homosexual relations with men in his company." Rather than face the consequences—corporal punishment and two years in prison—and the shame the trial would bring upon his family, he walked into enemy fire and was killed.

Two years before *The Lord of the Rings* was published, war-winning codebreaker and genius mathematician Alan Turing stood trial for "homosexual acts and gross indecency"—that is, being caught in his own home with another man. He was sentenced to chemical castration, and took his own life—six weeks, in fact, before *The Fellowship of the Ring* came out.

Tolkien lived in a world where open same-sex romance was a social and often literal death sentence, where even writing about it (except to condemn it) was forbidden. For an example, we can look at Tolkien's good friend C.S. Lewis. Lewis wrote in a letter to Sheldon Vanauken (later reprinted in Vanauken's autobiography) that Lewis had received a letter from a "pious male homosexual [. . .] but of course it was the sort of letter one takes care to destroy."

Tolkien's fame as a Catholic writer leads people to assume he wasn't tolerant of queerness, though his published writing does not provide any evidence for this (unlike Lewis'). The only mention is a bland reference in his biography by Humphrey Carpenter: "As to homosexuality, Tolkien claimed that at nineteen he did not even know the word."

Many accounts of queerness from this time, especially ones that are neutral or positive, have been destroyed. We only know Brittain's story because his sister took the unusual step of preserving his letters. Of course, queer people and queer desire exist no matter what the laws say. So do we have any evidence that Tolkien had interactions with his queer contemporaries?

Tolkien wrote of the openly gay poet W.H. Auden as "one of my great friends," and Auden wrote glowing reviews of *The Lord of the Rings* when it came out. (They also had a fight because Auden visited Tolkien's house and said that it was "hideous," but that's another story.) As described by author Reynolds Price, at least one member of Tolkien's friend group, the Inklings, "separated from his wife and lived a quietly homosexual life." Most interesting to me, Tolkien was a teacher and fan of Mary Renault, a writer who spent her life in a romantic relationship with another woman. She became an icon in the gay male community for writing sympathetically about same-sex relationships in ancient Greece. Tolkien wrote that he was "deeply engaged" in her books, and that a letter she sent him was "the piece of 'Fan-mail' that gives me the most pleasure."

How would an author in England in the 1950s allude to queerness in his fiction? Tolkien notes in the introduction to *The Lord of the Rings* that "Bilbo and Frodo Baggins were as bachelors very exceptional" compared to other residents of the Shire—and Bilbo, who adopted his nephew and had "whole rooms devoted to clothes," certainly reads as queer. He never married, despite several drafts where Tolkien tried and failed to imagine a wife for him, and this fact is discussed in *Unfinished Tales*, a collection of stories and essays published

after his death. "[Bilbo] wanted to remain 'unattached,'" Tolkien wrote, "for some reason deep down which he did not understand himself—or would not acknowledge, for it alarmed him."

Bilbo and Frodo's home of Bag End is described by other hobbits as "a queer place, and its folk are queerer"—an adjective which had a strong connotation of homosexuality by the late 1800s. And then there's "strange fates," from one of Tolkien's letters, referring to elves who did not marry. The most notable example of this is the other implied same-sex romance of the book—Legolas, an elf who overcomes the ancestral enmity between dwarves and elves through his relationship with Gimli.

Delving into queer history can be frustrating, because so often you hit the wall of "we can never know for sure." It's tricky to apply modern labels to people that they did not claim in life—but modern labels include "straight" and "cisgender" just as much as "gay" or "transgender." All we can do is look at their lives and be open to the possibility. Sean Astin, the actor who played Sam, summed up this lack of definition excellently in a video on the Cameo video-sharing website in 2020 that subsequently went a bit viral: "I think Sam and Frodo should have kissed [. . .] how do you know they didn't?"

Near the end of the book, Sam marries Rosie Cotton with Frodo's encouragement (after dithering, because he wants to live with Frodo but also wants to start a family), and all three of them move into Bag End.

Samwise the Brave gets the hero's reward—wife and family, pastoral bliss—with the understanding that it would be no reward at all if he didn't get to live with Frodo. Sam and Rosie's marriage, and the other two that close out the book, indicate a future for Middle-earth

in the form of a new generation. But as Tolkien notes in another letter, "The greatest of [romances] do not tell of the happy marriage of such great lovers, but of their tragic separation." And that is the logic he applies to the central romance of his book.

While the quest is over and the story should be wrapping up neatly, Frodo is suffering from wounds that refuse to heal. He cannot claim his own hero's reward and enjoy his home and the people he loves—and so he leaves Middle-earth for the Undying Lands with the elves. And he does it, explicitly, because Sam describes himself as being "torn in two" by his love for Frodo and his love for his family. Frodo knows Sam can never live a full life while he is there, suffering.

I have to wonder about Tolkien's lived experience. He had a little fellowship of schoolmates, other young men equal to him in genius and creativity. They were drafted in the Great War, where nearly all of them died. One of them was Geoffrey Bache Smith, a poet whose work is considered homoromantic by modern readers. Smith died from enemy shrapnel at age 22. Before going into battle one day, anticipating his death, he wrote to his friend Tolkien: "My dear John Ronald [. . .] may you say things I have tried to say long after I am not there to say them."

Tolkien was haunted by Smith's death, driven to collect his poems and publish them. There are echoes of Frodo and Sam here—echoes of Frodo leaving, of Sam having to finish the literal book telling the tale of their quest.

Sam's struggle to finish their story is the framing device of a rejected epilogue (eventually published in *The History of Middle-earth*) set years after Frodo has left. Tolkien was fond of this final chapter, but cut it because early readers told him it was too sentimental. "Your treasure left,"

Sam's teenage daughter observes in the epilogue, referring to Frodo. She directly compares Sam's love of Frodo to the elf Celeborn's love of his wife Galadriel. The epilogue ends with Sam hearing the sound of the sea that separates him from Frodo, "deep and unstilled." As though even in a full and well-lived life there is the unspoken sense of something missing.

Tolkien had his beloved wife, Edith. Sam had his Rose. But there is room, I think, for another kind of love, specific to both the real and invented worlds that Tolkien inhabited. A love that grew in extraordinary hardship, and ultimately could not survive outside of it, but that was deeply meaningful all the same. A love that deserves to be seen for what it was, and to have its story told.

Queer people have always existed. The words for us have changed, will always change, but our hearts are the same. When we look at history, we must follow breadcrumbs to find ourselves. And like many of us, Sam Gamgee is obsessed with stories. He's always noting that he and Frodo are in a great tale, and wondering whether it will be happy or sad. When he thinks he will die to defend Frodo's body, he wonders if there will be songs written about this last act of loving defiance. He wonders, like so many others, if this love will be remembered.

So here's a final breadcrumb: Tolkien wrote that Sam rejoins Frodo in the Undying Lands at the end of his life. It's alluded to in the book, and briefly noted in the appendices. Why Sam goes, and what happens when he is reunited with his "treasure," is not a story Tolkien could tell. For clues, perhaps we can look to Tolkien's other great romance, as told by Aragorn in "The Tale of Beren and Lúthien":

"It is sung that they met again beyond the Sundering Sea, and after a brief time walking alive once more in the green woods, together they passed, long ago, beyond the confines of this world."

With thanks to the Rev. Tom Emanuel, Putri Prihatini, Paul Springer, and several other Tolkien experts for their feedback.

If you want to read more about…

> *Masculine relationships in the* Lord of the Rings, *turn to page 90*–"The Lord of the Rings *Revived Hollywood's Soft Masculinity with Boromir's Tender Death*" (February)

> *Queer perspective on the* Lord of the Rings, *turn to page 77*–"Peter Jackson Knows Exactly When to Be "Too Much"" (January)

Works Cited

Berry, Paul, and Mark Bostridge. *Vera Brittain: A Life*, Chatto & Windus, 1995.

Carpenter, Humphrey. *J. R. R. Tolkien: A Biography*, George Allen & Unwin, 1977.

Carpenter, Humphrey, and Christopher Tolkien, editors, *The Letters of J. R. R. Tolkien*, George Allen & Unwin, 1981.

Garth, John. *Tolkien and the Great War: The Threshold of Middle-earth*, HarperCollins, 2003.

Lewis, C. S. *Yours, Jack: Spiritual Direction from C. S. Lewis*, HarperOne, 2008.

McGhee, Beth. "Homosexuality in the First World War." *East Sussex WW1 Project.* Accessed 30 June 2021.

Price, Reynolds. *Ardent Spirits: Leaving Home, Coming Back*, Scribner's, 2009.

Tolkien, J. R. R. *Sauron Defeated*, edited by Christopher Tolkien, George Allen & Unwin, 1992.

Tolkien, J. R. R. *Unfinished Tales of Númenor and Middle-earth*, edited by Christopher Tolkien, George Allen & Unwin, 1981.

Rohy, Valerie. "On Fairy Stories." *Modern Fiction Studies*, vol. 50, no. 4, Winter 2004, pp. 927–948.

Tolkien and Alterity, edited by Christopher Vaccaro and Yvette Kisor, Palgrave Macmillan, 2017.

SECOND OCTOBER: THE MAKING OF

WHAT PETER JACKSON'S ORIGINAL TWO-MOVIE *THE LORD OF THE RINGS* ALMOST LOOKED LIKE

COMMISSIONED BY HARVEY WEINSTEIN, THE JOURNEY
TO MORDOR WAS SUPPOSED TO TAKE HALF THE TIME

Drew McWeeny

Hollywood careers are like icebergs, and the movies you actually see are just the tip breaking through the surface.

One of the great painful truths of working inside the system is that filmmakers can build entire careers out of developing material and selling work without having anything to show the ticket-buying public. It's why so many films get announced, then never happen. For directors, it's a numbers game. Staying afloat means developing 10 things and praying to God at least one of them actually gets made.

Even films that eventually get made can go through several incarnations before that happens. In the case of the *Lord of the Rings* trilogy, it's amazing how many moving parts there were in the process that eventually resulted in Peter Jackson's three films—which were nearly a two-movie project. I may be one of the few people outside of Jackson's production company, WingNut Films, to have ever read that version of the project, which would have compacted the action told in 558 minutes into two-thirds of that runtime. This story, of how *The Fellowship of the Ring*, *The Two Towers*, and *The Return of the King* came to be the

films that we know, is the movie business in a nutshell.

An adaptation of J.R.R. Tolkien's books produced by Peter Jackson was such an unlikely prospect in the first place. Jackson began his career as a fiercely independent artist not by design but by necessity. Growing up in New Zealand, he felt like he was a million miles from Hollywood. When he made his early horror movies *Bad Taste*, *Dead Alive*, and *Meet the Feebles*, he was launching them like one blood-soaked Hail Mary after another out into the larger world.

Those films earned Jackson and his partner Fran Walsh enough attention to attract interest from Los Angeles. In the 1990s, they found themselves developing the *A Nightmare on Elm Street* sequel and an adaptation of Paul Chadwick's cult comic *Concrete*, neither of which made it in front of the camera. One of the projects that put some money in their pocket started as a pitch for a *Tales from the Crypt* movie for Robert Zemeckis. As they worked on that script, they got serious about making their own films, their own way.

Heavenly Creatures, Jackson and Walsh's return to independent films,

finally punched through, netting them an Academy Award nomination for Best Screenplay and launching the careers of Kate Winslet and Melanie Lynskey. To pull it off, they created their own digital company, now known as Wētā FX, to handle the visual effects, and founded WingNut Films, specifically to develop projects that would provide Wētā with enough work to stay open full-time. As part of the distribution deal for *Heavenly Creatures* in 1994, producer Harvey Weinstein of Miramax made a first-look deal with Jackson and Walsh for their next film. The director later spoke about regretting the deal, which gave them some up-front development money, but obligated the pair to work with Weinstein.

Just as they started pitching projects to Weinstein, Zemeckis finally did something with Jackson's no-longer-*Tales-from-the-Crypt*-related script, now called *The Frighteners*. Without the ghost story, we would not have *The Lord of the Rings*. Not only did Jackson make the film himself in New Zealand at a greatly reduced price, expanding on the digital team he originally put together for *Heavenly Creatures*, but he also brought in Hollywood movie stars that primed the film for the international market. Casting Michael J. Fox in the lead was a coup.

In order to make the film, though, he had to talk Weinstein into allowing him to defer the start of their first-look deal. Weinstein made it clear to Universal Pictures, the studio backing *The Frighteners*, that he was doing the studio a huge favor. The producer made sure Jackson knew it, too.

Jackson and Walsh started toying with the idea of an original fantasy film while they were in production on *The Frighteners*, convinced that would be the thing they took to Weinstein. The longer Jackson and Walsh worked to figure out a story, however, the more

they kept coming back to Tolkien and his enormous influence on the entire genre. They felt themselves inadvertently ripping off Tolkien's *The Lord of the Rings* no matter how hard they tried to avoid the monolithic text. Eventually, Jackson asked Weinstein to figure out who owned the rights to the Middle-earth books. The producer agreed to hunt it down. In the meantime, he encouraged Jackson to crack the code and actually turn this material into something they would be able to film.

Here's what no one talks about when they talk about the projects that directors develop that never happen: They take a toll. And not just on the director, but also on all of the artists who work with them. It can be difficult to put one's heart and soul into something over and over and then not see it happen. The loss breaks people if it happens enough times. Jackson was devoted to keeping Wētā open and working, and the *Lord of the Rings* films were a huge promise to its employees' financial future. Weinstein kept telling Jackson that they were going to make their Middle-earth trilogy—the idea being to do *The Hobbit* first, then adapt *The Lord of the Rings* as a two-film follow-up—and the filmmaker had to believe him. That created a tremendous amount of pressure. But behind the scenes, Weinstein was struggling to lock the rights down because of the late, great producer Saul Zaentz.

Like Weinstein, Zaentz was a towering presence in the film community. He only produced 10 movies, but I'd call at least five of those masterpieces. One of those that I would not call a masterpiece is Ralph Bakshi's 1978 animated *The Lord of the Rings*, but because of that project, Zaentz found himself in control of the book rights (though a strange deal involving United Artists gave him only partial ownership over *The Hobbit*). When

Harvey Weinstein came calling, Zaentz wasn't especially interested in working with him after their recent, bruising experience together on *The English Patient*, and it took the better part of a year to hammer out the deal. Weinstein felt the same way, and part of what complicated things was his insistence that Zaentz be contractually barred from participating in the actual development process.

Meanwhile, Universal was so pleased with the way *The Frighteners* was going during production that executives asked Jackson if he wanted to make his dream project: a remake of *King Kong*. 20th Century Fox also came calling to see if he wanted to get a long-gestating reboot of *Planet of the Apes* off the ground. The longer Weinstein took to pin down Zaentz, the harder it was for Jackson say no to other offers. He finally reached a breaking point, and told Universal that *King Kong* would be his next film.

Harvey, predictably, went apeshit. By all accounts, he threw an epic tantrum that ended with Miramax co-producing *Kong* with Universal, and him somehow owning Tom Stoppard's *Shakespeare in Love* script, which he had coveted for years. No matter: Universal got what they wanted. The studio locked in Jackson for his follow-up to what was seen as such a surefire hit that *The Frighteners* was bumped up to a coveted July release date. Harvey got what he wanted, too. Jackson committed to make his *The Lord of the Rings* as two

films as soon as he was done, and Harvey ended up owning two more films in the process.

Then, in the summer of 1996, *The Frighteners* came out.

Universal couldn't have pulled that *Kong* plug any faster. Jackson's entire company was already fully focused on bringing Skull Island's favorite son and all of his dinosaur buddies to life when *The Frighteners* flopped with a mere $16 million box office gross in the United States. Universal wasn't interested in spending another dollar, though, and cut things off abruptly. In doing so, it cornered Jackson—and Harvey was ready and waiting. All of the energy and enthusiasm was immediately funneled into *The Lord of the Rings* out of necessity as much as passion. And while the art departments went to work figuring out how the world would look, Jackson and Walsh finally started the thing they were most afraid of in the entire process: figuring out how to truly adapt the books into films.

The pair settled on a two-film structure before they even had the rights figured out. So when they prepared their first outline for Miramax, they leaned into the more streamlined structure because that's what they had agreed to, not because that's the shape the material naturally suggested. It was as much an economic decision as anything else, since Weinstein was determined to spend $75 million *total* on the two films.

TIMELINE
2002

OCTOBER **04**
Bilbo leaves Frodo the Red Book of Westmarch and charges him with finishing it.

OCTOBER **28**
The hobbits and Gandalf reach Bree.

OCTOBER **05**
Gandalf, Frodo, Sam, Merry, and Pippin leave Rivendell for the Shire.

Working with New Zealand playwright Stephen Sinclair, Jackson and Walsh created two scripts, *The Fellowship of the Ring* and *War of the Ring*. And over the course of three meetings and 18 months, they came to realize that they were never, ever, under any circumstances going to make these films with Harvey F%#king Weinstein.

For Harvey Weinstein and his brother/business partner, Bob, *Lord of the Rings* was all about making Peter Jackson happy, but within limits. They didn't understand Tolkien, and they didn't believe in the material. They only saw it as a chance to stay in the Peter Jackson business for a cost. What they never told him as they put him through a year and a half of script development was that they could only make the film for $75 million or less because of the terms of their financing deal with parent company Disney.

When I read Jackson and Walsh's two scripts, I was writing at the entertainment website Ain't It Cool. This was in the early days of the "movie internet," and at that point, conversation about something on our site was considered by studios to be a big deal. They were still trying to figure out what the internet was at that point, and how to harness all this energy that they saw online. Some filmmakers were savvy about it right away, while others still viewed the entire thing with suspicion. Peter Jackson had already had some contact with Ain't It Cool at that point and there were many people within WingNut and Wētā who were also reaching out. They felt like they were creating something great, and were worried they wouldn't be able to find a studio willing to step up. So a decision was made to leak the scripts to Ain't It Cool in a way that everyone could deny later. They didn't come directly from anyone and no one ever officially asked us to cover them, so

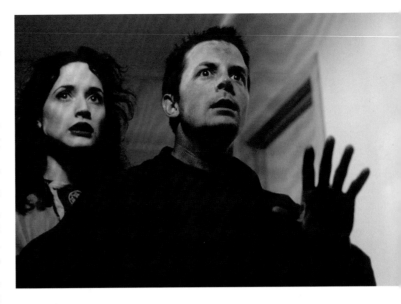

if I was ever pressed, I could honestly say that it wasn't Peter or Fran. What's clear, though, is that I was given access to them so I could talk about what I thought at the exact moment that New Line was trying to make their decision.

My script review became the second part of a carefully coordinated one-two punch. At that point, Ain't It Cool was a useful platform for filmmakers who were trying to convince studio heads that there was an audience out there for serious-minded genre fare produced with all of the resources required, and it was not always an easy sell. I was happy to make the case: The scripts were great enough that Jackson deserved the chance to see them through.

What did the two-movie version look like? Most of what you love about the eventual trilogy. Philippa Boyens was listed as a script editor on the document, which was codenamed "Jamboree." (By the time everything moved to New Line Cinema, the studio that eventually made the trilogy, Sinclair was gone and Boyens was a full-fledged co-writer on the films.) These early drafts managed to build in

most of the major incidents of the series but without the character texture that makes the trilogy so special. It felt like watching the eventual movies on 1.5x speed playback, everything compressed and accelerated. There were ideas that exited in an early form (Galadriel's haunting narration from the opening of *Fellowship* was originally delivered in slightly different form by Frodo, for example), and the original cliffhanger took place on Emyn Muil Bluff after Sam, Frodo, and Gollum had an encounter with the Nazgûl.

But the bones for Jackson's version were already in place, and that two-film version understood that Samwise Gamgee was the hero of the entire story, the main character whose journey ultimately punctuates things. There was more singing in these drafts, road songs that felt directly lifted from Tolkien's text, but everything was delivered at a clip. There was no time to actually get to enjoy the Shire, no room for Pippin and Merry to emerge as characters, and far less of the texture of Middle-earth. We met the elves in passing. There was an acknowledgment of Arwen and Aragorn, but no more. The main character who benefited from the expansion to three films was Gollum, who went from plot device to fully realized character. More than anything, the two-film version felt like every choice they made was about trying to turn these into more conventional blockbusters at the expense of the dense history and the poetry that defines Tolkien's work.

Eventually, the Weinsteins started asking for changes that Jackson and Walsh couldn't make. The primary breaking point came when they asked Jackson to consolidate everything into one four-hour film instead. When he refused, they put *Rings* in turnaround, meaning Jackson was free to take the film anywhere else as long as the next studio was willing to pay Miramax everything they'd already spent as well as enough to make Harvey feel good about the time they "wasted." Turnaround can be an amicable process, but in Harvey's case, it was punitive. He was angry at Jackson and Walsh for not making him their first priority. He was angry at them for entertaining other offers. In general, Harvey saw himself as their way into Hollywood, and he was offended that they didn't treat him that way. Miramax made the turnaround package expensive and they made it clear they would still be attached as executive producers, something few other studios would be happy about. When Wētā ran their numbers on the two-script version, the bare minimum they could see making it for was $150 million. At the time, when I read it, I wasn't sure how anyone could make it for any price, much less the kind of money Miramax had in mind.

New Line Cinema's Bob Shaye and Michael De Luca had the vision to read those same scripts and ask for all of the texture and more. They took a gamble on the world itself, and their attitude from the start was the opposite of Weinstein's. They recognized that these films were a journey and that the journey needed room to breathe. They were excited by the larger world suggested by the scripts, and when they asked questions, much of what they asked about was material that Jackson and Walsh had to cut to make Weinstein happy. Shaye had enjoyed working with Jackson on the proposed *A Nightmare on Elm Street* movie, and one of the reasons they didn't make it was because Jackson's vision was too expensive. This time, that was what they liked about it. They were trying to make the jump to a different level as a studio, and Jackson's dare came at the exact right time.

Not only did Shaye and De Luca say that they were willing to commit to the entire journey, they also wanted to do it the right way. They immediately committed to three films, asking Jackson and Walsh to not only put back everything they cut but also to expand on it, using all of that work they'd done to really bring the world to life. They gave Jackson, Walsh, and Boyens permission to dream even bigger. It's easy to sit on the sidelines as we did in the early days of Ain't It Cool, telling studios how to spend their money to placate fans, but for actual executives, entire fortunes hinged on those decisions. New Line was the one studio smart enough to look at all of the digital work that Wētā had done up to that point, all of the films Jackson had made and how he made them, and the imagination in those two scripts and add that up to what was eventually one of the biggest film series of all time.

When Jackson eventually got the chance to go back to *King Kong*, he threw out all of the script drafts he'd originally written, which was more like a big, pulpy Indiana Jones adventure. With *The Lord of the Rings*, his process was more of an evolution. They had the structure in place, but on fast-forward. Working with Boyens, who was a lifelong Tolkien super-nerd, they went back to the beginning of the process and looked at every character, every scene. Galadriel's monologue over the opening sequence that plunged us back into Middle-earth history is one of the most remarkable world-building scenes in film history, but it wasn't in those two-movie scripts. More importantly, a third script gave the trio room to show the full arc of Smeagol, evolving from a hobbit to a monster transformed by the Ring to something more sympathetic. The ents were another major addition to the expansion, as was much of the role of Saruman. Many supporting characters like Éowyn and Boromir and Faramir and even Aragorn were only fully fleshed out thanks to the move from two to three movies.

When I look back at the two-movie version now, I think the end result would have felt more like the film adaptation of *His Dark Materials*, breathless and busy at the expense of all those little details that give the audience room to fall in love. Without these scripts, though, and what they learned from trying to condense everything to this degree, it's unclear whether Jackson and Walsh would have been quite as nimble with the material. Between the two-script version, the theatrical trilogy, and the Extended Editions, which were in production all the way through *The Return of the King*'s historic Oscar win, Jackson shaped, reshaped, and re-reshaped this material while always managing to keep his eye on the things that make it resonate so loudly: the richly detailed sense that Middle-earth is a real place with a real history, one that was worthy of all of the expense and effort of a full trilogy.

If you want to read more about...

> *The writing process behind the films, turn to page 108—"Philippa Boyens Reflects on Éowyn's "I Am No Man!" (March)*

> The Lord of the Rings' *impact on Hollywood, turn to page 86—"The Return of the King* Won the Prize, but It Was Fellowship *That Changed the Oscars Forever" (February)*

AN INVESTIGATION OF HOW LEGOLAS GOT ON THAT HORSE THAT ONE TIME

THE LORD OF THE RINGS VFX ARTISTS AND A PHYSICIST WEIGH IN

Max Covill

The *Lord of the Rings* trilogy has a dragon's wealth of indelible cinematic moments to choose from. Who can forget when Samwise Gamgee swam to Frodo Baggins even though he couldn't swim? Or when Gandalf arrives at the first light to turn the tide against the forces of Isengard? These are touching moments of high emotion that resonate even 20 years after they were first encountered.

But the one that resonates the most is obviously when Legolas got on that horse like that.

In the warg-attack sequence of *The Two Towers*, Legolas has gone ahead to observe the oncoming foe, and as the Rohirrim catch up to him he senses Gimli approaching on horseback. Legolas turns, grabs his galloping steed by its breast collar, and then swings in front of the horse, rotates in the air, and lands in the saddle in front of Gimli.

It's a spectacular stunt, showcasing the elf's agility and strength. And it's a magnificent feat of visual-effects work from Wētā Digital. But why on Middle-earth was it necessary to have him get on a horse that way? And is there any chance that it's a physically possible thing to do, by man or elf?

Surely, a scientist and the folks at Wētā Digital had answers.

HOW TO PUT LEGOLAS ON A HORSE WITH (MOVIE) MAGIC

The Extended Edition of *The Two Towers* reveals the genesis of this particular shot in its half-hour "Wētā Digital" segment. In it, actor Orlando Bloom, director Peter Jackson, and Wētā Digital's Matt Aitken, Joe Letteri, and Jim Rygiel discuss the scene only briefly. Aitken, still a visual-effects supervisor at Wētā Digital today, spoke to Polygon to provide more details into how that scene was made.

As is made clear in the DVD featurette, digitally putting Legolas on a horse wasn't in the original plan. All three *The Lord of the Rings* movies were shot simultaneously, and on that scale, accidents occur. After falling off of a horse earlier in the day, Bloom had cracked a rib, and was unable to perform the stunt as planned. The filmmakers had footage of the Rohirrim reaching Legolas, with Bloom hopping into the air with one arm raised. In the editing room, Jackson and company discovered the need to complete that sequence. That's when they decided to use a digital double.

A digital double is a virtual re-creation of a live-action character, allowing filmmakers to fill in the gaps in production and innovate where the use of stunt doubles would be dangerous. Wētā Digital's digital-double work is commonplace nowadays, cropping up in movies like *Furious 7*, *Gemini Man*, and even the climatic sequence of *Avengers: Endgame*. But during the production of the *Lord of the Rings* trilogy, the company was still experimenting with this tech, as with a brief shot of digital miniatures of the Fellowship crossing the Bridge of Khazad-dûm in *The Fellowship of the Ring*. In the case of Legolas getting on the horse, the team at Wētā Digital had a more difficult job ahead of them: a handoff from the live-action footage of Legolas to a completely new CGI version of the character.

Aitken told Polygon, "In terms of Wētā Digital's history, I think it was probably our first big digital-double shot. It was a technology that we were working up. We had done little background figures and our massive armies in the battles, but they were already quite small in frame. To have a digital character that big in the frame, he's pretty much full frame. To have him hold up and not be too distracting for the audience, I think that shot was a turning point for us."

Having to make a full-frame digital model look convincing was intensive work. "[In] two and a half months, [former Wētā Digital animator Christopher Hatala] did about 35 different versions of what this action could be," said Atiken. "He had Legolas going up on one side of the horse, using a stirrup to get up. Another version, he does a backflip, spirals in the air, and lands behind Gimli. He does one [motion] just as the horse lifts its foot forward and creates a stepladder."

Eventually, they created the one you finally see in the film, though Aitken acknowledges that "if you looked at that action from any other angle, it would look ridiculous. It would defy the laws of physics. I think [Legolas] goes through the ground and goes through the horse. I think he probably goes right through Gimli."

Wētā Digital then needed to create a space where the 3D element of Legolas could live. "We've got the hill," Aitken explained, "we've got a wireframe version of the horse. We've got a low-res version of Gimli on the horse, and we've got a digital-puppet version of Legolas. The camera department creates this scene like you're playing a three-dimensional computer game, and it matches exactly to what was filmed." This technique, match moving, allowed Wētā Digital to manipulate a digital double of Legolas and integrate it into the scene.

In addition to settling on the specific movement, many factors work together to make the sequence believable. The lighting on the digital model has to match the real lighting on the day of the shoot, the hair and cloth simulation has to match the live performer, who themselves have to be painted out of the shot once the digital double takes over. All of those elements are then layered to create a convincing CGI character that is the focal point of the action.

The CGI version of Legolas wasn't even the only digital element in the scene. Aitken told me, "[Bloom] fires an arrow, and that would be digital as well. One thing that I can guarantee is, [Bloom] never fired a real arrow at any point of *The Lord of the Rings*. They were all added later in CGI."

HOW TO PUT LEGOLAS ON A HORSE, WITH SCIENCE

Understanding how the scene was made is one thing, but it's obviously impossible for a real human to do, right? Unless . . . Rhett Allain, who has a doctorate in physics and is a science consultant for *MacGyver*, talked with Polygon on the real-world logistics of Legolas' horse leap.

The first problem Allain raised was the amount of force his movement would have on a human arm. Allain told Polygon, "You grab on with one arm, and then you're going from 0 to 10 miles per hour in a very short amount of time. That's a very large force on your arm. If I did that I think it would dislocate my shoulder."

Another issue comes from how the artists approached the animation. Despite how epic it looks in motion, something about how Legolas moves remains odd. "I don't think that's physically realistic, but stylistically, I was trying to figure out why they would animate it that way. I couldn't figure out the reason artistically that they would do that," Allain said. "If he grabs on the horse, he's on the right side of the horse. You would think he would swing up on the right side of the horse, but instead he swings out in front of the horse and on the other side." Not only would a human seriously injure their arm trying to attempt the action, Allain said, it's more likely they would mount the horse from its right side or be dragged along trying.

But Legolas isn't exactly a human. Could his elf heritage have any bearing on our theorizing?

"Let's say he's an elf and elves don't weigh as much as humans," Allain said. "Or elves aren't as strong as humans, which we don't know either one. If they have a very high strength compared to their weight, maybe he could do this."

How much do elves weigh? In order to determine the weight of Legolas, there is a scene in *The Fellowship of the Ring* that acts as a guide. As the Fellowship attempts to travel through the Pass of Caradhras, they all struggle as the path

becomes choked with snow—except for Legolas, who displays his elven ability to walk on top of deep snow, leaving only the barest of traces. In 2017, Kyle Hill of the Because Science YouTube series on Nerdist used these parameters to show that Legolas' body has a density of 72 or fewer kilgrams per cubic meter.

With that information in hand, Allain said "His mass is probably, and I'm just guessing, 20 kilograms or something super small like that. That would make it easier for him to pull himself up on the horse, because you're not changing momentum as much with the lower mass." Even with that being the case, it doesn't hold up under scrutiny. "I would say it definitely stands out as a weird-looking motion. It's something that goes out of bounds of what we'd expect," Allain said.

But even if it looks a little odd when you see Legolas getting on that horse, there's no denying its effect in *The Two Towers*. It's a crowd pleaser in every aspect. And for Wētā Digital, it was an important scene in their history as well. It proved that digital doubles could be used in place of real actors.

"Digital doubles are a core part of our work that we get asked to do on pretty much every show we work on, and this was a real proving ground and turning point for us," Aitken said. "As a visual-effects facility, to be able to achieve that shot, it showed filmmakers that it was available to them to help them not just get out of sticky situations that they got into but also have their characters do things that maybe the actors wouldn't be able to do or wouldn't feel safe doing," said Aitken. "We're thrilled that we were able to pull it off, and I'd like to think [Jackson] was pretty happy as well."

The magnificent feat that Legolas performs might not be possible for man or elf, but nevertheless, Legolas got on that damn horse.

If you want to read more about...

> *The horses of* LotR, *turn to page 122–* "The Lord of the Rings *Wasn't a Horse Girl Story Until Peter Jackson Made It One*" *(April)*

> *Legolas' inexplicable behavior, turn to page 127–"Legolas' Dumb, Perfect Faces Are the Key to His Whole Character" (April)*

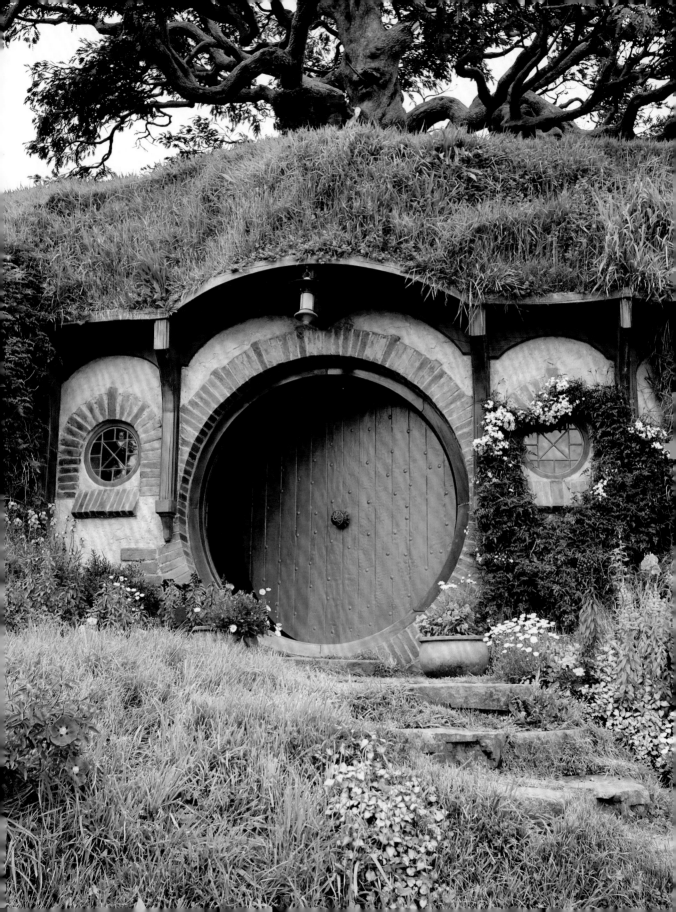

HOW HOBBITON CHANGED LIFE IN MATAMATA, NEW ZEALAND

AS TOLD BY THE RESIDENTS WHO LIVED IT

Jim Fishwick

People in Aotearoa (that's the Māori name for what's known to much of the world as New Zealand) have a complicated relationship with the *Lord of the Rings* movie trilogy. For some, it's something to be slightly embarrassed about, like a pop star dogged by a novelty record they put out a decade ago. For others, it's to be fiercely defended—the New Zealand government recently spent millions of dollars in tax breaks to entice Amazon to film its series *The Lord of the Rings: The Rings of Power* in New Zealand, only for production to move to the United Kingdom for season 2.

This polarized relationship is quite noticeable in Matamata. An hour's drive from the nearest city, the rural town has a population of around 8,500 people, holds strong connections to the horse racing industry, and is surrounded by rolling hills and farmland. And in 1998, a film director named Peter Jackson used a 1,250-head sheep farm, owned by Ian Alexander, as the filming location for Hobbiton.

Since the 2001 release of *The Fellowship of the Ring*, the Hobbiton set has become a full-fledged tour business and hotspot for Tolkien fans. Matamata has become incredibly busy, with hundreds of thousands of tourists visiting each year. Imagine Sandpoint, Idaho,

becoming the global home of Star Trek, and you're somewhere close.

Small-scale tours of the converted Alexander farm began running in 2002, departing from the Matamata Visitor Information Centre. In 2009, the Hobbiton set was rebuilt for the filming of the *Hobbit* trilogy, and the new, fleshed-out scenery led to a huge spike in tourism. But over the last two years, COVID-related travel restrictions have had a dire impact. Visitor numbers dropped 20% in 2020 alone, and remain nowhere near what they used to be, either to Hobbiton or Matamata. Some local businesses have shut down entirely.

What's it like to live around Hobbiton 20 years after Jackson's films became essential part of the area's history? I spoke to a number of people from Matamata to understand how the town has changed, and what it faces now that the *Lord of the Rings* movies are behind it.

In 1998, Matamata was pretty much a farming-service town. It's always been a prosperous town. Its heritage is based on dairy farming and the thoroughbred industry. But pretty much for anybody that was moving through, it was toilets and takeaways on your way to Rotorua or Tauranga. In those days it was a busy little hub, in a prosperous little town, but certainly not a tourist trap.

I have never come across a product like this in my entire life where you didn't have to do any advertising. No marketing whatsoever. [Even before it opened,] the people were banging the door down, basically, to go to Hobbiton. So of course, Matamata got very busy. And it took a little while, in fairness, for [some locals] to understand the benefits of tourism. But not a long time to understand. I think everybody was incredibly proud of the international media that Matamata was getting.

—Sue Whiting, former manager, Matamata Public Relations Association

I remember wandering into town for a coffee one morning and there were a couple of German lads standing in the queue with me, and I said, "What are you here for?" and they said, "We're here to see Hobbiton." I forget how much it was then, probably something like $60 ten years ago. I said to them, "What do you think about the price you have to pay?" And they said, "We come from Dusseldorf. The drive out on the bus is worth $60, through all the beautiful rolling countryside, and we see deer and sheep and cows and trees. It's just lovely." That sort of makes you stop and think.

—Richard Prevett, retired accountant and playwright

The sad thing about around here is that so much of the good farmland has been taken up. For many years, farmers weren't making a lot of money. They were doing a lot of hard work but not getting much for it. Then all of a sudden, they could get their life savings paid out by selling their land. The prices are going right the hell up, because someone wants to put it into houses. It's urban sprawl, just like in the cities.

—Ron Vosper, retired farmer

There's not much for young people in [Matamata]. That's probably the biggest thing. There's no pictures, or anything like that. Most of them move away, of course, for tertiary education. There's places where there is employment like KFC and the Warehouse—you'll get young people working in there. And on farms, there's a lot of farms. There still is a lot of potatoes grown, and onions, and somebody was saying that the asparagus was pulled up because they couldn't get enough workers. There's no asparagus because people don't want that sort of work. [But accommodation is probably the biggest issue.] Up where I am, near Parkside, a place will go on the market and be sold within three or four days now. The values have jumped a lot.

—Doris Elphick, Citizens Advice Bureau

Hobbiton has changed the village immensely. For one thing, being in the restaurant and food trade, once it really kicked in, we lost a lot of our retail and they were replaced by food. When Hobbiton first opened, there was my café and basically two others. Now there are 34. Every time a shop became vacant, in went a cafe and in went a little bar or something. We have no shopping in the village now, which is very, very sad.

Tourism has filled in that gap, but it's taken away the heart of the village. Everywhere you go, it's food, real estate, food, health shop, food, real estate, real estate. Where it used to be menswear, shoe shop, jewelers . . . there was a lot of general commerce trading in the village.

Now we've been overrun with second-hand shops, restaurants, real estate agents, and cafes. It's quite bizarre. But I'm still very passionate about the village. I love the village.

If I was honest, [Hobbiton] could have been a little bit more respectful of the village and sponsored it a little bit more. They don't do a lot for the village. And that, I suppose, is still a thorn in the side for a lot of people. Considering we've built new roads, we've done the information center, the village has done a lot. It's done a lot for the village financially, for the council and things like that. But they haven't been overly generous.

We did the information center up. I think that cost the council about $350,000. The smart move from [Hobbiton] would have been to say, "We'll go halves." And that would have changed the whole thing for the tight community in town. There would have been a few saying "They should have paid for the whole thing— what are you talking about?' But there's people like me who would have thought, "Hey, that was good. They didn't have to."

—*Syd Workman, owner, Workmans Cafe & Bar on Broadway*

[Note: According to Sue Whiting of the Matamata Public Relations Association, who oversaw the redevelopment of the information center, the total cost of the project was around $700,000, to which the district council contributed a $50,000 grant and a $150,000 loan. An additional loan of an undisclosed amount was provided by an anonymous local resident. The rest of the funds were provided by the center itself, some of which came from commissions on Hobbiton tickets and merchandise.]

I just fell in love with this place because it's filled with nature and trees, and the waterfall is one step away. I absolutely love how friendly and welcoming people are [. . . .] Wherever I go in town it's always a great conversation with all sorts of people. That was my first impression of Matamata: It was just a friendly, lovely little country town.

We love sharing our historical site with people visiting Matamatma and going to see Hobbiton. This site goes right back to 1881, when Firth Tower was built, so we're oozing with history and have so many great things to share. We're a great stopover on people's way to Hobbiton. Travelers can come and stretch their legs, climb the tower, and explore our historical buildings. For motorhomers traveling to Hobbiton, we can even provide a nice spot for them to park and stay for the night.

Hobbiton employed so many people [before COVID], so there were great opportunities for the locals to take up, interesting jobs too—not everyone can be a tour guide or a specialized gardener. We had a lot of out-of-towners that moved into the area and worked there too—the people it employs and the visitors it attracts has been a good support to Matamata. It brings a great vibe to the town—when Hobbiton's pumping, Matamata's pumping.

—*Amy Hunter, manager, Firth Tower Museum*

We spent probably four months negotiating with the film company, and they presented a sort of standard location agreement. [. . .] Part of the standard agreement, which we eventually signed (pretty standard, I believe—obviously, it had to be tailored to what we had here),

was that they have to return it to its natural state. [. . .] Effectively, they leased about 12 acres in the middle of our 1,200-acre farm, about 1% of our farm. And the day after they signed the contract, the set builders and the New Zealand army arrived to put the road in and to give them access and it started.

[Preserving the set and the land takes] a massive team of passionate people. We have five full-time gardeners, and we've had landscaping people, we have artists, we have scenic painters, we have builders, joiners, props people, art directors, general-maintenance people. All of those people are there continually maintaining it. And developing it, because Hobbiton's a living set. Look, there's four seasons in a year. So there's four different looks to start with, and Hobbiton's open all year round. It evolves, but you've also got to be authentic to everything that was in the film.

The Matamata community's embraced it all [. . . .] Not everyone's going to like it, because some people are going to prefer to live in a country quiet little town with no visitors. Some people are going to like it more than others. What do they say in the movie? "No more visitors and no more friends" or something like that? Some people will feel like that; others will want visitors because they want a café, etc. So there's mixed things, but I would like to think it's generally been pretty positive.

We're involved in a lot of sponsorship and engagement with groups, like the local rugby club; we've raised funds for the pool and hospital. We've done events for schools; we're doing lots of commercial events here for businesses. We've done some mentoring programs with students. . . . Look, it's probably the same as every business in the country. There's a lot of things you're doing within your community that you'd like to think are beneficial within the Matamata community. It's jobs, it's accommodation, people in the hotels, it's into the eateries area—that's the economic side, and there's a social side of it as well.

It's sponsorship with tickets and raising money, and we're getting vehicles serviced in town—you name it. There's a flow-on effect. But it's also, particularly pre-COVID, we used to bring 20 or 30 overseas students for the summer and they were staying in town. That is more than just the money—they're bringing a social vibrance to your town.

—Russell Alexander, CEO and co-founder, Hobbiton Movie Set

A lot of kids here don't have a plan outside of Matamata. They don't have the confidence to go out and say, "Yes, I want to go to Auckland and study this" or "I want to go to Auckland and get a job" or "I want to go down to the South Island and go traveling" or whatever. A lot of people stick to Matamata, and just don't have that confidence or that backing from their family or friends to go out and do that.

[Hobbiton] was always in the [local high school] advertising for summer work for anyone over 16 or however old you had to be, advertising summer work, advertising part-time work on the weekends, whether it's for a couple of weeks, or even it keeps going until they don't have any work, or whatever. So they have been quite involved in terms of employing local teenagers, and people in general. They've been quite good in our community. We get along with the Alexanders quite fine; they've sponsored a lot of things in the community.

I'll tell you one thing about Hobbiton: They don't pay well. One of my friends worked there one summer, and she was on minimum wage, which is fine. And then once summer had ended, they

said, "Would you like to come back and do one day a week on the weekends?" So she did that, and after the year she said to them "I might go get a job at [the supermarket]," and they talked her out of that and wanted her to stay. That whole two-year period, she was on the same minimum-wage pay at Hobbiton. They don't pay well.

There's two classes here—you're either rich or you're poor. There's no middle class in Matamata. I don't know why that is. A lot of families own farms, so their kids are all farmers—they've got money. Other kids' parents are in the racing industry, they own businesses in Matamata, they're in building, whatever. Or there's the workers. That's pretty much how I see it. Those kids who fit into that second group, they're the ones who usually end up dropping out of high school. [. . .] They need a hub. They need somewhere where they can go because there's not a lot in Matamata.

—Lathum Douglas, youth-services coach

I think anything that brings dollars into the community will impact it in some way. But for us, Hobbiton hasn't impacted a lot on us. There may be one or two who would have got a job there. But in terms of our culture, it doesn't impact on us. Well, I guess that with some of the tourism coming in, a lot of the restaurants and the food industry in Matamata would have flourished with it, and some of our families, some of our people, are working in those industries. So everything has an impact. But no, not a lot in terms of our culture. Our culture has always remained the same with us.

I think there's a lot more optimism [in young Māori people], especially with the development of our school. We're able to keep an eye on education and the educational development of our young ones. There are some that are more inclined to go to the mainstream schools that are in the area, but a lot of our people have taken a lot of them in and started designing a pathway forward for them.

In my day, I would not have thought that I could be a teacher. That was 100 miles away. My future was either in the factories or as a laborer or as a farm-worker. But now we can actually start looking at visions. There's nothing to stop our students from becoming academic. Before, that wasn't even on the radar. You were gonna get a job in the factory or on a farm or whatever else was out there. That's what you were geared to. I mean, those options are still there if we want. But our vision and our thinking is above that.

Now, with the settlement of our treaty [a 2013 settlement between the British crown and the Ngāti Hauā tribe of the Māori], and the other tribe in our area, Ngāti Hinerangi, we've both settled our treaties [the Ngāti Hinerangi Deed of Settlement, passed in New Zealand's parliament in 2021]. And we have confidence in our aims and objectives for the future for our young ones, the next generation. So we're going to be focusing on that. The everyday life in Matamata will go on.

—Mokoro Gillett, chairman,
Ngāti Hauā Iwi Trust, principal,
Te Wharekura o Te Rau Aroha

If you want to read more about...

> *The local New Zeland talent that contributed to* The Lord of the Rings, *turn to page 110—"The Jeweler Who Forged* Lord of the Rings' *One Ring Never Got to See It on Film" (March)*

> *Or turn to page 42—"Gimli's Uncredited Body Double Put in the Work, and He Has the Tattoo to Prove It" (October)*

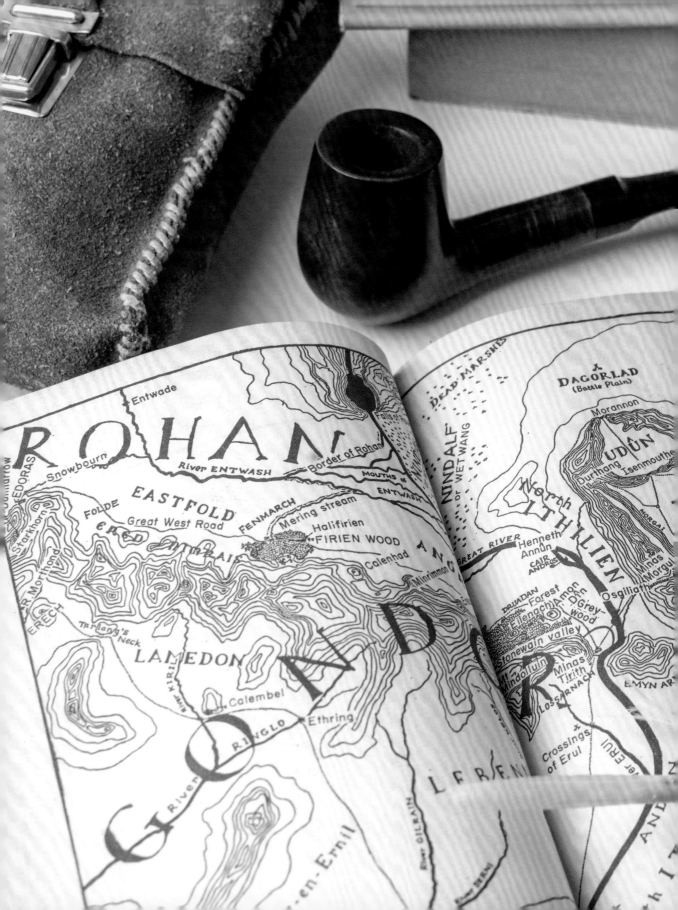

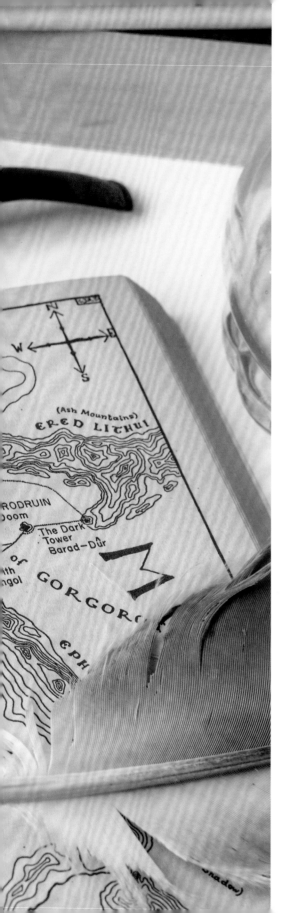

SECOND NOVEMBER: THE END OF THE WAR OF THE RING

THE RETURN OF THE KING NEEDED ONE MORE ENDING

THE CASE FOR THE SCOURING OF THE SHIRE

Susana Polo

One universally acknowledged truth is that if you watch the *Lord of the Rings* movies with a fan of the books, they're going to tell you about the things in the books that didn't make it into the movies, even in the Extended Editions. Tom Bombadil will come up, or Glorfindel, or Quickbeam, and finally, just as you round the bend on nine-plus hours of films, the book-lover will mention the Scouring of the Shire.

Filling two entire chapters of *The Return of the King*, the Scouring of the Shire is one of the largest omissions Philippa Boyens, Peter Jackson, and Fran Walsh made in adapting J.R.R. Tolkien's work for their screenplays. And while fans will argue Tom Bombadil should be included because he's fun, even if he doesn't really have an impact on the story, the Scouring of the Shire is the opposite.

The Scouring of the Shire isn't fun. It's anticlimactic. It's depressing. It complicates the themes of *The Lord of the Rings*, interrupting the flow of the happy homecoming we feel our heroes deserve. It's essentially another adventure into itself, a repetition in micro of the last several hundred pages we spent reading.

And speaking from experience, when you advocate for its inclusion to a movie viewer, you sound like you have fully lost your mind. *The Return of the King* already has four or five different endings—why on Middle-earth would you want another one? And it's true that it would take an enormous restructuring of Jackson's *The Return of the King*—and probably *The Two Towers* as well—to fit the Scouring into the film trilogy.

The *Lord of the Rings* movies still work, without the Scouring. They still captivate audiences, spreading Tolkien's legacy farther than it ever could have gone from the books alone. But without the Scouring, the movies are fundamentally not the same story as the *Lord of the Rings* novel.

OK, OK, WHAT IS THE SCOURING OF THE SHIRE?

In Tolkien's *The Return of the King*, Frodo, Sam, Merry, and Pippin arrive back in the Shire to find their home and its people have been conquered, oppressed, and in some cases enslaved by Saruman, his lackey Wormtongue, and a small group of local humans.

The idyllic countryside of the hobbits has been marred by exploitation, the old watermill replaced with a coal-powered one belching smoke, hobbit holes unearthed so quarries and ugly new houses could be built, fields flattened to park carts in,

elder trees wantonly hacked down to their stumps—including, most devastatingly, the Party Tree, which featured as the meeting site for Bilbo's birthday in the trilogy's opening chapter. Cozy Bag End was taken as Saruman's headquarters; the garden trampled, the door marred, the rooms ransacked and stinking.

Saruman, who was stripped of his magic at Isengard but not killed, has arrived home ahead of them and wormed his way into power with political skill, corrupting what hobbits he was able to and imprisoning others. Within a day of the four's arrival, however, Merry and Pippin's new martial experience is all it takes to rouse the Shire-folk against their oppressors, resulting in the Battle of Bywater, in which hobbits kill and die to deliver their home.

Frodo tries to spare Saruman's life and orders him to exile, only for Wormtongue to finally snap under the wizard's abuse, cut his master's throat, and be executed by several hobbit arrows before anyone can give an order not to fire. This final, ugly confrontation happens at the very door of Bag End, showering the pathstones of its garden with blood. The Shire recovers, rebuilds, and becomes a happy place again, but it is forever changed. And a few years later, Frodo resolves that it is too painful for him to stay. So he takes a ship west from the Grey Havens and sails the Straight Road to Valinor (page 152).

Readers and scholars have struggled to pin specific meaning to this odd denouement since *The Return of the King* was published. The Scouring has been called an anti-socialist statement, an anti-fascist statement, and a satire of the bureaucracy of post–World War II England. But Tolkien, as with most attempts to say that *The Lord of the Rings* is "about" any specific historical moment, loudly resisted such characterizations.

"It has been supposed by some that 'The Scouring of the Shire' reflects the situation in England at the time when I was finishing my tale [roughly 1949–1955]," he wrote in his foreword to the second edition of *The Lord of the Rings*. "It does not. It is an essential part of the plot, foreseen from the outset [circa 1936], though in the event modified by the character of Saruman as developed in the story without, need I say, any allegorical significance or contemporary political reference whatsoever."

The author's sole concession to critical interpretation was that, as with the rest of *The Lord of the Rings*, aspects of the Scouring were inspired by his own pain at watching urbanization encroach on the English countryside of his boyhood.

BUT WHAT DOES THE SCOURING *MEAN*?

With respect to Professor Tolkien, I won't argue that the Scouring is important because of what it says about history, but I will share what it says about his hero-hobbits.

One of the most celebrated passages in *The Lord of the Rings* is Sam's speech about how stories don't end,

The Shire recovers, rebuilds, and becomes a happy place again, but it is forever changed.

and the Scouring is how Tolkien shows the reader as well as tells them. It wraps Hobbiton and even Bag End itself up in the long tail of history; Wormtongue was the lackey of Saruman, who was the lackey of Sauron, who was the lackey of Morgoth, the first Dark Lord, born at the dawn of time.

Merry and Pippin's experiences make them the most martially qualified leaders on hand, and they proactively spearhead the armed resistance to Saruman. But the Scouring is also some of the most humanistic war writing Tolkien produced for *The Lord of the Rings*—here there are hardly any "fighters" who our heroes don't know by name. There isn't a drop of magic involved. The author carefully enumerates the casualties of the first armed conflict in the Shire in 300 years: 30 hobbits wounded and a dozen men captured, 19 hobbits and 70 men dead.

Our heroes can't return home, because even their home has been irreversibly marred by the conflict they prevailed against. And more than any other effect it has on the story of *The Lord of the Rings*, the Scouring of the Shire changes Frodo.

Frodo's story in Tolkien's *The Return of the King* is of a character who wants some control over his destiny, and fails to find it over and over. He's a reluctant hero whose long and perilous journey ended triumphantly in random chance— the chance that Frodo chose to spare Gollum and take him as a guide; the chance that, when he failed his charge, Gollum was there to wrest the Ring from Frodo by force; and the chance that, in Gollum's mad, capering dance of victory, he would take a wrong step and topple into the fire.

Sparing Gollum is one of the only free and un-counseled (you could even argue selfish!) decisions Frodo makes in *The Lord of the Rings*. And in the Scouring, we see him try to make that choice again. From the moment they realize something is very wrong in the Shire, Frodo insists that the hobbits' liberation be accomplished without bloodshed. He insists on absolution for Saruman, Wormtongue, their human forces, and all hobbits who colluded with them.

It's an attitude of radical mercy that mirrors his mercy for Gollum, and speaks to an attempt to find the meaning in a consequential choice made in an uncertain moment. But then, in another series of events beyond his control, Wormtongue lashes out at his master, and the very hobbits whom Frodo undertook the Ring Quest to protect execute him without even waiting for orders.

Frodo's post-Ring pacifism could be interpreted as a simple fatigue of war, but that feels off. Frodo was not present for any of the book's actual battles; he did not befriend any of its tragically fallen heroes, or see firsthand the suffering in the story's great sieges. His arc was not about fighting.

What fits more closely is that Frodo

TIMELINE
2002

NOVEMBER **01**
The four hobbits are arrested in the Shire.

NOVEMBER **03**
The Battle of Bywater. Saruman is slain. This marks the end of the War of the Ring.

NOVEMBER **02**
The Hobbits come to Saruman's desolation of Hobbiton and rouse the Shire-folk.

is looking for absolution and agency. He's looking for something that he does to matter, and it never does. He couldn't destroy the Ring, he couldn't keep an oath of pacifism, he couldn't protect the Shire, he couldn't free it without bloodshed, and he can't even successfully show Saruman and Wormtongue the mercy he wishes for himself.

HAS PETER JACKSON SAID WHY THEY OMITTED THE SCOURING OF THE SHIRE?

The special features of the Extended Edition of Peter Jackson's *The Return of the King* devotes a small section just to the Scouring of the Shire. The production did film scenes of hobbits battling orcs and being clapped in chains—but to create a homage to the Scouring in a *Fellowship of the Ring* scene in which Frodo looks into the Mirror of Galadriel, not to play out the whole sequence.

"The reason to lose the Scouring to me was very straightforward," Jackson says in a filmed interview for the Extended

Edition. "It was one of those no-brainers.

"At the very beginning of this process, we'd identified the spine of our movies— Frodo taking the ring to Mordor—which means that the climax of our movies is Frodo destroying the Ring. We obviously have a denouement; in fact, the denouement of *The Return of the King* is long and extensive; it's 20 minutes, which is 20 minutes that we wanted to spend covering the damage to Frodo as a result of this journey that he's had."

In the film version, Frodo, Sam, Merry, and Pippin arrive home to a Shire so untouched by war that they don't even bother explaining where they've been. The War of the Ring is a secret adventure they share in knowing looks over their half-pints at the Green Dragon, while behind them everyone else goes wide-eyed at an especially large pumpkin. Sam gets married. Frodo monologues a bit about how hard it's been to pick up his old life. In the very next shot, he's in a cart with Bilbo going off to the Grey Havens.

"To get to that point and then to

deviate into a completely different event and storyline," Jackson says in a DVD special features interview, "to me felt—anticlimactic, I guess, is how I would describe it."

In the movie, Frodo's victory is simple and obvious: The world was saved and the Shire remains an Eden that has never truly known evil. His newfound isolation is restrictively specific; his inability to reenter hobbit society is internal to his person, and was caused by events external to the Shire. The juxtaposition of the experienced hobbit heroes with the ruddy-faced farm-people cooing over a big gourd makes Frodo's isolation more of an "ignorance is bliss" problem.

If movie Hobbiton is an Eden, Frodo has eaten of the tree. His experience has made him too dark, too complex in thought, to masquerade as a happy, simple hobbit anymore—and so he throws up his hands and leaves his entire society behind. If you squint, it's the same decision he makes in the book, in the same way an abstract painting of vertical bars can resemble a photograph of a forest. They're each a well-considered work of art; they're just saying very different things.

THE LORD OF THE RINGS IS ANYTHING BUT SIMPLE

We think of fantasy as a genre of basic archetypes: The hero is born with a destiny, defeats a great and inhuman evil to restore or improve a status quo (maybe finding love along the way), and is rewarded with power, praise, and societal acceptance. We think of *The Lord of the Rings* as the foundational text of that genre. And the saga does have such a story: The rise of Aragorn II, high king of the Reunited Kingdom.

But no one would claim that Aragon was Tolkien's main character. *The Lord of the Rings* is about a hero with a duty rather than a destiny, one who struggles ingloriously to defeat an incorporeal evil that eventually fully overcomes them. A hero who has no more control over their destiny after completing their task than before or during it. In fact, the world is actually saved by a seemingly naive and disconnected choice they made oodles of time before the story's climax.

They are discomfited by their experience rather than empowered, isolated rather than embraced. They find they can neither reenter society (because they have changed beyond restoration) nor return home (because their home has as well).

The Scouring of the Shire is the element that expands *The Lord of the Rings* from intricately crafted adventure fiction to timeless literary relatability. It is what separates Tolkien from his imitators, who throw a hero and a wizard and a sword and a journey together and call their Aragorn Story *The Lord of the Rings*–inspired.

More than any other speech, or fight, or character, the Scouring of the Shire makes *The Lord of the Rings* a war story, in which some come home to fame, fortune, and just reward while others never truly come home at all—and both are still heroes. A story of glorious, necessary battles that, in its final chapter, shows that a thing can be glorious, necessary, celebrated, and still wrong.

If you want to read more about...

> A literary examination of the themes of The Lord of the Rings, *turn to page 202—"Queer Readings of* The Lord of the Rings *Are Not Accidents" (Second September)*

> *Things left out of Peter Jackson's trilogy, turn to page 19—"Tom Bombadil Is the Stan Lee of* The Lord of the Rings*" (September)*

THE LORD OF THE RINGS FAITHFULLY ADAPTED TOLKIEN'S UNRELENTING BELIEF IN HOPE

TOLKIEN SAW A LOT OF SHIT

Susana Polo

It is a quirk of history that we didn't lose J.R.R. Tolkien to a global flu pandemic. In the plague year of 1918, the author was 26, with a recurring illness keeping him in and out of army hospitals, the exact place the virus was at its hottest. He was an orphan married to another orphan, father to an infant son born in, as he would write in another wartime year a mere quarter-century later, "the starvation-year of 1917 [. . .] when the end of the war seemed as far off as it does now."

Tolkien didn't catch influenza. He lived to see the Great Depression and a second devastating global war before he put the final touches on *The Lord of the Rings*, a sword-and-sorcery epic where hard-fought victories turn on the smallest choices. The story's thousands of pages endured in the minds of readers for half a century before Philippa Boyens, Peter Jackson, and Fran Walsh's painstakingly adapted smash-hit film trilogy brought it to moviegoers.

Stripped down to its basic themes, *The Lord of the Rings* is a guide to keeping hope in the face of hopelessness. More than that, it's a dictum: Hope doesn't just keep us going in hard times—it gets us out of them. It was a maxim that J.R.R. Tolkien,

a pessimist in a cohort of pessimists, lived throughout his life.

THE LOST GENERATION

Imagine the trials of a Dickensian orphan, then drop a senseless global war, a pandemic, and economic depression on top of it, and you'd have an approximate biography of Tolkien's early life. When Tolkien was three, his father died while the family was on another continent visiting relatives, leaving them destitute in England. His mother's family had already disowned her for converting to Catholicism, leaving her to support her two children alone despite her uneven health. Tolkien blamed this rejection for her early death from undiagnosed diabetes when he was 12, describing her as "a martyr [. . .] who killed herself with labour and trouble to ensure us keeping the faith."

In addition to offering all that a loving mother could, Mabel Tolkien was her son's first teacher, introducing him to the study of plants and languages before he was 7. In his biography of the author, Humphrey Carpenter underscored her passing as a turning point in Tolkien's personality.

"Her death made him a pessimist; or rather, it made him capable of violent

J.R.R. Tolkien in his study at Merton College, Oxford, 1955

shifts of emotion. Once he had lost her, there was no security, and his natural optimism was balanced by deep uncertainty."

That uncertainty was indivisible from his Catholic faith in the Fall of Man—the belief that history is a story of decline, not progress. "When he was in this mood he had a deep sense of impending loss," Carpenter wrote. "Nothing was safe. Nothing would last. No battle would be won forever."

Tolkien scraped through school mentored but unparented, dependent on scholarships and the kind but strict guardianship of his mother's favorite priest, who at one point forbade him from speaking to his future wife for three years. He served in World War I, in which half his closest friends died in a single week during the Battle of the Somme. He survived

the 1918 pandemic, which particularly ravaged the young and able-bodied. He raised four children during the Great Depression, only to watch his sons serve in World War II.

Tolkien was a member of the Lost Generation, a cohort of literary greats whose work is generally characterized by disillusionment both with society as a whole and with optimism as a principle. And that's no great wonder, given the political, economic, and natural disasters that formed the bounds of their lives.

So it's interesting that Tolkien's work is one of the most *illusioned* texts of his time. Tolkien spent most of the Great Depression years writing *The Hobbit*, which debuted in 1937. By the time he'd finished *The Lord of the Rings*, which was published in the

mid-1950s, it was an epic of hope in the face of relentless devastation.

A LIGHT FROM THE SHADOWS SHALL SPRING

The *Lord of the Rings* movie trilogy did a heroic job of bringing the struggle of Tolkien's heroes and villains to the mainstream consciousness. But without the books' omniscient narrator to get inside the heads of characters, and with the omission of certain plot elements—all natural choices for the medium of film—the viewer misses some things that the reader cannot ignore.

By the beginning of *The Return of the King*, one thing is abundantly clear: The world is a hairbreadth from ending. In an event referred to as the Dawnless Day, Sauron sends dark clouds out from Mordor, covering the skies of Gondor and Rohan so thickly that it is dark as night for nearly a week. Death is so certain to characters like Théoden, Eomer, Éowyn, Denethor, and Faramir that they feel it is simply up to them to choose the manner of it. And then, of course, there's Sam and Frodo and Gollum, three hobbits (ish) taking their first steps into the impossible dangers of Mordor.

The only reason that all the land of Middle-earth is not covered in, as Gandalf puts it, "a second darkness" is because most of Tolkien's characters choose—in defiance of all available evidence—to act as if their actions are not futile. Gandalf and Aragorn make a huge wager on the chance that Frodo still lives and is making his way to Mount Doom by revealing Aragorn's identity as the scion of Isildur and bluffing that they have the Ring. They call Sauron's wrath down on Minas Tirith, and later march an army to Mordor to keep up the illusion.

At no point do they have any certainty of their success; rather, they feel they are making a simple choice: Either the race of men can fall defiant in front of the Black Gate, or it can fall cowering behind the walls of Minas Tirith. It's just a matter of time and dignity.

And their choices—Théoden's decision to come to Gondor's aid, Gandalf's plan to draw the Eye of Sauron out of Mordor, the bluff of marching to the Black Gate—turn out to have been the only possible path to victory. Even Frodo's choices, made from hopeful empathy for an obviously untrustworthy creature, become instrumental in the destruction of the Ring, when he himself fails to cast it into the fire and Gollum wrests it from him and falls.

The movies translate this well, even if they don't turn the lights off for two-thirds of *The Return of the King* (and, really, who can blame them?). But their most famous omission from the original text—no, I'm *not* talking about Tom Bombadil—elides the other half of the epic's ending. Choosing hope in the face of hopelessness wins a victory, but not a clean one.

By the end of Tolkien's *The Return of the King*, Frodo is broken by the Ring Quest. He swears never to carry a weapon

Either the race of men can fall defiant in front of the Black Gate, or it can fall cowering behind the walls of Minas Tirith. It's just a matter of time and dignity.

again, but is browbeaten into doing so for a triumphant ceremony in honor of his achievement—an achievement that he ultimately failed at and which was accomplished by happenstance. He strives to free the Shire from Saruman's takeover without bloodshed, but he fails at that, too, and lives to see even his idyllic home marred by the War of the Ring.

Less localized to Frodo, the destruction of the Ring also means that Middle-earth's last great sanctuaries must fade, with Galadriel, Gandalf, and Elrond reduced in their power. They give up their long watches to cross the western sea, and Frodo goes with them, constitutionally unable to enjoy the fruits of his victory.

Tolkien believed that the history of humankind was a story of a decline from paradise, and the legendarium of Middle-earth is a reflection of that. Evil begets more evil, good begets just enough good to stop it, and both are always dwindling in power. The world changes for the worse in ways that cannot be undone. And yet . . .

THERE AND BACK AGAIN

Both the *Lord of the Rings* books and movies end with the same almost hilariously simple scene. Sam returns to Bag End after saying farewell to a good deal of the principal characters of the saga, including a resurrected wizard, an elven witch queen, and his beloved Master Frodo, who saved the whole freakin' world.

> . . . Sam turned to Bywater,
> and so came back up the Hill,
> as day was ending once more.
> And he went on, and there
> was yellow light, and fire
> within; and the evening meal
> was ready, and he was
> expected. And Rose drew him

in, and set him in his chair, and put little Elanor upon his lap.

> He drew a deep breath.
> "Well, I'm back," he said.

And then the book ends. It's hard not to chuckle awkwardly the first time you read it, especially if you're a teenager to whom the entire joy of the story was the wizards and witch queens and world-saving heroes.

Tolkien's celebration of the mundane was not the mark of a guy who didn't know how to end a story. (He was very bad at *finishing* stories, but that's perfectionism for you.) And "Well, I'm back" was not meant as a cheerful motivational poster yelping "Count your blessings" or "Appreciate the small things." It was an ending written by a man who'd brought his life to a point of hard-won stability, who relished finding joy in mundane moments in part because he could never be certain those moments would last.

"He was never moderate," Carpenter wrote in his biography. "Love, intellectual enthusiasm, distaste, anger, self-doubt, guilt, laughter, each was in his mind exclusively and in full force when he experienced it; and at that moment no other emotion was permitted to modify it. He was thus a man of extreme contrasts. When in a black mood he would feel that there was no hope, either for himself or the world [. . .] but five minutes later in the company of a friend he would forget this black gloom and be in the best of humor."

The most important thing that the *Lord of the Rings* movies grabbed from the books wasn't any particular plot detail, but an earnest belief that hope can coexist with despair, so long as we never surrender to it. Boyens, Jackson, and Walsh took the emotional themes of their subject entirely seriously and sincerely,

imbuing the trilogy with humor that never pointed back on itself, no matter how operatic it got.

Hollywood took many lessons from the *Lord of the Rings* trilogy, reframing big-budget film ever since. Fantasy adaptations could make truly enormous amounts of money. Audiences would sit through a three-plus-hour action film. And they would return year after year for the next installment of a story.

But blockbuster film didn't embrace the sincerity of the *Lord of the Rings* movies—the way they elevated deep and pure emotions to the level of an adult epic—in the same manner. There are still a few films of that kind that break into the cultural consciousness, either as cult favorites (*Pacific Rim*) or unexpected successes (*Mad Max: Fury Road*), but they are the exception to the Marvel Studios/DC Films/Sony Pictures/HBO rules of self-referential, self-effacing, sometimes-even-fully-cynical fantasy and hero tales.

In a way, the Romantic blockbuster is kind of like the ending of Tolkien's magnum opus itself: diminished, and gone into the West. But that's why the movies have proved themselves so timeless. In hard times, we do not look for a story that winks and says, "All this drama is a little silly and unrealistic, isn't it?"

We look for a story about when times were hard and showed no sign of ever getting easier, and the heroic path was to believe against all evidence that they would. A story about how there is nothing trite in everyday happiness, and that even when everything else declines such happiness will persist. That the Dawnless Days will be followed by a sunrise if we just keep going, keep going, keep going.

If you want to read more about...

> The legacy of Tolkien's faith, turn to page 198—"Evangelicals Saw Their Foes in Harry Potter and Themselves in The Lord of the Rings" (Second September)

> The meaning of the The Lord of the Rings in uncertain times, turn to page 56—"The Ecstasy of Seeing The Lord of the Rings in Theaters in 2021" (November)

ABOUT THE AUTHOR

Susana Polo is a journalist and writer living in New York City, and a senior entertainment editor at Polygon.com. Her wheelhouse includes superhero comics, The Lord of the Rings, Star Trek, and many more strange and wonderful corners of popular culture.

Raised in New Jersey, she graduated from the creative writing program of Oberlin College and began her career at Abrams Media, where she founded TheMarySue.com in 2011. She joined Polygon in 2015 to start the site's expansion from covering the world of video games to the wide world of entertainment and culture. She has been invited to speak on comics, pop culture, fandom, and their intersections with queerness, race, and feminism at venues like San Diego Comic-Con, New York Comic Con, WorldCon, and the Brooklyn Historical Society, as well as for broadcasters like NPR and the BBC.

In her free time she reads millions of comic books, does a lot of cross-stitch, watches horse videos on YouTube, and plays video games and TTRPGs. Her favorite non-Middle-earth-related thing that J.R.R. Tolkien wrote is his short story "Leaf by Niggle," and she would recommend it to anyone.

Andrea Ayres is a writer living in San Jose, California.

Austen Goslin is a writer and editor currently working at Polygon.com and living in Los Angeles

Chris Feil is a writer and the co-host of the podcast This Had Oscar Buzz. His work has been seen in *Vanity Fair*, *Vulture*, *The Daily Beast*, and elsewhere.

Chris Plante is a writer and editor living in Southern California. He co-founded Polygon and co-hosts The Besties podcast.

Clifford S. Broadway, Senior Writer and Livesteam Host for TheOneRing.net, is co-author of "The People's Guide to J.R.R. Tolkien" (2003) and co-writer/producer of the award-winning documentary feature *RINGERS: LORD OF THE FANS* (Sony, 2005). Residing in Los Angeles, his writings on Tolkien have appeared in places as varied as "Famous Monsters of Filmland" magazine and DeviantArt.

Daniel Dockery is a writer for Crunchyroll, Vulture, Polygon, Inverse and Wired. His debut nonfiction book, *Monster Kids: How Pokémon Taught A Generation To Catch Them All*, is available wherever books are sold.

Drew McWeeny has been living and working in Los Angeles since 1990. He's an award-winning playwright, a produced screenwriter, and he's been a major force in online film criticism since 1997. His best work is his two sons.

Isaac Butler is the author of *The Method: How the 20th Century Learned to Act* and co-author with Dan Kois of *The World Only Spins Forward: The Ascent of Angels in America*.

James Grebey is an entertainment journalist and editor living in Los Angeles. His work has appeared on Polygon, Vulture, TIME, Inverse, and more.

Jeremy Gordon is a senior editor at *The Atlantic* whose work has appeared in the *New York Times*, the *Nation*, and *GQ*. His debut novel, *See Friendship*, will be published in 2025 by Harper Perennial.

Jeremy Mathai is a pop culture writer and film/TV critic based in New York. He's currently a staff writer for SlashFilm and has had prior bylines at IGN, Nerdist, StarTrek.com, and Polygon.

Jim Fishwick (they/them) is a writer, performer and theatremaker based between Australia and Aotearoa. They are the general manager of Jetpack Theatre and contribute questions to the BBC2 show *Only Connect*.

Joshua Rivera is a writer and critic based in Philadelphia.

Karen Han is a screenwriter and culture writer whose criticism has appeared in outlets such as the *New York Times*, *The Atlantic*, *Vanity Fair*, and *New York Magazine*. She is the author of the book *Bong Joon Ho: Dissident Cinema*.

Kendra James is writer living in Los Angeles. Her first book, *Admissions: A Memoir of Surviving Boarding School*, was released in 2022.

Kenneth Lowe is a writer in Springfield, Illinois, and has worked in newspapers, state government, and public relations. He's been a regular contributor to *Paste Magazine* since 2015.

Kyle Turner is a queer freelance writer based in Brooklyn, whose work has appeared in *Slate*, *The Village Voice*, and the *New York Times*. He is also the author of *The Queer Film Guide*, available from Smith Street Books and Rizzoli. He is relieved to know that he is not a golem.

Leon Miller is an Australian freelance writer and professional pop culture geek based in the UK. He writes about film, TV, video games, and comic books for a range of leading online outlets and magazines.

Liz Anderson is a Chicago-based comedy writer and game developer. Her writing credits include The Onion, "Wait, Wait, Don't Tell Me - The NPR News Quiz," and is a writer and editorial lead at Jackbox Games.

Luke Ottenhof is a writer and editor living in Montreal.

Maggie Lovitt is an entertainment journalist and editor living in Northern Virginia. She earned her Bachelor's in Historic Preservation from the University of Mary Washington, and her Master's in Engaged Anthropology at the University of Wales, Trinity Saint David.

Max Covill is a writer and pop culture enthusiast living in Rhode Island.

Molly Knox Ostertag is a graphic novelist and TV writer living in Los Angeles. She is the creator of the graphic novels *THE WITCH BOY* trilogy, *THE GIRL FROM THE SEA*, *THE DEEP DARK*, as well as many more, and was a writer for *THE OWL HOUSE*.

Rebecca Long is an editor and writer whose work has appeared in *The Guardian*, *The Boston Globe*, *Teen Vogue*, and others. Connect with her at rebeccaclong.com.

Sara Murphy is a writer living outside of Asheville, North Carolina. Aside from Polygon, her work has appeared in places the *New York Times*, *National Geographic*, and elsewhere, and she writes about literature and history on her Substack, Seeing Sh*t in Books.

Tim Hanley is a comic book historian and the author of *Wonder Woman Unbound*, *Investigating Lois Lane*, *The Many Lives of Catwoman*, *Betty and Veronica: The Leading Ladies of Riverdale*, *Not All Supermen*, and *Batgirl and Beyond: The Dynamic History of the Heroines of Gotham City*.

Tom Emanuel (he/him) is a theologian, Tolkien scholar, and doctoral researcher at the University of Glasgow. His current research explores why readers have continued to find deep meaning in The Lord of the Rings well into the twenty-first century.

Toussaint Egan is a writer and editor living in the Chicago-land area. He has served as a curation editor for Polygon since 2021.

Zev Chevat is an award-winning animator, director, and media critic, whose non-fiction writing is primarily concerned with depictions of gender and masculinity in genre work. He lives and works in New York City, where he is a film and animation professor.

IMAGE CREDITS

INSIGHT
EDITIONS

PO Box 3088
San Rafael, CA 94912
www.insighteditions.com

www.facebook.com/InsightEditions
Follow us on Instagram: @insighteditions

ISBN: 979-8-88663-555-3

Publisher: Raoul Goff
VP, Co-Publisher: Vanessa Lopez
VP, Creative: Chrissy Kwasnik
VP, Manufacturing: Alix Nicholaeff
VP, Group Managing Editor: Vicki Jaeger
Publishing Director: Mike Degler
Art Director: Catherine San Juan
Designer: Tabula Rasa
Executive Editor: Jennifer Sims
Editorial Assistant: Jeff Chiarelli
Senior Production Editor: Nora Milman
Senior Production Manager: Greg Steffen
Senior Production Manager, Subsidiary Rights:
 Lina s Palma-Tenema

Insight Editions would like to thank the wonderful team at Polygon: Chris Plante, Chris Grant, Andrew Melnizek, Russ Frushtick, Eric Karp, Matt Patches, and Parker Ortolani.

ROOTS of PEACE REPLANTED PAPER

Insight Editions, in association with Roots of Peace, will plant two trees for each tree used in the manufacturing of this book. Roots of Peace is an internationally renowned humanitarian organization dedicated to eradicating land mines worldwide and converting war-torn lands into productive farms and wildlife habitats. Roots of Peace will plant two million fruit and nut trees in Afghanistan and provide farmers there with the skills and support necessary for sustainable land use.

Manufactured in China by Insight Editions

10 9 8 7 6 5 4 3 2 1

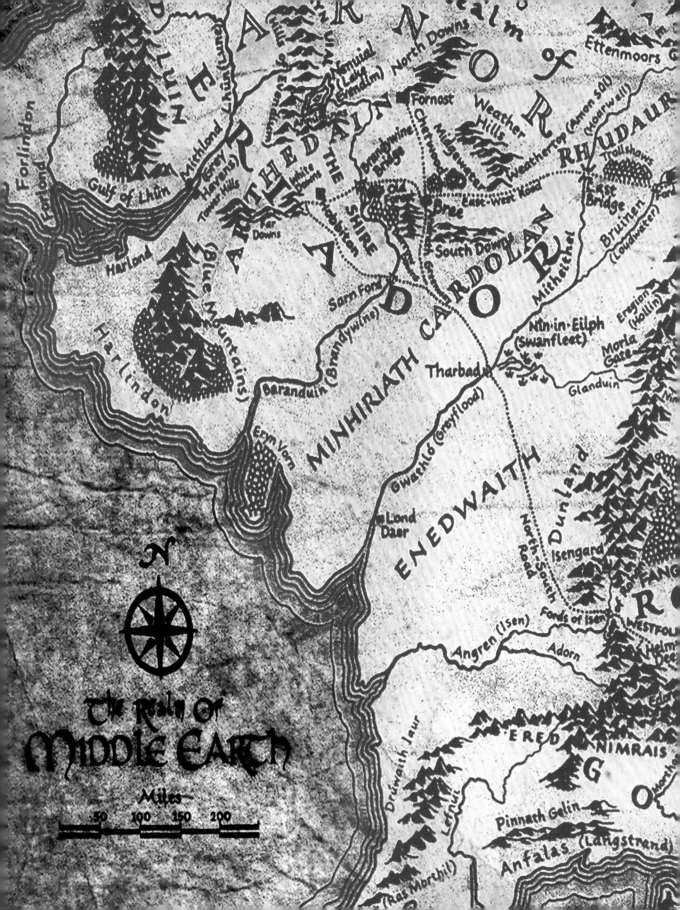